THE
REASONABLENESS OF REASON

THE REASONABLENESS OF REASON
Explaining Rationality Naturalistically

Bruce W. Hauptli

OPEN COURT
Chicago and La Salle, Illinois

OPEN COURT and the above logo are registered in the U.S. Patent and Trademark Office.

© 1995 by Open Court Publishing Company

First printing 1995

All rights reserved. No part of this publication may be reproduced, stored in a retrieval system, or transmitted, in any form or by any means, electronic, mechanical, photocopying, recording, or otherwise, without the prior written permission of the publisher, Open Court Publishing Company, 315 Fifth Street, P.O. Box 599, Peru, Illinois 61354-0599.

Printed and bound in the United States of America.

Library of Congress Cataloging-in-Publication Data

Hauptli, Bruce W., 1948–
 The reasonableness of reason : explaining rationality naturalistically / Bruce W. Hauptli.
 p. cm.
 Includes bibliographical references and index.
 ISBN 0-8126-9283-7 (pbk.)
 1. Reason. 2. Justification (Theory of knowledge) 3. Naturalism.
 I. Title.
BD212.H38 1995
121'.3—dc20 95-14893
 CIP

Contents

Preface	vii
1. JUSTIFICATORY AND KERYGMATIC RATIONALISM	1
1. The Challenge	1
2. Kekes' Justificatory Rationalism	3
3. Briskman's Aim-Oriented Rationalism	7
4. Contextual Justification	9
5. Weakly and Strongly Independent Evaluations	10
6. Appeal to Suitable Metaphysical Assumptions	11
7. Popper's "Faith" in Reason	16
8. Comprehensively Critical Rationalism and Kerygmaticism	20
2. THE REALISTS' RESPONSE TO THE JUSTIFICATIONALISTS' PROBLEMS	27
9. Justificatory Rationalism vs. Realistic Rationalism	27
10. Realism, a Revised Rationalistic Maxim, and Kerygmaticism	30
11. The Realists' Appeal to Regulative Principles	38
12. Qualified Realism and the Appeal to Logic	45
13. Qualified Realism: Skepticism, Arbitrariness, or Therapy?	51
3. NATURALISM AND THE PROBLEMS IT ENCOUNTERS	61
14. Naturalism's Rejection of Strongly Independent Evaluations	61
15. Naturalism, the Rationalists' Maxim, and the Standard Meter	66
16. Naturalism and Groundless Believing	76
17. The Challenges Naturalists Must Confront	79
18. The Naturalists' Initial Response to the Arbitrariness Worry	82
19. Naturalism and Self-Refutation	86
20. Quine's *Reductio*: A Failed Naturalistic Argument	91
21. Qualified Naturalism	94
4. THE NATURALISTS' CASE AGAINST QUALIFIED REALISM AND SKEPTICISM	101
22. The Dialectical Situation—A Brief Overview	101
23. Wittgenstein's Therapy Argument against Moore	103
24. Quine's Therapy Argument against Traditional Epistemologists	108
25. The Naturalists' Naturalistic Response to Skeptical Worries	113

5. DESCRIPTIVE AND EXPLANATORY NATURALISM 125
26. Diverse and Changing Enablers—A Problem for Naturalism 125
27. Descriptive Naturalism: Therapy and Fideism 128
28. Explanatory Naturalism and Our Role as Theory-Changers 136
29. Explanatory Naturalism and Realism 145

6. THE APPROPRIATENESS OF THE EXPLANATORY NATURALISTS' THERAPY 149
30. The Dialectical Situation—Therapy and Ultimate Differences 149
31. Therapy, Qualified Realism, and the Internal Argument 152
32. Therapy, Fideism, and the External Argument 156
33. Therapy, Unqualified Realism, and Kerygmatic Rationalism 161
34. The Interplay of Therapy Arguments and Arbitrariness 173

7. NATURALIZED RATIONALITY: EFFECTIVE, NONARBITRARY, GROUNDLESS BELIEF 183
35. Conceptual Diversity, Arbitrariness and Naturalism 183
36. Fideistic "Alternative" Held Theories and Naturalism 191
37. Explanatory Naturalism, Arbitrariness, and Conceptual Change 196
38. Alternative Evaluative Standards 202

8. EXPLAINING NATURALISTICALLY WHY WE SHOULD BE RATIONAL 207
39. Naturalism, Being Rational, and the Perennial Question 207
40. Understanding the Challenge to Rationality 215
41. Why the Explanatory Naturalists' Recommendations Regarding Conceptual Change Are Preferable to the Fideists' Proposals 224
42. The Explanatory Naturalists' "Hypothetical Imperative" of Rationality 234

Notes 241

Bibliography 261

Index 269

Preface

Rationalists, in the sense in which this over-worked label will be employed here, have traditionally maintained that we have an epistemic responsibility to accept only those beliefs, theories, and commitments which we can justify rationally. Skeptics and fideists challenge such rationalists to rationally justify *this* claim—they ask them to rationally justify their commitment to rationalism. In raising this challenge, they mean to hold the rationalists to their word— skeptics and fideists require that rationalists provide a rational justification for the adoption of the commitment to rationality which they recommend to us.

Skeptics contend that rationalists confront a pernicious paradox here: a rational justification for the adoption of the rational orientation will presume what it is to establish, and any attempt to provide a non-rational grounding for the commitment will constitute a significant retreat from the fundamental tenet of the traditional rationalists' position. Moreover, skeptics contend that the rationalists' inability to fulfill the epistemic responsibility which they accept indicates that we should "suspend belief." Fideists arrive at a different conclusion. They contend that there are beliefs and commitments which are beyond the scope of reason, and they maintain that we must embrace these beliefs and commitments rather than limit ourselves to what we can rationally justify.

The debate between rationalists, skeptics, and fideists has a long history, but I believe that contemporary naturalized epistemology

provides rationalists with what they have sought—a way of adequately responding to the challenges to rationality. In this work I develop a naturalistic explanation of the reasonableness of the rationalists' commitment and, thus, respond to the skeptical and fideistic challenges.

Chapter 1 begins with an examination of the traditional rationalists' orientation and shows that they often fail to fully appreciate the depth of the fideistic and skeptical challenges. While they claim to champion a thorough-going commitment to fulfill the justificatory responsibility which they take on (for this reason, I will call them *justificatory rationalists*), they turn out to be committed to some beliefs or theories which they do not rationally justify; and this provides the skeptics and fideists with all the opening they need.

Some rationalists contend that it is the acceptance of justificationalism which is the problem here—they maintain that if we reject justificationalism we can develop a consistent rationalism which avoids the skeptical and fideistic challenges. In sections 7 and 8 of the first chapter, I consider Karl Popper and W.W. Bartley's versions of such an orientation, and I argue that rationalists who follow this route are ultimately limited to proclaiming their commitment to rationality. In rejecting justificationalism these rationalists seem to mimic the traditional fideists who reject the enterprise of rational argumentation and, instead, proclaim their faith. For this reason I term such theorists *kerygmatic rationalists*—like the Christian fideists, they ultimately proclaim their commitment rather than argue for it. This orientation runs the risk of manifesting an arbitrary commitment to rationality which is fundamentally indistinguishable from the traditional fideists' commitments.

In chapter 2 a different sort of rationalistic response to the justificationalists' problem is considered. *Realistic rationalists*, as I shall call them, re-define the nature of the commitment to rationality and maintain that rationalists should distinguish between one's beliefs, theories, and commitments *being justified* and one's *having a justification* for them. Where justificatory rationalists accept a justificatory responsibility, realists contend that possession of the best possible justification for a belief, theory, or commitment does not ensure that it is, in fact, justified. Their maxim of rationality holds that we have a responsibility to hold those beliefs, theories, and commitments which are, in fact, justified; but they reject the justificatory responsibility which rationalists have traditionally ac-

cepted. These theorists avoid the justificatory rationalists' problems, but I argue that their recommendation of their maxim seems to differ little from the kerygmatic rationalists' (or the fideists') recommendation of their maxims.

Naturalized epistemologists contend that the justificatory, kerygmatic, and realistic rationalists (as well as the skeptics and fideists) all fundamentally misconceive the challenges raised by the phenomena of conceptual diversity and change (which lie behind the skeptical and fideistic challenges). In chapter 3 the naturalists' orientation is introduced. These theorists contend that our justifications and evaluations must be made and offered relative to the acceptance of our held-theory. That is, they contend that the search for independent evaluations of alternative conceptual orientations is a will-o'-the-wisp. Like the kerygmatic and realistic rationalists, the naturalists at best seem to be able to offer an arbitrary preference for the rationalists' orientation (as opposed, say, to the fideistic one).

Chapter 4 examines two naturalistic arguments—L. Wittgenstein's argument against G.E. Moore's version of realistic rationalism, and W.V. Quine's argument against the traditional epistemological orientation and skepticism. This discussion lays the groundwork for the distinction between *descriptive naturalism* and *explanatory naturalism* in Chapter 5. Descriptive naturalists fall prey to the arbitrariness problem noted above, but I develop an argument which contends that explanatory naturalists are able to offer an adequate response to the challenges which are actually raised by the phenomena of conceptual diversity and change.

In chapters 6 and 7 I clarify and assess the explanatory naturalists' argument against realistic rationalists, skeptics and fideists. Finally, in chapter 8 I explain why, according to the explanatory naturalists, we should be rational. To attempt to clarify the argument of these chapters further at this point would be to extend this preface into the whole of the book, and so with but a brief pause to acknowledge my debt to a number of individuals, I turn to the elaboration of the argument sketched here.

My debt to many individuals will be obvious as the overall argument unfolds, but there are several individuals whose influence is not obvious and I wish to acknowledge my debt to them here. As teachers, William Boardman, Carl Wellman, Donald Sievert, and Robert Barrett exerted an influence for which I am most grateful. As I worked through this problem over the past decade, I benefited

greatly from discussions with Eddy Zemach, George Bailey, Howard Bennett, Alice Perrin, Dick Ketchum, Steve Leighton, Paul Draper, and Ken Henley (though none would believe I had taken any of their advice sufficiently to heart). I would also like to thank several anonymous reviewers commissioned by Open Court as well as the copyeditor, all of whose comments made this a far better work. A half-year sabbatical leave and a summer research grant from Florida International University provided opportunities for sustained writing which made it possible to embark upon and continue my writing.

Most important, however, was the sustaining support of my wife Laurie and of my children Meghan and Ian; and, so, I dedicate this work to them.

1
Justificatory and Kerygmatic Rationalism

1. The Challenge

Rationalists have traditionally recommended that we appeal to a rational standard when we evaluate particular beliefs, theories, or actions; when we judge the appropriateness of changes in our belief or conceptual structures; and when we attempt to settle competing claims to intellectual authority amongst diverse conceptual structures. While individual rationalists have recommended radically different rational standards, they have traditionally agreed that we should adopt only those theories and beliefs, and do only those acts, which we can rationally justify (which we can show to accord with the rational standard). Were our beliefs and theories static and our actions rote, such a standard might be of little interest. The phenomena of conceptual diversity and change, and the fact that we are frequently called upon to act in novel situations ensures there is a good deal of interest in such standards however.

Skeptics take the rationalists' justificatory requirements seriously —they demand that rationalists justify their commitment to their rationalistic orientation. Given the rationalists' model of justification as appeal to rational standards, however, any rational argument for the rationalists' commitment to rationalism will itself have to presuppose the acceptability of some rational ground. Skeptics maintain that presupposing the standard to be grounded engenders a question-begging defense, and appealing to some other rational standard engenders a regress which merely delays the question. Whatever criterion rationalists propose for cognitive evaluation and validation, the skeptics maintain, they eventually face the problem of the validation of this criterion.[1]

Fideists claim that there are some beliefs, theories, and commitments which we ought to embrace which we cannot rationally justify. Given the limitations of human reason, they claim, we must accept some beliefs, theories, and commitments on faith. They believe that the rationalists' insistence that we limit ourselves to beliefs and

actions which can garner rational justification means that we would have to forsake important truths. Fideists often offer a *tu quoque* argument against rationalists—they claim that the rationalists' continued commitment to their rationalistic orientation despite their failure to meet the skeptics' challenge shows that these theorists themselves adopt a commitment which is not rationally justifiable. The fideists note that they at least acknowledge the fact that we all must, finally, accept some unjustified commitments whereas the rationalists seem to deny this while nonetheless adhering to a commitment which they cannot rationally justify.[2]

Many Christian fideists would agree with Hume (though they might well doubt his sincerity) when he says: "to be a philosophic sceptic is in a man of letters, the first and most essential step towards being a sound, believing Christian."[3] Kierkegaard, in his *Philosophic Fragments*, maintains there are two responses to such philosophic doubts: one may become a pyrrhonistic skeptic or a person of faith and he, of course, recommends the latter response.[4] Similarly, Pascal maintains that our reason leads us to skepticism while nature confutes the skeptic and keeps us from skepticism. Pascal maintains people are caught in hopeless contradictions as they are pulled one way by reason and another by nature, and faith provides for our salvation here—thus skepticism is one step on the road to faith.[5]

This sort of argument has been offered by philosophers (Kierkegaard and Pascal) who are classified as sincere believers, and by others (Hume and Bayle) who are regarded as skeptics. R.H. Popkin draws a distinction between "theological skepticism" (doubt concerning reasons offered for one's faith) and "religious skepticism" (doubt concerning faith itself) and points out that the former neither entails the latter nor provides any rationale in favor of any given belief.[6] This leaves us with a problem if we wish to distinguish skeptics and fideists—both Kierkegaard and Hume wrote works with underlying skeptical tones, both Bayle and Pascal "confessed" their faith. A writer of even moderate satirical ability could make it almost impossible to separate the believers from the unbelievers.

Whether or not we can point to some factor which allows us to distinguish skeptics and fideists, it is clear that traditional rationalists have maintained that their position *is* different from, and preferable to, those of the skeptics and fideists. In response to the skeptical and fideistic challenges, rationalists have traditionally attempted to rationally justify their claim that their standard is the preferable one

without begging the question or entering into a vicious regress. I will call such rationalists "justificatory rationalists," and in sections 2 through 7 below several such attempts are critically examined. The examination reveals the pervasiveness of the skeptical and fideistic challenges, and the difficulties which these rationalists confront.

The problems encountered by justificatory rationalists provide a powerful reason for rejecting the justificational enterprise, and in the final two sections of this chapter I examine the views of two theorists (Karl Popper and W.W. Bartley) who would champion rationalism against skepticism and fideism while avoiding justificationalism. For reasons which will become clear, I call such rationalists "kerygmatic rationalists"—these theorists reject justificationalism and, ultimately, must simply "profess" their preference for the rational orientation which they recommend. As the remainder of this chapter will show, neither justificatory nor kerygmatic rationalism offers an adequate response to the skeptical and fideistic challenges to rationality.

2. Kekes's Justificatory Rationalism

John Kekes believes that philosophers should provide justified world views.[7] They are to provide systematic and comprehensive theories which combine a reliable account of the nature of reality with a system of ideals which represent possible solutions to our "enduring problems."[8] Kekes terms debates about either the acceptability of, or the precise nature of, our ideals perennial arguments; and he distinguishes two sorts of such argumentation. In *internal* perennial arguments, disputants accept an ideal but disagree as to its nature or specification, while in *external* perennial arguments, they disagree about the appropriateness or acceptability of an ideal.

Kekes writes to defend a particular specification of the justificatory rationalists' ideal against the skeptical and fideistic challenges. According to him, an individual who adheres to the rationalists' ideal incurs

> the obligation of holding only those beliefs and performing only those actions which can be explained and justified on rational grounds. Such an explanation and justification consists in his ability to provide arguments for his beliefs and actions and arguments against rival beliefs and actions.[9]

As I indicated, I will call individuals who accept this specification of the rationalists' ideal *justificatory rationalists*. While such rationalists accept a justificatory responsibility, they offer differing conceptions of the norms and standards of rational justification, explanation, and evaluation. Such disagreements constitute the core of the traditional internal perennial argument with regard to the rationalists' ideal.

According to Kekes, our problems constitute the fundamental link between our theories and the world. Since theories are advanced relative to a background of problems which they are to solve, problem-solving provides the appropriate standard for the evaluation of the adequacy of theories and the yardstick for assessing the rationality of beliefs. Kekes maintains that some problems are such that we are *all* forced to confront them independently of the beliefs and theories we may have and hold. He terms these "problems of life." While it is not logically necessary that we have such problems, given the sort of creatures we are and the sort of environment we inhabit, we must confront them.

As he sees it, then, problem-solving is not a matter of choice—it is required by what we all regard as our well-being. Thus, a commitment to the rational standard of problem-solving is not an unjustified commitment, rather it is externally, universally, and non-arbitrarily forced upon us. While other rationalists champion other standards of rational justification and evaluation, Kekes argues that his version is preferable; and he claims that his version of rationalism overcomes the skeptical challenge which arises in the internal perennial argument with regard to rationalism.

Unfortunately, his attempt does not succeed. The assertion that the problems of life are problems we all must confront is one which the skeptic may question. Kekes holds that our natural sciences provide us with the requisite characterization of ourselves and of our environment. His response to the skeptical challenge to his conception of the rationalists' ideal consists of an appeal to these sciences. The characterizations of persons and their environment offered by the scientists, however, are advanced by biologists, physicists, psychologists, and physiologists to meet certain problems. Clearly, the scientists are not directly confronting problems of life here. The problems they confront directly are those Kekes terms "problems of reflection." He points out, however, that in the final analysis we theorize in order to resolve basic problems of life.[10]

Kekes's appeal to the universal and unavoidable problems of life

2. Kekes's Justificatory Rationalism

seems to provide a ground for the rational standard of problem-solving only as long as one does not demand that he justify his appeal (justify the claim that such problems are universal and unavoidable) and his claim that they ground the standard. His response to such a demand consists of an appeal to the sciences and, he holds, any evaluation of the adequacy of scientific theorizing involves an acceptance of the problem-solving methodology and an examination of how well such theories meet, ultimately, the basic problems of life. However, it is just the appeal to these problems and this standard which was to be supported. To appeal to them here is to beg the question at issue.

The skeptical challenge to the assertion that we all unavoidably and inevitably have and seek to resolve such problems may seem disingenuous. The characterization of ourselves and our environment appealed to seems less a result of advanced scientific theorizing (a hypothesis in a Darwinian explanation, say) than a well-entrenched bit of ordinary common sense. Indeed, a possible response to this skeptical critique seems to be contained in Kekes's remarks on common-sense beliefs.[11] He maintains that common sense beliefs are *basic*. According to Kekes, we have no alternative to interpreting our experience in light of such beliefs—they are "physiologically based" beliefs which normal human beings *must* start with.[12] In short, beliefs about the universality, unavoidability, and necessity of our confronting and resolving the basic problems of life would be beliefs the skeptics *themselves* accept, and any attempt to question, contradict, or raise alternatives here would be disingenuous.

Unfortunately this response merely parallels the initial move on the part of Kekes's rationalist. As a justificatory rationalist, such a theorist is committed to rationally justifying all his or her beliefs, theories, actions, and commitments. Clearly, then, the belief that the common-sense beliefs are "physiologically based" and that they have no alternatives is itself one which must be justified. Appeal to common sense, therefore, begs the question at this point (as does appeal to the basic problems of life); similarly, an appeal to some unmentioned factor would threaten to engender a vicious regress. Either way, failure to provide a justification plays into the skeptic's hand.

Kekes also tries to show that fideists like Tertullian, Luther, and Kierkegaard are wrong. According to him, such fideists maintain "that rational choices among conflicting worldviews are impossi-

ble."[13] Such views provide the very antithesis of the conception of philosophy which Kekes champions. His refutation of such "irrationalist" views parallels his response to the skeptical challenge to rationalism—he claims that the enduring problems of life which we all unavoidably face provide a standard of justification which is context-independent, universal, and nonarbitrary; and he claims that the fideists' views are based upon an *absurd view* of human nature and of our environment. Their view is absurd

> because it flies in the face of facts whose existence no reasonable person would deny. These facts are that human beings always, everywhere share certain basic characteristics. Indeed, they are identifiably human because they have these shared features. They have human bodies with human sensory, physiological, and motor capacities and limitations; they have to obtain the necessities for survival from their environment; they form social groups and live in the midst of other people; they are capable of psychological and physiological pleasure and pain; they can remember the past and plan for the future; they are capable of learning from experience; and so on. These features are universally human, historically constant, and culturally invariant. Having them occasions what I have called problems of life. All human beings have problems of life.[14]

According to Kekes, by relying upon some other authority than reason, fideists run the risk of adopting unsuccessful world views. Rational examination maximizes our chances of solving our enduring problems. Therefore, in eschewing rationality, the fideists pay too high a price for their kerygmatic commitments.

Kekes's response to the fideists is no more adequate than his response to the skeptics, however. Both hinge upon his claim that given our nature and the nature of our environment, the enduring problems of life necessarily arise for us all. While his appeal to a generally Darwinistic account is one many accept today, it is an appeal which a justificatory rationalist must justify. To claim no reasonable individual would deny it is not to offer a justification— especially within the context of an external perennial argument used in the service of the rationalists' ideal.

Kekes believes other justificatory rationalists run into problems because they cannot provide a theory-neutral access to reality which could be used to provide a check upon our theories. He believes his

problem-solving account overcomes this defect and claims that "since the point of theories is to solve problems . . . the ultimate test of their adequacy is whether or not the problems are solved."[15] Unfortunately, his rationalism demands that he justify this claim, and he is only able to appeal to a "truism" here—one he finds himself unable to argue for:

> the best I can do is to repeat what seems obvious: protecting one's physical well-being and security, the resolution of conflicts between one's desires and the rules of society, finding a way of living a satisfactory life are universal human problems that do not come from theoretical commitments, but from the human condition. The thesis is open to objection; it needs merely to be shown that contrary to my claim, these problems do presuppose a theoretical background. But I cannot imagine what such a background could be.[16]

Fideists like Pascal and Kierkegaard *would* question Kekes's claim that the rationalists' orientation is essential in the construction of successful world views. While they might agree that our "human condition" places us in a "problematic situation," their specification of the problems and condition does not accord with Kekes's "Darwinistic" view. Where he maintains that we may rationally recognize the nature of our predicament and come to know what our perennial problems are, they maintain that it is only when we forsake reason and rely upon faith that such enlightenment may be bestowed upon us.

3. Briskman's Aim-Oriented Rationalism

Larry Briskman offers a related view as he attempts to meet the skeptical challenge.[17] He begins by noting that conceptual diversity and change pose a problem only where the logic of the situation is one wherein the theories or beliefs in question *conflict*.[18] Where one is confronted with nonconflicting beliefs, theories, or standards, diversity poses no epistemological problem—one may embrace all the diverse elements. The skeptical demand for a ground or justification of one's choice amongst beliefs, theories, or actions, then, is premised upon the assumption that the alternatives are *competitors*. Briskman points out that where there are competing beliefs, theo-

ries, or actions, however, that feature in virtue of which they are termed "competitors" provides us with a nonarbitrary evaluative standard.

Briskman maintains that our evaluations are ultimately made relative to our aims or goals. Clearly, an appeal to our aims and goals will provide a justificatory rationalist with a viable response to the skeptical challenge only if the phenomena of diversity and change are confined to the level of beliefs and theories, and do not extend to that of aims and goals. Briskman responds to this point by noting that mere multiplicity of aims presents no epistemological problem here—the aims or goals must be competitors before such problems may arise. According to Briskman, aims and goals may be termed competitors only if they are "surrogate-aims" for still more basic aims or goals, and these more basic aims will provide a nonarbitrary evaluative perspective from which the diverse or competing alternatives may be evaluated.

Briskman maintains that our most basic practical aims are not chosen—they are the result of evolutionary selection.[19] At this level we are dealing with species-wide aims and goals and there are no competitors.[20] Evaluations of diverse conceptual alternatives or of various changes in our conceptual and belief structures must be made, ultimately, relative to these fundamental goals, because these goals are forced upon us all, and there are no alternatives at this level. Consequently, the appeal to these goals provides a nonarbitrary and nonquestion-begging evaluative ground which can answer the skeptical challenge to the justificatory rationalists' orientation.

Unfortunately, a justificatory rationalism which relies upon Briskman's discussion runs into the same sort of problem which Kekes's justificatory account encounters. To assert that "our most basic practical aims are those most closely related to our biological survival,"[21] is to assert that *given Darwinism* these are our most basic and primary goals. But Darwinism is not given. Scientists who advance this theory do so because they would solve certain problems and attain certain goals. When the skeptic issues the inevitable justificatory demands regarding these theories, we are led, eventually, to the scientists' basic practical aims—as is the case with the rest of us, they theorize to resolve such problems.

In short, aim-oriented justificatory rationalists assert that the appeal to the Darwinistic basic practical aims provides a nonarbitrary

evaluative foundation. They ground this assertion by appealing to how well the Darwinistic theories meet these basic aims. The grounding is circular and, as a *justification* of the rationalists' commitment, it is inadequate. The skeptical challenge appears to be met only as long as the assumed characterization of ourselves and our predicament is accepted, and the fideistic challenge gains strength from the uncompleted justificatory program.

4. Contextual Justification

David Annis offers a "contextualistic theory of justification" which might seem to be of use in defending justificatory rationalism. He stresses the social character of justification, holding that whether or not one is justified in believing something will depend upon the norms and practices of the community one belongs to.[22] According to him, however, "just as there is no theory-neutral observation language in science, so there is no standard-neutral epistemic position one can adopt."[23] As he sees it, justification is always relative to the social practices and norms of some group and it requires no appeal to beliefs which are justified independently of a social setting. Individuals' statements or beliefs are justified when they are able to meet various objections, and objections are always raised relative to an "issue-context" which determines the appropriate "objector-group."

My statement to another parent that my child's illness is not contagious, for example, is subject to different challenges than would be the case were the assertion made in the context of an examination for the M.D. degree—differing degrees of understanding and differing abilities to meet challenges are requisite in the different contexts. While some beliefs are always "contextually-basic" in that one is never asked for a reason for believing them within a given issue-context, these beliefs change from context to context and from group to group.

Such a view seems to lead toward a subjectivistic account of epistemic justification, and Annis would avoid subjectivism by holding that our evaluations are goal or aim-dependent. In epistemic justification, he says, our most central goals are those of having true beliefs and avoiding false ones. While the specific practices and norms

of justification and evaluation may vary from time to time and from group to group, the two central aims provide for criticism of such differing views.

This response avoids subjectivism only insofar as his assertion that the central epistemic goals are those of having true beliefs and avoiding false ones is acceptable, however. Clearly, skeptics may raise questions here. Indeed, they may appeal to the sorts of problem-solving views of rationality just discussed. A motivating rationale for such theories is the view that problem-solving (rather than truth) is our central aim or goal. Larry Laudan forcefully argues for this orientation as he maintains that the history of science has been one where conceptual changes were motivated not by considerations of truth but, rather, by a concern for problem-resolution.[24] But Annis's orientation offers a response to the skeptical challenge only as long as one does not question his claim as to the central epistemic goals. Once the question is raised, and once one recognizes that alternative accounts of our aims have been offered, one realizes that the skeptical challenge still confronts the justificatory rationalist here.

5. Weakly and Strongly Independent Evaluations

Justificatory rationalists recognize that they will meet the skeptical and fideistic challenges only if nonquestion-begging and nonarbitrary evaluations of conceptual diversity and change are possible. Their theories attempt to provide us with an *independent evaluative perspective* which will allow rationalists to justify their orientation. "Independent" may be used in two senses, however. *Weakly independent* evaluations of conceptual alternatives are those which are independent of the particular conceptual alternatives in question but which depend, ultimately, upon the acceptance of a particular conceptual structure. *Strongly independent* evaluations are those which are not offered relative to an acceptance of *any* particular conceptual structure.

Kekes, Briskman, and Annis offer theories which provide weakly independent evaluations. Justificatory rationalists employing their "problem-solving," "aim-oriented," or "contextualistic" approaches present certain "basic problems of life," "basic practical aims," or "fundamental epistemic aims" as independent evaluative grounds which may be employed in adjudicating changes within (or diversity

amongst) conceptual structures. As we have seen, however, skeptics may demand that they justify the characterization of ourselves and our environment which they rely upon here. As these theorists have accepted a thoroughgoing justificationalism, these presumptions must be defended—no matter how natural they may seem.

It is at this point that any defense of the justificatory rationalists' orientation which appeals to weakly independent evaluations of conceptual alternatives will falter. Such evaluations always depend upon the presumption of some particular conceptual structure. As long as one accepts the appeal to this structure, their justifications and evaluations appear legitimate. Such an acceptance must be justified by justificatory rationalists, however, and here they either beg the question or continue the regress. Having accepted a thoroughgoing justificationalism, these theorists open up an unending series of justificational questions and a continued regress here is a vicious one.

6. Appeal to Suitable Metaphysical Assumptions

In his *Methodological Pragmatism* Nicholas Rescher offers a different sort of response to the skeptical challenge. He maintains that our cognitive methodologies are oriented toward both theoretical and practical ends, and, thus, his view of cognitive justification involves two "distinct yet interlocked feedback cycles": a *theoretical* one where questions of cognitive coherence, systematicity, and comprehensiveness are of paramount importance, and a *pragmatic* one where the central concern is with our welfare. In each case the evaluations are instrumentalistic, but only in the latter case are they pragmatic.

Our logical and other formal methodologies, for example, are to be validated and evaluated by appeal to our goal of systematizing our presystematic practices as well as by appeal to our goal of developing more coherent and comprehensive methodologies. Rescher believes that emphasis upon this sort of instrumentalistic evaluation of formal methodologies allows him to avoid an error which he attributes to W.V. Quine's pragmatic treatment of formal methodologies. Quine views our cognitive structure as a "web of belief" which is not differentiated into theoretical and practical (or logical and empirical) categories, and offers a thoroughgoing pragmatism which subjects this structure *as a whole* to pragmatic appraisal.[25] Rescher

maintains that any revision or evaluation of our empirical beliefs and theories is possible only if we antecedently accept some logical beliefs and principles—it would be impossible to recognize inconsistency, recalcitrant beliefs, or the need for revision unless one presumes some logical principles.[26] If some logical principles and beliefs are presupposed in our empirical inquiries, however, it will not do to maintain that our cognitive structure *as a whole* is subject to evaluation and appraisal—a two-tier approach is necessary.

Rescher maintains that formal methodologies are not merely to "slavishly summarize" the presystematic practices. They have a *normative* aspect and are to criticize them where necessary. Considerations of consistency and generality alone will not lead to such a critique however—some attention will have to be paid to the ends of the practice being generalized, systematized, and rendered coherent:

> coherence when narrowly interpreted is only a matter of the *internal* conditions of adequacy, whereas the normative aspect must also include *external* considerations of functional adequacy and purposive efficacy. These external considerations reflect the purposes for which logic is instituted as a problem-solving (and so end-serving) methodology. . . . coherence becomes coherence *with something*—namely practice. At this stage our instrumentalism takes on a pragmatic coloration. . . .[27]

While Rescher offers a complex picture of the telos of our cognitive methodologies, the pragmatic factor is clearly the most important one. His remarks in regard to the superiority of the scientific methodology further clarify the priority of the pragmatic ends:

> the superiority of the scientific framework does not revolve only—or even primarily—about theoretical considerations (such as that of explanatory adequacy, or—more broadly—considerations of coherence in general), but also and particularly about the pragmatic issues of *problem-solving* and *control*. It is ultimately in *this* regard—and thus not with respect to wholly theoretical considerations—that the scientific method is able to make good its claims to predominance.[28]

Rescher emphasizes that the pragmatism he would offer is *methodological*. From Russell and Lovejoy on, it has been obvious that beliefs which are survival-conducive (those which offer practical advantage or meet our welfare needs) need not be (and, perhaps, are not

generally) those which are true.[29] Here a dilemma confronts pragmatists who concentrate upon *theses* (rather than upon methodologies) according to Rescher: they may maintain that rationally acceptable theories and beliefs are those which, in fact, meet the pragmatic test, thus sacrificing an interest in "the truth"[30]; or they may maintain there is, indeed, a link between pragmatic utility and truth but must sacrifice their pragmatism (since they will have to recognize some criterion of truth other than pragmatic success if they are to establish this link without begging the question).[31]

Rescher's methodological pragmatism is to avoid this difficulty. He contends that while pragmatic success is not necessarily correlated with truth at the level of theses, "given a suitable framework of metaphysical assumptions, it is effectively impossible that success should crown the products of *systematically* error-producing cognitive procedures."[32] The suitable framework of metaphysical assumptions which he appeals to consists of the same sort of picture of ourselves and of our environment offered by Kekes and Briskman. Unlike Kekes, however, Rescher does not appeal to the Darwinian science of the day to validate his appeal to this general perspective. Instead he offers a "metaphysical deduction" which is to justify his conception of the rationalistic ideal:

> the process of reasoning ... involves an inference from certain actual or presumed facts to a suitable explanatory rationale for them, a rationale that of itself may well transcend altogether our information-acquiring techniques in the empirical area. The argumentation calls for a presuppositional regress from the *de facto* realities of a certain practice into the fact-transcending regulative principles by which the workings of this practice are accounted for (i.e., explained and validated).[33]

The Kantian procedure he would follow, then, goes from the successful character of the scientific enterprise (on both the practical and theoretical levels) to a description of what we and our world must be like if this success is to be explained.

According to Rescher, these metaphysical assumptions make our epistemic predicament *conditionally necessary*:

> *given* that we are inquiring beings of a certain kind operating in a world-setting of a certain sort (both of which factors are throughout

contingent), we *necessarily* find ourselves in a position where we can ascertain the adequacy of our cognitive methodology only in a certain way—one which involves reliance on the initially indicated contingent facts.[34]

According to Rescher, these facts provide a suitable explanatory rationale which, while it transcends what we may empirically establish, explains why our cognitive methodology works as it does: given these facts we see why we are driven, ultimately, to pragmatic validation and evaluation and why we are so successful. Moreover, these facts are subject to *ex post facto* validation: though they are "assumptions," they do not arise *ex nihilo*—they must be consistent with our empirical inquiries. Thus the empirical inquiries undergirded by these metaphysical assumptions provide a cyclic support for them.[35]

A predictable move on the part of the skeptic would be to question the appropriateness of these assumptions. Rescher anticipates this move and maintains that any rational discussion will, of necessity, obey certain ground rules. These regulative principles will specify which sorts of expressions and assertions count as evidence, and will assign the burden of proof to one or another party in the discussion—some presumptive truths will have to be accepted. In refusing to grant any assertion the status of presumptive truth and demanding that everything be proven, the skeptics do not lay the burden of proof upon their opponents, instead they make proof and rational discussion impossible—they deny the very ground-rules which govern this enterprise.[36]

Rescher recognizes this complaint will not count as an effective response to all forms of skepticism—skeptics may point out that it is the justificatory rationalist who maintains all our beliefs, theories, and actions should be rationally justified and *this* is what the skeptics would question. In short such skeptics could say:

> "Very well, so acceptance is necessary to the project of rational inquiry or what you call 'cognitive enterprise.' But why should you seek to play this game at all?" At this stage, of course, considerations of theoretical rationality can no longer be deployed appropriately and one must take the pragmatic turn. One clearly cannot marshal an ultimately adequate defense of rational cognition by an appeal that proceeds wholly on its own ground.[37]

6. Appeal to Suitable Metaphysical Assumptions 15

Rescher responds to this skeptical challenge to justificatory rationalism by pragmatically justifying the preferability and appropriateness of the rationalists' cognitive methodologies:

> we justify the adoption of this method in terms of certain *practical* criteria: success in prediction and efficacy in control. (With respect to *methodology*, at any rate, the pragmatists were surely on firm ground —there is certainly no better way of justifying a *method* than by establishing that it "works" with respect to the specific tasks held in view.)[38]

Putting the various points noted thus far together, we may summarize Rescher's response to the skeptical challenge to justificatory rationalism in a manner which exposes its circularity: theses are validated by appeal to methodology; methodology itself is justified instrumentally, and a complex teleology is recognized; though both theoretical and practical ends are recognized, the latter are assigned a priority and, thus, the question of the relation of success and truth must be met; a metaphysical deduction is offered which links successful methodologies and truth provided certain metaphysical assumptions are accepted; and these assumptions are adjudged plausible as they both explain our predicament and are validated by the theses which result from the methodology which they ground; skeptics who challenge all presumptions are convicted of unreasonableness since they refuse to play the "rationality-game"; and those skeptics who question the worth of the game are answered pragmatically.

Rescher might object that while I have shown his view is circular, I have not yet established the viciousness of this circularity. Indeed, one cannot count it as a major accomplishment that one has been able to point to a circularity in an account which emphasizes the role of feedback mechanisms in validations and evaluations. While it might seem that a system-theoretician might legitimately argue that the pragmatic tests and metaphysical assumptions could validate each other in a complex feedback loop, Rescher contends that there must be a "reality principle"—a justificatory loop cannot simply justify itself:

> the pivotal element of action *and reaction* thus provides for the operation of a *"reality principle."* And this is vital to the justificatory

capacities of the whole process, because it blocks the prospect of a futile spinning around in reality-detached cycles of purely theoretical gyrations. Someplace along the line of justification there must be provision for a corrective contact with the bedrock of an uncooperative and largely unmanipulable reality—a brute force independent of the whims of our theorizing. This crucial reality principle is provided for in the framework of the present theory by the factor of the reactive success consequent upon implementing action.[39]

Rescher is not content to offer a "pure" coherence theory of justification (he maintains that "all coherence must be coherence with something"[40]). Pragmatic tests are to provide the crucial "reality principle" which ensures that feedback loops lead to improved methodologies and, thus, to warranted theses. Since he also admits that such tests provide a justification only if we are given the appropriate metaphysical perspective, the proposed system-theoretic mutual justification of the pragmatic appeal and metaphysical assumptions has to appeal to itself as it offers the "reality principle" which is called for by such system-theoretic justification. In short, it must appeal to what it would establish.

Like Kekes, Rescher ultimately offers a weakly independent justification for his version of justificatory rationalism. Whether justificatory rationalists appeal to common sense, science, basic epistemic aims, or to metaphysics, however, they can live up to their goal of accepting no unjustified theories or beliefs (and, thus, meet the skeptical and fideistic challenges) only when they offer a strongly independent justification of their conception of the rationalists' ideal.

7. Popper's "Faith" in Reason

Karl Popper maintains rationalists should respond to the difficulties inherent in the justificatory rationalists' enterprise by rejecting justificationalism. According to him, demands for justification are ultimately satisfied only by an appeal to authority.[41] When the authority which justificatory rationalists (he calls them "comprehensive rationalists") appeal to is questioned, these theorists face what W.W. Bartley calls "the dilemma of ultimate commitment."[42] According to Popper,

7. Popper's "Faith" in Reason

the rationalist attitude is characterized by the importance it attaches to argument and experience. But neither logical argumentation nor experience can establish the rationalist attitude, for only those who are ready to consider argument or experience, and who have therefore adopted this attitude already, will be impressed by them.[43]

Where comprehensive [justificatory] rationalists felt obligated to justify all their beliefs and theories, Popperian "critical" rationalists abandon justificationism and maintain that a commitment to *criticism* is the defining characteristic of rationalism. In his early works, Popper suggests that the critical rationalists' commitment to criticism must be accepted as an *article of faith*: "the fundamental rationalist attitude results from an . . . act of faith—from faith in reason."[44] According to this view, our choice between rationalism and fideism is not a choice between reason and faith but, rather, between the faith of the critical rationalist and that of the fideist.

Popper does not believe that the choice is an arbitrary one, however. He claims we are confronted with a *moral* decision as we choose between the faiths of the critical rationalists and the fideists (or "irrationalists"). Such decisions may be made only by examining the consequences of each choice.[45] According to him, a judgment of preference is called for and, clearly, such judgments require some standard of preference. Popper's standard is made quite clear: he prefers democracy to tyranny, tolerance to intolerance, and a critical attitude to an uncritical one. As he sees it, the consequences of other commitments are partiality, crime, intolerance, and ignorance; thus, he prefers (and believes we should prefer) the critical rationalists' faith.

In addition to this moral argument, the early Popper provides an epistemic argument for his faith. He advances an "objective theory of truth" according to which truth is something we can at best grope for since our attainment of it is a fact we could never recognize. According to him, truth functions as a "regulative principle" for us.[46] He believes that following the critical method will allow us to indirectly approach the goal of truth by allowing us to detect and eliminate error—"the very idea of error . . . involves the idea of an objective truth as the standard of which we may fall short."[47] While we may not know exactly where revisions should be made when our theories are falsified, as long as we hold our new theories tentatively and continue to employ the critical methodology, our knowledge

will grow. While we will continue to hold inadequate theories, our later theories will avoid the errors of our earlier ones, and we will come closer to attaining our goal of truth.

Pragmatists, instrumentalists, and problem-solving theorists would disagree with Popper's view of our epistemic goal, however. Others might question his claim that the critical methodology is truth-conducive. Still other theorists might find fault with Popper's standard of preference—like Plato, they might prefer tyranny to democracy, or intolerance to tolerance. Following Popper's lead, such individuals might also maintain we are confronted with a choice of faiths and maintain that we should (given their standard of preference and their conception of our epistemic goals) adopt their faith or commitment. The early Popper would reject such recommendations—his *Open Society and Its Enemies* and his *Conjectures and Refutations* present sustained arguments for his orientation and against the pragmatists', instrumentalists', and irrationalists' orientations.

Kekes is similar to Popper in maintaining that a pragmatic account of theory preference is inadequate. According to him, an adequate rationalism must distinguish two contexts of justification each having its own standard.[48] In the first, the context of introduction, the main question is whether it is reasonable to suppose that given theories or beliefs could constitute successful resolutions of our underlying problems. Here problem-solving provides the evaluative standard. Since an appeal to this standard allows for the introduction of several theories or beliefs, an additional winnowing process is necessary. In the second context, that of acceptance, the question is one of truth, and the evaluative standard is that of truth-directedness rather than problem-resolution. In maintaining that we must concern ourselves with both contexts, Kekes would distinguish his view from the pragmatists'.

Both Kekes and Popper recognize our fallibility and maintain that there is a gap between the truth and falsity of our beliefs and theories, on the one hand, and the justifiability of our acceptance of them, on the other. They maintain truth and falsity are ideals, and each cites Xenophanes who maintains that were we actually to attain our goal of truth, we could not recognize that this was the case.[49] Both theorists also advance the view that those beliefs or theories which survive critical scrutiny are preferable to those which do not or could not.[50]

When one accepts the fallibility of our theorizing (and, thus, of our criticizing) and the ideality of truth, however, it becomes difficult to legitimately claim that critically-induced changes in our theories and beliefs constitute *progress* or *growth*. The unrecognizability of the goal and the fallibility of our criticisms threaten to make relative truth-directedness indeterminable—one cannot justifiably claim one is closer to a goal which one cannot recognize when one has merely taken a series of tentative and perhaps misdirected steps.

Kekes would meet this problem by appealing to the context-independent standard provided by the underlying problems of life: according to him, the goal of theorizing and of criticism is the development of theories which meet these problems and, thus, they provide a set of facts which any true theory must recognize.[51] Unfortunately, this defense will not do—it confuses the contexts of justification. If the notion of truth-directedness is ultimately given this sort of a pragmatic ground, his two contexts of justification collapse into one. The standards of problem-resolution and truth were to be distinct and operate in different contexts—his appeal to the latter in the context of acceptance was to distinguish his view of justification from the pragmatists'. Yet the measure of truth-directedness seems, ultimately, to be one which appeals to the same problem-resolving ground found in the context of introduction. Thus truth-directedness amounts to nothing more than an indirect appeal to problem-resolution.

To the extent that his appeal to these problems is meant to ground his claims about the truth-directedness of a critical methodology, Kekes must deal with the gap between problem-resolution and truth which he recognizes with his distinction between contexts of justification. Rescher's metaphysical assumptions are meant to meet such a problem. As we have seen, however, his appeal to these assumptions does not provide the justificatory rationalist with the desired strongly independent justification of rationalism. Here, of course, the difference between Kekes and Rescher, on the one hand, and Popper, on the other, surfaces. The former individuals are justificatory rationalists who would meet the skeptical challenge, while Popper would dismiss it—if he is to be consistent, Popper must eschew justificationalism and limit himself to proclaiming his *faith* in the critical methodology which he champions and to proclaiming his faith that this methodology is truth-conducive.

While his rejection of justificationalism allows Popper to avoid the skeptical challenge which the justificatory rationalists face, he faces the challenge of establishing the nonarbitrariness of his preference for the critical methodology. To the extent that he attempts to *argue* for his preference with his moral and epistemic arguments, he embarks upon the very justificationalist path he would avoid. Borrowing from W.W. Bartley, we may say that Popper should abandon the rationalists' correlate of *apologetic theology* (the enterprise of giving rational reasons for one's commitment) and adopt, instead, the correlate of *kerygmatic theology* (the enterprise of describing and proclaiming the fundamental message of one's commitment).[52]

To the extent that Popper's critical rationalists are thoroughgoing in their rejection of justificationalism, however, we find the distinction between rationalism and fideism blurred. Both the fideist and the critical rationalist begin with an item of faith—a belief they must refuse to argue for (since they believe rational argumentation is inappropriate at this point). Here only a *kerygmatic rationalism* may be offered—instead of offering a justification for their specification of the rationalists' ideal, such rationalists must confine themselves to professing their faith in their orientation. Such rationalists face the charge that their commitment to their particular version of the rationalists' ideal is an arbitrary commitment, and Popper would avoid this arbitrariness charge.

8. Comprehensively Critical Rationalism and Kerygmaticism

W.W. Bartley believes the comprehensive (justificatory) and critical (early Popperian) rationalists' responses to the skeptical and fideistic challenges have lacked intellectual integrity. According to him, these theorists have "limited" rationalism by allowing for nonrational commitments and, therefore, aided skeptics and fideists who claim that rationalism is an appropriate orientation only within certain limits. Building upon Popper's early views, Bartley advocates a *comprehensively critical rationalism* which is to avoid placing limitations upon rationality. For Bartley (and for the later Popper) even the "doctrine of criticism"—the view that criticized beliefs are (morally and epistemically) preferable to uncriticizable ones—is open to criticism. *All* one's theories and commitments (even one's

commitment to criticism) are to be tentative, and "rationality" becomes synonymous with "openness to criticism."[53]

Comprehensively critical rationalists follow the early Popper in rejecting justificationalism:

> while agreeing ... that principles and standards of rationality, or frameworks and ways of life, cannot be justified rationally, we regard this as a triviality rather than as an indication of the limits of rationality. For we contend that nothing at all can be justified rationally. *Not only do we not attempt to justify the standards; we do not attempt to justify anything else in terms of the standards.* We do not think that there is any such thing as "well-founded belief" anywhere in the "system."[54]

This position differs from comprehensive [justificatory] rationalism

> in having altogether abandoned the ideal of comprehensive *rational* justification. And it also differs from critical rationalism wherein a rationalist accepted that his position was rationally unjustifiable but went on to justify it irrationally by his personal and social moral commitment to standards and practices that were not themselves open to assessment or criticism.[55]

Bartley believes that the comprehensively critical rationalists' rejection of justificationalism mutes the skeptics' argument that rationality is limited—since they reject the justificatory demand, these rationalists need not attempt to satisfy the skeptics' demand that they justify their commitment to rationalism. Bartley also notes that fideists may not legitimately appeal to the rationalists' failure to meet the skeptical challenge. Indeed, fideists may not offer a criticism of the comprehensively critical rationalists' commitment to criticism unless they are willing to countenance the criticism of commitments. While fideists may shield their position from rationalists' criticisms by claiming that *any* criticism of commitments requires an unargued commitment to criticism, the consequence of this is that *no* criticism of commitments is possible—including, of course, a fideistic criticism of the comprehensively critical rationalists' commitment to criticism:

> one gains the right to be irrational at the expense of losing the right to criticize. One gains immunity from criticism for one's commitment by making any criticism of commitments impossible.[56]

Moreover, Bartley maintains that comprehensively critical rationalists do not fall prey to the arbitrariness worry which plagues the early Popper's critical rationalism since they do not sacrifice their intellectual integrity by adopting an irrational commitment—they are willing to criticize even their commitment to criticism:

> the case [against other rationalists] for arbitrary ultimate commitment rested entirely on the claim that rationality was so limited logically that such [e.g., an arbitrary] commitment was inescapable. As we have seen, there are no such logical limitations for rationality in the proposed nonjustificational approach.[57]

Where other rationalists limited rationality and, thus, had to allow that "the rationalist position, being unjustifiable, was itself not rational,"[58] comprehensively critical rationalists are willing to allow that their orientation is to be rejected if it is successfully criticized and, thus, they do not limit rationality (criticism).

While comprehensively critical rationalists may be able to avoid the "limitations" which justificatory rationalists and skeptics place upon rationality, however, they do not seem to be able to meet the charge of arbitrariness which worried the early Popper. Like the comprehensive (justificatory) rationalists, the comprehensively critical rationalists place great store in one's right (or obligation) to criticize. Others may deny this right (or obligation), value it less highly, or freely sacrifice it for some other perceived good. Such individuals might maintain that the consistency of the comprehensively critical rationalists is, indeed, praiseworthy (as opposed to the less than thoroughgoing critical attitudes of the comprehensive and critical rationalists), *provided that one accepts the value of criticism.* These individuals, however, would not share this preference.

Bartley recognizes that we all hold "countless unexamined presuppositions and assumptions, many of which may be false."[59] He denies that the comprehensively critical rationalists' assumptions are arbitrary however. Since comprehensively critical rationalists are critical of *all* of their commitments, he maintains, their preference for criticism is nonarbitrary; if there are other commitments which are better, the comprehensively critical methodology will expose this fact.

Clearly, proponents of other commitments would point out that this sort of argument for the nonarbitrariness of the comprehensively

8. Critical Rationalism and Kerygmaticism

critical rationalists' preference for their orientation presupposes that one is convinced of the value and efficacy of criticism. Bartley *is* convinced of this, of course. According to him, the main task for the nonjustificatory epistemologist is to answer the following question:

> *how can our intellectual life and institutions be arranged so as to expose our beliefs, conjectures, policies, positions, source of ideas, traditions, and the like—whether or not they are justifiable—to maximum criticism, in order to counteract and eliminate as much intellectual error as possible?*[60]

Clearly others need not share this conviction, however—a "comprehensively uncritical dogmatist," for example, could offer an orientation which was as consistent as the comprehensively critical rationalists'. As long as such theorists consistently abstain from the critical endeavor and champion dogmatically held beliefs, they may maintain that our chief problem is the arrangement of our intellectual life and social institutions in a fashion which wholly forsakes criticism and, instead, ensures that we retain the specific dogmatic commitments recommended. Such individuals would maintain that we will counteract and eliminate intellectual error only if we dogmatically hold on to certain dogmatically given truths.

Such a modern day Tertullian or Pascal might kerygmatically recommend her noncritical orientation as against the critical orientation championed by Bartley and Popper. Where the historical Pascal attempts to convince his reader that the justificatory endeavors of the traditional justificatory rationalists leads them to ignore the true human problems, the modern day "comprehensively uncritical dogmatist" could content herself with a dogmatic assertion that the critical orientation leads us away from the truly human concerns and truths.

When considering such "irrationalist" opponents, the early Popper followed two incompatible impulses: (a) he kerygmatically confessed his "faith" in reason and criticism, and (b) he reverted to justificationalism (offering both a moral and an epistemological argument in favor of his preference for a critical orientation). The comprehensively critical rationalist would avoid both these options.[61] Bartley recognizes that the comprehensively critical rationalists' critical arguments for their commitment to criticism will not persuade opponents who eschew criticism altogether that they should adopt the critical orientation:

[their] argument does not force anyone to be a rationalist; it only shows that there is no rational or logical excuse for being an irrationalist. Anyone who wishes, or who is personally able to do so, may remain an irrationalist. And it may be difficult indeed to argue with any such person, for he will have abandoned argument. No one, for instance, can expect to convince a psychotic that he is ill if he cannot or will not accept the diagnosis. . . .

How should a man who is trying to be a rationalist act toward such people?[62]

Bartley maintains that informed critical rationalists (individuals who recognize that many of their "presuppositions and assumptions" will be overturned upon critical scrutiny) will seriously examine such orientations and attempt to learn and profit from them:

when our object is to learn rather than to win a debate, we must take our opponents' arguments seriously and not reject them unless we can refute them. As far as our aim, learning about the world and ourselves, is concerned, it does not matter whether our opponent reciprocates, or whether he treats our own arguments as no more than emotive signals.[63]

As a version of the external perennial argument with regard to rationality, however, this response constitutes no advance over the early Popper's kerygmatic rationalism. Those who shun the critical enterprise will not consider it a positive sign that the comprehensively critical rationalists would critically examine all sorts of commitments and attempt to critically extract the best possible commitment from the diversity. They would point out that those who firmly believe that a critical methodology is the best way to "learn about the world and ourselves" will, of course, believe this is the appropriate attitude. These "irrationalists" will maintain that these goals are not served by this methodology, however. Since Bartley recognizes that the comprehensively critical rationalists' arguments cannot persuade a committed opponent here, however, we seem to be faced with an arbitrary choice: either we join the comprehensively critical rationalists in adopting the critical orientation, or we join the irrationalists in their noncritical orientation. Bartley's claim that a strength of the comprehensively critical rationalists' orientation is that they can confront their opponents' orientations critically and

"learn" from them, establishes an advantage for his orientation, only if we first take his side and accept the value of the critical orientation.

While such irrationalists could not consistently *argue* against the comprehensively critical rationalists' orientation, the possibility of such an orientation indicates that these rationalists confront the very arbitrariness problem which the early Popper confronts—they must consider whether or not their commitment is but one of several possible ones and they must convince us that their commitment to their critical orientation is indeed preferable to others' commitments. Having rejected justificationalism, however, they are limited to a defense which relies upon the virtue of criticism and such a defense is question-begging. These rationalists, then, must either return to justificationalism or embrace a kerygmatic rationalism.

One might wish to point out that there is a great difference between the rationalists' and the irrationalists' "presuppositions" here. Irrationalists disallow any and all criticism of commitments while the comprehensively critical rationalists seek criticisms—even of their tentative commitment to criticism—and they are willing to revise or change their orientation if such criticisms are forthcoming. Indeed, both Popper and Bartley mark out such a distinction in their discussions of demarcation. They distinguish science from pseudoscience in terms of methodology—the former is the product of a critical methodology while criticism is less than thoroughgoing in the latter. If the fact that the fideists' commitment is uncritical is to tell against such a commitment, however, there must be some basis for the preference for a critical methodology here.[64] It is this question of preference which these rationalists are unable to settle however. The consistent fideist could well admit there is a difference here and yet demur from the conclusion that this difference yields any degree of preferability for the comprehensively critical rationalists' orientation or preference.

While the comprehensively critical rationalists' commitment to the doctrine of criticism is tentative, then, their recommendation that we adopt their orientation may not be issued as a result of deliberation upon independent criteria and grounds for such commitments (for they reject the justificationalists' endeavor). Given a commitment to the critical orientation which Popper and Bartley favor, certain fallibilistic criteria may be appropriate in the evaluation of conceptual change and diversity. Given some other commitment,

however, other criteria may be appropriate. While consistent irrationalists may not criticize the comprehensively critical rationalists' commitment without losing their integrity, consistent comprehensively critical rationalists may not criticize a consistent fideistic commitment without begging the question. In short, each side ends up in a kerygmatic position—they countenance no justification of commitments; they cannot argue for their own commitment (or against others'); and, thus, they may only kerygmatically proclaim their "faith." At worst, the distinction between the rationalists' and fideists' orientations seems to disappear here. At best, such kerygmatic rationalists seem to offer an arbitrary view. Kerygmatic rationalists may well seem to be throwing the baby out with the bathwater, and this leads one to hope for a third alternative. In the next chapter *realistic rationalism* is introduced, and the nature of the response it offers to the skeptical and fideistic challenges is considered.

2

The Realist's Response to the Justificationalists' Problems

9. Justificatory Rationalism vs. Realistic Rationalism

In his "Level Confusions in Epistemology," William Alston maintains that the skeptical arguments raised against justificatory rationalism are flawed because the skeptics fail to note a distinction between one's *being justified* and one's *showing or knowing that one is justified*.[1] According to Alston, the former requires only that there be a "valid epistemic principle" if one's belief, p, is to be justified—one's knowledge of the principle and one's justification for supposing its existence are irrelevant. Alston believes these factors become relevant only when we rise to the next level and question the justifiability of the higher-level belief q: the belief that one is justified in believing that p.

Alston's point may be used by rationalists to develop a rationalism which will not fall prey to either the justificationalists' difficulties or the fideistic challenge. Like Alston, such *realistic rationalists* contend that skeptics and justificatory rationalists confuse "epistemic levels" when they move from questions concerning one's being justified to questions concerning one's showing or knowing that one is justified. They would maintain that the rationalists' maxim requires that we hold only those beliefs, theories, and commitments which, in fact, are justified; but they would not assign or accept a justificatory responsibility—they would not maintain that the rationalists must be able to show that their beliefs, theories, or commitments are justified.

Realistic rationalists might appeal to this distinction between being justified and showing one is justified in order to identify the sort of mistake which justificatory rationalists make. The justificationalists assume that for one's commitment to the rational standard to *be* justified, one must be able to *show* that this is the case. But the "unavoidable problems of life" or the "basic aims" could

provide the valid epistemic principle to which one's beliefs should conform and one's knowing or showing that this was the case could be something additional to the belief's being justified. Thus the skeptics' question "What justifies your assertion that these problems are universal, unavoidable, and necessary?" or "What justifies your assertion that these aims are basic?", would be a challenge to the higher-level belief that we are justified in believing that such problems are unavoidable (or that such aims are basic); and, the realistic rationalists contend, the rationalists' views could *be* justified even where they fail to meet this higher level challenge.

In an earlier article Alston discusses such level confusions and the underlying rationale for foundationalism.[2] As he sees it, the leading rationale for the rejection of foundationalism is the fact that it appears that foundationalists are committed to adopting some beliefs in the absence of any reasons which might render them acceptable. In short, the skeptic would point to the apparent arbitrariness and dogmatism inherent in the foundationalists' appeal to foundations. According to Alston, there is a straightforward reply to such worries:

> for any belief that one is immediately justified in believing, one *may* find adequate reasons for accepting the proposition that one is so justified. The curse (of dogmatism) is taken off immediate justification at the lower level, just by virtue of the fact that propositions at the higher level are acceptable only on the basis of reasons.[3]

Foundationalists need not merely *dogmatically assert* their foundational belief p—they may attempt to establish the higher level proposition that they are immediately justified in believing that p (that is, q). The skeptics' question as to their justification for believing *this* yields not a vicious regress but, rather, a yet higher level rationalistic response.

While one's being justified in supposing that one is justified in believing that p certainly provides one with reasons for believing that p is justified, and while the justificatory questions may be different on each level, a serious justificatory regress arises here for *justificatory* rationalists. If the distinction between epistemic levels is to allow them to avoid the skeptical challenge, then any skeptical challenges which arise on the higher level(s) must be met. While Alston is correct in pointing out the distinction between a belief's being justified and one's knowing or being able to show that this is the case, it is the latter which is requisite for justificatory rationalists.

9. Justificatory Rationalism vs. Realistic Rationalism

The justificatory rationalists' commitment to their rational maxim (that one should accept only those beliefs and perform only those actions "which can be explained and justified on rational grounds"[4]) is what is to distinguish them from the fideists. What is central to the fideistic position is the claim that we *cannot* justify some of our pivotal beliefs, theories, commitments and evaluations—that these must be *accepted on faith* rather than questioned and justified. Fideists accept a limitation upon human reason which justificatory rationalists reject. In rejecting the idea of such limitations, the justificationalists incur an obligation to meet the skeptical challenge —they need to show that their beliefs, theories, and commitments are in fact justified. Thus the skeptical challenge is not an external demand imposed by the skeptics upon justificatory rationalists—it is a *self-imposed* demand. A healthy skepticism ensures there will be no fideistic moments for justificatory rationalists.

This demand engenders their central difficulty however: justificatory rationalists open themselves to the question "What justifies your commitment to your rational standard?" Whatever they appeal to, the skeptics maintain, the appeal will leave them in an objectionable position: (a) if they appeal to their rational standard, they beg the question at issue; (b) if they offer no justification, they confess their fideism; and, finally, (c) if they appeal to some other standard (or if they ascend to another epistemic level), they merely delay the issue and either engender a regress, beg the question at a higher level, or come, ultimately, to confess their fideism.

Alston would avoid such difficulties. As I have indicated, he claims that all that is requisite is that there *be* a "valid epistemic principle" if one's belief, *p*, is to be justified—one's knowledge of the principle and one's justification for supposing its existence are irrelevant:

> what my *being* justified in believing that *p* depends on is the existence of a valid epistemic principle that applies to my belief that *p*. So long as there *is* such a principle, that belief *is* justified whether I know anything about the principle or not and whether or not I am justified in supposing that there is such a principle.[5]

A *realistic rationalist* builds on Alston's distinction. Such a rationalist accepts metaphysical realism and, thus, distinguishes between the truth of an assertion and our evidence for (or awareness

of) this fact; and she maintains that no matter how well-grounded a belief or theory may be (no matter what lengths we go to to *show* that it is justified), it is always possible that it *is not*, in fact, justified. Since our best possible theories (the best that persons however advanced could conceivably offer) might not, in fact, be justified, such realistic rationalists reject justificationalism and maintain that we should embrace those beliefs and theories which *are* justified. Their realism *precludes* their accepting the justificatory responsibility which justificatory rationalists accept.

Clearly, rationalists who adhere to this sort of realism while *also* adhering to justificationalism place themselves in an untenable position. They would require both (a) that one accept only those beliefs, theories, and actions which *are* justified while recognizing that one's justificatory efforts will not identify these beliefs, theories and actions; and (b) that one hold only those beliefs, theories, and actions which one can *show* to be rationally justified. One is to accept only those beliefs which are justified which one can also rationally justify, while recognizing that our best possible justifications may not yield beliefs which are justified. The untenability of such a position indicates that it would be absurd for us to consider the realistic response to the justificatory rationalists' problems as an attempt to rescue justificatory rationalism. The realistic reading of the rationalistic maxim must differ significantly from the justificationalists' reading if it is to constitute a significant position in the internal and external perennial arguments with regard to rationality. In this chapter, two versions of realistic rationalism will be distinguished (an unqualified version and a qualified one), and it will become clear that realistic rationalists will need to confront the arbitrariness challenge which kerygmatic rationalists must confront if they are to provide an adequate response to the skeptical and fideistic challenges to rationality.

10. Realism, a Revised Rationalistic Maxim, and Kerygmaticism

The realistic response to the skeptical dilemma is best construed as a *redefinition* of the rationalistic position. On such a reading, the realists' version of the rationalistic maxim would impose no obligation upon rationalists to justify their theories and commitments—

the only obligation it would impose is that they limit themselves to holding those theories, beliefs, commitments, and evaluations which *are*, in fact, justified.

Realistically-minded rationalists will have to allow that their orientation *itself* is either justified or unjustified. If the latter is the case, however, their position is paradoxical: since the maxim applies to all of our theories and beliefs (everyday, scientific, and epistemic), accepting it seems to require that we also reject it. Such an incongruity might be avoided if one chose to champion a maxim which maintains that "One should accept no theories, beliefs, commitments, or evaluations which are in fact unjustified—except this maxim." While holding such a view avoids the problem of self-refutation, at least one unjustified belief or theory is allowed (one unjustified commitment is made).

Within the context of the external perennial argument with regard to rationalism such a view is not a promising development. The central thrust of the rationalists' position (whether it is construed justificationally or kerygmatically), certainly, is the assertion that one has an obligation to avoid holding such beliefs. In fact, even the traditional fideists or irrationalists do not recommend that we accept such beliefs. They limit rationality and claim that we cannot employ reason to find out which beliefs and theories we ought to hold, but they do not maintain we ought to adopt beliefs or theories which are, in fact, unjustified. Thus, the price paid by those who would accept a view which embraces such beliefs, theories, or actions is too great.

Given the other alternative (that their orientation *is* in fact justified), realistic rationalists could resolve the problems of conceptual change and diversity—they could offer a standard which allows us to examine alternative theories or changes in theory and select those which *are* justified. As realists, of course, they could only demand that the standard employed yield justified beliefs and theories—our ability to *show* that this is the case would be irrelevant. Given this description of their position, however, these realists must admit that traditional fideists might well be paradigmatic realistic rationalists.

As I indicated above, these fideists did not maintain that we ought to accept beliefs, theories, commitments, and evaluations which are *un*justified. While it is often our unhappy lot to unknowingly believe what is not justified, they do not recommend that we adopt such

beliefs but, rather, they hold that human reason is limited and that some beliefs (which *are*, in fact, justified) must be *accepted on faith* rather than being *rationally established*. Like the realists, then, they maintain that we should not accept a responsibility to *show* that our beliefs and theories are justified—all that is relevant is that we accept the right beliefs (those which *are* justified).

Some traditional fideists, like Kierkegaard, maintain these beliefs are contrary to those which might be rationally established.[6] Others, like Montaigne, maintain these beliefs and theories are unreachable by rational methods.[7] Still others pursue an Augustinian approach which maintains faith should precede reason.[8] Whether they recommended a Christian fideism like Pascal, an animal faith like Santayana, or a new mode of nonrational knowing like Bergson, however, fideists maintain that some beliefs which are justified are *beyond the bounds of reason* and of any possible rational justification. Appealing to Alston's distinction, then, we can note that while the beliefs and theories they discuss are not rationally *justifiable*, they are not *unjustified*.

Clearly, these fideists could embrace the sort of realistic rationalism just described without falling prey to any inconsistency. They could maintain one ought to accept only those beliefs, theories, commitments, and evaluations which are justified; they could offer an evaluative standard which selected those beliefs and commitments which are justified; their standard could, in fact, be justified; and they would, certainly, avidly embrace the realists' view that we cannot (and should not attempt to) justify our standards and maxim here—they would willingly reject the justificatory responsibility which the realistic rationalists reject. The only epistemic obligation such fideists would impose, is one which the realistic rationalists also accept—that we hold no beliefs or theories which *are not*, in fact, justified.

Clearly, neither the realistic rationalists nor the fideists should attempt to justify the standard of evaluation or preference they propose to employ in evaluating proposals for conceptual change or cases of conceptual diversity—indeed, each should assert one *could not* provide any assurance that their standard was, in fact, the one which should be accepted. Any attempt to justify their standards here would require that they accept the very justificationalism they reject as they distinguish between a belief's *being justified* and our *showing*

or *knowing* that this is the case. The kerygmatic character of traditional fideisms has often been seen as their main problem by justificatory rationalists however. "If faith and revelation (or some other 'nonrational way of knowing') are all one has to go on," justificatory rationalists ask, "how does one distinguish authentic faith and revelation from their counterfeits?"

Pierre Bayle maintained, as have many Christian fideists, that the essential feature of faith is its *independence of evidence*—it, unlike reason, seeks no reasons, justifications, or evidence—indeed, were there the slightest bit of evidence for those things one accepts on faith, they would be rational claims rather than articles of faith.[9] Similarly, Kierkegaard maintained that fideism and skepticism are opposed to reason: "belief is the opposite of doubt . . . neither of them is a cognitive act; they are opposite passions."[10] While the skeptics fear to believe since no evidence will ensure they are not deceived, fideists faithfully believe—but their commitment is not based upon evidence.

R.H. Popkin notes it is sometimes difficult, given an individual's denial of reason, to determine whether one is confronting a skeptic or a fideist.[11] People have felt, for example, that Montaigne, Charron, and Bayle were insincere in their kerygmatic confessions of faith. Each of these thinkers maintained that all was in doubt, that reason could not reach the truth (at least not without the guidance of faith), and that, thus, one must be a believing Christian. Kierkegaard, of course, subscribes to the same views yet few doubt his sincerity. If one maintains that one's evidence for one's claim is irrelevant, and if there are a variety of different kerygmatic claims, it is difficult for us to see (justificatory rationalists have felt) what we ought to believe— any argument that we ought to adopt some particular beliefs or theories in such a context seems, to them, a non-sequitur. Moreover, to say one must embrace the truth here is an empty platitude—yet this seems to be exactly the position that the realistic rationalists are in.

Realistic rationalists would, of course, point out that there is a difference between accepting an obligation and fulfilling it or living according to its demands. While we and they might not be *able to distinguish* rationalists and fideists, there could nonetheless *be* a difference here—one of the sets of maxims, standards, and beliefs might, in fact, *be* justified while the other might not. Acceptance of

metaphysical realism here, however, requires that one recognize that any claim that a particular maxim, standard, or belief is the one which the rationalists' maxim recommends (no matter how well justified this assertion may be) might well be wrong. In short, even given the assumption that the realistically-minded rationalists' maxim, evaluative standard, and beliefs are justified, the realist must confess that were one confronted with their maxim, standard, and beliefs on the one hand and those of a fideist on the other: (i) one ought to adopt that view which is justified; (ii) one can never know which view this is (the fact of the matter as to which view *is* justified is forever hidden from view); and (iii) any justifications one presents as to the preferability of one view over the other are irrelevant in terms of fulfilling the obligation specified in (i).

Indeed, realistic rationalists cannot argue against the possibility that *both* they and the fideists might fulfill the obligation of offering only justified theories, maxims, and standards equally well—to claim that this could not be the case would be to claim an insight into what possible theories, standards, and maxims are justified. No matter how well justified such a claim might be, realists must recognize that it might not be correct. At best, then, even given the assumption that the realists' orientation is justified, their assertion that it is and that the fideists' is not (or more minimally, that they both are not) can only be regarded as an article of faith on their part. Thus they appear to be in the same position as the Popperian kerygmatic rationalist and they confront an arbitrariness charge which they seem able to meet only kerygmatically.

It is not clear that realistic rationalists will want to concede this point. Consider again Alston's discussion of epistemic levels. He would combat the appearance of arbitrariness and kerygmaticism (on any level) by advancing to a higher level—he would attempt to establish on the higher level that his lower level beliefs are justifiably held. If Alston's realism is a thoroughgoing (or unqualified) one, however, he must recognize that the move to higher level beliefs does not blunt the kerygmatic character of the orientation which he recommends—on *any* level, all that is relevant is that one's beliefs and theories *are* justified. Any higher level beliefs which justify one's belief that one's lower level beliefs are justified will themselves presuppose a valid principle (on a still higher level): the justification offered for one's holding a first level belief which is to allow one to

escape from kerygmaticism and arbitrariness on that level will be accomplished on the second level only given a third level valid principle which stands outside such a justification. On the second level, then, kerygmaticism and the threat of arbitrariness remain.

A brief examination of a view Alston once held is helpful here.[12] He maintained that an individual's self-warranting beliefs that he or she is in a certain psychological state (beliefs Alston termed B's) are in fact justified if there is a valid self-warranting principle. Alston recognized that "the question of whether B's are self-warranted could be construed as a question about the status of this principle."[13] He wished to justify his acceptance of both the beliefs and the self-warranting principle and this, of course, required assent to a yet higher level—as he said, "to be justified in that higher level belief, there has to be a ([yet] higher level) epistemic principle of justification that applies in the right way to the belief in question."[14]

Alston appealed to a reliability principle to justify his acceptance of the self-warranting principle:

> to be justified a belief must be reliable, must be at least highly likely to be correct. . . . there must be relevant facts about the way in which . . . the belief is acquired and/or held, such that given these facts it is at least highly likely that a belief of that sort will be correct.[15]

Appeal to this principle, while it empowers the justification of the self-warranting principle which empowers the justification of various self-warranting B's, leaves us with either a kerygmatic assertion of the reliability principle or with the higher level task of justifying our belief that this principle is in fact justified. That is, appeal to the reliability principle will establish that we justifiably or validly accept the self-warranting principle (which will establish that we justifiably accept the various B's), but it will leave open the question of whether we justifiably accept the reliability principle. Of course, for the thoroughgoing realist, what is important is only whether the principle is valid—whether we can show or know that it is such is unimportant.

Alston's discussion of the valid principles is addressed to the question of the justification of our *epistemic* beliefs—he was interested in establishing that his belief that B's were self-warranted and his belief that the self-warranting principle was justified were both

justifiably accepted. Given his realism and his view of justification, however, he had to ascend to higher and higher levels. While this ascent may continue indefinitely, he maintained that such a regress does not endanger the lower level beliefs and principles since all that is relevant is that these lower level beliefs and principles in fact *be* justified. The coherence of his view does not require that, in his appeal to the reliability principle, he demonstrate that his acceptance of the self-warranting principle and the individual B's is *justified;* our ability to show these things is irrelevant when we are considering whether or not we have fulfilled the responsibility the realists' rational maxim specifies.

Given this, however, it is difficult to see *why* he ascended to the level of the reliability principle. He could have stopped at the first level, maintaining that the individual B's *are* justified and responding to any justificatory queries or to any charges of arbitrariness or dogmatism by insisting upon his realistic distinction. A kerygmaticism on the third level is no less kerygmatic than one on the first one, and a kerygmaticism on some level or other is unavoidable given the thoroughgoing realists' rejection of justificationalism.

As we have seen, while Popper embraces a kerygmatic rationalism he also is tempted to re-adopt the justificationalists' orientation. Realistic rationalists must avoid any re-adoption of justificationalism if they are to avoid the untenability of a "realistic justificationalism." To do so, however, they must be unrepentantly kerygmatic (at some level). In this case, however, there will be little which will distinguish the realistic rationalists' orientation from the traditional fideists' orientations. Such rationalists may feel that their (limited) ability to countenance and answer the "epistemic" questions differentiates their view from the fideists'. This is not the case however. It is open to any fideist to ascending to higher levels while, ultimately, retaining a kerygmatic orientation. Indeed, many fideists have offered justifications for their claims that their first level beliefs are justified by appealing to second or (higher) level beliefs, while holding that on these higher levels one must eschew justificationalism and, simply, have faith.[16]

Realistic rationalists must recognize that their claims that their theories, beliefs, actions, and commitments are justified (and any arguments which they adduce to show this) are irrelevant to the issue

of whether they are indeed fulfilling the obligation specified by their rational maxim. All that is relevant is that the beliefs *be justified*—that there be a "valid epistemic principle." The move to higher levels will not blunt the kerygmatic character of their rationalism—ultimately the justifications one offers for one's actions, commitments, beliefs, and theories are irrelevant if one wishes to live up to the dictates of the realists' rationalistic maxim.

Where it is indeed the case that the realistic rationalists' beliefs, theories, and commitments are in fact justified, it does not seem these theorists deserve any praise for fulfilling the obligation which their maxim assigns. Their thoroughgoing realism ensures that they may never know that this is the case, and ensures that they would reject as irrelevant any attempts to justify their orientation. While their maxim instructs them to adopt only those views which *are* justified, it provides no help (and could provide none) in determining which views are such—they must kerygmatically claim their beliefs and theories are such. Moreover, they may not claim that their orientation is the *only* one which allows one to fulfill the indicated obligation. Thus if they encounter another orientation, their realism renders attempts to defend or justify their orientation pointless when they are concerned with meeting the obligation stipulated by their rational maxim.

In short, their maxim imposes an obligation which may only be met by chance: no matter how well-warranted a belief, standard, or methodology may appear to be, such realists must recognize that it may not *be* justified. Moreover, realistically-minded rationalists, if their view is in fact justified, fulfill their obligation in the same sense (and with the same degree of virtue) as would the fideists who happen to unknowingly (and kerygmatically) champion orientations which *are* justified. To the extent one employs one or the other and, consequently, attains theories and beliefs which are justified, one has fulfilled the epistemic responsibility which the realistic rationalists' maxim imposes. Of course, one can never *know* or *show* that one has attained such theories—all that is relevant is that one *in fact* have them.

Unable to distinguish fideistic and rationalistic commitments or to establish which commitments, actions, beliefs, or theories fulfill this obligation, realistic rationalists may only assert that one should accept those which do fulfill it. Asked which these are, or confronted

with a challenge to their claim that the ones which they champion are such, they must confess both their inability to decide the issue and its irrelevance—they must ultimately limit themselves to the claim that one should accept those alternatives and changes which are justified. Of course, they must also assume their maxim, standards, and theories are such; but they must be, ultimately, unrepentantly kerygmatic here.

11. The Realists' Appeal to Regulative Principles

Some realists appeal to "regulative principles" to avoid the pitfalls which entrap justificatory rationalists while also trying to avoid a kerygmatic rationalism. They maintain that these principles function as *constitutive rules* which govern and guide our cognitive enterprises. Popper may be attempting such a maneuver where he claims truth functions as a regulative principle. According to him, while coherence and consistency cannot function as criteria of truth, incoherence and inconsistency establish falsity and the notion of falsity or error implies an objective truth which is not attained.[17] Without truth as a goal, he claims, the enterprise of exchanging one set of beliefs and theories for another loses its point.

Given Popper's rejection of justificationalism, of course, he should not attempt to justify these claims. Where he does not offer a justification for his claims, however, others may offer different conceptions of our practice and principles, and the specter of arbitrariness arises. Instrumentalists and problem-solving theorists, for example, might maintain that we exchange one set of beliefs and theories for another which more adequately predicts future events or allows us greater control.[18] Popper claims this sort of view cannot account for the real tests which refutations provide for our theorizing—instruments are not refutable; therefore, instrumental theories could be false, even if useful. According to him, then, to adopt the instrumentalists' view is to adopt a view which "is unable to account for the importance to pure science of testing severely even the most remote implications of its theories, since it is unable to account for the pure scientist's interest in truth and falsity."[19] He claims that the instrumentalists' view does not accord with the practice of scientific investigators because it runs counter to the

11. The Realists' Appeal to Regulative Principles

regulative principle which demands that we seek theories which approach the truth. In claiming that his orientation is to be preferred since it accords with both our cognitive practice and the constitutive rules which govern it, however, Popper must either re-adopt the justificationalists' orientation or, ultimately, confine himself to kerygmatic claims.

Rescher also appeals to regulative principles. While he does not reject justificationalism, the "metaphysical deduction" which he offers clarifies the general features of most appeals to regulative principles. According to him, his deduction

> involves an inference from certain actual or presumed facts to a suitable rationale for them, a rationale that of itself may well transcend altogether our information-acquiring techniques in the empirical area. The argument calls for a presuppositional regress from the *de facto* realities of a certain practice into the fact-transcending regulative principles by which the workings of this practice are accounted for (i.e., explained and validated).[20]

His appeal to regulative principles is meant to show that the sort of methodology which he champions yields cognitive development and the growth of knowledge rather than mere change of belief. Rescher maintains that a skeptic who questions the regulative principles grounded by this metaphysical deduction shows that he or she "is unwilling to play the rationality game because he refuses to abide by the evidential ground-rules that govern its management. The skeptic is not a defender of reason, but a fugitive from the enterprise of rational discussion."[21]

He criticizes this skeptical maneuver pointing out (a) that it is self-defeating since it attempts to rationally argue against rational argumentation[22] and (b) that "the practical circumstances of the human condition preclude the systematic suspension of belief as a viable policy."[23] The former argument is not the strong sort of criticism it seems to be however—as a justificatory rationalist, Rescher must recognize that the skeptical challenge arises from within his own view (as a reflection of a thoroughgoing commitment to justificationalism). Here the reference to the skeptical challenge is merely a convenient way of speaking of the justificatory rationalists' self-imposed justificatory responsibility. The latter argument, on the other hand, merely takes us back to the issue of vicious circularity: if

one accepts the metaphysical assumptions, (b) validates the regulative principles—but the skeptic does not seem obligated or necessitated to accept them, and any attempt to argue from Rescher's view of our predicament to the unavoidability of these assumptions will run into the problems noted in section 6.

An important recent variant of the appeal to regulative principles is to be found in the work of those who follow Gilbert Harman. Rather than attempting to meet the skeptical challenge, Harman would show what is wrong with the arguments for such views. He believes that the skeptical problems which justificationalists encounter are the direct result of the fact that they accept deductive argumentation as their model of inference. In doing so, they accept a demand that their beliefs and theories be derived from some yet more basic beliefs and theories, and they must (ultimately) deal with the question of the status of the most basic beliefs and theories. At this point, of course, they encounter the challenges posed by fideists and skeptics. To avoid such unpalatable alternatives Harman discards the deductivist model of inference. His inductivism *begins* with the supposition that the skeptical view is false and seeks to uncover the principles which regulate our cognitive enterprises given this assumption. Here skepticism is turned on its head as we appeal to "intuitive judgments about when people know things to discover when reasoning occurs and what its principles are."[24]

Harman's analysis yields an account of our knowledge as *inference to the best total explanatory account*. According to this view,

> our "premises" are all our antecedent beliefs; our "conclusion" is our total resulting view. Our conclusion is not a single explanatory statement but a more or less complete explanatory account. Induction is an attempt to increase the explanatory coherence of our view, making it more complete, less ad hoc, more plausible. At the same time we are conservative. We seek to minimize change. We attempt to make the least change in our antecedent view which will maximize explanatory coherence.[25]

The regulative principle he arrives at, then, demands that our cognitive inquiries be conducted inductively and that they seek to provide the best total explanatory account of that which we are theorizing about.

Alan Goldman utilizes Harman's theory in his defense of a

realistic rationalism.[26] He would develop a "middle ground" position between the traditional options of foundationalism and coherentism. As Goldman sees it, coherentists maintain all our beliefs and theories must be justified by an appeal to other beliefs and theories—they deny there are any basic or immediately justified beliefs. Foundationalists, on the other hand, maintain there are such basic beliefs and hold that they provide the justificatory foundation upon which all our other beliefs and theories should rest. Traditionally, foundationalists have difficulties when they attempt to delimit the basic beliefs, when they are asked to defend their assertion that these basic beliefs are basic, and when they attempt to ground or validate other beliefs or theories by means of the selected basis. Coherentists, on the other hand, seem to mistake a necessary condition for justification (coherence) for a sufficient condition and, thus, at best they seem to offer only a partial account.

Goldman develops a concept of *self-justification* which is based upon Harman's inductivism: "a belief that p is self-justified according to the model of justification by inference to the best explanation if the truth of p alone best explains the belief that p."[27] Goldman believes "appearing statements" (i.e., "x appears F [to S]," where F refers to a phenomenal property) are self-justified. In defending this view he would not defend a foundationalism however. A foundationalist claim here would be met by the traditional skeptical objections. Goldman admits that his claim that appearing statements are self-justifying itself relies upon an appeal to other beliefs. Instead of seeking yet more basic beliefs, however, he offers a coherentist argument which rests on the claims that "inferring to the best explanation justifies the belief one infers and the belief that one's being appeared to F-ly best explains in itself the belief that one is appeared to F-ly."[28] He would avoid the skeptical demand that basic beliefs be grounded in yet more basic ones by appealing to explanatory coherence considerations. Instead of seeking basic beliefs, he grounds his claims in the regulative principles which guide and govern our cognitive endeavors.

Goldman does not avoid the skeptical and fideistic challenges however. Skeptics may question his appeal to these particular regulative principles and fideists may claim that a preference for these particular principles is arbitrary. In his "Realism" Goldman attempts to meet such challenges and establish the preferability of the realistic

orientation he believes these principles codify.[29] The antirealistic orientation he contrasts his view with is a phenomenalistic one which offers a purely instrumentalistic view of the appearing statements. While Goldman allows that phenomenalists may well be able to offer a coherent instrumentalistic account, he believes they will not be able to offer as *deep* an explanation of experiential phenomena as that offered by the realists:

> accepting then that the same range of experiential phenomena can be explained within a nonrealist metaphysics, there remains the question of the depth of the explanations. It is here that I believe the realist must make his case. Appeal to objects in a phenomenalist sense can explain particular experiences or sequences only in the way in which reference to the generalization that all emeralds are green explains why particular emeralds are green. . . . But there is . . . a difference between explaining the fact that x is F in this way . . . and explaining *why* x is F. While a phenomenalist can explain any phenomenon that a realist can explain in the former way, it is only by appeal to objects in a realist sense that we can explain more deeply why experiences occur, in the sense of showing how they are caused. . . . Regularities within experience that are ultimate or inexplicable for the phenomenalist need not be for the realist, who can appeal to entities which enter into explanations of why these regularities within experience occur.[30]

According to Goldman, a realistic view is preferable to any one which antirealists might offer since it yields deeper explanations, and the best explanation of our cognitive successes is that the realists' view is true. Antirealists who would refrain from the inference from methodological success to truth (or, at least, truth-conduciveness) must admit that it is possible that "grossly misleading theories and beliefs" might be successful and yet be false. But, Goldman contends,

> this thesis seems more complex and more in need of further explanation (of how we could be so successful in these projects if operating with grossly inaccurate beliefs) than the thesis which connects success with approximate truth. . . . If there is this difference, then skepticism regarding realism should reduce to skepticism about the principle of inference to the best explanation. . . . Here I

11. The Realists' Appeal to Regulative Principles 43

am not sure that the skeptic can be answered or needs to be. All the realist need say is that if this principle of inference does not preserve truth, then the world is not susceptible to rational inquiry, however metaphysically construed.[31]

Clearly, Goldman's account falters at the same point as do Popper's and Rescher's. The skeptical and fideistic challenges arise at the point where he appeals to regulative principles and he confronts the options of justificationalism and kerygmaticism. Goldman would avoid the deductivists' pitfall here—he would not attempt to ground the regulative principles he appeals to in some yet more basic beliefs. Instead he offers an inductivist response to the skeptical challenge to these principles:

> in fact a thoroughgoing sceptic cannot be satisfied here, but it seems to me much more reasonable to say that belief in the principle is justified on the basis of the system of belief and (perhaps) knowledge which results from utilizing it, an essentially coherentist reply. Inference to the best explanation itself generates a kind of coherence among beliefs, the justificatory character of which cannot be argued from any immediately justified grounds, as it is presupposed in immediate justification. That the criterion is not itself immediately justified does not show that no beliefs satisfying it are, since it does not function as evidence for them.[32]

The final sentence here clearly shows his adherence to the realists' central distinction. Like Alston, Goldman would claim justificationalists make a major blunder when they demand that we *justify* our beliefs, theories, and commitments rather than simply demanding that we adhere to only those beliefs, theories, and commitments which are justified. According to Goldman, the principle of inference and the application of it in the case of appearing statements function as the "valid principles" which Alston speaks of—they provide realistic rationalists with an evaluative and justificatory standard which *is* justified.

As long as one accepts the regulative principles which he recommends, it will seem reasonable to accept the orientation which Goldman champions. While his preference claims may be compelling if one presumes the realists' perspective, as a *defense* of that preference his argument against phenomenalism is *question-begging*. Goldman

allows the possibility that a phenomenalistic account has all the predictive power of a realistic account. The strength of the realists' account is said to be its *depth*. But this claim is warranted only if one accepts a variety of realistic notions—especially the realists' views on the nature of explanation and on what needs explaining. Their opponents would not grant these assumptions but would, rather, content themselves with explanations which limit themselves to questions of predictive success—to proceed any further than this, they maintain, would be to go beyond what the empirical evidence legitimates.

The appeal to regulative principles here does not seem to settle the issue in favor of realism (nor, of course, would it settle the case in favor of phenomenalism). Individuals may appeal to *other* principles and may question whether we must engage in the practices which realists consider important. Goldman recognizes this and says that we here seem to arrive at a point of "ultimate philosophical difference for which there is no clear resolution through argument."[33] Like the early Popper, he would appeal to the "political and moral" implications of realism and relativism to carry the case for realism against such opponents.[34] Such an appeal encounters exactly those challenges which Popper's appeal confronts however.

It should be noted that the transcendental arguments typically offered by realists to establish their regulative principles employ a "presuppositional regress" from a certain *praxis* to the regulative and constitutive principles which govern and explain that activity. If this sort of argument is otherwise unproblematic, at least one additional point needs to be established if we are to be led to the desired result (the necessity or appropriateness of our acceptance and employment of these principles): we will have to be convinced that these principles are *uniquely suited* to regulate and explain this practice. If this point is not addressed, the appeal to some particular regulative principles will allow for the possibility of an appeal to some *other* principles which might equally well govern and explain the praxis. Clearly this would open the door to the charge of arbitrariness and the fideists' challenge would not be met. Stephen Korner emphasizes the importance of such "uniqueness proofs" for transcendental deductions and notes that they are uniformly absent from such philosophical arguments.[35] Certainly Popper, Rescher, and Goldman do not offer such proofs.

When the appeal to regulative principles is made by justificatory

rationalists (as it is in Rescher's case), it may be seen as an additional case wherein philosophers mistake weakly independent justifications and evaluations for strongly independent ones. Thoroughgoing realists should not attempt to rescue traditional rationalism by answering the skeptic—their realism is to avoid the justificationalists' difficulties without engendering arbitrariness or falling prey to the fideists' challenge. Realists who appeal to regulative principles usually wish to maintain that these principles and the practices which they govern are not *optional*—to allow an appeal to other principles would be to encourage the charge of arbitrariness and to fall prey to the fideists' challenge.

While no inconsistencies need arise if one presumes that the realists' claims are correct, it does not seem inconsistent for others to appeal to a different set of principles. Indeed, barring a "uniqueness proof" on the part of the realists, *all* such views might be correct. Thus, thoroughgoing realists must countenance the possibility that their appeal to regulative principles may not be the one (or may not be the only one) which is appropriate—others may appeal to *different* regulative principles or claim we need *not* engage in the particular practices which the realists would recommend, and their claim may *be* justified. The realists' rejection of justificationalism and their recognition of this possibility seem to legitimate the charge of arbitrariness, and their appeal to regulative principles seems to amount to a kerygmatic expression of a faith in a certain form of rationalism which may be opposed by other expressions of faith.

12. Qualified Realism and the Appeal to Logic

I suspect few realistic rationalists would be willing to advance a kerygmatic view. To avoid this, however, they must establish the appropriateness of their orientation without falling prey to the justificationalists' problems. Clearly it will not do for them to appeal to a set of metaphysical assumptions as does Rescher. Nor may they follow justificatory rationalists and appeal to contemporary science to distinguish their sort of commitment and faith from the fideists'. Such metaphysical and scientific appeals will, certainly, *differentiate* the rationalistic and fideistic orientations. These appeals cannot establish the superiority, preferability, or appropriateness of one

orientation over the others, however. When the appeals are offered in this spirit they involve an illicit return to the justificationalists' program. As we saw in section 9, realistically-minded rationalists who pursue the justificationalists' program find themselves in an untenable position.

The variety of arguments which realistic rationalists might make has not been exhaustively surveyed in the above discussions. Such a comprehensive treatment is unnecessary, however. No matter what strategy they pursue, if they attempt to *defend* their commitment, evaluative standard, beliefs, or theories (if they attempt to *show* that they meet the obligation their rational maxim specifies), they run afoul of their realism. They maintain no matter how careful we are in supplying justifications, it is always possible that the beliefs countenanced may not *be* justified. They do not long for some future epistemological paradise where our justificatory efforts will yield beliefs which *are* justified. Instead, their point is that the obligation which the rationalists' maxim specifies is only that we hold beliefs, theories, and commitments which *are*, in fact, justified. Given their realism, efforts to *establish* that any of their beliefs, theories, or commitments are justified must be higher level efforts—attempts aimed at establishing that we are justified in believing that our lower level beliefs *are* justified. But they must allow that these higher level efforts are, ultimately, irrelevant when it comes to the question of whether or not the epistemological responsibility specified by the rational maxim has been met (since they allow that our best justificatory efforts may yield beliefs and theories which are not, in fact, justified).

Perhaps the unqualified characterization of realistic rationalism I have offered is but a caricature however. Rather than being thoroughgoing in their realism, many realists offer a *qualified realistic rationalism* which holds that some of their beliefs, theories, or commitments both *are*, in fact, justified and are beliefs which they legitimately claim to *know*. Where unqualified realists maintain that even those beliefs for which we have the best possible justification might, in fact, not be justified, qualified realists contend that in the case of certain beliefs we can legitimately claim that we have *knowledge* (and, of course, this means that these beliefs are, in fact, justified). Appeal to such beliefs, of course, would mute the charges of kerygmaticism and arbitrariness which the unqualified realists must confront.

12. Qualified Realism and the Appeal to Logic 47

Many qualified realists, for example, would be loath to countenance the possibility that their claims to know the laws of logic could fail to be legitimate. The truth of these laws is a fact which even the skeptics and fideists must recognize. Any attempt to deny the law of contradiction, for example, will presuppose its acceptance. Here they might cite Aristotle's argument:

> but we have now posited that it is impossible for anything at the same time to be and not to be, and by this means have shown that this is the most indisputable of all principles.—Some indeed demand that even this shall be demonstrated, but this they do through want of education, for not to know of what things one should demand demonstration, and of what one should not, argues want of education. For it is impossible that there should be demonstration of absolutely everything (there would be an infinite regress, so that there would still be no demonstration); but if there are things of which one should not demand demonstration, these persons could not say what principle they maintain to be more self-evident than the present one.
>
> We can, however, demonstrate negatively even that this view is impossible, if our opponent will only say something; and if he says nothing, it is absurd to give an account of our views to one who cannot give an account of anything, in so far as he cannot do so. . . . Now negative demonstration I distinguish from demonstration proper, because in a demonstration one might be thought to be begging the question, but if another person is responsible for the assumption we shall have negative proof, not demonstration. The starting point for all such arguments is not the demand that our opponent shall say that something either is or is not (for this one might perhaps take to be a begging of the question), but that he shall say something which is *significant* both for himself and for another; for this is necessary, if he is to say anything.[36]

If the opponent *says* anything, of course, he or she either *asserts* or denies something and, thus, says that it is true (or false). If, for example, the opponent denies the law of contradiction, he or she must be taken as saying something true—that the law is false. But surely, then, that opponent could not be willing to also assert that the law is true. Thus, in saying the law is false and in saying something meaningful, the opponent must *assume* the very law he or

she would deny—denying the principle requires asserting it. Such a contradictory position is, surely, hopeless; and this helps us see the legitimacy of our knowledge claims in the case of these logical laws.

Unlike the "unqualified" realists (who hold that our best justified beliefs might not, in fact, be justified; and who reject any justificatory responsibility), the qualified realists hold that some of our beliefs are, legitimately, cases of *knowledge* (and, thus, in fact justified). They respond to the skeptics' justificational challenge and the fideists' arbitrariness worry with regard to these knowledge claims in Aristotle's manner: the demand that one demonstrate or justify these claims shows a want of education. Recognizing the tendency of traditional epistemologists to mistake weakly independent justifications for strongly independent ones, qualified realistic rationalists recognize that our best efforts at justification often go astray (that there is a distinction between a belief's *being* justified and our *showing* that this is the case). They could maintain that the skeptics' and fideists' mistake comes in thinking that accepting the distinction at many points implies we must accept it at *all* points.

Following Aristotle yet further, the qualified realistic rationalists could maintain that there is a "negative demonstration" which applies in the case of the beliefs in question (in this case the law of contradiction). This sort of argument hinges upon the charge that those who would deny such beliefs offer views which are *self-refuting*. This "negative demonstration" is to establish that the qualified realists' opponents must agree with them or withdraw into a quiet solipsism.

Two things should be noted about this sort of "negative demonstration" however. First, it would certainly be open for skeptics and fideists to claim that the most that such a line of argumentation could establish would be that the beliefs in question are *unavoidable* for human beings. In short, they could allow the qualified realists' claim that "we all" *presume* such beliefs, that we need them to argue, or that they are at the basis of our argumentative practice, but they could question whether this establishes that such presumptions are *known* (and, thus, in fact justified). It is the stronger claim which is relevant if the qualified realists are to avoid the skeptical and fideistic challenges, however.

The second point to be noted with regard to the qualified realists' "negative demonstration" is that this argument is not as logically forceful as it first appears. In mathematics and logic such "indirect"

12. Qualified Realism and the Appeal to Logic

proofs proceed by (a) assuming the contradictory of that which is to be established, (b) deriving from this a contradiction which (c) establishes the falsity of that assumption and, thus, since its denial must, then, be true, (d) the argument claims that which was to be established is established. In adopting this model of argumentation against their opponents, then, qualified realists will presuppose several things, among which figure prominently the notion that their opponents' views are the contradictory of their own, the notion that the denial of the denial of a proposition is equivalent to its affirmation, and the claim that every proposition is either true or false.

Since the point of this argument is to show that the qualified realists' opponents' views are *self*-refuting, these assumptions must be ones the opponents would grant. But there is little reason to expect they have to accept the realists' semantics, their concepts of assertion and denial, and their view of truth. Here a distinction Michael Dummett draws is of value. He distinguishes four logical laws:

(i) $A \vee -A$ law of excluded middle,
(ii) $--(A \vee -A)$,
(iii) $-(A \& -A)$ law of contradiction, and
(iv) $--A \rightarrow A$ law of double negation;

from four semantic principles:

(i′) every statement is either true or false (the principle of bivalence),
(ii′) no statement is neither true nor false (principle of *tertitium non datur*),
(iii′) no statement is both true and false (principle of exclusion), and
(iv′) every statement that is not false is true (the principle of stability).

He also maintains that "while acceptance of the semantic principle seems to entail acceptance of the corresponding logical law, the converse does not hold."[37] In particular, then, acceptance of the principle of bivalence seems to entail acceptance of the law of the excluded middle, but the reverse need not be the case. Dummett subsumes the various realism-antirealism debates under the "higher-

order" issue of "under what circumstances are we entitled to assume the principle of bivalence for some class of statements?"[38] He believes the thoroughgoing realistic response ("for all classes of statements") and the thoroughgoing antirealist response ("only when we have an effective means of deciding the truth or falsity of each statement in the class") are each "wildly implausible" and his writings constitute an in-depth attempt, for a number of such classes, to adjudicate this issue.

What is important for our purposes here is that Dummett seems to be correct in stressing that the issue resides in the semantic principles. Aristotle's argument with regard to the undeniability of the (logical) laws of contradiction and excluded middle is premised upon a view of meaning and truth—one which seems to imply the (semantic) principle of bivalence applies to all statements:

> those . . . who are to join in argument with one another must to some extent understand one another. . . . therefore every word must be intelligible and indicate something, and not many things but only one. . . . He, then, who says 'this is and is not' denies what he affirms, so that what the word signifies, he says it does not signify. . . . if 'this is' signifies something, one cannot truly assert its contradictory. . . . [Protagoras] said that man is the measure of all things. . . . If this is so, it follows that the something both is and is not . . . that the contents of all other opposite statements are true.[39]

Here, and in the earlier citation, Aristotle is presupposing the principle of bivalence and offering a realists' view of assertion, meaning, and truth. Once it is recognized that the qualified realists' opponents may not be employing the realists' views of truth, assertion, and meaning, however, this sort of argument must be seen as question-begging. Whether or not they accept the same *logical* laws, they may differ with regard to the semantic principles and there is nothing either self-refuting or contradictory in one's not employing the principle of bivalence.

The unqualified realistic rationalists' appeal to logic was to refine the realistic position so that they could avoid an arbitrary kerygmatic commitment without falling into the trap which justificatory rationalists fall into. Their "negative demonstration" was to *establish* their claim that some of their beliefs *are* known (and, thus, in fact justified) while leaving no room for further skeptical or fideistic

challenges. Unfortunately the argument fails to fulfill its promise—it involves an appeal to semantic principles, theories of meaning, and views of assertion and denial which may be doubted or rejected.

13. Qualified Realism: Skepticism, Arbitrariness, or Therapy?

Qualified realistic rationalists would not simply *presuppose* the beliefs which they appeal to—they would avoid the kerygmaticism which accompanies unqualified realism and this means that the beliefs which they appeal to must be *known* (and hence, in fact, justified). Here, of course, the skeptical challenge arises. The skeptics ask why we should accept the qualified realists' claim to knowledge in these cases, and it seems that any attempt to provide a validation of the qualified realists' knowledge claims will fall prey to the skeptical challenge: either the validation will itself appeal to these very claims in question, or it will not; but if it does, it begs the question; and if it does not, it must appeal to other beliefs, and these will in turn have to be validated.

The dilemma may be avoided if qualified realistic rationalists can deny the presupposition here or if they can show that one or the other of the horns of the dilemma can be met head-on. The only way it seems to be possible to avoid the presumption of the challenge here will be if one can argue successfully (i.e., without raising the arbitrariness challenge) that these knowledge claims *require no validation*. After examining whether there is any promise in efforts to address one or the other of the horns of the dilemma, this strategy is examined in this section.

If qualified realistic rationalists attempt to validate their claim to knowledge by appealing to the very knowledge claims in question, they will have to be willing to accept a coherence theory of justification, or they will have to claim that these beliefs are "self-warranting." The latter option will be discussed below. Were they to offer a coherence theory, however, these realists would have to maintain that a knowledge claim may only be evaluated relative to a group of beliefs and theories of which it itself is a part. This view engenders a relativism unless it specifies some group of beliefs or theories *to which* others must cohere and such a relativism will not

allow the qualified realists to escape the skeptical challenges or the arbitrariness worries.

Rescher advances a coherence theory yet maintains that "'to cohere' is a transitive verb: all coherence must be coherence with *something*."[40] He develops a notion of the "data" which are to fulfill this role. Clearly, qualified realists who pursue this line of reasoning will have to respond to the skeptics' question "What validates a particular 'criterion of datahood'?"[41] If they do not do so, they offer a view which embraces the very sort of kerygmaticism they are attempting to eschew. Any attempt to validate these beliefs and theories, however, again confronts the skeptics' challenge. If these theorists are to avoid kerygmaticism and skepticism, then, they will have to defuse the challenge in some other fashion.

Since the qualified realistic rationalists do not seem to be able to validate their knowledge claims by appealing to a coherence theory, one might hope that they could escape the skeptical challenge by claiming that an infinite regress of validating steps would not be vicious here. To allow an infinite regress of validation is to confess one can never actually *validate* one's claims however. One would "validate" one's claims by appealing to others which one has not validated; and if one does "validate" them later, one does so only by relying upon yet others (still further down the line) which one has not validated. Since an infinite regress is allowed, there will always be unanswered validation questions.

Since qualified realistic rationalists hope to avoid the kerygmaticism and arbitrariness allowed for by an unqualified realism (which accepts beliefs without fulfilling any justificatory responsibility), they would be relying upon beliefs they do not validate if they countenanced such a regress. This appears to lead them to the very kerygmaticism and arbitrariness they would eschew and, thus, this sort of response to the skeptical challenge should not be attractive to them. If these theorists are to avoid kerygmaticism and skepticism, then, they will have to defuse the challenge in some other fashion.

The only responses to the skeptical challenge which hold any promise for the qualified realistic rationalists are for them to maintain that the regress of justification ends when one reaches beliefs which are *self-justifying*; or for them to deny the presupposition behind the skeptical dilemma, and to claim that these knowledge claims are in no need of validation (for reasons which will

become clear, these cases may be treated together). Clearly, individuals who maintain that some of their beliefs are self-justified (or in no need of validation) will never concede that they are without justification for these beliefs. Thus, as Alston notes, "self-warrant involves a kind of immunity, immunity from lack of warrant (justification) . . . while at the same time constituting a respect in which one is *in principle and of necessity* in a very strong epistemic position."[42] Alston maintains that this sort of immunity should not be confused with immunity from error (infallibility), from doubtfulness (indubitability), or from refutation (incorrigibility).

In his "Self-Warrant: A Neglected Form of Privileged Access," Alston found the other forms of immunity suspect but he believed self-warrant was defensible. The view which he advanced allowed that an individual's belief about his or her mental states was self-warranted "in cases in which a person is mistaken about his current mental states . . . it even allows for cases in which someone else can show that one is mistaken."[43] For Alston, then, to say that a belief is self-warranting was to say only that if one believed it, this belief cannot fail to be warranted.

Qualified realistic rationalists will not be able to limit themselves to self-warranted beliefs in Alston's sense however. The appeal to self-warranted beliefs is to provide them with an epistemic foundation where the beliefs appealed to are not simply claims but are *knowledge* (and hence are, in fact, justified). If they apply the realistic distinction between having a justification and, in fact, being justified to the "self-warranting" beliefs, their appeal to these beliefs will not meet the skeptical demand for validation of their knowledge claims (indeed, the qualified realists must have *knowledge,* not simply knowledge *claims,* here). Thus qualified realists will have to maintain that the realistic distinction *does not* apply at the level of self-warranted beliefs. These beliefs will have to carry an immunity from *both* lack of justification and from error.[44]

Roderick Chisholm follows the tradition of Thomas Reid and G.E. Moore and offers such a view. He terms his orientation "particularism" and distinguishes it from skepticism and "methodism" by distinguishing two questions:

> (A) "What do we know? What is the *extent* of our knowledge?" and
> (B) "How do we decide *whether* we know? What are the *criteria* of knowledge?"[45]

According to him, "methodists" believe they have an answer to (B), and would work out an answer to (A) in terms of it; "particularists" believe they have an answer to (A), and would work out an answer to (B) in terms of it; and skeptics believe one cannot answer either (A) or (B) without presupposing an answer to the other.

Chisholm begins with the presumption that we do in fact know many things.[46] Since our knowledge claims will, in fact, be justified in such cases, he believes we can develop a theory of evidence from them. In most cases, he says, we can come to recognize that

> "what justifies me in thinking that I know that a is F is the fact that it is evident to me that b is G." For example: "What justifies one in thinking I know that he has that disorder is the fact that it is evident to one that he has those symptoms." Such an answer, therefore, presupposes an epistemic principle, what we might call a "rule of evidence." The rule would have the form:
>
> If it is evident to me that b is G, then it is evident to me that a is F.[47]

Chisholm recognizes that a regress is possible given this rule but he believes it stops when we reach that which is *directly evident*.

According to Chisholm, terms like 'seems' and 'appears' may be used to provide phenomenological descriptions, and if "I can justify a claim to knowledge by saying of something that it *appears* F (by saying of the wine that it *looks* red, or *tastes* sour, to me), where the verb is intended in the descriptive, phenomenological sense . . . my statement expresses what is directly evident."[48] In such cases the statement is not only immune from lack of warrant, it is also immune from error:

> in the case of . . . the "directly evident," conditions of truth and criteria of evidence may be said to coincide. . . . But in the case of other beliefs, conditions of truth and criteria of evidence do not seem to coincide. . . . Hence, if we are not to be sceptics, and if we are not to restrict the evident to what is directly evident, we must face the possibility that a belief may be a belief in what is evident, or a belief for which we have adequate evidence, and, at the same time, be a belief in what is false.[49]

Skeptics and "methodists" would, of course, question these claims —they would demand that "particularists" make manifest the general criterion which would differentiate these claims from "indi-

13. Skepticism, Arbitrariness, or Therapy? 55

rectly evident" ones and which would justify them. Chisholm replies that

> in order to find out whether you know such a thing as that this is a hand, you don't have to apply any test or criterion.
>
> There are many things which, quite obviously, we do know to be true. If I report to you the things I now see and hear and feel—or, if you prefer, the things I now think I see and hear and feel—the chances are that my report will be correct; I will be telling you something I know. And so, too, if you report the things that you think you now see and hear and feel. To be sure, there are hallucinations and illusions. People often think they see or hear or feel things which in fact they do not see or hear or feel. But from this fact—that our senses do sometimes deceive us—it hardly follows that your senses and mine are deceiving you and me right now.[50]

Chisholm does not believe passages such as this *prove* his claims to knowledge. His "particularism" (qualified realism) precludes the need for such proof however. When confronted with doubts with regard to these claims, he appeals to "what we all *know*" rather than attempting to validate his claims by appeal to a general criterion of knowledge—indeed, the general criterion must be grounded in these particular knowledge claims.

In effect, Chisholm *presumes* the perspective of "particularism" in his debate with the "methodists" and skeptics. He is well aware of the fact that skeptics and "methodists" will claim he begins at the wrong point. He also recognizes that any attempt to answer their "challenge" immediately confronts the skeptics' challenge. Thus he says,

> what few philosophers have had the courage to recognize is this: we can deal with the problem only by begging the question. It seems to me that, if we do recognize this fact, as we should, then it is unnecessary for us to try to pretend that it isn't so.
>
> One may object: "Doesn't this mean, then, that the skeptic is right after all?" I would answer: "Not at all. His view is only one of three possibilities and in itself has no more to recommend it that the others do. And in favor of our approach there is the fact that we *do* know many things, after all."[51]

Thus Chisholm's final defense against the skeptics' challenge is to be found in his appeal to "our" knowledge claims.

As was noted earlier in this section, individuals who claim that some of their beliefs are self-warranted will never be willing to concede that these beliefs are unwarranted. If they, like Chisholm, are qualified realistic rationalists who believe that these beliefs are immune from lack of warrant and from lack of error, they will offer no further defense of these knowledge claims. This will not be because they believe such proof is proper but cannot be supplied, however. On their view, *such proof is neither appropriate nor necessary*. Of course, their view is not the only possible one here—skeptics and "methodists" offer differing responses to the two basic questions posed above.

Chisholm does not believe that we are presented with an arbitrary choice amongst these orientations however: his view accords with what we do in fact know—it accords with common sense.[52] Since we do have this knowledge, he claims, skepticism never "rings true" and "methodism" always finds its way back to the particular claims which must be used to ground any general criterion.[53] In short, the demand that they *validate* their claims seems incongruous to such qualified realistic rationalists—since they hold these beliefs are immune to lack of warrant and error, they cannot be led to question them.

G.E. Moore provides a list of nine such claims as he begins his "A Defense of Common Sense," and he employs such claims as premises in his "Proof of An External World."[54] He recognizes that some philosophers have demanded that one *prove* such statements as "Here is one hand" and "Here is another" (uttered as he raises his hands before an audience):

> of course, what they really want is not merely a proof of these . . . but something like a general statement as to how *any* propositions of this sort may be proved. This, of course, I haven't given; and I do not believe it can be given. . . . Of course, in some cases what may be called a proof . . . can be got. If one of you suspected that one of my hands was artificial he might be said to get a proof of my proposition . . . by coming up and examining the suspected hand close up, perhaps touching and pressing it, and so establishing that it really was a human hand.[55]

Moore is well aware of the fact that a multitude of "doubts" could arise here, however, and he claims that no "proof" could dispel them all. A skeptic might raise a version of the "dreaming argument"

offered by Descartes, for example. Such a criticism might seem to undercut Moore's claim that he is standing before an audience with his raised hands. Moore notes, however, that

> I agree ... that if I don't know that I'm not dreaming, it follows that I don't know that I am standing up, even if I both actually am and think I am. But this ... is a consideration which cuts both ways. For, if it is true, it follows that it is also true that if I *do* know that I am standing up, then I do know that I am not dreaming. I can therefore just as well argue: since I do know that I'm standing up, it follows that I do know that I'm not dreaming; as my opponent can argue: since you don't know that you're not dreaming, it follows that you don't know that you're standing up.[56]

Moore believes some philosophers will not only think he has attempted to *prove* such statements as "Here is a hand" or "I am standing up" on the way to proving there is an external world, but that unless he can provide such proofs he will have failed entirely.[57] Such philosophers will, perhaps, go so far as to be fideistic at this point and maintain that the existence of external things must be taken on faith alone.[58] He responds that

> such a view, though it has been very common among philosophers, can, I think, be shown to be wrong—though shown only by the use of premises which are not known to be true, unless we do know of the existence of external things. I can know things which I cannot prove; and among things which I certainly did know, even if (as I think) I could not prove them, were the premises of my two proofs. I should say, therefore, that those, if any, who are dissatisfied with these proofs merely on the ground that I did not know their premises, have no good reason for their dissatisfaction.[59]

According to Moore (and to qualified realistic rationalists who claim that some of their beliefs are both justified and known), the claims appealed to are *not in need of justification*—they end the justificatory regress. The call for justification here is met by the assertion that while one cannot justify these beliefs, they are nonetheless *known*. These beliefs stand as an epistemic bedrock, and this status renders impossible an internal critique which is centered upon the demand for justification. An *internal* attempt to question the

veracity of these beliefs must begin by accepting the claim that these beliefs are immune to lack of warrant and immune to error. Once these immunities are granted, however, the enterprise of criticizing the beliefs becomes hopeless—after all, they are *known to be true*.

It might seem that the qualified realistic rationalists' claim that they cannot lack warrant and cannot be in error in the case of these beliefs is dogmatic. Moore recognizes this fear but maintains that

> in the case of assertions such as I made, made under the circumstances under which I made them, the charge would be absurd. On the contrary, I should have been guilty of absurdity if, under the circumstances, I had *not* spoken positively about these things.[60]

While doubt might be appropriate and error may be possible for others (under different circumstances), in these circumstances these contingent propositions are known to be true by all of us. Qualified realistic rationalists may differ among themselves as to which claims have such a status, but they agree that self-warrant and immunity from error coincide, and they maintain that the fact that we all know such things ensures that their view is neither dogmatic nor arbitrary while allowing them to avoid the skeptical challenge and the fideistic suggestion of arbitrariness.

According to Chisholm, "methodists" may also offer a view which is immune to the skeptical challenge. Such theorists would appeal to a *methodology* rather than to particular beliefs. This appeal would allow them to avoid the skeptical challenge and the charge of arbitrariness as well as any fideistic challenge which might confront them. While others might question their claims about the methodology they champion, such questions could not arise as a part of an internal argument against their view—the methodological principles they appeal to would be ones which they hold to be self-warranted and immune to error. Like the "particularists," then, these theorists would rest their response to the charges of arbitrariness and dogmatism upon an appeal to what we all know to be true.

While justificatory rationalists, unqualified realistic rationalists, and qualified realistic rationalists who maintain their self-warranting beliefs are not immune to error, *all* seem to offer versions of rationalism which fall prey to skeptical challenges or to kerygmaticism; qualified realistic rationalists who claim self-warrant and immunity to error for some of their knowledge claims (or

methodologies) do not seem to fall prey to these problems. These qualified realistic rationalists offer a view which avoids the skeptical dilemma and which also avoids the kerygmaticism (and arbitrariness) which seems inappropriate in the kerygmatic rationalists' and in the unqualified realistic rationalists' rationalism. As I will show, however, such rationalists offer a version of rationalism which makes the same central philosophical mistake as that made by the skeptics, the fideists, the justificatory rationalists, and the unqualified realists. In order to expose the error of their ways, however, I will first have to introduce one final position in the internal and external perennial arguments with regard to rationalism—that of the naturalists. After introducing the naturalists' orientation in the next chapter, I will turn to developing a naturalistic argument against the skeptics', fideists', unqualified realists', and qualified realists' orientations in the internal and external perennial arguments regarding rationality.

3
Naturalism and the Problems It Encounters

14. Naturalism's Rejection of Strongly Independent Evaluations

Traditionally, those who have sought to provide strongly independent evaluations and justifications in an effort to justify their rationalism have embraced a conception of epistemology as *prior philosophy,* maintaining that epistemic inquiries should be ahistoric, prior to, and independent of any particular conceptual structures. Many contemporary epistemologists view this traditional conception with disfavor, however.[1] Naturalists are among this group. They maintain that justifications, evaluations, and knowledge claims are such only relative to particular conceptual structures. That is, they claim that knowers, evaluators, and justifiers must presume a particular evaluative or justificatory perspective as they engage in their endeavors.

Naturalists maintain that the sort of epistemological endeavor recommended by justificatory rationalists is futile—since every evaluation is relative to some particular conceptual structure or other, none may be offered independently of *all* such structures. According to naturalists, the question "What justifies our justificatory standard?" is an incoherent one. They maintain that this standard is just that—a standard. *Relative to it*, rational justifications may be advanced and questioned and rational evaluations may be offered. The standard itself is not subject to such justification and evaluation, however.

Larry Briskman attempts to occupy a middle-ground between such a view and justificationalism. He would acknowledge the "relativity or variability of *all* our knowledge without thereby sinking into the self-defeating relativism of an historicist anti-

epistemology."[2] According to him, historicism is the view that "all knowledge is relative to given historical frameworks whose own change and replacement cannot be rationally explained."[3] Such a view is termed "antiepistemological" because it precludes strongly independent evaluations when one is confronted with the phenomena of conceptual diversity and change. Briskman would contend that naturalists may offer only question-begging evaluations of responses to the problems posed by the phenomena of conceptual diversity and change—they must restrict themselves to relativistic justifications and evaluations, and can offer, at most, a sociology, psychology, or history of conceptual change and diversity rather than an epistemology.[4]

Briskman maintains, against the claims of naturalists, that "there *is* a place for prior philosophy"[5]—it provides for the strongly independent (or transcendent)[6] evaluative standards which will enable us to resolve the problems of conceptual diversity and change. He believes that his aim-oriented epistemology offers such a strongly independent (transcendent) standard. As we saw in section 3, Briskman actually offers only a weakly independent standard, however. While he criticizes naturalists like Quine who relativize epistemology to psychology, Briskman ultimately offers a similar view (naturalizing epistemology to *biology*).

Briskman would reject naturalism because he believes it entails relativism. According to him,

> the main claim of relativism . . . is just that the intellectual products of *all* historical periods must . . . be accorded equal intellectual status. Therefore, the anti-relativist . . . positions are the intellectual equals of relativism. . . . So no relativist . . . can coherently argue the intellectual superiority (or preferability) of relativism . . . without (implicitly) denying the very doctrine which he seeks to defend.[7]

This argument is misdirected however—it confuses naturalism and subjectivism. Were naturalists to maintain the "Equipreferability Thesis" (the view that "the intellectual products of all cultures must be accorded equal intellectual status"), their position would certainly be untenable.[8] The main claims of the sort of Quinean naturalism which Briskman attacks are that all our evaluative judgments are made relative to the particular conceptual structure we happen to occupy and that there may be no independent judgments of prefer-

ence.[9] The latter claim is primarily negative—it amounts to the rejection of the enterprise of prior philosophy. The former claim lays the basis for how epistemology is to proceed once the traditional enterprise is rejected—it is to proceed *naturalistically*. That is, epistemologists must conduct their studies relative to the conceptual structure which they presently occupy.

The naturalists' argument against the traditional epistemologists' orientation begins with a critical consideration of the traditional epistemologists' demands for a strongly independent (or transcendent) perspective for evaluations of conceptual changes, and for preference orderings amongst diverse sets of concepts. Such evaluations and preference orderings are not to be offered from within the conceptual structures occupied by those whose concepts, theories, or aims are under consideration and evaluation. Thus, the evaluations to be offered would either have to be relative to the concepts, theories, and aims of the evaluator (the epistemologist), or they would have to be wholly independent of the aims, theories, and concepts of the evaluator as well as of the subjects.

If the former is the case, naturalists note, then traditional epistemologists themselves actually adopt a naturalistic orientation. The evaluations to be offered (while external to the aims, theories and concepts of the individuals whose concepts and preference orderings are under scrutiny) are relativized to the concepts and preferences of the evaluator (the epistemologist)—they are only weakly independent. This is the sort of situation we are actually confronted with in the case of Briskman (as well as in the views of Kekes, Rescher, and Annis). All questions of conceptual change and diversity are actually to be resolved in reference to the account of basic aims which he offers, and this account, as we have seen, is justified by appeal to the conceptual structure of which our modern biology is a central part. Relative to this structure (which we share with Briskman), such evaluations are possible—but they do not provide the strongly independent evaluations required by the traditional epistemologist.

If the evaluations are to be made wholly independently of the aims, theories, and concepts of both the evaluator and the subjects, on the other hand, naturalists maintain that we find that evaluation becomes *impossible*. Conceptual evaluations, like determinations of motion, are always made relative to a· frame of reference. To determine motion one must first choose a frame of reference, a unit

of measure, a method for distinguishing objects, etc., then, *from such a framework*, one may evaluate the motion of the object in question. The same holds for judgments of preference according to the naturalists. Before such judgments may be offered, the judges must be equipped with concepts, theories, standards, and aims—in short, they must judge from the perspective of some conceptual structure or other. Individuals who would offer strongly independent (or transcendent) evaluations of conceptual alternatives, attempt to offer judgments while depriving themselves of such concepts, theories, and aims. This makes talk of evaluation incoherent.

Briskman's aim-oriented epistemology has the virtue of clarifying this incoherence. In offering strongly independent (transcendent) evaluations, traditional epistemologists must abstract from others' concepts, aims, and theories, and they must abstract from (or judge independently of) their own as well. When confronted with a diversity of types of paint, however, one may offer no evaluations until questions of aims and problems are included. Evaluations are possible only relative to such difficulties as children's hand-prints, tropical sun, and sub-zero cold; and only relative to such aims as camouflage, identification, and conformity. To demand a choice of the *best paint* (or any other evaluation of this diversity) from an independent perspective, prior to and independently of any consideration of aims and problems, is to attempt to make a preference ordering without providing any reason or rationale for such preferences.

Consider also the evaluation of alternative investments or changes in a stock portfolio. Weakly independent evaluations would be those offered from the perspective of some particular conceptualization of such transactions and some particular evaluative standard—that which counsels long-term capital gain, or income from investment, or investment to promote social change, for example. A strongly independent evaluation would be one which depended upon no such presumption of a particular perspective or standard. Here one would have to determine the preferable investments or changes in portfolio independent of any consideration of the aims, problems, concepts, or values of either the investors or the evaluators involved. But to attempt to evaluate investments without knowing whether the goal is capital maintenance, investment income, tax loss considerations, social responsibility, political power, or social status, and without any understanding of the problems and concepts available to the inves-

14. Rejection of Strongly Independent Evaluations

tors and evaluators in question is to attempt to make evaluations in a total vacuum. Such a vacuum precludes evaluations—until questions of aims, problems, concepts, and standards are included, evaluations of the preferability of investments or changes in portfolio are impossible.

Naturalists maintain that the argument just sketched shows the incoherence of the notion of nonrelativized evaluative judgments. In arguing in this fashion, they do not argue that the traditional epistemologists' position is "the intellectual equal" of the naturalists'; rather, they argue that the traditional epistemologists' view requires that we make evaluative judgments where we find the notion of such judgments incoherent. Thus, surely, there is a strong reason for abandoning the search for such evaluations and justifications.[10]

The incoherence inherent in the notion of strongly independent (transcendent) evaluations may explain why justificatory rationalists actually offer weakly independent evaluations even though they aspire to provide strongly independent ones. Given the perspective, for example, of the universality, unavoidability, and necessity of the basic problems of life, conceptual alternatives and changes may be independently evaluated (since some perspective and some standards are available from which evaluations may be offered). Without the presumption of some such perspective and standard, however, no evaluations would be possible.

Similarly, Rescher's metaphysical assumptions provide an evaluative perspective only as long as one grants them—and this is exactly what the skeptic will question. The strongly independent evaluations required if the enterprise of prior philosophy is to be possible are ones which cannot be grounded upon a transcendent perspective which is *conditionally* necessary. In offering such a conditional necessity, Rescher provides *weakly* rather than *strongly* independent validations and evaluations. Were he to try to provide for strongly independent ones, his metaphysical perspective and assumption could not be conditionally necessary, and he would have to try to provide evaluations in a vacuum.

If the naturalists' argument can be sustained, it seems that the justificatory rationalists' enterprise is doomed to failure. Transcendent evaluations are impossible and weakly independent ones require an unargued commitment which cannot be justified. This argument raises a question however. If one accepts the naturalists' view that evaluations and justifications take place relativistically, one must next

ask *"relative to what should or do we evaluate and justify?"* Naturalists maintain that we must appeal to the conceptual scheme which we *presently* utilize. In terms of the earlier investment argument, for example, naturalists would claim that our evaluation of investments or changes in portfolio must make reference to our present theories and values, our situation, and our desires.

According to the naturalists, we must make use of the conceptual apparatus presently available until (by employing this apparatus) we can come up with something better.[11] They recommend that we pay full attention to our role as holders of theories or conceptual structures—even as we study our propensity to change the theories and structures we have. Thus the naturalists' full response to the problems posed by the phenomena of conceptual change and diversity will come into clear focus only if we understand their claims about our held theory.

15. Naturalism, the Rationalists' Maxim, and the Standard Meter

Rationalists maintain that rational justification, evaluation, and explanation involve an appeal to a standard of rationality. They differ amongst themselves over the specification of this standard (we have seen appeals to problem-resolution, aim-fulfillment, criticism, and truth). These differences engender one of the recurrent themes in the internal perennial argument regarding rationality—many rationalists attempt to establish that their specification of the rational standard is preferable to any other. This is not the only sort of argument which arises amongst rationalists however. On a more fundamental level, they may disagree as to what, exactly, rationalism requires of us—they may offer different versions of the rationalists' maxim.

As we have seen, Kekes is a *justificatory rationalist*. Such rationalists claim that the rationalists' maxim requires that individuals accept only those beliefs, theories, and commitments "which can be explained and justified on rational grounds."[12] They maintain this stricture applies to their commitment to rationalism as well as to their other beliefs, theories, and commitments; and in the internal perennial argument they attempt to rationally *justify* their claim that their version of the rational standard provides an evaluative standard

which is superior to other conceptions of the rational standard. In the external perennial argument they attempt to *justify* their claim that the rational orientation is preferable to the fideistic orientation.

The difficulties which Kekes encounters as he seeks to provide the requisite strongly independent justifications and evaluations point to the problems which justificatory rationalists confront—their maxim imposes an unending justificatory responsibility. No matter what they appeal to in an attempt to justify their appeal to their rational standards and their preferences, they must justify *this appeal* (given their conception of the rationalists' maxim), and this appeal itself must be justified, and so on. Thus they bring the skeptical challenge down upon themselves in the internal perennial argument.

Skeptics claim, of course, that the justificatory rationalists' failure to meet this responsibility entails that one should (given the maxim) hold no beliefs, theories, or commitments. *Fideists* appeal to the justificatory rationalists' justificatory problems and maintain that such a rationalism is actually a species of fideism. They maintain that justificatory rationalists must ultimately adopt some beliefs, theories, or commitments which they cannot rationally justify.

Kerygmatic rationalists and unqualified realistic rationalists attempt to avoid the difficulties which justificatory rationalists encounter by rejecting justificationalism. When they are as forthright as was the early Popper, they limit themselves to proclaiming their "faith in reason" and their version of the rational maxim requires a kerygmatic commitment to an otherwise thoroughgoing rationalism. No matter how "comprehensive" or "critical" their rationalism is, their rejection of justificationalism requires that they kerygmatically commit themselves; and thus they face an arbitrariness charge—it becomes difficult to differentiate their orientation from that of the traditional fideists.

The *unqualified realistic rationalists* draw a distinction between those beliefs, theories, and commitments which are, in fact, justified and those which we can justify, and they maintain that no matter how well-justified a given belief is, it may not be one which *is*, in fact, justified. According to them, the rationalists' maxim demands that we accept only those beliefs, theories, and commitments which are justified—it imposes no justificatory responsibility upon us.

Since the unqualified realists reject justificationalism, the skeptical challenge to rationalism is muted. Such a position also raises the specter of arbitrariness, however. After all, whatever particular

rational standard these theorists champion, it is open to others to offer other versions of rationalism or to profess other primary virtues. In the internal perennial argument, then, unqualified realistic rationalists will ultimately have to end their case with a kerygmatic statement—since their realism is unqualified, they will have to take it as an article of faith that their version of rationalism is, in fact, justified (that they are fulfilling the responsibility specified by their version of the rationalists' maxim).

In the external perennial argument these theorists confront fideists who kerygmatically profess their unjustified faith and reject justificationalism. Clearly, unqualified realistic rationalists may not attempt to *justify* their preference for their orientation without qualifying their realism and, thus, they must respond to such fideists kerygmatically. Whether they participate in the internal or external perennial arguments, then, the price of avoiding justificationalism by adopting the unqualified realistic rationalists' version of the rational maxim is the acceptance of kerygmaticism.

Qualified realistic rationalists would also avoid the justificatory rationalists' difficulties. Like the unqualified realists, they reject the justificatory responsibility which justificatory rationalists accept. Their specification of the rationalists' maxim also requires that individuals hold *only* those beliefs, theories, and commitments which *are*, in fact, justified. Unlike the unqualified realists, however, qualified realists maintain that we are not forced to adopt a kerygmatic attitude—they qualify their realism by maintaining that some of our beliefs constitute *knowledge*. We are assured that these beliefs are, in fact, justified; we are thus assured that, at least in their case, holding them means we have met the responsibility specified by the qualified realists' version of the rationalists' maxim.

In the internal perennial argument, these qualified realists appeal to common-sense beliefs and offer what I will call a *therapy* argument when faced with those who would question these knowledge claims. Moore and Chisholm, for example, maintain that some of our claims are known but do not require (and cannot be given) a justification. The claims of skeptics and other rationalists are to be met by an appeal to "what we all know." Since these "common-sense" beliefs constitute knowledge, neither the skeptical nor arbitrariness challenges apply against them.

In the external perennial argument, they defend their preference

for rationalism similarly. Their "therapy" arguments show that fideists fail to take our common-sense knowledge claims seriously: when the fideist claims that "since one cannot rationally justify these claims one must rely upon a faith that they are in fact justified (one must provide some nonrational justification)," according to the qualified realist, she fails to recognize that we can legitimately claim to know things which we cannot prove. In his "Proof of An External World," for example, Moore claims that while some (Kant, for example) may feel that it is "a scandal to philosophy" that these common-sense beliefs have not been proven, no such scandal results from our inability to prove them—these knowledge claims do not require justification. This does not mean they must be accepted on faith, however—since they are *known*, faith need not come into play.

The naturalists' orientation may be clarified by contrasting it with these other orientations. Naturalists maintain that qualified realistic rationalists are half right—our rational or evaluative standards are not in need of justification. Like the unqualified and qualified realists, then, they reject the justificatory responsibility accepted by the justificatory rationalists when it comes to our acceptance of our standards. While naturalists agree with the realists that we cannot (or need not) justify our rational or evaluative standards, they offer a different rationale for this claim.

Naturalists *accept* the justificationalists' maxim maintaining that we should accept only those beliefs, theories, and commitments which we can rationally justify. Unlike the justificatory rationalists, however, naturalists do not apply this stricture to the rational standards. This is not because they believe our standards must be accepted on faith, nor is it because they believe we can have knowledge here though we are under no justificatory obligation. Naturalists maintain that the justificatory responsibility does not apply in this case because of the *special role* these standards play in our justificatory and evaluative endeavors: they provide the presumed background against which our justificatory and evaluative endeavors take place; and, thus, they *cannot* be subject to such evaluation or justification.

Naturalists maintain that an understanding of this point undercuts the other orientations and provides us with an understanding of how we may meet the problems posed by the phenomena of conceptual change and diversity. In what follows, I will be concerned

to clarify and assess the naturalists' arguments on these points. Rather than developing a detailed naturalistic conception of rationality, I am concerned with addressing the argument between the justificationalists, skeptics, realistic rationalists, fideists, and naturalists. While the argument offered will be naturalistic, it will not be premised upon any detailed specification of what it is to be rational (to provide reasons, grounds, evaluations, or justifications). I believe that the questions raised in the internal and external perennial arguments regarding rationality should be addressed *before* one attempts such a detailed specification—if the skeptical and fideistic challenges (and the arbitrariness worries raised by Popper and the unqualified realistic rationalists) cannot be met, the endeavor of providing a detailed specification seems to lose much of its point.

Justificatory rationalists, unqualified realistic rationalists, and qualified realistic rationalists agree that one must appeal to rational standards as one offers rational justifications and evaluations. While individual theorists will offer different particular rational standards, the underlying disagreement amongst these theorists concerns the question of the rational status or standing of our rational standards —these theorists offer different responses to the question "*Must our acceptance of the rational standard itself be subject to the same strictures which the rational maxim places upon our acceptance of our other theories, beliefs, and commitments?*"

Justificatory rationalists respond in the affirmative—they maintain that our acceptance of the rational standards must be rationally defended. Where justificatory rationalists attempt to take up this challenge, skeptics agree that rationalists must do so and they maintain it cannot be met. Unqualified realistic rationalists respond in the negative—they maintain that there is no guarantee that even our best justifications will pick out those beliefs, theories, and justifications which *are*, in fact, justified; and, therefore, they maintain that we must ultimately content ourselves with a kerygmatic faith when addressing our acceptance of the rational standards. Fideists also maintain that our justificatory abilities (even in the ideal case) are too limited to capture all of the beliefs, theories, or commitments we should hold. They claim that when it comes to our acceptance of our basic standards, we must content ourselves with a kerygmatic faith (of course, they would offer a different sort of faith than that offered by unqualified realists). Qualified realistic rationalists, finally, maintain that while we cannot justify our appeal

to our standards, these standards are nonetheless known and, thus, we need not settle for a kerygmatic rationalism.

Naturalists maintain that these theorists overemphasize our role as epistemologists (or theory-builders) and this leads them astray. This overemphasis leads them to consider our acceptance of our evaluative and justificatory standards to be similar to our acceptance of other beliefs, theories, and commitments. It leads them to wonder whether the strictures which the rationalists' maxim places upon our acceptance of our other beliefs, theories, and commitments apply when it comes to the acceptance of our standards. While these theorists take a variety of different positions on this issue, naturalists contend that they all radically misconstrue the role which our rational standards play.

According to naturalists, these standards function as the *enablers* relative to which our justificatory and evaluative endeavors take place—it is our acceptance of these standards which enables us to engage in our various evaluative and justificatory practices.[13] Naturalists maintain that the strictures which the rationalists' maxim places upon our acceptance of other beliefs, theories, and commitments *cannot* apply in the case of our standards or enablers. The *special role* they play precludes the justificatory demand in their case. The attempt to rationally evaluate or justify these enablers amounts to an attempt to apply these standards to themselves, and the skeptical and fideistic challenges which arise at this level ask that we rationally evaluate the standards of rational evaluation. Naturalists maintain that the pointlessness of such evaluative or justificatory demands and efforts becomes clear when we understand the special role played by these enablers and cease to overemphasize our role as theory-builders by recognizing the importance of our role as theory-holders.

Wittgenstein's claim that the standard meter in Paris neither is nor is not one meter long provides an example of the naturalists' treatment of our standards which aids one in seeing why naturalists claim that we should not countenance the application of our standards to themselves. According to him, this claim is not meant to "ascribe any extraordinary property to it [the standard meter], but only to mark its peculiar role in the language-game of measuring with a metre-rule."[14] His point here is a "grammatical" or "logical" one—a standard cannot be applied against itself in the way it can be applied against those things it functions as the standard of since it provides the criterion for such an evaluation.

The adoption of a standard meter amounts to assigning a special role to an object—it becomes the means, ultimately, for determining whether objects are or are not one meter in length. In each such measurement, objects are evaluated in terms of the criterion or rule specified by this standard. Clearly the adoption of a standard cannot hinge upon the application of that standard then. The standard meter cannot be adopted because it is a meter long—there could be no judgment that *any* object was a meter long until a standard is adopted. Other considerations may influence the adoption of a standard—we might choose a particular object as a standard because of its beauty, its utility, or because of some inherent or social trait which encourages us to pick out certain sorts of things as standards.

Once a standard meter has been adopted, however, it might seem as if one could maintain that *it* is (exactly) one meter long. After all, it certainly is as long as itself and that is how other things are judged to be or fail to be a meter in length. This view is founded upon a confusion in regard to the standard's role and status however. While one might appeal to *other* standards to offer an evaluation of the standard meter (attempting to evaluate its beauty or utility for example), the attempt to evaluate this standard's conformity to itself would be an "evaluation" radically different from any other which involves an appeal to this standard. Although the standard certainly has all the properties it has and, thus, has those relevant properties which allow *other* things to be judged one meter in length, its special role precludes a "normal" evaluation in its own case. Failure to note this engenders philosophic confusion, according to naturalists.

It may seem that an evaluation of the standard meter by the criterion it specifies yields an obvious truth rather than a confusion: if anything is a meter long *it* certainly must be so. A closer examination of this sort of claim reveals the naturalists' reason for rejecting this claim, however. In the case of any other lengthy object, it is an open question as to whether it is or is not a meter long. An evaluation in such a case would require that one examine the conformity of the object in question to the standard supplied; and there is a margin of error in the application of the standard. But these considerations do not apply to the "evaluation" of the standard itself. Here we confront an "evaluation" which requires no examination of either the standard or the object to be evaluated, yields an exact "measurement," and is completely certain. No examination is requisite since the

15. Naturalism and the Rationalists' Maxim

the standard and the object to be "evaluated" are one and the same (there can be no open question as to whether this object has the properties specified by this standard), and this "measurement" must be exact and certain (allowing for no margin of error) since the degree of conformity of object to standard is a foregone conclusion.

The unique character of this "evaluation" is a warning that the claim that the standard meter is a meter long is radically different from other claims that objects are so (e.g., "This bookshelf is one meter long"). Of course, being unique does not mean the judgment or evaluation is mistaken or incoherent. Indeed, by appropriately controlling the circumstances of the case we might well be able to *assign* a perfectly respectable meaning to evaluations such as "The standard meter is a meter long." What naturalists wish to point out is that philosophers have been misled when they have considered such evaluations—they have construed the issue of the applicability of our standards to themselves as a question about the normal application of our standards and this has led them to radically misunderstand their role.

While confusion with regard to the special role played by the standard meter in the "game" of meter measurement and with regard to the special character of a "judgment" or "evaluation" that the standard meter is a meter long may not seem serious, naturalists maintain this sort of mistake has serious repercussions. If one fails to recognize the special role played by our rational standards, for example, one is led to think of them as on a par with our other beliefs, theories, and commitments. Here philosophical confusion arises as one asks for their credentials while failing to recognize that these beliefs, theories, and commitments function as the standards which allow us to engage in our various evaluative and justificatory "games." Individuals who attempt to treat our rational standards or enablers in this fashion fall prey to the peculiarly philosophical fallacy of ignoring our role as theory-holders.

G.E. Moore makes this sort of mistake according to Wittgenstein. While he certainly seems correct when he says things like "I know this is a hand," Wittgenstein maintains that such "enabling" propositions play a special role which renders Moore's "knowledge" claims inappropriate. Insofar as we are speaking about our enablers, he maintains, it is not *knowledge* which we possess:

> I should like to say: Moore does not *know* what he asserts he knows, but it stands fast for him, as also for me; regarding it as absolutely solid is part of our *method* of doubt and enquiry.[15]

Wittgenstein maintains that our enablers provide us with the background standards which make our evaluative and justificatory endeavors possible. While there may be nothing *necessary* in the particular enablers or standards which we employ (as long as other things could "stand fast" for us), some standards or enablers are requisite:

> for you to be able to carry out an order there must be some empirical fact about which you are not in doubt. Doubt itself rests only on what is beyond doubt.
>
> But since a language-game is something that consists in the recurrent procedures of the game in time, it seems impossible to say in any *individual* case that such-and-such must be beyond doubt if there is to be a language-game—though it is right enough to say that *as a rule* some empirical judgment or other must be beyond doubt.[16]

While we do not normally recognize this background as such, we can uncover it. Moore does so, but he mistakes its status or role: believing that his acceptance of his enablers or standards is subject to the same strictures which his acceptance of other beliefs, theories, and commitments are subject to, he responds to those who are skeptical or fideistic when it comes to accepting them by claiming that he has knowledge in such situations. According to naturalists, recognizing the special character of the propositions Moore affirms and the special role played by our enablers amounts to understanding that *neither doubt nor knowledge* are appropriate here. Instead of treating the propositions Moore discusses as if they were "normal" propositions uttered in the normal course of his endeavors, naturalists would point out that their special character is an indication that we should examine their role carefully.

Naturalists maintain that "a language-game is only possible if one trusts something (I did not say 'can trust something')".[17] The "trusted" things here, of course, are the enablers which are presumed —they are the rules which are requisite if there are to be any "games." These standards are not justified by (or in) the "games," rather they are the socially inculcated background which "enable" our endeavors: "the child, I should like to say, learns to react in

such-and-such a way; and in so reacting it doesn't so far know anything. Knowing only begins at a later level."[18] While our standards can be replaced, at present they are *our* enablers (they provide our standards of rational justification, evaluation, and explanation). If they were replaced, some other standards would come to be our enablers and *they* would provide our standards of justification, evaluation, and explanation. It would then be as inappropriate to attempt to evaluate them by appeal to themselves as it is now to attempt to do so with our present enablers.

Naturalists maintain that we should *not* attempt to rationally justify or evaluate our acceptance of our rational standards of justification and evaluation. This is not because these standards are known (though not subject to justification) nor is it because they must be kerygmatically accepted. As we have seen, naturalists reject fideism and realism (whether qualified or unqualified) for the same reason that they reject justificatory rationalism and skepticism. According to them, while our enablers and standards may seem to be merely "posits" when we consider them *qua* theory-builders,

> everything to which we concede existence is a posit from the standpoint of a description of the theory-building process, and simultaneously real from the standpoint of the theory that is being built. Nor let us look down on the standpoint of the theory as make-believe; for we can never do better than occupy the standpoint of some theory or other.[19]

Rather than attempting to examine the rational credentials and standing of our presumed background (instead of attempting to evaluate our standards by themselves), then, naturalists would point out that as theory-holders we must *presume* this background as we engage in our evaluative and justificatory endeavors.

Like the justificatory rationalists and skeptics, naturalists maintain that we should accept only those beliefs, theories, or commitments which we can rationally justify. Like the realists and fideists, however, they reject the justificationalism of the justificatory rationalists when it comes to our acceptance of our rational standards. Where the traditional epistemologists (whether they were justificatory rationalists, skeptics, unqualified realists, fideists, or qualified realists) believed a commitment to rationalism engendered the problem of the legitimation of our cognitive methodology, however, naturalists

consider both the problem and the various orientations offered in response to it to be based upon a misunderstanding.

Naturalists maintain that while some sense might be assigned to cases where the rules or criteria specified by our standards are applied to these standards themselves, this sense would not serve to answer the problem which exercises the traditional epistemologists. Both the problem which these theorists would address (or raise) and the responses they offer to it treat the question of our acceptance of the rational maxim as of a piece with our acceptance of our other beliefs, theories, and commitments. Whether they claim this acceptance can be rationally justified or claim that here we see the ineliminable kerygmaticism upon which all our believing ultimately rests, these theorists overemphasize our role as theory-builders and fail to recognize that our standards play a special role which precludes their normal application when it comes to themselves. Naturalists hope that an understanding of our role as theory-holders and of the role which our standards or enablers play will ensure that we will not be vexed by this "problem" in the future. They maintain that when it comes to our acceptance of our standards or enablers, instead of investigating their rational credentials or standing, we must recognize the "groundlessness of our believing."[20]

16. Naturalism and Groundless Believing

The naturalists' claim that our acceptance of our rational standards is "groundless" is not meant to indicate that these claims must be taken as articles of faith, nor is it meant to encourage us to become incredulous and withhold our assent pending the discovery of some justification. Instead, when Wittgenstein makes this claim he is maintaining that Moore misconstrues the role of our enablers, and he is trying to show what role these enablers actually play. According to him, they provide the socially inculcated background which must be accepted if we are to engage in our various "games."

This does not mean that they provide a "foundation" in the sense justificatory rationalists or qualified realistic rationalists would uncover however. While our other statements are judged true or false relative to them, these standards cannot themselves be termed true: "if the true is what is grounded, then the ground is not *true*, nor yet

false."[21] To say our believing here is *groundless* is to say that the background, standards, or enablers which are acknowledged are neither true nor false, neither known nor doubted, neither grounded nor ungrounded. Instead they provide the shared background which underlies our practices and which we acquire as we learn to engage in these activities:

> when a child learns language it learns at the same time what is to be investigated and what not. When it learns that there is a cupboard in the room, it isn't taught to doubt whether what it sees later on is still a cupboard or only a kind of stage set. Children do not learn that books exist, that armchairs exist, etc. etc.,—they learn to fetch books, sit in armchairs, etc. etc.
>
> Later, questions about the existence of things do of course arise. "Is there such a thing as a unicorn?" and so on. But such a question is possible only because as a rule no corresponding question presents itself. For how does one know how to set about satisfying oneself of the existence of unicorns? How did one learn the method for determining whether something exists or not?[22]

Wittgenstein maintains that when it comes to these enablers, philosophers are limited to providing *descriptions* and *therapy*.[23] While he discusses cases where individuals employ other enablers and engage in different practices, these cases are generally meant to be wholly fictional and are engineered specifically to get us to recognize *our* enablers and the special role which they play. Wittgenstein recognizes that these enablers are subject to change, and he is very alive to the possibility that others might employ different sets of enablers; but he sees in these facts no reason for reintroducing the search for grounds or justifications. Instead, he says, "somewhere we must be finished with justification, and then there remains the proposition that *this* is how we calculate."[24]

Were we to encounter individuals who have had a different education and employed different enablers, *reasons* could not be offered in favor of our view and against theirs. We would have to admit that "we could not find our feet with them."[25] That is, we would not agree with their doubts or their claims and would not find their practices to be sensible. We could not *argue* with them however—any argument we might offer would appeal to the standards or enablers which we presume. At such points "each man

declares the other a fool and heretic."[26] Since we cannot mount nonquestion-begging arguments against these individuals, our discourse with them will have to employ persuasion: "at the end of reasons comes *persuasion*."[27] This description of our predicament seems to suggest that a recognition of the groundlessness of our believing ultimately leaves individuals with a "blind commitment" to their enablers or standards. Other commitments seem open and this seems to leave *us* with the choice of making an arbitrary choice amongst commitments, being skeptical about any commitment, or adopting a fideistic attitude.

Naturalists maintain that those who raise such worries fall prey to the same sort of mistake which the traditional epistemologists fall prey to. Because they overemphasize our role as theory-builders, they wish to subject our commitment to our rational standards (or enablers) to rational scrutiny. Since they demand an independent evaluation of these standards, they find the naturalists' statements that "we must recognize the groundlessness of our believing" and that "we must simply say 'this is how we calculate'" to be completely inadequate. Naturalists reject the charge that their orientation entails fideism, skepticism, or arbitrariness, and maintain that individuals who demand that they ground or justify their acceptance of their standards or enablers if they are to offer nonarbitrary preferences demand a separation of the notions of justification and evaluation from the very context which gives them their sense.[28]

In short, naturalists maintain that they do not intend to use the term 'groundless' as a synonym for 'supra-rationally (rather than rationally) justified,' 'arbitrary,' or 'doubtful'. According to them, individuals who would raise the arbitrariness worries and the skeptical and fideistic challenges with regard to our enablers must raise these worries and challenges from some particular conceptual perspective or other. That is, to worry about which of the "alternative" sets of standards or enablers we should accept, one must stand outside the "alternative" orientations and attempt to evaluate them. In such an "evaluation," of course, none of the "alternative" sets of enablers should function as the standards one employs in evaluating and judging. Whatever one does appeal to, however, it seems legitimate to ask "Why not consider *this* an arbitrary evaluative perspective?" Here a regress threatens—it is with this sort of worry that the traditional problem of the legitimation of our cognitive methodologies gets its start.

Naturalists maintain that the issue here is to be met by recognizing that we are theory-holders as well as theory-builders and that our role as theory-holders provides us with the standards which we do employ. The sort of doubts about our commitment to our standards which suggest arbitrariness, fideism, or skepticism do not arise for us as theory-holders: "this doubt isn't one of the doubts in our game. (But not as if we *chose* this game!)"[29] Accepting the groundlessness of our believing is accepting our enablers as the standards which we presume in evaluating, justifying, and explaining. According to naturalists, we have no choice but to do so (although we can easily become confused about the status of these enablers or standards). By ignoring our role as theory-holders and failing to recognize the special role played by our standards, we may fall prey to linguistic bewilderment and treat our standards as on a par with those things they serve as standards for. If we overemphasize our role as theory-builders in this manner, our standards' status as standards is ignored and we come to question our acceptance of them.

The most general arbitrariness charge arises in exactly this fashion: (i) one ignores the special role which one's enablers play, (ii) one takes a "historical" perspective which recognizes that groups of individuals change their standards over time, and (iii) one countenances the possibility that others may employ enablers which differ from those employed within one's culture. Ignoring one's role as a theory-holder, one concludes that the enablers or standards which individuals accept are arbitrarily accepted. By emphasizing our role as theory-holders, Wittgenstein would expose the status of our enablers as standards and aid us in avoiding the philosophical fallacy which has trapped earlier philosophers. Instead of attempting to ground our enablers or establish the superiority of his enablers over others, he maintains, we must recognize that "knowledge is in the end based on acknowledgement"[30] and that "what has to be accepted, the given, is—so one could say—*forms of life.*"[31]

17. The Challenges Naturalists Must Confront

If one joins the naturalists in rejecting the call for strongly independent justifications and evaluations, then the problems posed by the phenomena of conceptual change and diversity, and the challenges posed in both the internal and external perennial arguments, may

seem intractable. Naturalists may offer weakly-independent justifications and evaluations and may appeal to their held theory as they attempt to respond to the views of skeptics, fideists, and to the positions championed by other rationalists; but that means that the acceptability of their responses will be conditioned upon an acceptance of the particular evaluative perspective which they presume. In terms of an earlier example, for example, a given naturalist would offer weakly-independent justifications for her or his choice of an investment given the acceptance of certain aims, theories, beliefs, and standards. Others might choose to offer their evaluations relative to *different* aims, theories, beliefs, or standards however. Thus, they might well reject the naturalist's evaluations and justifications even though they agree with the naturalist as to the impossibility of providing strongly-independent justifications and evaluations.

It seems, then, that naturalists may be forced to adopt the sort of kerygmatic position which Popper accepts. *Relative to the acceptance of their orientation*, their arguments against their opponents and their rationale for accepting their orientation may be as strong as one likes, but their opponents (in either the internal or external perennial arguments with regard to rationality) may not accept their beginning points. In such a case, of course, it appears that the naturalists' arguments are question-begging, and it appears that their orientation engenders *arbitrary* evaluations, justifications, and commitments.

Naturalists may not attempt to avoid the appearance of arbitrariness by trying to provide a strongly independent justification for the particular evaluative or justificatory perspective which they presume. They may not attempt to *independently ground* the held theory relative to which we must offer our evaluations and justifications of cases of conceptual diversity and of proposals for conceptual change — to do so would be to reject their naturalistic view of evaluation and justification. Similarly, they may not attempt to offer an independent evaluation of any alternative evaluative or justificatory perspectives—at least not if they are to be thoroughgoing in their naturalism. Instead, they will have to admit that *their claims about the justificatory and evaluative perspective which they employ (about their held theory) are themselves claims which must be offered naturalistically*.

That is, naturalists will not be able to rule out *a priori* the possibility that others might agree with their claim that we must make our evaluations and justifications relativistically, yet reject the

17. The Challenges Naturalists Must Confront

characterization of our held theory which the naturalists offer. This suggests that others might well offer *different* responses to the problems posed by the phenomena of conceptual diversity and change—responses which the naturalists could not reject given their naturalistic orientation. In short, the naturalists' rejection of the appeal to strongly independent (or transcendent) evaluations seems to raise the same sorts of skeptical and fideistic challenges and the same sorts of arbitrariness worries which confront the justificatory rationalists, kerygmatic rationalists, and the unqualified realists.

In the last section we saw that naturalists respond to the skeptical and fideistic challenges (and to the arbitrariness worries generated by their rejection of the justificatory demands with regard to their acceptance of their enablers) by claiming that those who raise such worries and challenges commit the same mistake as do the justificatory rationalists—individuals who call for the justification or evaluation of our acceptance of the enablers which stand at the basis of our justificatory and evaluative practices commit the peculiarly philosophical fallacy of overemphasizing our role as theory-builders. This naturalistic response seems to foster the appearance of arbitrariness rather than dispel it, however. It requires that we "recognize" the groundlessness of our believing, that certain "forms of life" must be taken as "given," and it leaves open the possibility that others may employ other enablers or standards. In short, it suggests that our commitment to our enablers is an *arbitrary* one which others might not share with us.

Naturalists also confront a *dilemma* as they attempt to argue for their naturalism and against the traditional search for strongly independent evaluations and justifications. Traditional epistemologists may respond to the naturalists' claim that "conceptual evaluations are always made relative to a frame of reference or conceptual scheme" (or R) by noting that R either is a naturalistic thesis or it is not. If it is not, the traditional epistemologists claim, it provides no good reason for them to adopt the naturalists' orientation. If, on the other hand, R is a nonnaturalistic thesis, it cannot effectively argue against the traditional epistemologists' orientation. Whether the naturalists are offering their version of the rationalistic maxim in the internal or the external perennial argument, this paradox seems to leave them with a question-begging argument against their opponents and for their orientation.

In the remainder of this chapter, I will discuss the naturalists' initial response to the arbitrariness worry and two false starts which naturalists might pursue in an attempt to avoid the dilemma. These preliminaries will enable us to better understand the naturalists' overall strategy for resolving the internal and external perennial arguments with regard to rationality.

18. The Naturalists' Initial Response to the Arbitrariness Worry

Traditional epistemologists would provide strongly independent (transcendent) evaluations of conceptual structures. It is this sense of 'independent' which naturalists reject when they maintain "all evaluative judgments are relative." They need not reject the notion of weakly independent evaluations and judgments however. Briskman's discussion of our most basic aims illustrates this point. Aim-oriented epistemologists who are naturalists may still argue, as did Briskman, that the problems of conceptual diversity and change require that one be confronted with alternatives which are competitors—it is only when there are *common* problems to be solved or goals to be attained that the phenomena of conceptual diversity and change provide an epistemological problem. Furthermore, these theorists will agree with Briskman that our evaluations are to be relativized to our basic aims and goals. They may, finally, claim that certain aims are forced upon us all—given an acceptance of the Darwinistic account of basic aims, they find an evaluative perspective which all individuals employ.

The naturalists' appeal to Darwinism here is not a justificatory one however. Instead of attempting to provide a strongly independent (transcendent) evaluative perspective, naturalists appeal to Darwinism to indicate why their evaluations, justifications, and preferences should not be considered to be simply arbitrary. Their view will offer *arbitrary* conceptual evaluations only if there is an epistemically relevant diversity at the level of our most basic aims. If there were several "alternative most basic aims," appeal to any particular basic aim could not provide a nonarbitrary standard for our evaluations of conceptual diversity and change.

Naturalists should note that it would be difficult to assign any

18. Initial Response to the Arbitrariness Worry

sense to the notion of "alternatives" at this basic level, however. With Briskman, they should insist that to call two concepts, methodological rules, or aims *alternatives* or *competitors* is to require something relative to which they compete. What sense, then, could be attached to the phrase "alternative basic practical aims"? They should point out that such aims are not alternatives in that they are surrogates for some other, more basic, aims—they are to be the most basic aims themselves. Nor may they be alternatives in respect to particular concepts or problem-situations as each of these is fully specified only relative to basic aims. Unless some sense may be supplied here, however, no epistemological problem arises—one is, instead, confronted with *different but noncompetitive aims* and may (quite consistently) adopt each such aim.

Such a naturalistic response will be unpalatable to many. Like Briskman, they will feel the need for transcendent (strongly independent) evaluations and preferences. Without such evaluations, they believe, epistemologists would be unable to provide adjudication in the face of diverse conceptual alternatives and unable to provide guidance as to the desirability and direction of conceptual change. The traditional epistemologists' desire to provide adjudications and evaluations here differs not at all from that of one who would provide absolute (nonrelativized) determinations of motion or absolute preferences amongst types of paint however. Without common aims or problems, it is not clear how different sets of basic aims could even be presented to the epistemologist. Merely to recognize some set of basic beliefs as "basic" and "different" would require some frame of reference which embraced both the belief sets, and this common coordinate system would provide a weakly independent foundation for evaluative judgments for the naturalist. Where such a common ground is lacking, however, naturalists maintain we are precluded from ordering preferences or offering weakly independent evaluations and any attempt to provide a stronger sort of independent evaluation leads to incoherence.

Some will find the naturalistic argument unpalatable because they take it to be an argument for the "Equipreferability Thesis." As we have seen, however, this is not the naturalists' thesis. Another source of dissatisfaction with naturalism is a tendency to read the naturalists' position too strongly. Naturalists need not maintain there actually exist such differing yet noncompetitive basic aims. Indeed, as we

shall see, their Darwinian account provides them with good naturalistic reasons for maintaining there is a significant body of pervasively shared basic problems, aims, and theories. They need only hold that were we actually presented with a case of such diversity, we would be precluded from offering preferences or evaluations. Furthermore, as the above argument indicated, it is unlikely that one would encounter such a situation since it seems to make no sense to speak of "different" basic aims without presupposing there is, indeed, a common frame of reference which the naturalist may appeal to.

The naturalists' argument may also seem unsatisfactory since naturalists would have the epistemologist study human preferences and evaluations relativistically—it appears that the choice of a frame of reference from which the naturalists' studies are to be pursued is an arbitrary one. Naturalists may respond to this worry by maintaining that although we theorize relativistically, we all share a common set of problems, aims, and basic conceptualizations. This common nexus of problems, aims, and conceptualizations provides for the possibility of nonarbitrary resolutions to those problems posed by the phenomena of conceptual change and diversity.

Here naturalists may appeal to the very sorts of problems, aims, and beliefs which theorists like Kekes, Briskman, and Moore appeal to. They may claim that our physiological, psychological, sociological, epistemological, and ecological studies provide us with good evidence that we all (a) share certain general problems and aims regarding our physiological well-being and security (problems and aims which arise because of the sorts of creatures we are and the sort of environment which we inhabit); (b) confront certain general problems regarding how to resolve conflicts between our individual desires and the rules and mores of the families, groups, and societies we inhabit (problems and aims which arise because of our social nature); and (c) confront certain general problems regarding self-knowledge and self-acceptance.

In arguing in this fashion, naturalists must not (at least if they are to offer a thoroughgoing naturalism) attempt to independently justify or legitimate their "acceptance" of the evaluative perspective or held theory which they presume. While they may appeal to many of the considerations which the justificatory rationalists appeal to in responding to the appearance of arbitrariness, naturalists may not do this in an attempt to independently justify their orientation. Thus

18. Initial Response to the Arbitrariness Worry

the naturalists must offer a naturalistic response to the skeptical and fideistic challenges (and to the arbitrariness worries). Such challenges and worries arise, of course, precisely because the naturalists cannot offer a strongly independent characterization of the evaluative perspective which they maintain we must presume as we offer our justifications and evaluations.

For naturalists who follow Briskman, the frame of reference is not one which may be called either "arbitrary" or "chosen." It is, rather, one which is selected for us all by evolutionary processes. Indeed we are here provided with the naturalists' basic reason for believing it would be unlikely that naturalists would be confronted with a situation wherein others held different though noncompetitive basic aims. The basic aims, according to Briskman's Darwinistic aim-oriented epistemology, are ones which are basic for *all* members of our species. To hold that some population had different basic aims which were not in conflict with our own, but which were also incompatible with ours would be to require (leaving aside for the moment the senselessness of 'different' and 'basic' here) that we hold the claims of our biological and physical sciences to be wrong, or at least not as universal as we had supposed. While such a state of affairs certainly is possible, the naturalist requires that some positive reason be supplied for such a supposition. As long as one is not forthcoming, there can be no reason to object to naturalism on the grounds that it cannot offer evaluations when different yet noncompetitive basic aims are involved.

The central insight of Briskman's view is that the phenomena of conceptual diversity and change pose an epistemological problem only where there is some common aim or problem which each of the diverse sets of concepts would achieve or resolve. These aims and problems, in turn, provide for evaluative judgments. In his attempt to provide for a prior philosophy, however, Briskman loses sight of his main point. No independent, ultimate, or prior standard of evaluation is necessary if evaluative judgments are to be offered in the face of alternative or competing conceptual structures (or aims)—the relevant aims and problems provide the necessary standard of evaluation. Were the differing sets noncompetitive, no evaluation would be called for (transcendent or otherwise)—individuals could simply adopt all the aims and try to meet all the problems. The occurrence of the latter case, from our perspective, seems unlikely.

Were such a case to occur, however, no evaluation could be offered. The lack of common problems, common aims, and common concepts renders such evaluations impossible.

Briskman loses sight of the relativistic character of the evaluations he would offer because he fails to note the status of his "basic aims." Their status as basic is established only relative to our held theory. Rather than providing a strongly independent evaluative standard, then, his Darwinistic aim-oriented epistemology provides for evaluations of conceptual diversity and alternatives only where there is agreement as to the basic aims. He has provided no way of dealing with the case wherein differing though noncompetitive basic aims are supposed, and according to the naturalists he should not attempt to do so.

What is sketched in this section, however, is the *naturalistic* argument against the arbitrariness charge. This charge arose in light of two factors: the naturalists' thesis that our evaluations and justifications must be offered relativistically (R), and the naturalists' "inability" to independently ground their appeal to the particular held theory. But naturalists dismiss the appearance of arbitrariness and respond to the skeptical and fideistic challenges by appealing to our current account of our basic aims, problems, and problematic situation—by appealing, in short, to the Darwinistic picture. Traditional epistemologists may maintain that this sort of response is inadequate in the face of the problem posed by the dilemma mentioned in the previous section—it is a question-begging argument in support of naturalism (since it rests upon the acceptance of various naturalistic theses).

19. Naturalism and Self-Refutation

In the past century the relativistic character of our beliefs, theories, and commitments has come to be widely accepted. While many are tempted to adopt such an orientation acknowledging that individuals' justifications and evaluations are essentially tied to their background network of beliefs, theories, problems, and goals, most are also predisposed to eschew a thoroughgoing naturalism. In addition to the worries about arbitrariness, many believe that the dilemma which naturalists face in arguing for their view (and against tradition-

al epistemology) shows that naturalists offer a self-refuting doctrine —they feel that such a view actually precludes evaluations and justifications since it allows each individual or group to serve as the final arbiter of truth.

Here Protagoras' "measure doctrine," which holds that man is the measure of all things, is taken as the prototype of the naturalists' argument. Since individuals or groups are the ultimate court of appeal, it seems that naturalists must allow that all beliefs, theories, and commitments are equally valid and this means, in effect, that there can be no justification, disagreement, or evaluation; as Wittgenstein notes, when one says "whatever seems right to me is right," one seems to preclude all talk of right and wrong.[32]

Such a view is actually *subjectivistic* rather than *relativistic* according to M.F. Burnyeat:

> to illustrate the difference: the subjectivist version of the Measure doctrine is in clear violation of the law of contradiction, since it allows one person's judgment that something is so and another's judgment that it is not so both to be true together; whereas the relativist version can plead that there is no contradiction in something being so for one person and not so for another.[33]

Burnyeat carefully examines each of these versions of the measure doctrine in light of the traditional critique that they are self-refuting.

Strict self-refutation arises where a statement itself legitimates its contradictory (consider "All things are false" or "There are no truths"). In such situations the thesis is falsified by its own content. J.L. Mackie discusses two other sorts of self-refutation: *pragmatic* self-refutation wherein a proposition (such as "I am not writing") is falsified by the particular way it happens to be presented (i.e., by my writing it) and *operational* self-refutation wherein there is no way the proposition may be presented which does not falsify it (e.g., when one wishes to assert—whether by speech, pen, etc.—that one is not asserting).[34]

To this list Burnyeat adds a fourth category: *dialectical* self-refutation. The Greek skeptics' challenge to the subjective version of Protagoras' measure doctrine provides an excellent example of this last sort of self-refuting argument according to Burnyeat. Here Protagoras is construed as asserting that every judgment is true, and the following argument is adduced against this view:

> If (A) (every appearance is true),
> and (B) (it appears that not every appearance is true),
> then (C) (not every appearance is true).

Here, clearly, we do not have a case of strict self-refutation—the second premise is necessary if the conclusion is to be accepted. For the same reason, it does not seem proper to charge the Protagoreans with either pragmatic or operational self-refutation. It is not the way they present their doctrine but the opposition which arises to it in (B) which contributes the difficulty.

If the subjectivistic Protagoras is to be charged with self-refutation, then, we must indicate why he or she ought to accept (B). According to Burnyeat, the reason for this lies in the fact that the subjectivist is participating in a dialectic:

> we are to imagine Protagoras putting forward a subjectivist doctrine according to which whatever appears to anyone to be so is so in fact, (A). He is opposed by someone saying that to him it appears, on the contrary, that not everything that appears to someone to be so is so in fact, (B). But Protagoras has only to be opposed like this and he will be forced to deny his own thesis and admit defeat, (C).[35]

The only way for the subjectivists to avoid (C) is to deny (B) but to do so would be to deny a "presupposition of debate"—the possibility of genuine disagreement. That is, to avoid (C) they must avoid any inquiry into, critical discussion of, or evaluation of their own orientation. Such activities must allow for the possibility that their view is inadequate (for (B)). Since they would advance (A) as a thesis within such a discussion or dialectic, their view is dialectically self-refuting.

They may avoid this criticism if they recant their dialectical objectives. Here, like the kerygmatic rationalists and fideists, they would eschew justificationalism, refrain from any attempts to establish their view, and settle for a mere proclamation of their orientation. Such subjectivists, of course, are led in the direction of solipsism. Withdrawing from the dialectic, they retreat into the self and offer a position as secure as that of the consistent fideists. This view, of course, would not *argue* against opposing viewpoints and, thus, would not prevent a return to justificationalism. Indeed, it is ironic that skeptics like Sextus Empiricus should adduce this sort of argument against Protagoras since they may themselves be accused of denying the presuppositions of debate: in seeking to induce a

suspension of judgment they deny reason a role and maintain that opposed assertions are equally adequate. Yet, as the stoics pointed out, when skeptics advance such a view in the dialectic they seem to refute themselves.[36]

The above sort of argument against Protagoras may not be a fair one, however. It bears a marked similarity to Plato's critique in his *Theaetetus*. But Plato's Protagoras, unlike Sextus', holds that every judgment is true *for* the person whose judgment it is. In short, he is a relativist not a subjectivist. Thus, arguments such as the following are deeply flawed:[37]

If (D) (every judgment is true),
and (E) (it is judged that (D) is false),
then (F) (it is true that (D) is false),
and, thus, (G) ((D) is false).

The relativistic qualifiers are dropped and the argument is, thus, irrelevant. If the qualifiers are reintroduced, no self-refutation seems to follow, however. Instead, we are presented with the following:

If (H) (every judgment is true *for* the person whose judgment it is),
and (I) (S judges (H) is false),
then (J) ((H) is false *for* S).

Such a sequence establishes only that the measure doctrine is false *for the Protagoreans' opponent*. This view is not self-refuting in any of the four senses discussed.

The naturalists' central thesis, that our evaluations and justifications must be offered relativistically (R), is not strictly, pragmatically, or operationally self-refuting. Individuals have contended, however, that it is dialectically self-refuting. The argument for this claim runs as follows: if the naturalists' central thesis, R, is itself a relativized truth, naturalists appear to be unable to confront the traditional epistemologists head-on; if they assert R relativistically, they merely maintain that *from their own perspective* no strongly independent justifications or evaluations are possible, and this leaves wholly open the possibility that from another perspective such justifications are possible; thus, a thoroughgoing naturalism (one which offers no qualifications upon R) poses no serious threat to traditional epistemology. In other words, naturalists who offer their thesis, R, as part of an argument *against* traditional epistemology,

would offer an argument which was dialectically self-refuting: in asserting R within the context of such a dialectic, they would be attempting to argue traditional epistemology was false while admitting only relativized notions of truth and falsity. Thus, they would, at most, be able to establish that traditional epistemology (and its search for strongly independent justifications and evaluations) is false for them; but, of course, this is not the same as establishing that it is false (nonrelativistically speaking).

Naturalists might well reply, however, that their view appears self-refuting only as long as one demands they supply exactly the sort of nonrelativistic justification which they would deny exists. That is, while traditional epistemologists seem to be correct in noting naturalists cannot meet traditional epistemology head-on, they do not thereby buttress their orientation. Naturalists may point out that to claim naturalism is deficient because naturalists cannot objectively defend it is as question-begging as to claim traditional epistemology is deficient because traditional epistemologists cannot relativistically argue there are strongly independent evaluations and justifications. That is to say, it would be question-begging for naturalized epistemologists to maintain that given an acceptance of R, the impossibility of strongly independent evaluations and traditional epistemology immediately follows (since traditional epistemologists do not accept R and would not be willing to begin their arguments with a premise which naturalized all philosophical argumentation); it would be equally question-begging for traditional epistemologists to maintain that given that strongly independent evaluations and justifications are necessary, a naturalistic R is wholly inadequate (since the naturalized epistemologists do not admit that such evaluations are necessary).

If this is the case, however, we seem left at an inconclusive point: the naturalists' inability to provide a strongly independent evaluation of naturalism and traditional epistemology which favors their view is significant only if there is good reason to suppose there are such strongly independent evaluations; and, similarly, the fact that the traditional epistemologists' attempts to advance such evaluations have uncovered only varieties of weakly independent justifications and evaluations shows nothing about the value of their pursuit or the eventual possibilities of success unless there is some antecedent reason for believing that their quest for strongly independent

justifications and evaluations is flawed. Neither side seems able to mount a consistent and effective attack upon the other and we are left with an inconclusive situation.

While the traditional epistemologists' charge that naturalists offer a view which is self-refuting may not be sustained, then, the argument offered in this section does not seem promising when we consider the situation of naturalists who would participate in the debates with regard to the internal and external perennial questions concerning rationality. Naturalists who would respond to their opponents (rather than limit themselves to a kerygmatic statement of their position) must develop some sort of response which effectively addresses their opponents' views.

20. Quine's *Reductio:* A Failed Naturalistic Argument

Quine's argument against traditional epistemology seems to provide the sort of nonquestion-begging argumentation naturalists might employ to undercut the traditional epistemologists' endeavor and, thus, defend their own orientation. Central to the traditional conception of epistemology, according to Quine, is the correspondence theory or "the myth of the museum." A correspondence theorist maintains that determinate and unique world-word relationships ground our talk of truth and reference. Quine's offers a *reductio* argument against this view which runs through three cases: radical translation, the case of one's linguistic neighbor, and the case of oneself. In each of these cases he argues that if one assumes that reference is to be accounted for in terms of such determinate relations, it is possible that one could find oneself confronted with distinct sets of correspondence relations between the speakers' words (whether the speaker is native, neighbor, or self) and the world such that each set of relations is equally adequate, there is no better set of correspondence relations, and all the possible (behavioral) evidence could not legitimate a choice.

Now in the case of the natives, or even (less obviously) in that of one's linguistic neighbors, it may not be wholly counterintuitive to conclude that *we* cannot tell what it is that is referred to unless we "go beyond the (behavioral) evidence" and make some presupposi-

tions about the natives' (or neighbors') apparatus of individuation and identity. Nonetheless, one might maintain, all that this shows is that *we* are not able to discover what it is that they refer to. Such a conclusion, of course, in no way shows that the traditional conception is fundamentally flawed—the natives' (or neighbors') reference might still be correctly cast in terms of such a unique and determinate correspondence relation, even though we might be perpetually in the dark about the fact of this relation.

This is not the conclusion Quine would draw however. According to him, "the inscrutability of reference is not the inscrutability of a fact; there is no fact of the matter."[38] To make this point clear we turn to the final step in his *reductio*. He points out that it is possible, assuming the traditional conception, to find that there are several referentially distinct yet evidentially equivalent sets of correspondence relations which characterize one's own case. Thus, we are unable to make a legitimate choice amongst this variety, and are forced to conclude that *our own* reference is (behaviorally) inscrutable. Consequently, the response considered one paragraph ago—that reference might be correctly characterized by some correspondence relation, but this characterization is perpetually unavailable to us—is one which makes no sense. If talk of correspondence relations is to have any efficacy in explaining reference, it must, certainly, provide for known and determinate relations in the case of our own terms. In fact, however, this account leads to the reference of our own terms being (behaviorally) inscrutable to us. This, surely, is nonsense and, thus, Quine concludes that "reference *is* nonsense except relative to a coordinate system."[39]

In saying this, Quine advances a naturalistic view of reference. Traditional epistemologists maintain there is a nonrelativistic "fact of the matter" in questions of reference and ontology. The facts here are to be "objective," which means that the answers to referential and ontological queries do not depend upon the beliefs and theories we hold or the conceptual structure we occupy. While *we* may not know which relations in fact embody these facts and while the answers *we* give to such queries will depend upon our beliefs, theories, and concepts, the question of the correctness of a correspondence relation is an absolute one. That is, the referential and ontological questions are, ultimately, to be asked and answered independently of our beliefs, theories, and concepts. According to Quine, such

20. Quine's *Reductio*

absolutistic questions lead to incoherence: "a question of the form 'What is an F?' can be answered only by recourse to a further term: 'An F is a G.' The answer makes only relative sense: sense relative to the uncritical acceptance of 'G.' "[40] As Quine sees it, the asking of such absolutistic referential questions is what engenders the nonsense at the end of the *reductio*.

Traditional epistemologists also offer an account of truth which Quine would reject—they accept metaphysical realism. Quine maintains that sensible questions about truth, like those about reference, are relative ones. He holds that it is *meaningless* to inquire absolutely into the correctness of a conceptual scheme.[41] Thus, from the Quinean perspective, the metaphysical realists' assertion that our overall theory might be false is one which makes no sense. The realist might agree that in order for us to *speak* about truth, we must speak relatively while holding that for a statement to *be* true no such relativity need obtain. Statements are true if they, in fact, correspond to reality. Our inability to determine whether such a relation obtains tells us nothing about the nature of truth.

Quine's *reductio* with regard to reference points to the error in this reply.[42] It yields an account of significance which holds that "unless pretty firmly conditioned to sensory stimulation, a sentence S is meaningless except relative to its own theory, meaningless intertheoretically."[43] The metaphysical realists would separate a theory or utterance from its background or context and yet consider the question of its truth or falsity to be a meaningful one. Quine, however, points out that by itself the theory or utterance *says* nothing. It is only relative to a background theory or conceptual structure that it has significance or reference (given the *reductio*) and it is only if it has significance or reference that it may be said to be true or false.

Clearly, this *reductio* argument against traditional epistemology will beg the question if it presupposes naturalistic theses. Unfortunately, it commits exactly this sort of error. The naturalistic nature of the argument becomes apparent when we note that it establishes that traditional epistemologists must recognize that the reference of their own terms is *behaviorally* inscrutable. The "nonsense" which this destructive argument uncovers, then, is premised upon an acceptance of the behavioral theory of meaning. Indeed, Quine holds that an acceptance of a "behavioristic semantics" is integral to natural-

ism.⁴⁴ Few, if any, traditional epistemologists would accept such a thesis and, thus, Quine's argument does not show the traditional epistemological endeavor is unacceptable *on its own terms*.⁴⁵

21. Qualified Naturalism

Justificatory rationalists are unable to meet the skeptical challenge unless they offer strongly independent justifications, and naturalists maintain that the notion of such justifications and evaluations is incoherent. Central to the naturalists' claim is the assertion that conceptual evaluations, like determinations of motion, are always made relative to a frame of reference or conceptual structure. *If* this is the case, we are forced to abandon the justificationalists' search for strongly independent evaluations and justifications. Weakly independent ones become the best we may offer and we must settle for an unargued and primitive commitment to some conceptual scheme or evaluative standard.

Justificatory rationalists may maintain there is a very good reason why we should not accept this conclusion, however: the assertion "conceptual evaluations are always made relative to a frame of reference or conceptual scheme," or R, must be relativized to some conceptual scheme (presumably the naturalists'), and *only from that perspective* would such an assertion cohere. Such a situation does not establish the incoherence of the notion of strongly independent evaluations and justifications. If R is true relative to the naturalists' perspective, then from some *other* perspective (that of the antinaturalists, say) there may well be such strongly independent evaluations. If R is an unrelativized truth, however, its truth yields its falsity—it would nonrelativistically assert that there are no unrelativized true assertions. Thus naturalists either offer a relativized R which is dialectically self-refuting, fails to meet antinaturalism head-on, and poses no serious threat to the latter; or they offer a nonrelativized R which is inconsistent.

Bernard Williams believes that only "vulgar relativists" face such a paradox.⁴⁶ They maintain "right" means "right for a given society." The only evaluations and justifications which they countenance, then, are those which are relativized to a particular societal context. Such relativists declare all "cross-societal" evaluations and justifications wrong. Here they employ the very sense of "right" they would

preclude however. A more consistent relativism, Williams alleges, would instead discuss the preconditions or prerequisites of appraisals in general. He proceeds to do this by developing a set of criteria for "genuine" appraisals and arguing that intersocietal evaluations fail to meet these criteria.

According to Jack Meiland, one need not master the details of Williams's proposal, however.[47] He maintains that Williams appraises appraisals and, like the vulgar relativists, offers the very sort of nonrelativized evaluations which relativists are to eschew. Thus, his view of "genuine" appraisals either is a relativistic appraisal of appraisals offered relative to Williams' own societal context, conceptual scheme, and evaluative standard, or it is not. If it is, then it provides no genuine challenge to antirelativism; if it is not, it seems as inconsistent as the vulgar relativists' declaration that "all cross-societal evaluations are wrong."

Traditional epistemologists maintain it would be paradoxical for naturalists to claim R is nonnaturalistically true. To make that claim would be to offer a view which is strictly self-refuting and which commits what Maurice Mandlebaum calls the "self-excepting fallacy."[48] Here would be a generalization one would apply to everyone yet fail to apply to oneself. Naturalists might avoid this inconsistency if they were to advance the *qualified naturalism* of R', which would claim that no position *except naturalism* is objectively true.[49] R', unlike R, would allow a nonrelativized truth or evaluation—the truth of R' itself, which is advanced as a metalevel thesis *about* evaluations.

Williams might well be understood to offer such a view. His discussion of "genuine appraisals" would, then, not be an attempt to evaluate appraisals but, rather, an attempt to elucidate *a priori* the criteria for all appraisals. The "truths" he would arrive at in his discussion of these criteria would be nonrelativistic metalevel truths established independently of any appeal to particular conceptual schemes. In offering nonrelativized truths, he would not be inconsistent in the way that vulgar relativists are, because as a qualified naturalist he would allow for, indeed require, the notion of strongly independent evaluations and justifications.[50]

Paul Roth clarifies the underlying rationale for qualified naturalism in his discussion of Quine,[51] and an examination of Roth's view indicates why such a response to the paradox of relativism is not promising. Roth maintains that Quine offers a "theory of theoriz-

ing" which constitutes a "prolegomena to a naturalized epistemology." According to him, Quine conflates his "Duhemian Thesis" (DT), which asserts that theories have their meaning and evidence only as parts of larger theories, and his "Epistemology Naturalized Thesis" (ENT), which asserts that epistemology is contained within natural science. Roth believes that these theses should be clearly distinguished since DT is to be a ground upon which ENT rests. That is, DT is an *a priori* truth—a part of Quine's "theorizing about the nature of theories." It provides an effective argument against the traditional conception of epistemology as "prior philosophy," and in favor of ENT, *only if* it is not itself a thesis of naturalized epistemology. If it were, the argument from it to ENT would beg the question.

The general rationale for qualified naturalism is exhibited here: naturalists will be able to meet the antinaturalists head-on and argue them into accepting naturalism only if they do not beg the question. Thus their arguments cannot require the initial acceptance of the naturalistic orientation. The truth of naturalism, then, must rest upon some strongly independent evaluations and justifications.

I believe such a qualified naturalism will appear attractive to many epistemologists. It has the "virtue" of reserving for philosophers a unique, foundational endeavor—they are to establish that R' (or DT) is a nonrelativized truth which grounds a qualified naturalism. The motivation here is the one which is operative in Briskman's attempt to recognize the "historical" character of our knowledge while allowing for prior philosophy. Unfortunately, what makes such a view attractive is also what makes it implausible. Roth's interpretation of Quine clearly shows this. He maintains that Quine *must* so distinguish DT and ENT if he is to argue effectively for his naturalized epistemology, yet that this distinction not only yields an ineffective argument for this thesis, but also requires us to surrender what is most interesting about ENT—its claim to provide a general, unified, and naturalized theory of human inquiry which is an alternative to the traditional justificationalists' theory.[52]

Traditional epistemologists allow for an *a priori* perspective, and hold that (at least some) epistemological endeavors must be pursued nonrelativistically. Roth's Quine would approach such philosophers and argue that the *a priori* precept DT shows that epistemology *must* be pursued from within the natural sciences (or naturalistically)— DT establishes ENT. Surely the traditional epistemologist confronted with such an argument would point out that if they accept it,

they must allow (as they would anyway) that there is a place for *a priori* philosophizing in epistemology (i.e., in DT's role in grounding ENT). Furthermore, since they are to accept DT as *a priori* true and argue to the truth of ENT (in an argument which does not assume the stance of naturalized epistemology), it is clear there is much more to epistemology than the natural sciences. Roth's Quinean argument would, at most, convince traditional epistemologists that the only refuge for the traditional conception of epistemology is in the grounding of ENT.

Roth recommends a qualified naturalism because he believes naturalists must offer some *a priori* theses (some strongly independent justifications for the naturalistic thesis) if they are to argue against traditional epistemology. However, if one pursues this procedure, one is not arguing *against* traditional epistemology—rather, one is *adopting* the traditional epistemologists' view. To the extent, then, that qualified naturalists embrace antinaturalism, their argument against antinaturalism is ineffective: Roth's Quine can succeed in getting traditional epistemologists to reject (or to qualify) their orientation only if he successfully argues (non-naturalistically) that a nonnaturalistic DT is true and that it grounds ENT. Furthermore, since ENT is not a logical consequence of DT, other *a priori* theses become necessary. They place further limitations upon the naturalistic thesis because they expand the scope of the *a priori* theorizing about theories. Each additional *a priori* thesis significantly increases the limits of naturalism. The greater the scope that qualified naturalists grant to traditional epistemology, of course, the more difficult it is for them to argue against this view.

The problem here is one which any qualified naturalist must face. The inconsistency indicated by the paradox is avoided, but consistency is purchased at a high price. Naturalists who adopt such a dualistic view of truth, justification, meaning, and theorizing must offer an *a priori* defense of their metatheory and, thus, embrace traditional epistemology. The interesting feature of the naturalists' position is its rejection of the call for strongly independent (transcendent) justifications, however. A qualified naturalism sacrifices this and seems to collapse the distinction between the justificationalist and the naturalist. To adopt the two-tier view, the naturalists must adopt (on the metalevel) the very justificational methodology of the traditional epistemologists.

I do not believe Quine offers such a two-tier theory. ENT would

place *everyone* in a Neurathian predicament. That is, he sees philosophy "not as an *a priori* propaedeutic or groundwork for science, but as continuous with science."[53] According to this view, philosophers are barred from offering *a priori* theories and must disclaim any attempt at "prior philosophy." Their ascriptions of truth are to be made only from within the perspective of their own theories. To adhere to Roth's interpretation, one must maintain that a similar distinction as that between DT and ENT must be offered here—that Quine's remarks about philosophizing specifically exempt themselves from the naturalism they espouse. I find no evidence for such a view. Instead of countenancing a special status for philosophers, Quine maintains that

> the philosopher's task differs from the others', then, in detail; but in no such drastic way as those suppose who imagine for the philosopher a vantage point outside the conceptual scheme he takes in charge. There is no cosmic exile. He cannot study and revise the fundamental conceptual scheme of science and common sense without having some conceptual scheme . . . in which to work.[54]

Here he does not seem to be excepting his own philosophizing from the "Neurathian predicament" (or ENT). Whether one is speaking methodologically, epistemically, or ontologically,[55] then, there is to be no essential difference between the scientists' and the philosophers' endeavors. In short, ENT is to offer us a thoroughgoing naturalism.

Roth might wish to maintain that naturalists such as Quine *should* raise the requisite distinction and offer a nonnaturalized DT to avoid the paradox of relativism. Indeed, given his claim that Quine "consistently conflates" DT and ENT, it seems likely that he is suggesting an improved theory. His justification for this improvement is that one may offer an effective argument against the traditional conception of epistemology *only if* one offers such a two-tier theory.

While naturalists who offered such a view would not commit the self-excepting fallacy, their view does not provide for a clear-cut victory of naturalism over traditional epistemology. To argue *a priori* and nonnaturalistically for their thesis, they have to adopt the justificationalists' orientation. They thus only seem to raise the debate about justificationalism to a higher level. The skeptic will

question their metalevel justification, the traditional epistemologist will attempt to show that this metalevel thesis is wrong (that R' is not a nonnaturalistic truth), and the fideist will maintain that the ensuing unresolved dialectic (or still higher level versions thereof) actually supports their view that there must, ultimately, be some unargued faith. Here the "effective argument" against the traditional conception (the argument against antinaturalism which Roth promises) seems elusive at best, and there seems little chance of convincing antinaturalists to adopt naturalism (or ENT).

In the larger dialectic that relates to rationalism, the naturalists provide an interesting thesis when their naturalism is thoroughgoing —it seems to seal the fate of the justificationalists' enterprise. To the extent that a qualified naturalism distinguishes between justificationalism on the metalevel and on the lower levels and adopts it on the first, the picture becomes less clear and the argument less interesting. While such a two-tier approach is consistent, it does not defend the naturalistic thesis in a way which allows it to play the same role in the internal and external perennial arguments with regard to rationality. Were Roth correct in asserting that the naturalists *must* adopt such a view to avoid the dilemma and to effectively argue against the traditional epistemologists, the dialectic might continue upon an inconclusive path. He is wrong here, however. Naturalists can argue against the traditional view without adopting such a two-tier theory. In other words, naturalists need not compromise their views; a consistent and thoroughgoing naturalism is possible in the face of traditional epistemology. Given such an alternative, qualified naturalism does not seem the appropriate response to the dilemma. The next two chapters develop this argument, chapter 7 assesses it, and, finally, chapter 8 clarifies the naturalists' response to the question "Why should we be rational?"

4

The Naturalists' Case against Qualified Realism and Skepticism

22. The Dialectical Situation—A Brief Overview

The most effective arguments against a philosophic position are those which accept the theses of the position under investigation and show that these theses themselves lead to problems. As we saw in the first two chapters, naturalists may offer such arguments against justificatory rationalists (who impose a justificatory responsibility upon themselves which they cannot meet) and against any realists who accept the justificatory responsibility (and thus find themselves in an untenable position).

Naturalists will not be able to offer such "internal" criticisms of the qualified realistic rationalists, however. Given their claim that the particular claims or methods which they appeal to are immune to error and lack of warrant, it will be impossible to adduce internal arguments which call these claims or methods into question. Similarly, since the unqualified realistic rationalists will be unrepentantly kerygmatic, and since their realism will be thoroughgoing, they will not feel the need to justify their claims. Given this, it will be impossible to call their claims into question with internal arguments —as long as they assume their orientation is in fact correct (an assumption they must make if they are to avoid the self-excepting fallacy), they may continue to kerygmatically champion their claims while rejecting justificatory questions and demands as irrelevant.

If naturalists are to argue against the qualified and unqualified realistic rationalists, then, they will have to employ arguments which presume theses that the theorists being criticized may not accept. Generally, such arguments allege that the individuals being criticized accept some theses which they should not accept, or that they fail to accept certain theses which they should accept. In arguing in this manner against these realists, naturalists will have to avoid adopting

any nonnaturalistic theses if they hope to defend a thoroughly naturalistic orientation—if they presume nonnaturalistic theses they will have to offer a qualified naturalism and, as we saw in section 21, such *a priori* theories of theorizing do not offer effective defenses of naturalized versions of epistemology.

Thus the thoroughgoing naturalists' argument against these realists will be advanced from within the naturalistic orientation rather than from within the realistic orientations. Naturalists will have to presuppose various naturalistic theses when arguing that these realists accept some theses which they should not accept, or that they fail to accept certain theses which they should accept. Clearly, however, qualified and unqualified realistic rationalists may wish to reject such presuppositions. If the naturalists' arguments are to have any force at all, then, they must explain why the realistic rationalists do not accept the naturalistic presuppositions that the naturalists rely upon, and they must explain why this refusal should be considered to be an error. As was the case with Moore's response to skepticism, the naturalists' argument must diagnose the opponents' mistakes and propose an antidote, treatment, or cure. Ideally, the argument should lead realists to agree with naturalists. I believe that Wittgenstein's argument against Moore charts, at least partially, the strategy which naturalists should pursue in developing such a "therapy" argument.

In this chapter I will detail two versions of the naturalistic therapy argument against the qualified realists and skeptics—those of W.V. Quine and L. Wittgenstein. Ultimately, the naturalisms which these theorists champion are fundamentally different, however, and this will lead, in chapter 5, to a distinction between two forms of naturalism (naturalisms of the sort attributed to Wittgenstein will be termed "descriptive" naturalisms, and naturalisms of the sort attributed to Quine will be termed "explanatory" naturalisms). I will argue that the descriptive naturalists are unable to provide a satisfactory response to the fideistic challenge or the arbitrariness worries which we have seen confront the naturalists and other theorists in the internal and external perennial arguments with regard to rationality. Chapter 5 argues that explanatory naturalists are able to deal effectively with the problems posed by the phenomena of conceptual change and diversity. In chapters 6 and 7 I will clarify how the explanatory naturalists respond to the fideistic challenge and the arbitrariness worries (and, thus, clarify their argument against the

fideists and unqualified realists), and I will consider the appropriateness and effectiveness of the explanatory naturalists' argument.

23. Wittgenstein's Therapy Argument against Moore

As we saw in section 13, G.E. Moore claims that he knows certain propositions, and claims that skepticism with regard to these propositions would be absurd. He does not claim that he can justify or validate these propositions, however. Instead, Moore would show skeptics the absurdity of their doubts with regard to such claims. In effect, he offers a *therapy* argument against skepticism—he tries to diagnose the skeptics' mistake and offer an antidote which will cure us of our skeptical propensities. According to Moore, while under some circumstances it might not be absurd to doubt these claims, it would be absurd for one to doubt them in the context in which he offers them. While these claims about the external world cannot be proven without appealing to others which are of a similar nature, they are nonetheless known to be true, and this knowledge undercuts skepticism.

Wittgenstein begins his *On Certainty* by pointing out that any proposition may be derived from other propositions. The problem is that "they may be no more certain than it is itself."[1] This, of course, is why Moore believes that the "proofs" he can offer (for an external world, for example) will not settle the issue between himself and the skeptics. One can, it seems, always question these premises once one allows the skeptical questions in regard to such claims. Cartesian "dreaming arguments" and other skeptical ploys abound, and it would be an endless philosophic task to show what was wrong with each such argument individually.

While Wittgenstein would reject Moore's claims to knowledge, he does not defend a skeptical view. He agrees with Moore that the skeptics raise absurd questions, but he maintains that Moore's claims to knowledge are *also* absurd:

> when Moore says he *knows* such and such, he is really enumerating a lot of empirical propositions which we affirm without special testing; propositions, that is, which have a peculiar logical role in the system of our empirical propositions. (136)

In effect, Wittgenstein offers a therapy argument as he discusses Moore's claims to knowledge and Moore's therapy argument. According to Wittgenstein, we do not hold these propositions because of any investigation. (138) Their peculiar role is that they form the bedrock of our conceptual structure. This bedrock is not a foundation in the foundationalists' sense however. As we saw in section 15, these propositions function as enablers—they function as the rules or standards relative to which we "play" our various "language games." Although these beliefs or propositions have the form of normal empirical propositions,

> it is clear that our empirical propositions do not all have the same status, since one can lay down such a proposition and turn it from an empirical proposition into a norm of description.
>
> Think of chemical investigations. Lavoisier makes experiments with substances in his laboratory and now he concludes that this and that takes place when there is burning. He does not say that it might happen otherwise another time. He has got hold of a definite world-picture—not of course one that he invented: he learned it as a child. I say world-picture and not hypothesis, because it is the matter-of-course foundation for his research and as such also goes unmentioned. (167)

Enabling propositions such as "12 × 12 = 144" function as "propositions of logic" which enable us to "play" our language games (in this case, the "game" of calculation). Given their peculiar role, these propositions are not themselves subject to justification within the "game" for which they function as the bedrock:

> in certain circumstances, for example, we regard a calculation as sufficiently checked. What gives us a right to do so? Experience? May that not have deceived us? Somewhere we must be finished with justification, and then there remains the proposition that *this* is how we calculate. (212)
>
> If someone supposed that *all* our calculations were uncertain and that we could rely on none of them (justifying himself by saying that mistakes are always possible) perhaps we would say he was crazy. But can we say he is in error? Does he not just react differently? We rely upon calculations, he doesn't; we are sure, he isn't. (217)

23. Wittgenstein's Therapy Argument against Moore

Wittgenstein rejects the skeptics' and justificationalists' orientation because he believes these individuals do not properly understand the peculiar role played by our enablers:

> if you demand a rule from which it follows that there can't have been a miscalculation here, the answer is that we did not learn this through a rule, but by learning to calculate. (44)
>
> *This* is how one calculates. Calculating is *this*. What we learn at school, for example. Forget this transcendent certainty, which is connected with your concept of spirit.[2] (47)
>
> Something must be taught us as a foundation. (449)

The enablers provide the "axis" or "hinge" (341–44) upon which our system of beliefs turns. It is with our "agreements" at this level that we invest our systems with their sense.[3] It is only relative to our agreement here that we may make our evaluations and offer our justifications, according to him:

> all testing, all confirmation and disconfirmation of a hypothesis takes place already within a system. And this system is not a more or less arbitrary and doubtful point of departure for all our arguments: no, it belongs to the essence of what we call an argument. The system is not so much the point of departure, as the element in which arguments have their life.[4] (105)

Wittgenstein maintains that it is a part of judging that one accept such enablers—it is a part of judging that there be accepted standards of judgment. Thus he says, "knowledge is in the end based on acknowledgement."[5] (378) According to him it is difficult for us to recognize that justification must come to an end, however. The end is not a set of known and certain propositions or beliefs as the qualified realists such as Moore would have it, but, rather, it is "our *acting*, which lies at the bottom of the language-game."[6] (204)

Wittgenstein's therapy argument attempts to show skeptics and qualified realistic rationalists like Moore that they are "bewitched" by our language.[7] The therapy which he offers consists of reminding us of how our "language-game" of justification functions (e.g., "*This* is how one calculates. Calculating is *this*"[47]). Skeptics and qualified realistic rationalists fall prey to the same error here—each attempts to treat the enablers as if they were ordinary empirical propositions.

Wittgenstein's therapy is designed to free them from this misconception.

According to Wittgenstein, the 'cannot' in such statements as "We cannot say the standard meter is a meter long," "We cannot be mistaken in calculating $12 \times 12 = 144$," and "One cannot doubt that this is a hand" indicates the peculiar role which such propositions play. Wittgenstein says such statements are "logical" or "grammatical" ones. He means that they describe or show something about the language-game which we engage in. Thus, of Moore's "I know" he says,

> if "I know etc." is conceived as a grammatical proposition, of course the "I" cannot be important. And it properly means "There is no such thing as doubt in this case" or "The expression 'I do not know' makes no sense in this case." And of course it follows from this that "I *know*" makes no sense either. (58)

These propositions "describe the conceptual (linguistic) situation" (51). While they seem to have the form of ordinary empirical propositions, they actually offer logical or grammatical insights—they display the enablers which lie at the core of our inherited practices. Thus, while "The earth has existed for more than one hundred years" is a queer thing for one to claim to *know*, if someone claimed to *doubt* this, one would be at a loss: "I would not know what such a person would still allow to be counted as evidence and what not." (231)

Such claims expose bedrock. Doubts at the level of bedrock are to be brushed aside, but knowledge claims should not do the sweeping here. Knowledge requires evidence, and one does not have evidence in such cases. (504) The enablers are what stand at the heart of the process of acquiring evidence, making claims, doubting, asking questions, etc.; and Wittgenstein maintains that "a language-game is only possible if one trusts something (I did not say 'can trust something')". (509)

Skeptics and qualified realistic rationalists such as Moore may respond that this sort of argument begs the question. It is premised upon the assumption that "knowledge requires evidence," and skeptics would ask for our evidence for this while qualified realistic rationalists would claim that, at least with regard to the particular knowledge claims *they* are concerned with, this is not so—these

claims are known and require no evidence. For example, qualified realistic rationalists might respond to the therapy argument raised by the "standard meter" argument discussed above in section 15 by claiming the following: "certainly the naturalist is not denying that the standard meter bar has a length! Moreover, 'any lengthy object either is or is not a meter long' is an obvious truism. But then it seems that the standard meter bar, being a lengthy object, must either be or not be a meter long. And certainly it *is* a meter long—it is so *paradigmatically*. Moore's claims, similarly, are paradigmatic knowledge claims which require no justification." Such a response would be mistaken, however, because it presumes that thoroughgoing naturalists offer an argument against qualified realistic rationalism which *accepts* the qualified realists' presuppositions. To the contrary, naturalists recognize that they offer a question-begging argument which proceeds *from the naturalistic perspective*. They presume naturalistic theses in their attempts to show the qualified realistic rationalists that even though the skeptics' doubts are absurd, this is not because we have *knowledge* in the case of these claims. According to them, the confusion in the qualified realists' response stems from the premise "any lengthy object either is or is not a meter long."

According to the naturalists, this statement makes sense (and the activity of meter measurement is possible) only relative to an antecedent acceptance of a standard of evaluation; and in this case, of course, the standard meter is the standard. But this means that the statement "The standard meter is a meter long" is a *"logical"* one—it says something about the particular language-game. Like Moore's "I know"s, it appears to be a straightforward empirical proposition. Closer examination exposes the peculiar role which such propositions play, however.

Failure to recognize this role ensures that one will become entrapped in philosophic confusions. Such statements appear meaningful and true when uttered in confrontation with skeptics who maintain that we do not know. Wittgenstein recommends a radically different sort of reply to the skeptics, however:

> One might simply say "O, rubbish!" to someone who wanted to make objections to the propositions that are beyond doubt. That is, not reply to him but admonish him. (495)
>
> The queer thing is that even though I find it quite correct for someone to say "Rubbish!" and so brush aside the attempt to

confuse him with doubts at bedrock, nevertheless, I hold it to be incorrect if he seeks to defend himself (using, e. g., the words "I know"). (498)

Wittgenstein would have us pay attention to our roles as theory-holders. While he agrees with qualified realistic rationalists like Moore that there is something wrong with the skeptics' doubts, he maintains that the qualified realists' approach to such errors is also wrong-headed. His therapy argument is intended to assist these rationalists (and the skeptics) in recognizing the role which their enablers and held theory play, and he hopes that this recognition will lead them to forsake their mistakes (and avoid both absurd doubts and absurd knowledge claims).

24. Quine's Therapy Argument against Traditional Epistemologists

W.V. Quine offers a thoroughgoing naturalism which eschews *all* attempts at prior philosophizing.[8] At several points, he cites approvingly Neurath's view that "we are like sailors who must rebuild their ship on the open sea, never able to dismantle it in dry-dock and to reconstruct it there out of the best materials."[9] According to him, the philosophers' inquiries, like those of the scientists, must be conducted from the perspective of the very conceptual scheme they occupy and would study. Unable to divorce themselves from this perspective or to stand outside it to evaluate and validate it, naturalized epistemologists must proceed relativistically. That is, when they are asked to confront skeptical worries, justificatory challenges, or the problems of conceptual change and diversity, naturalized epistemologists must assess and evaluate their beliefs, theories, and commitments while relying upon and appealing to these beliefs, theories, and commitments.

This circularity is not vicious, according to Quine. He maintains that traditional epistemologists sought a transcendent evaluative and justificatory perspective because they felt science could not justify itself: they held that "if the epistemologist's goal is validation of the grounds of empirical science, he defeats his purpose by using psychology or other empirical science in the validation."[10] That is, if science was all that one could appeal to in justifying scientific

theories, skepticism would be the only appropriate philosophical position.

Quine maintains that the traditional epistemologists' fear of circularity here is a "needless logical timidity" because the justificatory challenges they would meet actually come from *within science itself*:

> it is our understanding . . . of what lies beyond our surfaces, that shows our evidence for that understanding to be limited to our surfaces. But this reflection arouses certain logical misgivings: for is not our very talk of light rays, molecules, and men then only sound and fury, induced by irritation of our surfaces and signifying nothing? The world view which lent plausibility to this modest account of our knowledge is, according to this very account of our knowledge, a groundless fabrication.
>
> To reason thus is, however, to fall into fallacy: a peculiarly philosophical fallacy. . . . We cannot significantly question the reality of the external world, or deny that there is evidence of external objects in the testimony of our senses; for, to do so is simply to dissociate the terms 'reality' and 'evidence' from the very applications which originally did most to invest those terms with whatever intelligibility they may have for us.[11]

The ancient skeptical challenges to our empirical claims, for example, arose as traditional epistemologists came to better understand the nature of the evidence for their theories and beliefs. As they studied their perceptual knowledge and its evidential basis, they came to see that the former seems to radically transcend the latter. Indeed, they came to recognize that *both* our common sense and our scientific theories and beliefs radically transcend our sensory evidence:

> what are given in sensation are variformed and varicolored visual patches, varitextured and varitemperatured tactual feels, and an assortment of tones, tastes, smells, and other odds and ends; desks are no more to be found among these data than molecules. If we have evidence for the existence of the bodies of common sense, we have it only in the way in which we may be said to have evidence of molecules. The positing of either sort of body is good science insofar merely as it helps us formulate our laws—laws whose ultimate evidence lies in the sense data of the past, and whose ultimate vindication lies in anticipation of sense data of the future.[12]

Thus, as their scientific study of our evidential position progresses, our ordinary touchstones of reality, truth, and evidence fade away until, ultimately, these individuals seem forced to conclude that *none* of our beliefs and theories are supported by the available evidence. In short, they came to question the very notions of truth, evidence, and reality relative to which their initial questions about perceptual illusions arose.

Where traditional epistemologists believe the justificatory challenge must be met outside science, Quine insists that

> the crucial logical point is that the epistemologist is confronting a challenge to natural science that arises from within natural science. . . . Clearly, in confronting this challenge, the epistemologist may make free use of all scientific theory. His problem is that of finding ways, in keeping with natural science, whereby the human animal can have projected this same science from the sensory information that could reach him according to this science.[13]

With regard to both scientific and common-sense claims, traditional empirically minded epistemologists are led to the conclusion that the only evidence which they may provide for the truth of their claims is the fact that they help to organize their experience. The more clearly they see our evidential situation, the more our claims seem to amount to nothing more than mere "posits"—blind guesses which, while useful, illicitly transcend what our evidence legitimates. Quine, on the other hand, maintains that

> having noted that man has no evidence for the existence of bodies beyond the fact that their assumption helps him organize experience, we should have done well, instead of disclaiming evidence for the existence of bodies, to conclude: such, then, at bottom, is what evidence is, both for ordinary bodies and for molecules.[14]

According to Quine, those who would disavow our common-sense or scientific claims are not to be praised for their caution and demand for yet greater evidence but, rather, criticized for failing to note what evidence is. They would dissociate our notions of reality, truth, and evidence from the very contexts and applications which provide them with their sense:

> unbemused by philosophy, we would all go along with Dr. Johnson, whose toe was his touchstone of reality. Sheep are real, unicorns not.

Clouds are real, the sky (as a solid canopy) not. Odd numbers are perhaps real, but prime even numbers other than 2 not. Everything, of course, is real; but there are sheep and there are no unicorns, there are clouds and there is (in the specified sense of the term) no sky, there are odd numbers and there are no even primes other than 2. Such is the ordinary usage of the word 'real', a separation of the sheep from the unicorns. Failing some aberrant definition which is certainly not before us, this is the only usage we have to go on.[15]

When traditional epistemologists wonder whether desks and sheep are real, or claim that our talk of such ordinary physical objects and of molecules are on a par (since none of it is supported by the available evidence), or wonder whether our overall theory of the world is true, these theorists cannot be appealing to our ordinary concepts of evidence, reality, and truth. This ordinary background was initially presumed by them, however—the perceptual illusions which led them to study the relationship of theory and evidence, for example, are "*illusory*" only relative to our ordinary concepts of reality, truth, and evidence.

As the traditional epistemologists pursue their inquiries, they lose sight of this relativity. Their inquiries lead them to question the reality of sheep and desks and to maintain that our ordinarily unproblematic beliefs, theories, and posits are merely unwarranted convenient fictions. Clearly, their questions, claims, and challenges at this point cannot be raised relative to an acceptance of our ordinary concepts of evidence, reality, and truth. It is not clear that their inquiries provide them with some *other* background, however—the scientific posits, for example, are claimed to be on a par with the disreputable posits of common sense. But to claim something is unreal, untrue, or unsubstantiated one must appeal to some background notions of substantiation, reality, and truth.[16] Without such a background, claims and questions lack meaning.

According to Quine, the skeptical problems and the study of our evidence for our beliefs and theories do, indeed, force us to see sheep and desks (as well as molecules) as posits. In terms of their *epistemological* status, they are roughly on a par. But "everything to which we concede existence is a posit from the standpoint of a description of the theory-building process, and simultaneously real from the standpoint of the theory that is being built."[17] The former standpoint is the one which epistemologists have traditionally occu-

pied. Quine has no quarrel with this perspective *as long as the other perspective is also recognized*. From the epistemological perspective where we are concerned with evaluating, validating, and bettering our theories, beliefs, and commitments, we may seem to be limited to choosing amongst posits simply in terms of their efficacy:

> as an empiricist I continue to think of the conceptual schemes of science as a tool, ultimately, for predicting future experience in the light of past experience. Physical objects are conceptually imported into the situation as convenient intermediaries—not by definition in terms of experience, but simply as irreducible posits comparable, epistemologically, to the gods of Homer. For my part I do, qua lay physicist, believe in physical objects and not in Homer's gods; and I consider it a scientific error to believe otherwise. But in point of epistemological footing the physical objects and gods differ only in degree and not in kind. Both sorts of entities enter our conception only as cultural posits. The myth of physical objects is epistemically superior to most in that it has proved more efficacious than other myths as a device for working a manageable structure into the flux of experience.[18]

Skeptics and traditional epistemologists come to view our posits as mere convenient fictions because they overemphasize the theory-builders' perspective. Quine maintains that we cannot adopt the theory-builders' perspective exclusively—to question the validity and truth of our posits and the reality of the objects which we presume, we must have some background beliefs, theories, or commitments which provide us with our notions of truth, evidence, and reality. According to Quine, this background is provided by our common-sense posits regarding physical objects.[19]

In short, the therapy which Quine prescribes to the traditional epistemologists' peculiarly philosophical fallacy is that epistemologists recognize that theory-builders are also theory-holders. This recognition allows a different sort of response to the worries raised by our growing understanding of our evidential predicament: it allows for a naturalistic inquiry wherein epistemologists utilize our science to explain the ontogenesis and utility of our science, and it allows naturalistic epistemologists to answer the skeptical challenges actually raised by our scientific understanding. In the next section these naturalistic explanations and responses are clarified.

25. The Naturalists' Naturalistic Response to Skeptical Worries

Quine says that in its new setting, epistemology is contained in natural science, *and* natural science is contained in epistemology.[20] The containment of epistemology in science allows for a view of epistemologists as scientists. Like other scientists, they will have to "work from within"—they will conduct their inquiries while recognizing their roles as theory-holders. That is, they will not attempt to start from scratch or adopt a transcendent vantage point but, rather, will accept their presently held theories and beliefs as they utilize them in their inquiries. According to Quine, when we accept this orientation we

> accept physical reality, whether in the manner of unspoiled men in the street or with one or another degree of scientific sophistication. In so doing we constitute ourselves recipients and carriers of the evolving lore of the ages. Then, pursuing in detail our thus accepted theory of physical reality, we draw conclusions concerning, in particular, our own physical selves, and even concerning ourselves as lorebearers. One of these conclusions is that this very lore which we are engaged in has been induced in us by irritation of our physical surfaces and not otherwise. Here we have a little item of lore about lore. It does not, if rightly considered, tend to controvert the lore it is about.[21]

Justificatory rationalists find the transcendence of our theorizing (whether that of common sense or that of advanced science) to be a large stumbling block—they believe that when one is unable to trace a concept or theory back to its origin and justificatory basis, one is confronted with an illicit notion. Naturalized epistemologists are not similarly bothered by this transcendence. Since they recognize the role of their held theory, they are not tempted to disavow their ordinary concepts of reality, truth, and evidence. Quine does not believe that the transcendence of posits over sensory evidence warrants either a skeptical or fideistic attitude.

This transcendence does present naturalized epistemologists with a challenge, however. Given the lore about lore and the scientific discovery about our evidential predicament, one wonders how the

held theory could have evolved. While traditional epistemologists find a *justificatory* problem here, naturalized epistemologists encounter an *explanatory* one. Since they cannot attempt to justify the held theory (since attempts to question *its* truth or justificatory status raise pseudo-issues), they are left with the problem of explaining the acquisition, development, and nature of the held theory. Since the challenge arises within science, they are, of course, free to appeal to science in responding to it.

In responding to this challenge they will be studying their own predicament. That is, their studies will have as their subject

> a natural phenomenon, viz., a physical human subject. This human subject is accorded a certain experimentally controlled input—certain patterns of irradiation in assorted frequencies, for instance—and in the fullness of time the subject delivers as output a description of the three-dimensional external world and its history. The relation between the meager input and the torrential output is a relation that we are prompted to study for somewhat the same reasons that always prompted epistemology; namely, in order to see how evidence relates to theory, and in what ways one's theory of nature transcends any available evidence.[22]

This predicament will be familiar to psychologists who study human cognition and to physicists who would study the behavior of physical systems which are not impacted by man. They must each accept the fact that they are unavoidably intertwined with the phenomena they would study. Such scientific studies will be governed by a maxim of "relative empiricism": "don't venture further from sensory evidence than you need to."[23] That is, in studying how our theories relate to our evidence, these theorists will wish to limit, as much as possible, the extent to which their own theorizing transcends the available evidence (even as they are engaged in a study of this very transcendence).

While Quine may seem to "reduce" epistemology to psychology, the naturalized epistemologists' work is not exclusively within that science. Another important aspect of their attempts to account for the nature and development of our background theory will be their appeal to Darwinian biology. In answering the problem of induction and in providing an account of the phenomenon of positing, for example, Quine appeals to this theory: he accounts for both by

maintaining that a species with such traits benefits in the natural selection process.[24]

Again, it should be stressed, Quine is *not* offering a justificatory response to skeptical challenges in the manner attempted by traditional epistemologists. Thus, his appeal to Darwinian theory differs from the sort of appeal offered by Briskman which was discussed in section 3. While Briskman would avoid relativism by appealing to this scientific view in order to establish the nonarbitrariness of his orientation, Quine would utilizes this appeal to the Darwinian theory only in order to offer a naturalistic (and, hence, relativistic) *explanation* as to how and why our esoteric scientific posits and theories (or their exoteric counterparts) developed.

D.T. Campbell's work provides an excellent example of such a naturalistic explanatory theory. He appeals to a model of *blind variation and selective retention* as he explains conceptual change or evolution.[25] The Darwinian model which he utilizes maintains that variations are "blind" in the sense that there is no element of purpose or foresight in their occurrence. That is, they arise in "relative independence": their occurrence is independent of their eventual stability, utility, or potential. With Darwin, he sees selective systems as operating by hindsight. The evolution of the eye illustrates this. Here the progressive effect of a variety of blind variations is a powerful survival mechanism. This complex evolution is an

> opportunistic exploitation of a coincidence which no deductive operations on a protozoan's knowledge of the world could have anticipated. This is the coincidence of locomotor impenetrability with opaqueness, for a narrow band of electromagnetic waves.[26]

The model of blind variation and selective retention, then, provides a scientific explanation of the development of such selective structures.

Campbell maintains that this model may be used to account for the nature and development of our cognitive or scientific systems as well as to explain the fit of organism and environment. Many would consider it odd to propound a model which speaks of blind variations while discussing the growth of our scientific thought. Campbell offers an extensive historical discussion which shows that many have wished to propose such an epistemology, however.[27] Moreover, his works are rich with suggestions about how a program to explain the growth of knowledge naturalistically would proceed.

Peter Skagestad believes Campbell's emphasis upon blind variations in the attempt to explain our held theory and the phenomena of conceptual change is inappropriate. Elaborating upon a suggestion of Peirce, Skagestad would appeal to *"biological preadaptation"*:

> science progresses through chance guessing; but *correct* guessing is possible only because the explanatory requirements imposed by our fundamental world-view narrow the range of possible hypotheses to a manageable number, among which is the correct one. The correctness of our fundamental world-view is insured by the fact that *it* is a product of biological adaptation in the literal sense.[28]

While Skagestad recognizes that the growth of knowledge will proceed through a long series of non-adaptive steps (that there will be many blind alleys in our hypothesizing, theorizing, and positing), he believes progress would be impossible if the range of wild speculations were not significantly narrowed. The limiting constraints here are not themselves the product of chance guessing but, rather, "they could have been arrived at during man's pre-scientific mental evolution, because correct rudimentary ideas of physics would have immediate survival value."[29]

Where Campbell would employ one evolutionary model in accounting for both biological and cognitive evolution, Skagestad would employ two. I will not venture into the issue here nor cite Skagestad's rationale for preferring his preadaptive model. The issues have barely been joined and the adjudication of these views must await detailed development of the two (and other) explanatory models.[30] The central concern of this work is not with developing a detailed account of the naturalists' explanation of the origin and development of our held theory, nor is it with developing a detailed account of their explanation of the phenomenon of conceptual change. Instead, the concern here is to show that the naturalists offer an orientation which offers a more satisfactory response to the skeptical and fideistic challenges to rationalism than do the justificatory rationalists, kerygmatic rationalists, unqualified realistic rationalists, and qualified realistic rationalists.

Quine's own main naturalistic theorizing helps us understand the naturalists' account of our roles as theory-holders and theory-builders, and it provides the basis for a promising response to the other orientations in the internal and external perennial arguments

with regard to rationality. While his work is in the area of language theory, he describes his interest as an "ontological" one. He wishes to provide a naturalistic account of our referential apparatus in order to understand (both in terms of individuals and in terms of the species) how we have come to hold the sort of held theory we have inherited, and how and why we change this theory.

His behavioristic semantics is meant to provide a naturalistic language theory.[31] In many of his works he sketches the "roots" of our referential abilities from the early babbling instinct and our prelinguistic sensory capabilities up through our employment of quantification. Quine forthrightly declares that the picture he sketches is "imaginary."[32] Certainly when one discusses a child's acquisition of linguistic capabilities in terms of variables and substitutional or objectual quantification, one does not wish to maintain that the child "really knows" those things. While individuals may not be conscious of proceeding through the steps which he sketches, and while he does not claim that the sketch he offers is the final story of the language acquisition process, he does believe that the sketch which he offers comes close to portraying the stages which individuals pass through as they acquire our held theory.[33] When we assimilate this held theory, he says,

> we are little more aware of a distinction between report and invention, substance and style, cues and conceptualization, than we are of a distinction between the proteins and the carbohydrates of our material intake. Retrospectively we may distinguish the components of theory-building, as we may distinguish the proteins and carbohydrates while subsisting on them.[34]

The fact that children or primitive humans do not and cannot recognize the validity of the chemical account of the digestive process does not prejudice the adequacy of that account as an explanatory one and the same moral may be drawn in the case of linguistics.

While the transcendence of our evidence by our posits may lead many to believe they are disreputable, and while the sort of evolutionary epistemology Quine offers as he explains the acquisition of our held theory may lead them to conclude that we arrive at these disreputable views by happenstance, Quine points out that "the disreputability of origins is of itself no argument against preserving and prizing the abstract ontology."[35] As a naturalized epistemologist

who recognizes the important role played by the held theory, he will not be tempted to eschew this theory—it provides him with the very notions of truth, reference, and evidence which enable him to pursue his studies. Attempts to question *its* truth lead to the philosophic fallacy which was exposed in the previous section.

While he maintains that our held theory must be regarded as conceptually sovereign, Quine does not maintain that conceptual change is impossible, however. Here we encounter the other half of the mutual containment of epistemology and natural science noted above. Naturalized epistemologists are not only theory-holders, they are also theory-builders (or, better, theory-changers). The theory-changer's perspective is occupied by those who would systematize and simplify the held theory, cleansing it of inhibiting features and developing it into a more adequate tool. In commending the theory-changer's enterprise to us, Quine is not recommending a rejection of the theory-holder's perspective. Nor is he maintaining that the held theory is false, bad, or ontologically pernicious.

Given what has been said in regard to our role as theory-holders, it should be clear that Quine in no way wishes to countenance judgments as to the falsity of the held theory. Instead he claims this theory is not, at least not by the standards of science, a fully developed and cohesive theory:

> a fenced ontology is just not implicit in ordinary language. The idea of a boundary between being and nonbeing is a philosophical idea, an idea of technical science in a broad sense. Scientists and philosophers seek a comprehensive system of the world, and one that is oriented to reference even more squarely and utterly than ordinary language. Ontological concern is not a correction of a lay thought and practice; it is foreign to the lay culture, though an outgrowth of it.
>
> We can draw explicit ontological lines when desired. We can regiment our notation. . . . Then it is that we can say that the objects assumed are the values of the variables, or of the pronouns. Various turns of phrase in ordinary language that seemed to invoke novel sorts of objects may disappear under such regimentation. At other points new ontic commitments may emerge. There is room for choice, and one chooses with a view to simplicity in one's overall system of the world.[36]

25. Naturalistic Response to Skeptical Worries 119

The enterprises of the natural scientists and the ontological philosophers are natural outgrowths of the activities which are part of the language-acquisition process. A child's acquisition of the held theory stops sort of any deliberate ontologizing, however, while scientists and naturalized epistemologists will be most conscious and deliberate in their endeavors. They will seek to maximize prediction and will be guided in their efforts by considerations like those of conservatism and simplicity as they attempt to revise their held theory from within.[37]

According to Quine, when changes in the held theory yield a better predictive apparatus or provide us with a simpler or more general theory while preserving as much as possible of the old apparatus, we find ourselves led to accept such modifications.[38] Naturalized epistemologists maintain that the changes in our conceptual scheme occur not because it is false nor because one which is truer suddenly presents itself, but because a more simple, efficacious, or parsimonious scheme becomes available. That is, they maintain that "as far as knowledge is concerned, no more can be claimed for our whole body of affirmations than that it is a devious but convenient system for relating experiences to experiences."[39]

The posits, charged with deviously but conveniently ordering experience, are subject to replacement when others, which perform the desired tasks more readily, are discovered. Quine, of course, maintains that the tendency toward increasing systematization in science is directly tied to such success.[40] Thus, while we must conduct our inquiries from within the held theory, we are not doomed to occupy it forever—we may transcend it from within by changing it plank by plank.

Quine's appeal to pragmatism here differs from Rescher's. As we saw in section 6, Rescher would *justify* his rationalism by appealing to a metaphysical deduction which guarantees the relationship between successfulness and truth. While Rescher would reply to the skeptical challenge, Quine rejects the traditional epistemological justificatory endeavor and offers in its place a naturalistic account of the acquisition of (and of the processes of change within) our held theory. The pragmatic views noted in the previous paragraph, then, are not an external buttress to the naturalized theory he champions. Instead, such "truths" must themselves be put forward naturalistically.

It is only if one occupies the point of view of the theory-changer without reminding oneself that every theory-changer is also a

theory-holder that such views will seem to force us toward skeptical views which treat our posits as convenient fictions. One must recognize that it is relative to the held theory that the distinction between myth and reality or between posits and real things makes any sense. While recognizing the role of increasing systematization and the purpose of conceptual schemes, then, naturalistic epistemologists must acknowledge that the predicament of their human subjects is also their own: when they note that the only evidence human subjects can have for the existence of external objects is the fact that beliefs in these aid in the organization of experience, they do not conclude that there are no such objects, nor do they lament the limitations of the human condition.

Thus, Quine's appeal to biology, his appeal to pragmatism, and his general theory of theorizing are not offered independently of the held theory which provides the standards of truth, evidence, and reality during our theory-changing endeavors. These standards are affirmed within science, and the naturalist recognizes "no higher truth than that which science provides or seeks."[41] The held theory, then, provides the standards or background conceptions of reality, truth, and evidence which enable the theory-changers' constructive enterprises—enterprises which may themselves engender changes within the held theory.

As theory-changers who are also theory-holders, we must take the held theory seriously while we attempt to change it (bit by bit).[42] The theory-holder's perspective also provides the naturalized epistemologists with their methodological biases toward simplicity, conservatism, and systematization. Indeed, the held theory may well contain within itself the seeds of its own evolution: the search for a more simple, consistent, and efficacious held theory is a search which the presently held theory (which is inelegant, inconsistent, and inefficacious to some extent) may itself foster. Here science (the conscious attempt to ontologize and systematize) is seen as an extension of our common-sense orientation, and the naturalized epistemologists' scientific scrutiny of science is merely a further step in the same direction.[43]

According to Quine, naturalized epistemologists who study the theory-changing process itself come to recognize three differing sorts of fundamental particles which relate to three different views of the held theory:

sense data, if they are to be posited at all, are fundamental in one respect; the small particles of physics are fundamental in a second respect, and the common-sense bodies in a third. Sense data are *evidentially* fundamental: every man is beholden to his senses for every hint of bodies. The physical particles are *naturally* fundamental, in this kind of way: laws of behavior of those particles afford, so far as we know, the simplest formulation of a general theory of what happens. Common-sense bodies, finally, are *conceptually* fundamental: it is by reference to them that the very notions of reality and evidence are acquired, and that the concepts which have to do with physical particles or even with sense data tend to be formed and phrased. But these three types of priority must not be viewed as somehow determining three competing, self-sufficient conceptual schemes. Our one serious conceptual scheme is the inclusive, evolving one of science, which we inherit and, in our several small ways, help to improve.[44]

These three different kinds of fundamental particles correspond to three differing questions which naturalistic epistemologists ask themselves as they investigate their predicament. To the question "What evidence does one have for the reality of posits?" they find themselves (and all humans) limited to their sensory experiences. To the question "Which posits most systematically perform their function?" they find that the fundamental particles of science are what best relate experiences to experiences. To the question "How does one avoid skepticism in light of the dependence one has upon sensory evidence and the role of increasing systematization in science?" they find that one must not forget that one theorizes from within a theory and that it is this held theory which provides the sense for one's distinctions and claims.

The naturally fundamental particles (those posited by scientists) are in part the results of the desire for increasing systematization. *Qua* epistemologist the investigator may not only note this fact but also assert that the only difference between the posits of the scientist and those of child may consist in the greater care on the part of the scientist in the collection of evidence. Thus, *from an epistemological point of view,* the naturally and conceptually fundamental particles are dependent upon and must be explained in terms of the evidentially fundamental particles. As has been noted, it is in his appeal to our roles as theory-holders that Quine would defuse the skeptical worries

which the scientific epistemologists' studies seem to engender here: the held theory provides us with the conceptions of reality, truth, and evidence which we must employ even as we seek to revise this held theory itself.[45]

The preferability that attaches to the naturally fundamental particles arises from the fact that these provide a revision of the held theory that yields a simpler, more consistent, and more efficacious system. The systematic posits of the electromagnetic theory of radiation, for example, perform their function more successfully than the child's ordinary posits. In this respect, physicists find they can provide simpler laws than can the child, and we find good reason to formulate our advanced theories with reference to the scientists' posits.

Such departures from the held theory (the additions by scientists) are restricted by what Quine calls a *maxim of shallow analysis*.[46] This restriction holds that one should make the smallest possible departure from the held theory. While "regimentation" will refine the held theory, such refinements should proceed in a gradual and restricted fashion. This fact, of course, is due to the sort of confinement which the naturalist must accept. The onboard shipwright, to appeal once again to Neurath's metaphor, proceeds gradually in the rebuilding of the hull since he or she must work while at sea and afloat on the very vessel being repaired.

The theory-changers' main tool in such rebuilding enterprises is what Quine terms semantic ascent. This tool is not exclusively theirs—it is also utilized by both scientists and ordinary nonreflective theory-holders:

> for it is not as though considerations of systematic efficacy, broadly pragmatic considerations, were operative only when we make a semantic ascent and talk of theory, and factual considerations of the behavior of objects in the world were operative only when we avoid semantic ascent and talk within the theory. Considerations of systematic efficacy are equally essential in both cases; it is just that in the one case we voice them and in the other we are tacitly guided by them.[47]

What distinguishes the naturalized epistemologists' studies from those of the special scientists and from "lay" individuals is the breadth of their concerns.[48]

25. Naturalistic Response to Skeptical Worries

This account of Quine's naturalism shows that in addition to developing a "therapy" argument against the skeptical and traditional epistemological orientations (as does Wittgenstein), he develops a naturalistic explanation of our role as theory-holders and theory-changers. In the next chapter I will distinguish this sort of "explanatory" naturalism from the "descriptive" naturalism championed by Wittgenstein, and further clarify how the explanatory naturalists offer a preferable naturalistic response to the problems of conceptual change and diversity. In chapters 6, 7, and 8 we can then turn to the question of the adequacy and appropriateness of the explanatory naturalists' arguments and to their response to the question "Why should we be rational?"

5

Descriptive and Explanatory Naturalism

26. Diverse and Changing Enablers—A Problem for Naturalism

As we have seen, while naturalists emphasize the importance of our held theory and enablers, they need not maintain that our enablers or held theories are static—change at the level of the held theory is, certainly, possible. While Wittgenstein speaks about *the* standard meter, for example, the standard unit of length in the metric system has undergone change. From 1889 to 1960, for example, a meter was defined to be the distance between two lines on the "International Prototype Meter." After 1960, a meter was defined as 1,650,763.73 vacuum wavelengths of the orange-red radiation of Krypton 86 under certain specified conditions. This change was effected out of complex considerations of increased systematization within physics —earlier developments necessitated a unit of length called the angstrom which was defined to be the ten-thousandth-millionth part of a meter, and this unit came to be most easily measured in terms of wavelengths. The accuracy of this method of measurement so surpassed those which applied to the lines on the bar that the new standard came to be adopted.

Thoroughgoing naturalists, however, must evaluate all proposals for conceptual change relativistically (they must appeal to their held theory, and employ its enablers and standards, as they evaluate proposals for its revision); and this relativism raises a problem. While the new standard for metric measurement was adopted because the needs and interests of the *scientific* community had undergone a change, if one considered the needs and interests of *other communities* some other changes (or no change at all) might have been preferred. Since both the former and the latter perspectives may well be supported by the shared held theory, the naturalists' preference for one proposal for conceptual revision over others appears *arbitrary*.

The phenomenon of diversity at the level of the enablers or

standards also seems to raise the problem of arbitrariness. Since the naturalists' evaluations and justifications must be offered relative to the standards which *their* enablers provide, and since these enablers are beyond the realm of rational argumentation (as they are the very bedrock presumed by this enterprise), where the naturalists encounter individuals who employ *other* enablers, they seem to have to content themselves with kerygmaticism. Here the charge of arbitrariness again looms on the horizon for naturalists.

Several of Wittgenstein's remarks seem to support such an interpretation of his sort of naturalism:

> is it wrong for me to be guided in my actions by the propositions of physics? Am I to say I have no good ground for doing so? Isn't precisely this what we call a 'good ground'?[1]
>
> Supposing we met people who did not regard that as a telling reason. Now, how do we imagine this? Instead of the physicist, they consult an oracle. (And for that we consider them primitive). Is it wrong for them to consult an oracle and be guided by it?—If we call this "wrong" aren't we using our language-game as a base from which to *combat* theirs? (609)
>
> Where two principles really do meet which cannot be reconciled with one another, then each man declares the other a fool and heretic. (611)
>
> I said I would 'combat' the other man,—but wouldn't I give him *reasons*? Certainly; but how far do they go? At the end of reasons comes *persuasion*. (Think what happens when missionaries convert natives.) (612)

Wittgenstein does not mean to be discussing unlikely or merely possible differences in the enablers which individuals may appeal to, nor is he discussing a mere abstract possibility that our enablers are subject to change. He maintains that changes have occurred, and he contends that individuals have indeed differed regarding such changes:

> I believe that every human being has two human parents; but Catholics believe that Jesus only had a human mother. And other people might believe that there are human beings with no parents, and give no credence to all the contrary evidence. Catholics believe as well that in certain circumstances a wafer completely changes its nature, and at the same time that all evidence proves the contrary.

26. Diverse and Changing Enablers—A Problem for Naturalism

And so if Moore said "I know that this is wine and not blood", Catholics would contradict him. (239)

Very intelligent and well-educated people believe in the story of creation in the Bible, while others hold it as proven false, and the grounds of the latter are well known to the former.[2] (336)

Confronted with the phenomena of diversity and change on the level of the held theory or enablers, both Wittgenstein and Quine express a preference for the orientation which they champion—Wittgenstein maintains that being guided by the propositions of physics (rather than the proclamations of an oracle) is just what *we* call having a good ground for our actions, and Quine expresses a preference for *our* scientific evaluations and enablers over those of Homer's Greeks.[3] But the Catholics (or those who consult oracles) will also be able to offer their own relativistic evaluations and preferences (evaluations and preference claims which they make relative to the enablers which *they* believe we should appeal to).

Since the naturalists maintain that the giving of reasons ends when we reach the bedrock level, it seems that the price of embracing a thoroughgoing naturalism and emphasizing the peculiar role played by our enablers (and the importance of our role as theory-holders) may be that one must allow that others may appeal to *their* enablers (enablers which would be beyond the realm of rational argumentation since they are the very bedrock presumed by these theorists' enterprise). In short, naturalists seem to be trapped within their bedrock as they attempt to deal with the problems posed by the phenomena of conceptual change and diversity. They seem to be limited to kerygmatically professing their evaluations and preferences.

In this chapter the sort of naturalism championed by Quine ("explanatory" naturalism) is distinguished from that offered by Wittgenstein ("descriptive" naturalism), and the explanatory naturalists' orientation is further clarified. Their naturalistic studies of our role as theory-changers will provide them with a consistent (and thoroughly naturalistic) response to this arbitrariness worry. This chapter clarifies the points at which each of these naturalisms confronts the arbitrariness challenge and shows that the descriptive naturalists will not be able to avoid it. In chapters 6, 7, and 8 I argue that when combined with the naturalistic therapy argument, the explanatory naturalists' account of our role as theory-changers

enables them to avoid the problems which hobble the other rationalists as they endeavor to meet the skeptical and fideist challenges to rationalism.

27. Descriptive Naturalism: Therapy and Fideism

Wittgenstein maintains that as we philosophize about our enablers, we must eventually do away with explanation and simply offer *descriptions*: "philosophy may in no way interfere with the actual use of language; it can in the end only describe it."[4] These descriptions *show* us something about the nature of our background theory (they expose our enablers to us), and they can aid us in avoiding certain sorts of linguistic bewitchment. Individuals who employ *differing* enablers would presumably also be limited to describing their particular background theories, however, and Wittgenstein and these individuals would be unable to criticize each other. The only way to understand or disagree with others here would be for one to first agree with them on a fundamental level by accepting their enablers.

Kai Nielsen calls such an orientation "Wittgensteinian fideism,"[5] and he believes Peter Winch offers this sort of view in his *The Idea of a Social Science* when he says:

> criteria of logic are not a direct gift of God, but arise out of, and are only intelligible in the context of, ways of living or modes of social life. It follows that one cannot apply criteria of logic to modes of social life as such. For instance, science is one such mode and religion is another and each has criteria of intelligibility particular to itself. So within science or religion actions can be logical or illogical. . . . But we cannot sensibly say that either the practice of science itself or that of religion is either illogical or logical; both are nonlogical.[6]

Winch believes that anthropologists like Evans-Prichard and Frazer make a mistake when they attempt to evaluate other systems of belief by utilizing their standards and practices as the basis for their understanding of the other systems.[7] He notes that Evans-Prichard is sensitive to the fact that different "patterns of thought" are provided in different societies. Nonetheless Evans-Prichard would avoid the "excesses of relativism" by maintaining that it is *our* scientific notions (and not the Azande notions of magic, for example) which

27. Descriptive Naturalism: Therapy and Fideism

accord with objective reality—he would provide a nonrelativistic distinction between the real and the unreal which could be used to evaluate the particular distinctions between reality and unreality which different societies would draw. According to Winch, however, such an independent characterization may not be given—our pronouncements of reality and unreality must be relativistic ones.[8]

As Nielsen understands him, then, Winch maintains that each form of life has its own logic or grammar. Nielsen claims that even if we do have two different forms of life in the case of ourselves and the Azande, we do not have two such wholly distinct forms in the case of western religion and science. While he has a feeling, after reading Simone Weil's *Waiting for God*, for example, that he and she belong to different tribes, he realizes that Weil is not

> after all, to me like the Azande with his witchcraft substance. We both learned 'the language' of Christian belief; only I think it is illusion-producing while she thinks that certain crucial segments of it are our stammering way of talking about ultimate reality. A very deep gulf separates us. . . . But all the same, there remains a sense in which we do understand each other and in which we share a massive background of beliefs and assumptions. Given that, it is not so apparent that we do *not* have common grounds of arguing about which concepts of reality are correct or mistaken here.[9]

Nielsen maintains that if we agree with Winch that forms of life such as religion and science are conceptually self-sufficient and that we cannot rightly employ the logic or grammar of one to evaluate or criticize another, we overemphasize the independence of these human activities. To maintain there is *no* context-independent understanding of "the real" is to be too hasty, he claims:

> 'reality' may be systematically ambiguous, but what constitutes evidence, or tests for the truth or reliability of specific claims, is not completely idiosyncratic to the context or activity we are talking about. Activities are not that insulated. . . . once there was an ongoing form of life in which fairies and witches were taken to be real entities, but gradually, as we reflected on the criteria we actually use for determining whether various entities, including persons, are or are not part of the spatio-temporal world of experience, we came to give up believing in fairies and witches. That a language-game was

played, that a form of life existed, did not preclude our asking about the coherence of the concepts involved and about the reality of what they conceptualized.[10]

In short, the different forms of life are themselves relativized to a yet *broader shared context* and this broader context provides a standpoint from which evaluations of conceptual change and diversity may be offered.

Of course, such a view could still be a relativistic one—after all, Nielsen distinguishes the difference between himself and Weil from the difference between himself and the Azande. If he is serious here, he accepts the relativistic point from which Wittgenstein begins, and it seems that the difference between himself and Winch (or Wittgenstein) is only one as to *where* the bedrock is. If the relativistic thesis (R) is accepted, there comes a point at which evaluations, justifications, and criticisms become inappropriate. At such points the Wittgensteinian naturalist must settle for "mere" descriptions.

Winch does not (*pace* Nielsen) maintain that our language games are isolated from each other in mutually exclusive systems of rules, however. He claims that

> language games are played by men who have lives to live—lives involving a wide variety of different interests, which have all kinds of different bearings on each other. Because of this, what a man says or does may make a difference not merely to the performance of the activity upon which he is at present engaged, but to his *life* and to the lives of other people. Whether a man sees point in what he is doing will then depend on whether he is able to see any unity in his multifarious interests, activities, and relations with other men; what sort of sense he sees in his life will depend on the nature of this unity.[11]

According to Winch, primitive societies are not *wholly different* and incommensurable forms of life. He maintains that in coming to understand such societies, we learn different ways of making sense of human life—these societies show us something fundamental about ourselves and about all persons. Like Nielsen, then, he wishes to appeal to a "broader shared context." In his "Nature and Convention," Winch maintains (while speaking of morality) that though our evaluations and justifications may be relativistic and changeable in nature, this does *not* mean that

there are no fixed points in all this change and variety, that there are no norms of human behavior which could not be different from what they are in fact, and that everything in human morality is therefore ultimately conventional in character.[12]

Like Evans-Prichard, he would avoid such an "extreme relativism." According to Winch, however, it is not contemporary science which provides us with the requisite evaluational nexus, instead it is a "general understanding of the significance and nature of human life":

> no more than anyone else's are *our* rules and conventions immune from the danger of being or becoming pointless. So an account of this matter cannot be given simply in terms of any set of rules and conventions at all: our own or anyone else's; it requires us to consider the relation of a set of rules and conventions to something else. In my discussion of Azande magical rites just now what I tried to relate the magical rites to was a sense of the significance of human life. This notion is, I think, indispensable to any account of what is involved in understanding and learning from an alien culture.[13]

Winch believes that we may uncover certain fundamental characteristics of human life and society, and he believes that an appeal to these provides us with an evaluational perspective which is *necessary* rather than merely conventional.[14] Building upon Wittgenstein's analysis of what it is for someone to follow a rule, Winch maintains that social living and integrity are intimately intertwined. Were integrity missing, for example, individuals would fail to assume the responsibilities which their social roles impose upon them and, then, social living would be impossible.

What counts as "fair play" in any given game depends upon its particular conventions, even as the general notion of fair play is of central importance to all games; likewise, integrity is central to human institutions, even though what counts as integrity may vary from culture to culture. According to Winch, concepts like integrity present "limiting notions" upon human life so that while cultures may have different concepts which express them, they will always occupy a central position in any culture. Appeal to these notions shows the limits of relativism since "the very notion of human life is limited by these conceptions."[15] Thus, while there may be a variety of particular forms of life, a general evaluation of the sort Nielsen

desires is countenanced by Winch—in effect they both offer a "qualified naturalism."

Wittgenstein may also seem to offer a qualified orientation—some of his remarks suggest that he would offer a pragmatic evaluation of bedrock beliefs which could legitimate nonrelativistic evaluations of proposals for conceptual change and nonrelativistic evaluations of different sets of enablers or bedrocks:

> The procedure of putting a lump of cheese on a balance and fixing the price by the turn of the scale would lose its point if it frequently happened for such lumps to suddenly grow or shrink for no obvious reason.[16]
>
> So we do *sometimes* think because it has been found to pay.[17]
>
> Language is an instrument. Its concepts are instruments. Now perhaps one thinks that it can make no *great* difference *which* concepts we employ. As, after all, it is possible to do physics in feet and inches as well as in metres and centimetres; the difference is merely one of convenience. But even this is not true if, for instance, calculations in some system of measurement demand more time and trouble that it is possible for us to give them.[18]
>
> The same savage who, apparently in order to kill his enemy, sticks his knife through a picture of him, really does build his hut of wood and cuts his arrow with skill and not in effigy.[19]

Moreover, when Wittgenstein discusses such topics as what it is to follow a rule, whether there could be "private languages," how held theories are socially inculcated, and the peculiar role which enablers play, he seems to be making general claims about *all* language-games and bedrocks. When he claims "the child learns by believing the adult. Doubt comes *after* belief" (160), for example, he does not seem to be merely describing *our* held theory—instead such remarks seem to be intended to expose something about the logic of held theories in general.

If Wittgenstein is indeed offering such a view, he is pursuing the path which our earlier discussion of Roth laid bare in section 21: he is offering a nonrelativized "theory of language-games" just as Roth's Quine offers a nonnaturalized "theory of theorizing." As the earlier discussion of Roth's view revealed, however, a *qualified* naturalism will not do if one believes that the traditional epistemological enterprise is wrong-headed. It is for this reason that this sort of

interpretation of Wittgenstein does not seem correct—it does not fit well with the orientation expressed in those passages where he maintains philosophy can only describe. The hesitancy to interpret his remarks as those of a qualified naturalist is encouraged by Wittgenstein's view that descriptions are instruments which are tied to particular uses:

> what we call "*descriptions*" are instruments for particular uses. Think of a machine-drawing, a cross-section, an elevation with measurements, which an engineer has before him. Thinking of a description as a word-picture of the facts has something misleading about it: one tends to think only of such pictures as hang on our walls: which seem simply to portray how a thing looks, what it is like. (These pictures are as it were idle.)[20]

The "descriptions" which Wittgenstein offers and the language-games which he considers are intended to serve a *therapeutic* purpose. His remarks on Frazer, those about Catholics (and others) who seem to differ from Moore, his general comments about Moore's sort of error in regard to the bedrock, and his "general" remarks about language-games are all offered to expose a certain sort of philosophic error—he would offer a therapy which will enable us to avoid the sort of bewitchment which Moore and other philosophers fall prey to. According to him:

> Our investigation is therefore a grammatical one. Such an investigation sheds light on our problem by clearing misunderstandings away. Misunderstandings concerning the use of words, caused, among other things, by certain analogies between the forms of expression in different regions of language.[21]

In addition, it should be noted that Wittgenstein rejects the pragmatic turn suggested by some of the above citations—he does *not* wish to maintain that these pragmatic considerations provide for the sort of evaluation or justification which would ensure that there could be independently established evaluations and preferences when we are confronted with the problems posed by the phenomena of conceptual change and diversity:

> so I am trying to say something that sounds like pragmatism.
> Here I am being thwarted by a kind of *Weltanschauung*. (422)

> This game proves its worth. That may be the cause of its being played, but it is not the ground.[22] (474)

He does not attempt to ground his held theory or enablers: since all our evaluations, justifications, and preferences are to be offered relative to it, it cannot be evaluated or grounded.[23] Confronted with the phenomena of conceptual diversity or conceptual change, then, the pragmatic appeal will not settle the issue between those who would consult the physicist and those who would consult the oracle.

While Winch and Nielsen would offer a qualified naturalism so that they can avoid arbitrariness, relativism, and kerygmaticism when confronted with individuals who do not share their held theory, Wittgenstein simply says he "cannot find his feet with" such individuals since he has "different pictures."[24] He would neither offer an evaluation of their orientation nor belittle, condemn, or contradict such individuals—to do so, he claims, he would have to *share* many beliefs and theories with them.[25] Wittgenstein discusses such cases neither to develop a general "theory of language-games" nor to evaluate the others' (or our) viewpoints but, rather, to expose the special role played by *our* enablers:

> our clear and simple language-games are not preparatory studies for a future regularization of language—as it were first approximations ignoring friction and air-resistance. The language-games are rather set up as *objects of comparison* which are meant to throw light on the facts of our language by way not only of similarities, but also of dissimilarities.[26]

While Wittgenstein would recognize that our held theory changes over time,[27] he would not attempt to offer an independent evaluation of the appropriateness of such changes. Instead, he restricts himself to describing our held theory in an effort to cure us of the disease of linguistic bewitchment. Unlike Quine's naturalized epistemologists, then, Wittgensteinian naturalists are not interested in offering an explanatory account of the changeability of our held theory. Their primary focus is upon the therapy which they would administer to wrong-headed philosophers like Moore. For obvious reasons, I shall call such naturalists "descriptive" naturalists and contrast them with "explanatory" naturalists who *would* offer such explanatory accounts.

27. Descriptive Naturalism: Therapy and Fideism

Wittgenstein clearly maintains that the problems he would deal with are not empirical (or explanatory) ones:

> if the formation of concepts can be explained by facts of nature, should we not be interested, not in grammar, but rather in that in nature which is the basis of grammar?—Our interest certainly includes the correspondence between concepts and very general facts of nature. (Such facts as mostly do not strike us because of their generality.) But our interest does not fall back upon these possible causes of the formation of concepts; we are not doing natural science; nor yet natural history—since we can also invent fictitious natural history for our purposes.[28]

Since Wittgenstein's battle is against linguistic bewitchment, he is not interested in pursuing the empirical endeavors of the natural scientists, natural historians, or the naturalized epistemologists who would plot the acquisition and development of, and study the changes within, our held theory. He believes the misconceptions which bewitch traditional epistemologists are important ones and he thinks that to avoid them we must "bring words back from their metaphysical to their everyday use."[29] Thus, he maintains, "the work of the philosopher consists in assembling reminders for a particular purpose,"[30] and his purpose is to describe our held theory and remove the linguistic bewilderment which leads philosophers to utter nonsense.

Wittgenstein believes philosophy neither explains nor deduces:

> philosophy simply puts everything before us, and neither explains nor deduces anything.—Since everything lies open to view there is nothing to explain. For what is hidden, for example, is of no interest to us.
>
> One might also give the name "philosophy" to what is possible *before* all new discoveries and inventions.[31]

While Wittgenstein maintains that the worth of our game may be a *cause* of its being played (though not a *ground* for it), he is not interested in pursuing such a causal account. Such an account belongs to science rather than to philosophy, according to him. In saying this, he does not mean to dismiss attempts to offer a general causal account but, rather, to claim that that enterprise is not a philosophical one.

Such a thoroughgoing descriptive naturalism seems to leave Wittgensteinians trapped in the same sort of arbitrariness which renders fideism, kerygmatic rationalism, and unqualified realistic rationalism unsatisfactory—they are limited to describing *their* held theory and enablers, and they allow that *others* might well employ different enablers. Of course, Wittgensteinian descriptivists may reply to any arbitrariness worries which arise here by pointing out that the critics who raise them merely succumb to the very philosophic bewitchment which the naturalistic therapy argument would expose—that is, they could claim that the doubts which these critics would raise should be rejected because they surface only where one fails to pay proper attention to one's role as a theory-holder (where one is "bewitched").

Given Wittgenstein's willingness to accept the phenomena of conceptual change and diversity at the level of the enablers, however, such a therapy argument does not seem to respond adequately to the worry that others might either have or develop radically different conceptual structures, and thus that other individuals might only express an arbitrary preference for their particular preferences, enablers, or bedrock that is, nevertheless, as legitimate as the descriptive naturalists' preferences.

28. Explanatory Naturalism and Our Role as Theory-Changers

Clearly, while the therapeutic emphasis upon our role as theory-holders facilitates the avoidance of the traditional epistemologists' fallacy, an overemphasis on this role may lead one to ignore our role as theory-changers. Indeed, Quine believes that ordinary language philosophers who would treat our held theory as sacrosanct make exactly this sort of mistake: "they exalt ordinary language to the exclusion of one of its own traits: its disposition to keep on evolving."[32]

As we have seen, naturalized epistemologists who follow Quine's lead would avoid this mistake by emphasizing and studying *both* of our roles. These naturalists actively pursue the "causal" or explanatory questions and challenges which arise in regard to the acquisition, genesis, and changeability of our held theory (questions which, they maintain, replace the illicit justificatory questions which traditional

epistemologists ask). In addressing these questions and dealing with these challenges, such explanatory naturalists offer an account which explains (i) how we acquire our presently held background theory, (ii) how this theory itself may have developed or evolved, and (iii) the various forces which tend to govern and engender change or diversity at the bedrock level.

Quine's analysis of the process of language acquisition provides an example of the first of the three sorts of explanatory accounts which these naturalists offer (an account of our acquisition of the held theory). He sketches six general steps which provide an initial account of the language acquisition process that he takes to be central to the acquisition of the initial held theory.[33] This account is more detailed than any brief gloss could adequately portray, and it is only a small step in the direction of a naturalistic account of the acquisition of our held theory.

What is important for our discussion is not the particular stages into which Quine divides his account, but, rather, two general features of his account. First, we must note that in pursuing the roots of our referential apparatus, he is not attempting to offer a justificatory account. Instead, he would offer a *naturalistic* explanatory theory of the stages by which we acquire our background view. Such an account begins by accepting the science of the day—it accepts the picture of ourselves and our environment offered by our current theories as it attempts to offer a picture of the development of our linguistic abilities.

Secondly, we must note that Quine offers a *behavioristic* account —according to him, as children acquire the pervasively held initial common-sense theory, they respond to certain stimulations in certain ways, and are brought into outward conformity to an outward standard. Quine's commitment to a behavioristic account is not dictated transcendentally or nonnaturalistically, however. He would provide an account of our acquisition of the held theory from within that theory by appealing to the *best* science presently available and by accepting those restraints which any naturalistic inquirer must accept:

> our dissociation from the old epistemologists has brought both freedom and responsibility. We gain access to the resources of natural science and we accept the methodological restraints of natural science. In our account of how science might be acquired we

do not try to justify science by some prior and firmer philosophy, but neither are we to maintain less than scientific standards. Evidence must regularly be sought in external objects, out where observers can jointly observe it. Speculation is allowable if recognized for what it is and conducted with a view to the possible access of evidence at some future stage.[34]

Quine believes that "mentalistic" psychology does not accept this responsibility and, thus, he employs a behavioristic account. In moving from a mentalistic psychology to behavioral psychology, we forsake talk of "internal mechanisms" and demand that our theories be couched in terms of behavioral dispositions, according to Quine. The former account would explain the understanding and the equivalence of expressions in terms of "meanings" and "sameness of meanings," while the latter would look to behavioral dispositions. The latter sort of account more adequately fulfills the responsibility which Quine says naturalistic epistemologists must accept if they are to offer adequate explanations—it speaks more directly of the dispositions of physical systems.

Quine explains his preference for the dispositional explanations as follows:

> a disposition is . . . simply a physical trait, a configuration or mechanism. . . . What makes a disposition is no significant character of its own, but only the style in which we happen to specify it. Thus take the classical example, solubility in water. This is a physical trait that can be specified, with varying degrees of thoroughness, in various ways. It can be described quite fully, I gather, in terms of the relative positions of small particles. It can also be described, less fully, by citing a simple test: put an object in water and see if it dissolves. . . . physical traits themselves do not divide into dispositions and others, any more significantly than mankind divides into passers-by and others. The term 'disposition' has its significant application rather as a preface, each time, to actual singling out of some physical trait. . . . The dispositional way of specifying physical traits is as frequent and as useful as it is because we are so often not prepared, as we now happen to be in the case of solubility, to specify the intended physical trait in other than dispositional style.[35]

Ultimately, Quine would hope to offer a *physiological* rather than a psychological account since he believes that a physiological account

28. Explanatory Naturalism and Our Role as Theory-Changers 139

would fulfill the responsibility better than one which arises within behavioristic psychology—it, like the molecular account of solubility, better explains the phenomena by more rigorously accepting the methodological restraint of tying theory to public observation.

D.T. Campbell's evolutionary epistemology offers an explanatory account of the evolution or development of the held theory itself (and an example of the second of the three sorts of explanatory accounts of our theory-changing and theory-holding roles that explanatory naturalists provide). As we saw in section 25, both Campbell and Quine would appeal to Darwin's sort of biology to account for how the broad background features of our held theory have developed. They provide an evolutionary explanation for the following: our reliance upon sensory experience, the appropriateness of the behavioral analysis, the employment of induction, and the employment of the conceptually fundamental objects of common sense.

Again, it needs to be emphasized that the naturalists' account here is not a justificatory one. They would address the causal and explanatory issues by attempting to provide from *within* science (or our held theory) an account of its acquisition, its genesis, and development. Their account would be circular *if* it is intended as a justificatory one. Fortunately, this is not the sort of intention which motivates them. As Quine notes,

> once we have seen that in our knowledge of the external world we have nothing to go on but surface irritation, two questions obtrude themselves—a bad one and a good one. The bad one, lately dismissed, is the question whether there is really an external world after all. The good one is this: Whence the strength of our notion that there is an external world? Whence our persistence in representing discourse as somehow about a reality, and a reality beyond the irritation?[36]

The naturalists' therapy argument shows why the bad question is to be dismissed. Moreover, the arbitrariness charge which is adduced by those who demand that the naturalists ground their commitment to their enablers and establish the truth of the held theory is also rejected by the therapy argument (naturalists claim that an overemphasis upon our role as theory-holders is what leads such critics astray). Arbitrariness worries may also arise from *within* science,

however. Here the good question arises, and the explanatory naturalists' answer to it will take its cue from the scientific picture we have of ourselves and of our environment.

As with their account of language acquisition, the explanatory naturalists' account of the development of the held theory itself is based upon the view that we all have the ability to make similar sensory discriminations and to relate various of our sensory experiences to one another. According to Campbell, our similar discriminatory abilities gradually engender the complex conceptual structure in much the same way as the eye develops from an innocent beginning point.[37] The naturalists' account here will be more tentative than their account of the language acquisition process since the latter continues with each generation whereas the early stages of the development of our held theory will remain shrouded in our prehistory.

The explanatory naturalists' study of our theory-changing role will not be limited to offering accounts of the acquisition and development (or genesis) of our held theory. The third sort of explanatory account which they will offer explains naturalistically the held theory's disposition to change (or evolve). Here explanatory naturalists will attempt to uncover the general parameters which govern and engender such change. According to Quine, while our held theory provides us with our enablers and our starting point, it does not provide the sort of comprehensive and unified theory which allows us to accomplish many of our objectives—it engenders doubts, problems, and paradoxes. Our simplest theory about the physical world which speaks of sticks and water, for example, generates puzzles (e.g., straight sticks which appear to be bent in water) which lead us to construct the more refined theories of physical science.

Studying our theory-changing role naturalistically, explanatory naturalists come to the general conclusion that our held theory is a socially inculcated structure of "posits" which radically transcends the meager sensory stimulations which impinge upon us from without—they claim that

> as far as knowledge is concerned, no more can be claimed for our whole body of affirmations than that it is a devious but convenient system for relating experiences to experiences. The system as a whole is under-determined by experience, but implies, given certain experi-

28. Explanatory Naturalism and Our Role as Theory-Changers 141

ences, that certain others should be forthcoming. When such predictions turn out wrong, the system has to be changed somehow. But we retain wide latitude of choice as to what statements of the system to preserve and what ones to revise; any one of many revisions will be sufficient to unmake the particular implication which brought the system to grief.[38]

As theory-changers, they maintain, we reconstruct our initial held theory so that we may better anticipate the character of our future experience and better accomplish our objectives.

The explanatory naturalists' study of our role as theory-changers reveals that a variety of (sometimes conflicting) forces tug at us when revisions are called for: we manifest a conservative tendency to employ certain familiar sorts of conceptions, a propensity to obey empiricistic methodological restraints, and a disposition to appeal to pragmatic evaluative criteria. Moreover, we manifest desires for increased systematization and generality, for increased theoretic simplicity, for unity amongst our sciences, and for the conservation of our past successes.

Explanatory naturalists do not claim that revisions which meet such desiderata are *true* however—such claims are ruled out by their understanding of our role as theory-holders. According to the naturalists, truth, reference, and factuality are *immanent*.[39] According to them, the problems posed by the phenomenon of conceptual change are *not* problems of truth. They maintain that an analysis of our most successful theory revisions (those of the scientists) shows that they self-consciously examine our held theory in an effort to provide a more efficacious and systematic instrument which is more "explicitly oriented to reference":

> it is in deliberately ontological studies that the idea of objective reference gains full force and explicitness. The idea is alien to large parts of our ordinary language. Still it has its roots in ordinary language. A distinction between concrete general and abstract singular is sometimes visible in ordinary usage, and clean-cut standards of individuation are implicit in ordinary usage for wide ranges of objects. It is in imposing this referential pattern all across the board that scientific theory departs from ordinary language. We see the result: objective reference is central to our scientific picture of the world.[40]

Indeed, Quine recommends that explanatory naturalists be even more self-conscious than the natural scientists in playing their parts as theory-changers. According to him, as naturalized epistemologists engage in their theory-changing activities they take on the task

> of making explicit what had been tacit, and precise what had been vague; of exposing and resolving paradoxes, smoothing kinks, lopping off vestigial growths, clearing ontological slums.[41]

The ontological emphasis here is one which is of central importance to Quine and the explanatory naturalists. They maintain that our ordinary language is unlike the language of science—it is not explicit about its ontological commitments or assertions of factuality. This does not mean it is *defective*, but it does mean that it is an instrument ill-suited to some of our purposes. Thus we engage in what Quine calls "regimentation":

> I do not advise giving up ordinary language, not even mentalistic language. But I urge awareness of its pitfalls. There is an instructive parallel between questions of reference, on the part of ordinary language, and questions of factuality. . . . Ordinary language is only loosely referential, and any ontological accounting makes sense only relative to an appropriate regimentation of language. The regimentation is not a matter of eliciting some latent but determinate ontological content of ordinary language. It is a matter of freely creating an ontology-oriented language that can supplant ordinary language in serving some particular purposes that one has in mind.
> Now factuality is similar. Ordinary language is only loosely factual and needs to be variously regimented when our purpose is scientific understanding. The regimentation is again not a matter of eliciting a latent content. It is a free creation.[42]

According to the explanatory naturalists, then, our theory-changing activities are directed toward developing (from within the held theory) a more unified and systematic overall theory which will better satisfy some of our desires and needs. The photons, quarks, and weak forces which we speak of in contemporary physical science, for example, are not at all implicit in any way in our ordinary discourse or experience, but they provide us "the simplest formulation of a general theory of what happens."[43]

28. Explanatory Naturalism and Our Role as Theory-Changers 143

The explanatory naturalists' account of our theory-changing role allows for the possibility that we could be confronted with distinct yet equally adequate proposals for conceptual revision. In discussing the naturalists' position when they are confronted with such a situation, Quine says

> can we say that one, perhaps, is true, and the other therefore false, but it is impossible in principle to know which? Or, taking a more positivistic line, should we say that truth reaches only to the observation conditionals at most, and, in Kronecker's words, that *alles ubrige ist Menschenwerk*?
>
> I incline to neither line. Whatever we affirm, after all, we affirm as a statement within our aggregate theory of nature as we now see it; and to call a statement true is just to reaffirm it. . . . there is no extra-theoretic truth, no higher truth than the truth we are claiming or aspiring to as we continue to tinker with our system of the world from within. If ours were one of those two rival best theories . . . it would be our place to insist on the truth of our laws and the falsity of the other theory where it conflicts.[44]

That is, as a thoroughgoing naturalist, he must recognize that his evaluations and preferences must ultimately be made relative to the theory which he currently holds. Similarly, of course, the explanatory naturalists' overall account of our theory-changing activities (their discussion of our acquisition of our initial theory, their account of the development of this held theory, and their account of the factors which govern and engender conceptual change) must be relativized to their held theory.

Distinct yet equally adequate proposals for conceptual revision may come linked with all of the following: (a) the explanatory naturalists' acceptance of the relativistic thesis (which holds that conceptual evaluations are always made relative to a frame of reference or conceptual scheme), (b) the view that we have a "wide latitude" to decide where to revise our held theory, and (c) the view that the ontological specificity which our revisions engender is a "free creation." When such a linkage occurs, the specter of arbitrariness or relativism seems to loom large on the horizon. Although the explanatory naturalists' accounts of our role as theory-changers were designed to prevent overemphasis on our role as theory-holders, and thus to by-pass the kerygmaticism or fideism which descriptive

naturalists fall prey to, the fact that their account of theory-change embraces the above three factors actually seems to undercut the possibility of escaping from the descriptive naturalists' predicament. The latitude to freely create revised theories—to bring about explicit referential import where there had been not even implicit import in the original held theory—and to do so along a variety of distinct paths that might be equally adequate when referenced back to the evaluative context provided by the initial theory, does not seem to forestall the arbitrariness challenge.

To put the point a bit less generally, the explanatory naturalists' account of conceptual change does not seem to preclude arbitrary choice of conceptual revisions when we share the methodology and the goals of the natural scientists which Quine recommends. And if there are other problems, aims, and goals which are part of the initial held theory, there may be other revisions altogether which could be as legitimate as those recommended by the explanatory naturalists' desire for increased regimentation—especially given that the naturalists must ultimately evaluate proposals for conceptual revision by appeal to the held theory (which they contend is incredibly plastic).

Quine maintains that he does *not* intend to offer a version of "cultural relativism" in his account of theory-change. Such theories either fall prey to the "self-excepting fallacy" or, (if they offer a "qualified" view), defeat their original thesis. Equating relativism with "cultural relativisms," Quine declares he is not a relativist, and he recommends fallibilism and naturalism instead.[45]

I have not restricted the application of the term 'relativism' to cultural relativisms, however. Indeed, in maintaining that naturalists should not accept the "equipreferability thesis," I have indicated that such positions should be avoided. The important point is not whether we call explanatory naturalism a species of relativism, however, but that we recognize that it allows that there could be alternative regimentations which develop incompatible ontology-oriented languages (each of which is adequate for the purposes of scientific explanation and prediction and none of which is implicit in our held-theory). Whether this situation is construed as a case of the problems engendered by conceptual diversity, or is considered as a case of the problems engendered by conceptual change, it would appear that in allowing for this, explanatory naturalists run afoul of

the arbitrariness worries which undercut the descriptive naturalists' orientation.

In the next three chapters I will show how explanatory naturalists deal with this challenge and resolve the perennial arguments with regard to rationality. Before turning to this, however, it is important to foreclose the possibility that the explanatory naturalists might adhere to a qualified naturalism and, by discarding the relativistic thesis (R), attempt to deflect the arbitrariness challenge.

29. Explanatory Naturalism and Realism

It may seem that Quine's claim that he advances a *realism* undercuts the thoroughgoing explanatory naturalism which I am attributing to him here (and which, of course, generates the appearance of arbitrariness and relativism). An understanding of the nature of his commitment to realism will help us understand the explanatory naturalists' orientation, however.

While discussing conceptual change, Quine terms his orientation a "naive and unregenerate *realism*" and maintains that

> our system changes, yes. When it does, we do not say that truth changes with it; we say that we had wrongly supposed something true and have learned better. Fallibilism is the watchword, not relativism. Fallibilism and naturalism.[46]

His rejection of relativism and his acceptance of realism here should not mislead one into believing he offers the sort of qualified naturalism we saw Roth attribute to him in section 21, however. Instead of a realism which appeals to transcendent standards and allows for independent evaluations and preferences of background views, Quine maintains that our talk of truth must be relativized to our held theory.

In renouncing relativism he is rebelling against the idea that in embracing naturalism we must "settle for a relativistic doctrine of truth—rating the statements of each theory as true for that theory, and brooking no higher criticism."[47] As I have noted above, the relativism he seems to be concerned to deny here is a "cultural relativism" which accepts (either explicitly or implicitly) the equipreferability thesis.[48] Quine's account of our role as theory-

changers points to our role as theory-holders when it comes to talk of truth. According to him, we must accept the restrictions of Neurath's onboard shipwrights as we philosophize naturalistically (and engage in the explanatory studies of our roles as theory-holders and theory-changers): we must confront problems raised by the phenomena of conceptual change and diversity from *within* our held theory.

His claim that he is a "naive and unregenerate" or "robust" realist leads some to ignore or downplay this relativistic aspect of his orientation. Since he terms himself a realist *and* a naturalist, I suggest we look to Quine's naturalism when discussing his realism. Indeed, Quine recommends this when he writes:

> how is all this robust realism to be reconciled with the barren scene that I have just been depicting? The answer is naturalism; the recognition that it is within science itself, and not in some prior philosophy that reality is to be identified and described.[49]

The explanatory naturalists' "naive and unregenerate" or "robust" realism is, like *all* their doctrines, a *naturalistic* thesis—it is offered by epistemologists (or theory-changers) who recognize and acknowledge the importance of their role as theory-holders. *Pace* Roth and others, Quine's realism is a doctrine offered from within the held theory, and it does not qualify his naturalism in any fashion:

> there is an absolutism, a robust realism, that is part and parcel of my naturalism. Science itself, in a broad sense, and not some ulterior philosophy, is where judgment is properly passed, however fallibly, on questions of truth and reality. What is affirmed there, on the best available evidence, is affirmed as absolutely true.[50]

The explanatory naturalists' "absolutistic affirmations" are made from *within* their presently held theory, however.[51] The claim that *science* provides the best answer to questions of truth, reality, and reference is not a claim which is uttered from a perspective outside of science. Explanatory naturalists utter their truths—*even their truths about science*—from within science. Their realism, then, is a realism which arises *within their naturalism*.

As an explanatory naturalist, Quine would not qualify his naturalism at all—his realism is not to somehow ground his recommendations regarding conceptual change and ensure that the arbitrariness challenge may be met. This leaves the task of clarifying how

explanatory naturalists *can* meet this challenge. In the final three chapters, I show how these naturalists confront this challenge; I assess the adequacy and appropriateness of their argument against the skeptics, fideists, unqualified realists, and qualified realists; I show how they resolve the internal and external perennial arguments with regard to rationality; and I explain why they maintain that we should be rational.

6

The Appropriateness of the Explanatory Naturalists' Therapy

30. The Dialectical Situation—Therapy and Ultimate Differences

As we saw in chapter 4, explanatory naturalists contend that the skeptics and qualified realistic rationalists misconstrue the role played by our enablers. The naturalists' therapy argument is designed to show that an overemphasis upon our role as theory-changers leads traditional theorists astray. Naturalists recommend that we recognize the peculiar role played by our enablers and the importance of our role as theory-holders. As we have seen, explanatory naturalists would not overemphasize this role, however. Unlike the descriptive naturalists, they contend that it is philosophically important that we study and pay sufficient attention to our role as theory-changers. Their naturalistic studies of our role as theory-changers enable them to meet the arbitrariness challenge which confronts the descriptive naturalists.

If one accepts the naturalistic diagnosis of the other theorists' "mistakes," and if one accepts the legitimacy of the explanatory naturalists' appeal to our role as theory-changers in their effort to address the phenomena of conceptual diversity and change, then the other positions should be rejected. It is not clear why the skeptics or the qualified realistic rationalists (let alone the kerygmatic rationalists, the unqualified realistic rationalists, or the fideists) should accept these naturalistic views, however.

It is important to note that any attempt by explanatory naturalists to defend their therapy argument, and any defense of their appeal to their naturalistic studies of our role as theory-changers, will themselves have to be offered from within naturalism. The only way to avoid this would be for the naturalists to adopt a qualified naturalism; and in this case all the problems exposed in the discussion of

Roth's sort of qualified naturalism (in section 21) would arise. But skeptics and qualified realistic rationalists (as well as kerygmatic rationalists, unqualified realistic rationalists, and fideists) seem to be as free to reject a naturalistic defense of the naturalistic therapy argument (and a naturalistic defense of the appeal to naturalistic studies of our role as theory-changers) as they were to reject the original therapy (and naturalistic appeal).

On the other hand, we should also note that the other theorists seem to be caught in a position not unlike the one which explanatory naturalists find themselves in: the skeptics traditionally offer a therapy argument against their opponents, and they certainly may not accept nonskeptical theses when they argue against other theorists (at least not if they wish to be consistent); similarly, qualified realistic rationalists such as Moore and Chisholm offer a therapy argument against those who reject the knowledge claims which they appeal to, and they must limit themselves to these knowledge claims when they argue against their opponents if they are to be consistent. Furthermore, fideists, kerygmatic rationalists, and unqualified realistic rationalists all offer therapy arguments for their fundamental commitments; and these theorists must content themselves with a kerygmatic recommendation of their orientations if they are to be consistent—their rejection of justificationalism prohibits their appealing to anything in an effort to justify their orientations.

In short, each of the orientations offers a therapeutic critique of its opponents, and any defense (or kerygmatic affirmation) of their orientations which these theorists may consistently offer must presume theses (or commitments) which the opponents would reject. In assessing these orientations, then, *we* seem unable to adjudicate the dialectical issue. Thus it seems that we confront the sort of situation which Alan Goldman terms a "point of ultimate philosophical difference for which there is no clear resolution through argument."[1] I believe that this is not the case, however; and in this chapter I argue that the explanatory naturalists' therapy argument is appropriate, and I argue that the interplay of the various therapy arguments does not leave us with an arbitrary choice amongst these orientations. In chapter 7 I will argue that the explanatory naturalists' appeal to their studies of our role as theory-changers allows them to offer a non-arbitrary and effective response to the challenges actually posed by the phenomena of conceptual diversity and change.

30. The Dialectical Situation

In critically assessing the explanatory naturalists' therapy argument, we must first determine whether the skeptics, qualified realistic rationalists, kerygmatic rationalists, unqualified realistic rationalists, and fideists may simply dismiss it as inappropriate outright. If they may not, the argument may provide a legitimate dialectical move which allows us to avoid the conclusion that we confront a "point of ultimate philosophical difference." We need to distinguish three arguments as we assess the appropriateness of the explanatory naturalists' therapy argument: (i) the internal perennial argument (regarding the specification of the rationalists' ideal or maxim) between the explanatory naturalists on the one hand and the skeptics and qualified realistic rationalists on the other (here the disputants accept the ideal of rationality but disagree as to the responsibilities specified by the ideal or maxim); (ii) the external perennial argument (regarding the acceptability of the rationalists' ideal or maxim) between the explanatory naturalists and the fideists (here the disputants disagree over whether or not we should accept the rationalists' maxim or ideal); and (iii) the argument between the explanatory naturalists on the one hand, and the unqualified realistic rationalists and the kerygmatic rationalists on the other.

I have excluded consideration of the argument with the unqualified realists and kerygmatic rationalists from the first argument since some may question whether we should consider such theorists to be rationalists—unqualified realists and kerygmatic rationalists give up not only justificationalism, but they ultimately appeal to faith in just the manner of the traditional fideists. While their faith is a "faith in reason," it is a faith nonetheless. In terms of the distinction between internal and external perennial arguments with regard to the rationalists' ideal, then, these individuals seem to occupy a "middle position." In response to the internal argument (with regard to the specification of the rationalistic ideal), they offer a kerygmatic claim which they must refuse to justify given their unqualified realism (or kerygmaticism)—any argument they might offer for their view or against another one must ultimately end with a kerygmatic expression of their faith. I have excluded their view from the second argument since such theorists do not usually consider their views to be fideistic. We must now turn to a consideration of each of these cases and attempt to determine whether the naturalists' opponents may legitimately dismiss the naturalists' therapy argument by claiming that it is inappropriate.

31. Therapy, Qualified Realism, and the Internal Argument

Skeptics provide a critique which justificatory rationalists are unable to escape. Their challenge exposes the inherent flaw in this orientation, and they hope that in showing such rationalists the absurdity of their view, these theorists will come to reject their orientation. While unqualified realists and kerygmatic rationalists reject justificationalism to avoid this problem, qualified realistic rationalists do not completely reject it. They maintain that the realistic distinction does not apply to that class of beliefs which are immune to lack of warrant and to error. Their claim that they know certain things (and thus that they are, in fact, justified) is supposed to end the regress of justification (and, thus, the skeptics' challenge) while allowing them to avoid the kerygmaticism and arbitrariness which unqualified realistic rationalists seem forced to espouse.

As we saw in section 13, Chisholm and Moore maintain that the knowledge which they would appeal to is in no need of substantiation. Instead of maintaining that this supports skepticism, however, Chisholm notes that "in favor of our approach there is the fact that we *do* know many things, after all."[2] Similarly, Moore maintains that while he cannot *prove* that he is not dreaming he does, after all, *know* that he is not and we *all* know similar things.[3] He recognizes that the qualified realistic rationalists' claims here may appear dogmatic but says that

> in the case of assertions such as I made, made under the circumstances under which I made them, the charge would be absurd. On the contrary, I should have been guilty of absurdity if, under the circumstances, I had *not* spoken positively about these things.[4]

Qualified realists do not lament that they have nothing better to counter the skeptic with but, rather, point out that one could ask for nothing better than to be basing our further claims, beliefs, and commitments upon such knowledge claims. While it may seem that skepticism is undefeated since it cannot be criticized head-on, the telling consideration their therapy argument would adduce is the "fact" that the qualified realistic rationalists' orientation accords with what we all do know—and by "all of us," they of course mean to include the skeptics. Chisholm and Moore would expose the *absurdi-*

ty of the skeptics' doubts and, thus, would return us (and, hopefully, the skeptics) to "common sense."

Since they employ this sort of therapy argument, however, qualified realistic rationalists may not maintain that the explanatory naturalists' use of a therapy argument is inappropriate in the internal perennial argument. If they did not themselves offer such an argument, they might seem justified in complaining that in failing to meet them head-on explanatory naturalists violated one of the "forms or norms of argumentation." Since they themselves employ such an argument, however, this line of defense does not seem open to them as they respond to the explanatory naturalists' therapy argument.

While they may not be able to simply dismiss outright the explanatory naturalists' therapy argument as a nonargument which does not directly challenge their view, this does not mean they must *accept* the naturalists' argument—they may allow that the argument is appropriate, but deny that it is effective. Indeed, given that they maintain that the beliefs (or methods) in question are immune to lack of warrant and to error, it seems clear that no argument (therapy or otherwise) could *force* them to reject these claims.

Explanatory naturalists concur with the qualified realists' diagnosis of the skeptics' error, but they do not agree with the proposed therapy—they dissent from the view that we should claim to *know* in such cases. According to the explanatory naturalists, *neither doubt nor knowledge* are appropriate when one is at the level of the enablers. The naturalists' therapy argument attempts to show that the qualified realistic rationalists' error is similar to the skeptics'. Each fails to understand the role played by our enablers. While it is true, as the qualified realists claim, that doubts and questions cannot arise in a vacuum (that doubting and questioning presume some basis which is not doubted or questioned), explanatory naturalists point out that this does not establish that such a basis should be called *knowledge*.

The naturalists' studies of our role as theory-holders expose the necessity of posits or held theories (they reveal the fact that doubt, inquiry, and assertion take place relative to a background or system which "gives such enterprises their life").[5] Moreover, the explanatory naturalists' causal studies (their accounts of the development of the held theory over time, of the process of theory-acquisition, and of theory-change) indicate both what our held theory is like and why it

is the way it is. Most importantly, however, the naturalistic studies of our theory-holding role reveal the peculiar role played by our enablers.

In showing qualified realistic rationalists the importance of our role as theory-holders and in exposing the role played by our enablers, explanatory naturalists would wean them from their claims to *know*—they would show them that our options here are not simply those of doubt or knowledge. Qualified realists are, of course, free to disagree with the therapy offered by the naturalists. Since these realists claim it is absurd not to claim knowledge in the case of the beliefs or methodologies in question, and since the naturalists offer considerations designed to show that such claims are indeed absurd (as absurd as the skeptical "doubts"), however, these realists should show that the naturalists' denial of knowledge in the case of these claims is confused.

If qualified realistic rationalists, skeptics, or explanatory naturalists did not offer their therapy arguments, we would be confronted with several internally consistent views which could not offer nonfallacious arguments against each other. Qualified realistic rationalists could claim they had knowledge and reject any doubts which tried to infect these "immune" claims; skeptics could demand that we make no unjustified claims; and explanatory naturalists could espouse their relativistic view of the enablers. Any putative rationale for the rejection of the qualified realists' claims would encounter their claim that here they have beliefs (or methods) which are immune to lack of warrant and to error—they would not under any condition sacrifice such claims. Any putative rationale for the rejection of the skeptical view would encounter the skeptical demand that that rationale itself be justified and, thus, they could remain secure in their skepticism. Any realistic challenge to the explanatory naturalists' views would run up against their description of the role played by their enablers. In short, if these theorists were simply concerned with the development of internally consistent theories, they could dismiss the arguments of the other theorists on internal grounds. In such a case we *would* be confronted with a point of "ultimate difference" which was unresolvable by argument.

These theorists are *not* simply interested in developing such internally consistent positions, however. Each would show what is wrong with the views of the others and here is where both the therapy arguments and the possibility of resolution fit in. Their critical

endeavors provide a point of argumentative contact between the opposing theories—skeptics would show justificatory rationalists the error of their ways, qualified realistic rationalists would explain where skepticism goes wrong, and explanatory naturalists would expose the qualified realists' and the skeptics' fundamental mistake. To the extent that their therapy does not expose to others the error of their ways, each of these theorists will view his or her orientation as inadequate. Indeed, none of these theorists can settle for the demolition of straw-persons—they would show others that the alternative orientations are flawed.

While the arguments are developed from the therapists' perspective in each case, they are not simply aimed at pleasing or convincing the therapist. Since the therapist would convince others that the other orientations are faulty, she or he can ultimately consider this sort of argument to be successful only when it leads the others to reject the other orientations (ideally, perhaps, when it leads proponents of the other orientations to abandon their views). Therapy arguments are, therefore, both difficult to develop and often unsatisfactory. Certainly stubbornness and dogmatism present obstacles to such therapy, but the fact that individuals of each orientation engage in such therapeutic endeavors shows, I believe, that such obstacles need not inevitably constrain the discussion.

Undoubtedly, the dialogue between these theorists could continue for quite a while. I believe the considerations adduced in chapters 4 and 5 provide good reasons for preferring the explanatory naturalists' view and for rejecting both the qualified realistic rationalists' and the skeptics' orientations. The explanatory naturalists do not simply identify the skeptics' and qualified realistic rationalists' peculiarly philosophical fallacy; they also offer a naturalistic account of the acquisition and genesis of the held theory, and a naturalistic account of both the reasons for conceptual change and the factors which govern it. They argue (albeit naturalistically) that their explanatory account resolves the problems actually generated by the phenomena of conceptual diversity and change. Just as qualified realistic rationalists seem warranted in rejecting skepticism when skeptics cannot fault their diagnosis or therapy, so naturalists seem warranted in rejecting the qualified realistic rationalists' orientation when these realists cannot find a fault in their diagnosis, therapy, and account of conceptual change. It seems to me, then, that the burden of proof now shifts to the qualified realists (and the skeptics).

32. Therapy, Fideism, and the External Argument

Anyone who has attempted to argue with a fideist knows that external critiques of the fideist's commitment will be summarily rejected and that internal critiques are impossible (since they must begin with an acceptance of that fideist's articles of faith). Only if the fideist's commitments are contradictory does the latter technique hold any promise, and some fideistic commitments will survive even this "fault" (since contradiction is taken by some fideists as a sign of correctness). Are we to conclude, then, that the external perennial argument with regard to the rationalists' ideal is going to end, at best, by exposing a point of ultimate philosophical difference for which there is no hope of resolution through argument?

As we have seen, Kekes thinks not. He believes that the fideists have an "absurd view of human nature" which does not allow them to resolve the basic human problems. Fideists might agree with him that individuals have problems which they must seek to resolve yet reject his characterization of our basic problems: they might maintain that our religious nature, and the theistic, pantheistic, or deistic nature of our environment pose our enduring problems. They might also claim that the problems which Kekes places at the center of our lives should be construed as pseudo-problems offered to tempt us from our true concerns, and they might claim that the true problems cannot be resolved *via* rational argumentation.

According to Kekes, aside from the obvious pragmatic benefit of providing a comprehensive and consistent framework for solving enduring problems, the rationalists' orientation is important since it may provide individuals' lives with meaning and purpose. He maintains that individuals must possess not only a rationally justified world view, but also a *sensibility* if they are to be wise and live well. This sort of sensibility is developed by making critical comparisons amongst different ideals, and it requires imagination and emotional agility in addition to understanding. If an individual has this trait, "his beliefs and feelings about reality, his attitudes to nature, other people, and himself, the ideals which guide his action all harmoniously coexist and form a coherent whole."[6] This is important since ideals are to be pursued as desirable solutions to the problems which individuals have. Those who adopt unreasonable ideals will be left

32. Therapy, Fideism, and the External Argument

with unsolved or poorly solved problems. The adoption of ideals itself, then, is to be pursued rationally, according to Kekes.[7]

Kekes recognizes that religions (as well as ideologies) provide individuals with world views which are to provide meaning to their lives and resolve "problems," but he claims that

> acceptance of these authoritative answers is the price of participation in the worldview. And the thirst for having a worldview of one's own is so great that many people do not hesitate to pay this demeaning price . . . [but] the rational examination of all relevant questions is necessary to having a successful worldview. What makes a worldview successful is that it solves enduring problems. And what rational examination does is to maximize the chances of success by critically testing policies for action. If rational discussion of fundamental questions is eschewed, the possibility of having a successful worldview is undermined. The comfort provided by participation in an authoritatively founded worldview is thus false comfort, based on self-deception, and it leads to action against one's own interest.[8]

Fideists are likely to deny this claim, however. Pascal, for example, maintains that since the benefits of religious belief are so great if there is a deity, and the losses associated with this belief are so minimal if there is not, it is more reasonable to attempt to adopt the theistic orientation than to adopt the atheistic one. Pascal also maintains that the best that we may do rationally is to arrive at plausible hypotheses about the nature of the world—"first principles" are always beyond rational scrutiny. Here faith must enter in, and without faith we may never truly avoid the doubts and problems which make our lot so unhappy and empty. The happiness which we all seek, he says, is to be found in a deity and here we must have faith. Presumably he believes, *pace* Kekes, that a successful world view will *not* be forthcoming if we adopt the rationalists' orientation.

Kekes terms such views "supernaturalisms" and maintains that they rest

> on the totally unsubstantiated claim that the key to problem-solving lies in a rationally incomprehensible realm. If there exists such a realm, nothing about it can be known, not by us, nor by supernaturalists. For to know anything is to bring it within rational comprehension. It would be self-defeating, therefore, to look to such a realm for

guidance in solving our enduring problems. So in this external perennial argument I claim victory for my side on the grounds that the other side could not even begin to solve enduring problems.[9]

Pascal, Kierkegaard, Tertullian and other fideists would find this argument wholly unpersuasive. They might disagree with the claim that knowledge is subsumption under rational comprehension (consider, for example, Pascal's "intuitions of the heart"), or they might maintain that it is not knowledge but, rather, faith which is requisite if our enduring problems are to be resolved (consider, for example, Tertullian's "What does Jerusalem have to do with Athens" and his belief that the desire to understand implies a lack of faith). Certainly these individuals would maintain that the argument Kekes offers is question-begging: it begins with the premise that the rationalistic orientation leads to happiness and success, and it then claims the fideistic orientation is inadequate since it is not rationalistic. They may reject either the claim that the rationalists' orientation has the virtues Kekes cites in its favor or the implicit claim to uniqueness here.

Traditional rationalists find such fideistic views incomprehensible. They complain that if one denies the appropriateness and efficacy of rational choices at this level, one is left with only a *blind faith*—one seems forced to throw out the apparently successful rational methodologies we do employ and substitute in their place some authoritatively given procedures, beliefs, or commitments for which no reason or rationale may be offered. Fideists, of course, willingly concede this but maintain that a recognition of our true condition and plight shows the necessity of such "leaps of faith": our lives will have meaning, our doubts will be resolved, and our views will be correct only if we allow faith to play the central role which rationalists mistakenly assign to reason. They would maintain that the "success" which rationalists claim accompanies their orientation is success only if one would occupy oneself with resolving pseudo-problems.

Fideists offer therapy arguments designed to expose to rationalists the error of their ways. In this endeavor skepticism is their natural ally—appeal to skeptical arguments shows the difficulties which the rationalists' orientation encounters. Where skeptics are pessimistic, however, fideists are optimistic. They maintain that our nature is too strong for skepticism—we cannot settle for skepticism since belief comes so naturally to us. Here we are caught in a paradox: we are

unable to doubt, but we are also unable to rationally ground our beliefs and confute skepticism.

Fideists maintain that while human reason is indeed limited and cannot resolve this paradox, nonrational commitments may rescue us from our plight. Both Pascal and Kierkegaard believe a "leap of faith" will rescue us from the agony and unhappiness we experience given our propensity to believe and the limits of our rational abilities. Neither believes such faith comes easily however. Each felt he lived in an age where people were generally seduced away from the truth, security, knowledge, and peace which such faith can provide. Each felt that if he could make individuals aware of the fact that their misery and their lack of faith were related, then people might turn to such faith and begin to lead happy lives avoiding any estrangement from the deity who could provide the meaning and truth which we all seek.

Fideists maintain skepticism is the natural terminus of the rationalistic orientation. Human reason seeks the standards of justification and evaluation in vain since the finite can never encompass the infinite:

> we sail within a vast sphere, ever drifting in uncertainty, driven from end to end. When we think to attach ourselves to any point and to fasten to it, it wavers and leaves us; and if we follow it, it eludes our grasp, slips past us, and vanishes for ever. Nothing stays for us. This is our natural condition, and yet most contrary to our inclination; we burn with desire to find solid ground and an ultimate sure foundation whereon to build a tower reaching to the Infinite. But our whole groundwork cracks, and the earth opens to abysses.[10]

While they maintain that we can never come to rationally know the independent or external standards of justification and evaluation, however, fideists agree with rationalists that there are such standards and that our beliefs, theories, and commitments are correct or proper only if they are in accord with them. Since these standards are not rationally accessible, we must rely upon faith here. Their therapy arguments are designed to show this and to encourage individuals to forsake the rationalistic orientation.

The fideistic therapy is not offered as a rationalistic criticism of the rationalistic orientation. Were it intended to be such an argument, the rationalists would be justified in maintaining that fideists em-

ploying it were ultimately inconsistent—they would be countenancing the rational scrutiny of commitments while maintaining that such scrutiny must finally give way to faith. Thus, their therapy argument must be an argument which is offered *from the fideists' perspective*. While it is offered from within the fideists' orientation, it is not simply a question-begging argument against the rationalists, however. Their therapy argument is employed in an attempt to show others the inherent difficulties in their opponents' orientations. Its therapeutic character marks this argument as one which attempts to engage the opponent in a serious argument.

Clearly, then, fideists may not reject the explanatory naturalists' therapy argument as utterly inappropriate. Since they employ such an argument as they attempt to show rationalists the error of their ways, fideists will have to allow that the explanatory naturalists' use of this sort of argument is legitimate. Of course, they are not forced to *accept* the naturalists' therapy—they may claim that while the argument is appropriate, it is ineffective. In fact, such a result is highly likely: few who are firmly rooted in their kerygmatic articles of faith will accept the sort of naturalistic therapy which alleges that this faith is premised upon a misconstrual of the role played by our "enablers."

Although the fideists may develop responses to the explanatory naturalists' therapy argument, it seems clear that the external perennial argument is not doomed to end with the discovery of a point of ultimate difference for which there is no resolution through argument. The therapy argument provides a point of argumentative contact between the various positions, and the concern which each therapist has for uncovering the opposing theorists' errors ensures that such therapy arguments will not be simply directed at straw persons.

The explanatory naturalists' therapy argument is designed to show that fideists misunderstand our roles as theory-holders and theory-changers in the same manner as do the skeptics and unqualified realists. It is not faith but, rather, our role as theory-holders which supplies our "beginning points" or "first principles." While naturalists agree with fideists that our beginning points may not be rationally justified or evaluated, they do not seek some suprarational (or transcendental) ground for them. They maintain that fideists who do seek such a ground make the same sort of error which qualified realistic rationalists and skeptics make: they fail to recognize the peculiar role played by our enablers or held theory. While rationality

is indeed limited, then, there need be nothing behind it which buttresses it according to the explanatory naturalists.

Of course, fideists may reject the naturalists' claim that they misunderstand the nature of justification and our roles as theory-holders and theory-changers. Given their willingness to develop a therapy argument which shows others the error of their ways, however, the fideists will need to show what is wrong with the naturalists' therapy and analysis of our theory-holding and theory-changing roles. But they will not be able to build upon the skeptics' arguments (given the explanatory naturalists' analysis of the skeptics' errors); thus, they will have to develop a line of argument which differs from the one they deploy against justificatory rationalists.

Nielsen's discussion of "Wittgensteinian fideism" may well serve for a model as fideists attempt to establish that descriptive naturalists cannot avoid a kerygmatic commitment, but the explanatory naturalists' emphasis upon our role as theory-changers and their naturalistic studies will undercut such an argument if it is raised against them. In sections 36, 37, and 41 below I argue that the explanatory naturalists' appeal to their naturalistic studies of our theory-changing role provide them with an orientation which does not fall prey to arbitrariness worries or fideistic challenges. Given the explanatory naturalists' therapy argument and their naturalistic account of our role as theory-changers, it seems that the ball is, at least, in the fideists' court—they will need to develop an argument which shows that the explanatory naturalists cannot avoid a fideistic commitment.

33. Therapy, Unqualified Realism, and Kerygmatic Rationalism

Unqualified realistic rationalists maintain that even the beliefs or theories for which we possess the best possible justifications might possibly be ones which are not, in fact, justified, and they believe that the maxim of rationality imposes no justificatory responsibility. In light of this, their view is that we should hold beliefs and theories which are in fact justified. As as result, it seems that they cannot really participate in the internal perennial argument with regard to rationalism because they can neither justify their version of rationalism nor argue that other contenders are unjustified. That is, since they contend that the best possible justifications might well support

a position which we should not hold, it is difficult to see why they would wish to buttress their claims with justifications.

They might choose to participate in the internal perennial argument by offering a therapy argument, however. Rather than offering a justification of their claims here, they would utilize such argumentation to show (*from their own perspective*) where other rationalists' misconceptions arise. As is the case in all therapy arguments, the hope here would be that even though these arguments are offered from the therapists' perspective, an understanding of the arguments would lead to a recognition of the opponents' mistakes and to the adoption of the therapists' orientation.

Alston could be construed as offering this sort of therapy argument in his discussion of "level confusions"—he maintains that the skeptics' position is "misguided" because they confuse "the justification of the perceptual belief and the justification of the higher-level belief that the perceptual belief is justified."[11] Wherever one believes that one must be able to show that the higher level belief is justified in order for the lower one to be justified, he contends, one is trapped in this sort of confusion.

Alston maintains that all that is relevant is that our beliefs in fact be justified, and he tries to show the skeptics the error of their ways. Once one makes the relevant distinction, he claims, the skeptical challenge is dissolved and we are free to adopt a new orientation:

> the level-confusions we have been examining naturally lead to ignoring the possibility of what we might call unsophisticated, unreflective first-level knowledge or justification. Of course it may not be immediately obvious that there is unreflective knowledge or justification; the question needs careful consideration. But the point is that so long as we are victims of level-confusion we cannot even consider the possibility of a purely first-level cognition. The new look in epistemology introduced by the "reliability" theories of such thinkers as Dretske, Armstrong, and Goldman is largely built on the claim that first-level knowledge is independent of higher-level knowledge. We will be able to take this "new look" even experimentally, only to the extent that we can free ourselves from the blinders imposed by level-confusion.[12]

Whether or not Alston intended to advance the sort of view I have called unqualified realism, it is clear that such realists could offer such

a therapy argument. They should not, however, attempt to argue directly against other rationalists in the internal perennial argument —the attempt to argue that the others' views were unjustified (or that their views were justified) would be without point given their rejection of justificationalism. They must ultimately content themselves with a kerygmatic statement. Thus, the ascent to "higher" epistemic levels cannot be a justificatory endeavor. This makes it most reasonable to see the unqualified realists discussions of the "higher levels" as therapy arguments directed against others' orientations from within their own.

The early Popper's argument against skeptical, justificatory, and instrumental orientations might be construed as another example of an unqualified realist's therapy argument. In rejecting the justificationalists' orientation, he maintains that their questions "What grounds our beliefs and theories?" and "How do we know?" are *misasked questions*: "they are not formulated in an inexact or slovenly manner, but *they are entirely misconceived:* they are questions that beg for an authoritarian answer."[13] Throughout his *Conjectures and Refutations*, Popper tries to show us how the other rationalists' orientations fail to lead us toward our epistemic goal. This argument, of course, should be coupled with his "moral" argument (advanced in both his *The Open Society and Its Enemies* and in his "The History of our Time: An Optimist's View").

The early Popper does not really advance an unqualified realistic rationalism, however. If his orientation was that of an unqualified realist, he would ultimately have to content himself with a kerygmatic appeal. While he does offer such an appeal,[14] it does not arise in the context of his disagreement with other rationalists. In discussing the merits of his construal of rationalism in contrast to the other rationalists' conceptions, he maintains that

> one great advantage of the theory of objective or absolute truth is that it allows us to say—with Xenophanes—that we search for truth, but may not know when we have found it; that we have no criterion of truth, but are nevertheless guided by the idea of truth as a *regulative principle* . . . though there are no general criteria by which we can recognize truth . . . there are something like criteria of progress toward truth.[15]
>
> It is only the idea of truth which allows us to speak sensibly of mistakes and of rational criticism, and which makes rational discus-

sion possible—that is to say, critical discussion, in search of mistakes with the serious purpose of eliminating as many of these mistakes as we can, in order to get nearer to the truth. Thus the very idea of error—and of fallibility—involves the idea of an objective truth as the standard of which we may fall short. (It is in this sense that the idea of truth is a *regulative* idea.)[16]

In short, the early Popper believes that his orientation is preferable to the other rationalists' views because falsifications in fact provide us with the requisite contact with the transcendent standard. An unqualified realistic rationalist who wished to employ such a claim as the final step in a therapy argument aimed at exposing the misconceptions inherent in other rationalists' orientations should treat this as a kerygmatic claim—it would not be appropriate to attempt to offer reasons or justifications for it (or against the other orientations).

While Popper's claim here *might* simply express such a kerygmatic commitment, his comments seem to take him beyond simply stating his faith: he claims his falsificationism is shown to be the proper rationalistic orientation if we examine the constitutive principles behind rationalistic practice,[17] and he maintains other rationalistic orientations cannot claim this. According to him, instrumentalists, for example, do not fully appreciate the constitutive principles which underlie our investigative processes—they treat our theories as mere instruments, as instruments are neither true nor false nor can they be refuted:

> our aim is to discover the truth about our problem; and we must look at our theories as serious attempts to find the truth. If they are not true, they may be, admittedly, important stepping stones towards the truth, instruments for further discoveries. But this does not mean that we can ever be content to look at them as being *nothing but* stepping stones, *nothing but* instruments; for this would involve giving up even the view that they are instruments of theoretical *discoveries*; it would commit us to looking upon them as mere instruments for some observational or pragmatic purpose.[18]

According to the early Popper, then, instrumentalistic accounts cannot adequately account for the growth of our scientific knowledge, and an examination of the history of science shows that fallibilism is the key to progress in science. Fallibilism, on the other

33. Therapy and Unqualified Realism

hand, captures the constitutive principles of the rationalistic endeavor which we call science. The regulative status he assigns his views here suggests that he is offering a transcendental argument rather than a therapy argument against other rationalists' orientations. Rather than kerygmatically proclaiming his fallibilism, it seems, the early Popper would ground his orientation and criticize other rationalists' views by appealing to the regulative principles which are constitutive of the rationalistic orientation.

Of course, one might question whether one should adopt the rationalists' orientation. But one would then be concerned with the *external* perennial argument. At this point, the early Popper *is* avowedly kerygmatic—he maintains that our choice is not between reason and faith but, rather, between a "faith in reason" and a "faith in authority." Confronting the "irrationalists'" views in the external perennial argument, the early Popper offers a therapy argument which appeals to morals and politics:

> I frankly confess that I choose rationalism because I hate violence, and I do not deceive myself into believing that this hatred has any rational grounds. Or to put it another way, my rationalism is not self-contained, but rests on an irrational faith in the attitude of reasonableness. I do not see that we can go beyond this.[19]

The violence he hates is associated with the irrationalists' orientation *via* their acceptance of authority rather than reason. In a number of works he draws our attention to the political and moral consequences of a faith in authority and steadfastly professes a preference for his own sort of faith.[20] Again he may be inconsistent here—*if* his concern is justificatory rather than therapeutic, he departs from the constraints which his unqualified realism imposes upon him. Nonetheless, citations like the previous one clearly show that at times he would explicitly adopt a kerygmatic position and simply proclaim his "faith."

According to W.W. Bartley, this sort of kerygmaticism "limits" rationality—it requires that individuals make some commitments (accept some beliefs or theories) which are not rationally defensible. Since this is precisely the fideists' traditional position, it appears that individuals who embrace such a view actually subscribe to fideism instead of criticizing it. Bartley maintains that Popper need not adopt a kerygmatic orientation, however:

> these early fideistic remarks [of Popper's] are relatively unimportant
> ... [they] are superfluous remnants, out of line with the main thrust
> and intent of his methodology. ... They may be dropped without
> loss, as Popper himself has done, with considerable improvement in
> consistency, clarity, and generality in the position as a whole.[21]

As we have seen, Bartley and the later Popper maintain that rationality is to be located in criticism rather than in justification. Bartley believes that comprehensive rationalists (or justificatory rationalists) and critical rationalists (unqualified realists who advance views like that of the early Popper) sacrifice their "integrity" as they attempt to show that rationality is not limited (when they argue against skeptics and fideists who would limit the scope of rationality). They end up allowing that there are some beliefs, theories, or commitments which cannot be rationally defended (and thus fall prey to the fideists' critique).

Bartley would avoid this by embracing a thoroughgoing critical attitude. The comprehensively critical rationalists (or "pancritical" rationalists, as he came to call them) reject justificationalism altogether ("not only do we not attempt to justify the standards; we do not attempt to justify anything else in terms of the standards"[22]), and they hold that everything (including their commitment to criticism) must be held critically. Since such a view will not attempt to justify its basic claims, it is not surprising to find that Bartley employs a sustained therapy argument which purports to show that the comprehensive and critical rationalists were engaged in a misconceived venture. As he says in the introduction to the second edition of his *The Retreat to Commitment*:

> the book attempts to do what might be expected of an adequate
> presentation of any new approach. It delineates how it differs from
> earlier answers to the problems of criticism and of rationality, and it
> explains why such attempts failed, and how it succeeds where they
> failed. To perform the latter task it uncovers the common previously
> unrecognized "structure" that doomed previous answers, and then
> shows how to circumvent this structure. It explains how the
> character of past philosophical inquiry is due almost wholly to this
> structure, and goes on to suggest what new philosophical problems
> and lines of investigation open up once this structure is abandoned.[23]

33. Therapy and Unqualified Realism

Bartley recognizes that this "new conception of the rationalist identity"[24] abandons part of the rationalists' project as it is traditionally construed, but he claims that it retains the crucial central core: a comprehensively critical rationalist is an individual who would never protect a belief, theory, or commitment

> from criticism by justifying it irrationally; one who never cuts off an argument by resorting to faith or irrational commitment to justify some belief that has been under severe critical fire; one who is committed, attached, addicted to no position.[25]

The early Popper sacrifices the "integrity" of his rationalism (both when he attempts to justify his commitment to rationalism by appealing to moral and epistemic arguments and, thus, re-embraces justificationalism, and when he maintains that we must kerygmatically express an uncritical faith in reason and, thus, requires that we make irrational—or uncritical—commitments). Bartley believes that the pancritical rationalist may retain integrity by subjecting *everything* to criticism.

Bartley claims that this orientation allows these rationalists to avoid "the dilemma of ultimate commitment" because it assigns no limits to criticism: "if a pancritical rationalist accuses his opponent of protecting some belief from criticism through irrational commitment to it, he is not open to the charge that he is similarly committed. Criticism of commitments no longer boomerangs."[26] Like all individuals, these rationalists will hold many unexamined presuppositions, but they will willingly submit all of these to critical scrutiny and they will reject those which fail to withstand the test of critical fire. According to Bartley,

> the classical problem of rationality lay in the fact that, for logical reasons, the attempt to justify everything (or to criticize everything through justification) led to infinite regress or dogmatism. But nothing *in logic* prevents us from holding everything open to nonjustificational criticism.[27]

Even if we grant that Bartley is right that this version of rationalism avoids the logical problems of inconsistency and infinite regress, it is not clear that kerygmaticism is wholly avoided.[28] As was pointed out in section 8, the comprehensively critical (or pancritical)

rationalist's commitment to criticism may be as thoroughgoing (and as tentative) as possible, but while this ensures integrity, it does so only if one *presumes* the virtue of the critical endeavor—the fact that the pancritical rationalists may criticize their orientation without loss of integrity (while the fideists may not) counts in favor of the former orientation only if one believes criticism is a virtue. Perhaps Bartley is right in claiming that

> to abandon logic is to abandon rationality as surely as to abandon Christ is to abandon Christianity. The two positions differ, however, in that the [pancritical] rationalist can, from his own rationalist point of view consider and be moved by criticisms of logic and of rationalism, whereas the Christian cannot, from his own Christian point of view, consider and be moved by criticism of his Christian commitment.[29]

But this claim establishes the superiority of the pancritical rationalists' orientation only if one already is convinced that critically-held views are better than uncritically (or dogmatically) held ones, and this is not something the fideists need, or should, allow. They could well claim, in response, that to abandon Christ is to abandon Christianity as surely as to abandon logic is to abandon rationality. The two positions differ, however, in that the Christian can, from his own Christian point of view consider and be moved by dogmatic claims of Christianity, whereas the rationalist cannot, from his own rationalist point of view, consider and be moved by dogmatic claims regarding rational commitment.

Bartley is firmly convinced of the value of the critical enterprise. He would, certainly, respond to such an argument by noting that the Christian fideist may not use such an argument to criticize the pancritical rationalists' orientation without losing integrity. This does not stop the fideists from using such an argument to fend off any putative rational criticism of their commitment, however. That is, in ruling out the fideistic argument against pancritical rationalism, Bartley does not rule out the fideistic position—he only undercuts the fideistic challenge to rationalism as it is presented as an internal argument against rationalism. If these individuals are consistent in their dogmatism and kerygmaticism, however, and if they reject justificationalism completely, it seems that they may hold their views with as much integrity as the pancritical rationalists.

33. Therapy and Unqualified Realism

Of course, Bartley does not intend his argument to be one which would *force* these fideists to become rationalists—he only claims to show that "there is no rational or logical excuse for being an irrationalist."[30] That is, he recognizes that his argument does not offer a response to individuals who adhere to fideistic views but do not attempt to criticize rationalism. Bartley maintains we should try to learn from such individuals rather than argue with them, however:

> when our object is to learn rather than to win a debate, we must take our opponents' arguments seriously and not reject them unless we can refute them. As far as our aim, learning about the world and ourselves, is concerned, it does not matter whether our opponent reciprocates, or whether he treats our own arguments as no more than emotive signals. We may learn from the criticisms of our opponents even when their own practice prevents them from learning from us.[31]

While he cannot refute the fideists, then, he can offer a therapy argument against their orientation—one which, while it is offered from the pancritical rationalists' perspective, attempts to diagnose the error of the fideists' orientation and show why one should adopt the pancritical rationalists' orientation. Thus the above citation maintains that an advantage of the pancritical rationalists' orientation—one which Bartley suggests the fideists' orientation may not claim—is the fact that it can foster learning. In developing such an argument, of course, he must avoid justificationalism if he is to be consistent—if he is not to qualify his realism here, he must rely upon a kerygmatic claim as to the value of the critical orientation.

Whether the kerygmatic rationalists and unqualified realistic rationalists inconsistently return to justificationalism (like the early Popper) or whether they retain their consistency and rely upon an article of kerygmatic faith (while offering a therapy argument against other rationalists' specifications of the rationalistic ideal and against the fideists' orientations), we are not forced to conclude that the argument between them and the explanatory naturalists must end on a point of ultimate philosophical difference. On the one hand, an inconsistent return to justificationalism provides naturalists with a straightforward reply to such theorists. On the other hand, if such theorists offer a therapy argument, they may not rule the naturalists' therapy argument out of court as inappropriate.

Of course, the latter situation leaves us with two opposing therapy arguments, and the kerygmatic rationalists or unqualified realists are not *required* to accept the naturalists' analysis—they are free to argue that the naturalists' claim that they are confused about our role as theory-holders and theory-changers is incorrect. In fact, Bartley attempts to provide such an argument at one point: he maintains that an argument similar to the naturalistic one which I have elaborated actually has the consequence of limiting rationality.

According to Bartley, individuals who offer this sort of argument (he mentions Ayer, Putnam, Quine, and Wittgenstein among others) maintain that justification occurs only within systems, and they claim that there can be no rational justification of such a framework itself. To the extent that he rejects justificationalism altogether, of course, Bartley agrees with the naturalists' view that our enablers are not subject to valid justificatory demands. His disagreement with naturalism arises because they allow for justificationalism otherwise. Because they do so, his general therapy argument would be meant to apply to their version of rationalism. In particular Bartley criticizes such naturalists because they make two unwarranted assumptions:

> first they accept that grounds or reasons or justifications must be given if something is to be rational, but insist that the standards— criteria, authorities, presuppositions, frameworks, or ways of life— to which appeal is made in such justification cannot and need not be themselves justified, and that a commitment must hence be made to them.[32]

He claims that Ayer (in his *The Problem of Knowledge*) holds that the standards of rationality enjoy an immunity from any need for justification and, thus, that it is impossible to judge them to be irrational "since they set the standards on which any such judgement would have to be based."[33] Bartley maintains this first assumption leads such individuals to a problem, however:

> there is, however, an obvious objection to what Ayer says. It is true that *if* some particular standards of rationality *are* correct, then there can exist no other correct rational standards which conflict with them. This "if", however, marks a crucial assumption: that is precisely what is at issue. Thus this approach begs the question, is itself a variety of fideism, and hence is no answer to it.[34]

33. Therapy and Unqualified Realism 171

Of course, naturalists would *not* claim that the enablers (or standards of rationality) are correct or true (or rational). Indeed *their* therapy argument is designed to show what is wrong with such claims. At best, then, Bartley's reply to the first of the naturalists' assumptions is misdirected if it is meant to apply to the sort of naturalistic view I have elaborated (and attributed to Quine and Wittgenstein).

According to Bartley, the second assumption made by individuals who advance the sort of argument which Wittgenstein and Quine advance is that since philosophers may not *justify* their enablers, they must limit themselves to *descriptive* endeavors. He claims that this engenders an obvious problem: "not only justification is limited: criticism and evaluation are also limited: 'the framework propositions are not put to the test'; they are *merely* described."[35] Bartley calls such naturalistic positions "limited rationalisms" and points to their possible fideistic character.

He recognizes that there is a difference between the fideist who would speak about overt acts of commitment (counseling us to *choose* a certain orientation) and Wittgenstein who speaks of being taught a framework. Ultimately, however, the fact that the enablers are not subject to criticism and rational scrutiny leads Bartley to believe that these views will, as have other limited rationalisms (whether intentionally or unintentionally), foster the irrationalists' orientations. In opting for descriptivism, it would seem, the "limited" rationalists quit the field of battle, and fideists may easily claim that their orientations are as legitimate as the rationalists'—especially since these rationalists are unwilling to claim that their enablers are correct or true.

As we have seen, however, explanatory naturalists need not limit themselves to descriptive endeavors—they may follow Quine and pursue the explanatory tasks of a naturalized epistemology. This sort of endeavor, I have maintained, allows them to respond to the problems posed by the phenomena of conceptual change and diversity and allows them to distinguish their orientation from the fideists'. Moreover, their therapy argument provides them with an argument against the fideists' orientation. Naturalists, then, may deny that they are trapped in the sort of "Wittgensteinian fideism" which Bartley implies disables their orientation.

Bartley rejects the naturalistic orientation because it "limits criticism." His therapy argument here, like his therapy argument

against comprehensive rationalism, critical rationalism, and fideism, is founded upon a kerygmatic commitment to criticism, however. Ultimately his view falls prey to the very problem he thinks he finds in the naturalistic orientation—his orientation cannot be readily distinguished from the fideists' orientations.

While he may offer a therapy argument which claims that a virtue of the pancritical rationalists' orientation is that it fosters learning whereas the fideistic orientations do not, fideists are likely to question this claim. They may maintain that the rationalistic orientation precludes, rather than fosters, knowledge about ourselves and the world—they may claim, instead, that such knowledge is made possible only if one accepts the faith which they recommend.[36] The "dilemma of ultimate commitment" is resolved by Bartley only if one accepts the virtue of criticism. This, of course, is exactly what the traditional fideist *will not* accept. Nor will they count it a particular virtue that the pancritical rationalists are so consistent that they subject even their commitment to criticism to criticism—such consistency is a virtue only if one is predisposed to accept the efficacy or value of criticism. While fideists may not *criticize* the pancritical rationalists without losing integrity, the pancritical rationalists' response to the fideists clearly exposes the fact that their consistency requires a kerygmatic commitment to criticism.

Bartley's anti-justificationalism and realism require that he restrict himself, ultimately, to a kerygmatic praise of the critical orientation and to a therapy argument against his opponents. Thus, in distinguishing his orientation from a fideistic one he concludes the epilogue to the second edition of his *The Retreat to Commitment* as follows:

> the ethic of argument that I endorse invokes a different sort of sentiment, which can be spread far more widely: *respect* for people. Whether one owes love to few people or many, one owes respect to all—at least until they very definitely show themselves unworthy of it. One of the most important ways of indicating prima facie respect for a person is to attempt to take his views seriously. This would be impossible if rationality were so limited that critical argument was impossible. I have tried in this essay to promote this sort of respect by showing that the critical argument it calls for is possible and by illustrating some of the unfortunate consequences of the retreat to commitment.[37]

This citation shows that it is unclear that Bartley's pancritical rationalism is the sort of improvement over the early Popper's views which Bartley thinks it is. While he may be more consistent than the early Popper since he is explicitly willing to be critical about even the commitment to criticism, he must follow the early Popper in kerygmatically proclaiming his "faith" in the critical orientation.

Explanatory naturalists will, of course, maintain that this kerygmaticism arises because Bartley misconstrues the role played by his enablers. I believe the considerations offered here and in chapter 4 provide telling considerations which show why one ought to accept the naturalists' therapy argument, and I think the "burden of proof" (or better, perhaps, "the burden of criticism") is upon the unqualified realists and kerygmatic rationalists—they must show what is wrong with the naturalists' therapy argument. Whether or not one agrees with this, the therapeutic endeavor which each theorist takes up here clearly provides a point of argumentative contact between the naturalists on the one hand, and the unqualified realists and the kerygmatic rationalists on the other; and the perennial arguments with regard to rationality need not result in a stalemate here.

34. The Interplay of Therapy Arguments and Arbitrariness

Though the explanatory naturalists' therapy argument may not be inappropriate and may offer the *possibility* that their opponents will become convinced that they should reject or refine their orientations, such a result may seem *most unlikely* since these individuals may respond with therapy arguments of their own. Since each of these therapy arguments must be offered *from the therapist's perspective*, individuals who do not share that orientation may well be unwilling to accept them—they may claim that the therapy is founded upon views which *their own therapies* show to be confusions.

The interplay of these various therapy arguments may suggest that *we* are left with an arbitrary choice amongst the different orientations in the internal and external perennial arguments with regard to rationality. The charge of arbitrariness which is suggested here is a generalized one—it is not to be construed as one which is raised by any of the participants against the other orientations. As we have seen, qualified realistic rationalists maintain that the therapy argu-

ments which they employ *do not* generate a "merely arbitrary" preference for their orientation. A virtue of their position, according to Chisholm, is that it in fact accords with what we all know, and this explains why it is superior to other preferences:

> there is, of course, an element of arbitrariness involved in accepting any one of these . . . possible points of view. . . . But our view is no more arbitrary than . . . the others. And unlike them, it corresponds with what we do know.[38]

Of course, such a claim does not provide an *independent* defense of the qualified realistic rationalists' choice of orientation—it is premised upon an acceptance of the knowledge claims which these realists advance. Their view, then, has the virtue which Chisholm claims for it only if we do *know* the things which they claim we know. Chisholm explicitly recognizes the question-begging character of his defense of his version of qualified realism (he terms this orientation "particularism") over other versions of qualified realism (he terms the main opponents "methodists"), and over skepticism:

> but in all of this I have presupposed the approach I have called "particularism." The "methodist" and the "sceptic" will tell us that we have started in the wrong place. If now we try to reason with them, then, I am afraid, we will be back on the wheel [i.e., fall prey to the skeptical challenge].
>
> What few philosophers have had the courage to recognize is this: we can deal with the problem only by begging the question.[39]

But if Chisholm is correct in claiming that his question-begging argument for his preference shows that it is *no more* arbitrary than the skeptics' and methodists' defenses of their preferences, these opponents seem equally free to claim that given an acceptance of *their* orientations, their therapy arguments show that their orientations possess some virtue which is lacked by Chisholm's views. Such defenses seem to be equally question-begging and one preference seems to be neither more nor less arbitrary than the other. This interplay of different therapy arguments, of course, is exactly what generates the general charge of arbitrariness.

My examination of the internal and external perennial arguments with regard to rationalism shows that qualified realistic rationalists,

unqualified realistic rationalists, kerygmatic rationalists, skeptics, fideists, and explanatory naturalists are all in the same boat—since each theorist must recognize that the others may not accept the beginning points of their therapy argument, each theorist must either attempt to provide an independent and nonquestion-begging rationale for his or her preference or beg the question.[40]

Of course, none of these theorists may take the first option seriously. Fideists, unqualified realistic rationalists, and kerygmatic rationalists may not attempt to offer an independent justification of their preference—they maintain that at some point we must rely upon faith and eschew justification. Qualified realistic rationalists maintain we may not independently justify the knowledge claims in question. Skeptics may not attempt to offer an independent justification of their orientation—such a course of action would engender the self-refutation of skepticism. Finally, explanatory naturalists may not seek a nonnaturalistic ground for their naturalism without losing the central core of their naturalism.

Thus, each sort of theorist *must* beg the question when defending his or her preference and this, in turn, engenders the general charge of arbitrariness: the most the various therapy arguments seem capable of establishing is that one preference is *neither more nor less arbitrary* than the others, and this seems to leave *us* with an arbitrary choice amongst these internally defended preference claims. It might seem as if unqualified realistic rationalists, kerygmatic rationalists, and fideists could find some support for *their* preferences from this fact. They may not appeal to the dialectical predicament engendered by debates with regard to the internal perennial issue as a reason for preferring their orientation in the external perennial argument, however. In doing so they would allow for the external criticism of commitments; and since they maintain such criticism is improper, this allowance would be self-defeating.

Of course, most fideists wish to maintain that their preference for their orientation is not an arbitrary one. Pascal, for example, attempts to dispose of skeptical and atheistic views and show the appropriateness of his particular kerygmatic commitment. He maintains that without this commitment we lead empty lives and devolve into either pride or sloth—according to him, "the Christian religion alone has been able to cure these two vices."[41] His attempt to defend the nonarbitrariness of his orientation and therapy is an *internal* one,

though—only given his view of virtue and vice can one claim that his kerygmatic commitment is preferable since it allows us to eschew vice and embrace virtue.

Unqualified realistic rationalists and kerygmatic rationalists find themselves in the same situation. They claim that their preference for their orientation (pancritical rationalism, for example) is not an arbitrary one since it has a specific virtue lacked by other orientations. As the previous section showed, however, their defense of the nonarbitrariness of their preference presumes an acceptance of their critical orientation, and is as question-begging as the defenses offered by qualified realistic rationalists and skeptics. Whether they explicitly recognize this (as does the early Popper) or, instead, implicitly recognize this (as does Bartley when he recognizes that fideists will not be persuaded by his arguments), their defense of their preference for their realistic orientation will have to be question-begging if it is to preserve their "integrity."

Throughout this work I have been developing a *naturalistic* argument, and that fact may suggest to someone that the general charge of arbitrariness which we confront here should be attributed to the naturalistic perspective which has been presumed. That is, perhaps the naturalistic claim that the naturalists' opponents are limited to question-begging defenses of their preferences serves to attribute views to these opponents which they do not accept. But if this is the case, these theorists should be able to avail themselves of some nonquestion-begging defense of their orientation or for their preference.

I believe I have presented good reasons for believing this is not the case, however. Qualified realistic rationalists such as Chisholm and Moore *themselves* claim that they cannot argue for their preference for their orientation except by begging the question, and they offer a therapy which is designed to expose the absurdity of skeptical reservations in regard to their basic knowledge claims. Kerygmatic rationalists like Popper and Bartley *themselves* rule out any independent justification of (or rationale for) their orientation. Similarly, fideists *themselves* maintain one must first kerygmatically commit oneself and, then, upon this unargued faith one may evaluate, justify, and argue.

Unqualified realists seem to have no choice but to constrain themselves to such arguments—attempts to argue that their views are justified or that their opponents' justifications are inadequate

seem to be without point given their wholesale rejection of justificationalism. While skeptics do not admit that they beg the question against their opponents, they are not able to offer an independent defense of their skeptical orientation (or of their justificatory demand)—any attempt to ground or defend their orientation engenders inconsistency. I believe, then, that the explanatory naturalists' claim that the various theorists may resolve the internal and external perennial arguments and support their particular preference only by begging the question does not illicitly attribute anything to these theorists which these theorists do not themselves accept.

In responding to the general charge of arbitrariness which is suggested by the interplay of question-begging therapy arguments, explanatory naturalists may rightly appeal to the considerations adduced in chapters 4 and 5, and may claim that they provide good *naturalistic* reasons for valuing their preference and therapy over those of their opponents. Moreover, they may respond to the general charge of arbitrariness with a version of their therapy argument— they may point out that individuals who raise this charge demand that one provide strongly independent evaluations of the various preference claims in the perennial arguments before they will allow that *any* preferences are nonarbitrary.

Explanatory naturalists may note that the claim that "Our choice amongst the various orientations and preferences is an arbitrary one" may be interpreted in two different ways: it may amount to the claim that an independent evaluation establishes that the various internally defended preference claims are *equally preferable and adequate* so that no nonarbitrary choice amongst them is legitimate, or it may amount to the claim that *no* purely internal defense or argument can engender a nonarbitrary choice—some external factor *must* be adduced if any preferences at all are to be considered nonarbitrary.

One way to explicate the first interpretation is to assign an equal value to each claim by maintaining that each is utterly worthless. This, presumably, is the view of those who advance the second interpretation of the arbitrariness criticism, however. They maintain that nonarbitrary evaluations and preferences require a nonquestion-begging foundation and, thus, they reject the views of all the participants in the perennial arguments since these individuals must confine themselves to question-begging therapy arguments.

Individuals who raise the first interpretation of the general arbitrariness criticism maintain instead that an independent evalua-

tion of the various orientations and preferences assigns *the same* positive value to *each* of the orientations in the perennial arguments. They maintain that this makes any choice amongst these orientations a purely arbitrary one. Individuals who raise this version of the general arbitrariness criticism are forced to assign equal worth to (a) the qualified realistic rationalists' claim that qualified realism is correct and that fideists are wrong when they maintain we must rely upon a nonrational faith, and (b) the fideists' claim that the qualified realists' knowledge claims are wholly wrong and that we must instead rely upon a nonrational faith.

It is not easy to see how these claims can be accepted as equally correct, however, and it is certainly the responsibility of such individuals to explain both how the different orientations are being evaluated, and how and why the evaluations of each are assigned exactly the same value. The only rationale forthcoming for the claim that the orientations are equally correct, however, is the similarity of the participants' argumentative situations and the fact that no nonquestion-begging resolutions of the perennial arguments seem forthcoming. While such considerations might suggest that this means that none of the orientations are appropriate (the second way of interpreting the general arbitrariness charge), they do not seem to support the interpretation of the general arbitrariness charge which holds that they all have an equal positive value.

Perhaps the only way to support such a claim is by accepting the Equipreferability Thesis and adopting a subjectivistic orientation. Since each of the participants in the perennial arguments *rejects* the subjectivistic view, however, individuals who raise this version of the arbitrariness criticism would be committed to maintaining that those who say they are wrong are correct. At best, then, the rationale for the first interpretation of the general arbitrariness criticism must be supplied by those who would raise this criticism; at worst, this view is unacceptable since it adheres to the Equipreferability Thesis.

Consider, then, those individuals who maintain that nonarbitrary preferences *require* independent evaluations of the various orientations in the perennial arguments. These individuals may be demanding either that strongly or weakly independent evaluations be supplied. In the former case, naturalists would respond that it makes no sense to attempt to occupy the sort of evaluative perspective demanded by such theorists—instead of enabling nonarbitrary evaluations of the various preference claims in the internal and

external perennial arguments, they would claim, the desire to occupy such a transcendent evaluative perspective actually *precludes* evaluation.

This argument, of course, is identical to the explanatory naturalists' therapy argument against the other theorists. Individuals who wish to raise this version of the general arbitrariness criticism are *not* espousing any one of these particular orientations, however—to do so would be for them to offer exactly the sort of question-begging account which they reject. These individuals wish to stand completely outside the alternative positions in the internal and external perennial arguments so that they may offer a nonarbitrary evaluation of the various preference claims and orientations. Whether or not this position can avoid a vicious regress or begging the question, explanatory naturalists would reject it for the same reason they reject *all* talk of strongly independent (or transcendent) evaluation—it engenders nonsense since evaluation and justification require the acceptance of some particular evaluative perspective.

While the demand for an independent evaluation of the preference claims in the perennial arguments must be a demand for a *weakly* independent evaluation if it is to make sense, I have argued above that it is not at all clear what evaluational perspective the individuals who issue this call would embrace. It is of course clear what evaluative perspectives these individuals may *not* occupy if they are to be consistent: they may not be qualified realistic rationalists, skeptics, fideists, unqualified realistic rationalists, or explanatory naturalists. Since they reject the internal preference claims and question-begging therapy arguments which these theorists appeal to (demanding that there be some "independent" evaluative perspective upon which the perennial argumentation which arises here rests), they cannot (at least not initially) adopt any of these orientations.

Whatever evaluative perspective these theorists *do* occupy, however, if they offer a weakly independent evaluation of the various orientations and preferences which claims that they are arbitrary, they must face the question of the arbitrariness of *their own* evaluational perspective—the presumption of a different evaluative perspective might yield a *different* evaluation of the various orientations and preferences expressed by the participants in the perennial arguments. Given their view of evaluation, of course, such individuals will have to avoid accepting *any* of the views under scrutiny as they

attempt to establish the nonarbitrariness of their evaluation *vis-à-vis* such competitors. If they do not do so, they will have ultimately offered just the sort of question-begging evaluation which they seek to avoid. That is, their demand for an independent evaluation of the preferences and evaluations offered by the participants in the perennial arguments seems to legitimate a similar demand in regard to their own evaluation and its possible competitors.

Of course, an "independent" evaluation of their evaluation and the possible opposing ones must itself be either a strongly or a weakly independent one. In the former case the explanatory naturalists' therapy argument would again be relevant. On the other hand, if they maintain that a weakly independent evaluation is in order, they fall prey to a vicious infinite regress—they demand that independent evaluations and justifications be provided to ensure nonarbitrary preferences, yet they would continually be (at least) one step away from offering such an evaluation. According to the explanatory naturalists, then, the demand that we supply an independent evaluation of the various internally defended preference claims if we are to avoid arbitrariness engenders either an absurdity or a vicious regress.

The demand for an independent evaluation of the various preference claims offered by different theorists in the internal and external perennial arguments with regard to rationalism grows out of a frustration arising from seeing each of the participants in the arguments end up offering purely internal defenses of their orientations, and question-begging therapy arguments against others' views. It seems that such arguments only establish that one preference is *neither more nor less arbitrary* than the others and this, in turn, seems to leave *us* with an arbitrary choice. Explanatory naturalists respond to the general charge of arbitrariness which arises here by exposing the hollowness of the demand for strongly independent justifications and evaluations.

If these naturalists offered no more than this, however, it does not seem that they could claim to have offered a satisfactory defense of their orientation in either of the perennial arguments with regard to rationality. Given their repudiation of the project of seeking strongly independent evaluations and justifications, and given their recognition of the groundlessness of our believing, the phenomena of conceptual diversity and change seem to undercut their preference for their orientation and their claim that others share certain "fundamental" problems, aims, theories, and standards with them

34. Therapy Arguments and Arbitrariness

—other groundless commitments could well be as legitimate as the naturalists'. In other words, the naturalists' therapy argument does not seem to provide a positive reason for sharing their preference and for adopting their orientation.

As I indicated in section 28, however, explanatory naturalists offer a response to the problems posed by the phenomena of conceptual diversity and change which undercuts any legitimate arbitrariness worries suggested by these phenomena. This response provides a positive (and naturalistic) reason for believing that the naturalists' preference for naturalism is not an arbitrary preference. The next chapter further elaborates this aspect of the naturalists' argument and contends that the explanatory naturalists' argument against the other theorists in the internal and external perennial arguments is not only appropriate, but also effective.

7
Naturalized Rationality: Effective, Nonarbitrary, Groundless Belief

35. Conceptual Diversity, Arbitrariness, and Naturalism

The naturalistic therapy argument seems to establish at most that the explanatory naturalists' preference for their orientation is *neither more nor less arbitrary* than the other theorists' preferences for their orientations. As we have seen, the other theorists may offer their own therapy arguments, and may thus be unmoved by the naturalists' prescriptions. While the argument in section 34 shows what explanatory naturalists believe is wrong with the general arbitrariness criticism which may arise from the interplay of these different therapy arguments, this argument does not offer a strong reason for preferring the explanatory naturalists' orientation to their opponents' views—presumably the naturalists' opponents may also construct arguments which undercut the general arbitrariness criticism.

Since explanatory naturalists may not offer a nonnaturalistic argument for their preference, the most they may aspire to offer in the way of such a positive reason for their preference is an argument which attempts to show, *from within their orientation*, that their orientation resolves the problems at hand—that their orientation allows them to resolve the problems actually raised by the phenomena of conceptual diversity and change and, thus, that it meets the skeptical and fideistic challenges. In this chapter I develop this argument and show why explanatory naturalists believe that individuals generally *do* share their orientation. This argument not only provides a response to the problems posed by the phenomena of conceptual diversity and change, it also provides the basis for the discussion in the final chapter of the explanatory naturalists' response to the question "Why should I be rational?" While these arguments are naturalistic arguments, I believe they provide positive reasons for embracing the explanatory naturalists' orientation—especially when

they are supplemented with the naturalists' therapy arguments against the other orientations.

Since explanatory naturalists allow that we must give up the search for strongly independent justifications and evaluations and recognize, instead, the groundlessness of our believing, they seem forced to admit the possibility that others might employ *fundamentally different* enablers or held theories. Thus, their commitment to a particular held theory or orientation may appear to be arbitrary—even when viewed from within naturalism. That is, given the apparent diversity amongst the held theories or enablers which different individuals and cultures employ, and given the explanatory naturalists' contention that we must recognize the groundlessness of our believing, it seems that these naturalists will have to allow that the picture of human nature (and of the human predicament) which they offer is not the only one which applies; and, thus, the explanatory naturalists' preference for their orientation in the internal and external perennial arguments will be, at best, only *one* of the available and legitimate alternatives. In short, the phenomenon of conceptual diversity appears to pose a serious internal problem for the naturalists.

Clearly, naturalists may not dismiss *a priori* the possibility that others may employ fundamentally different held theories—to argue in this fashion would be to forsake their naturalism and to take up, instead, the justificatory rationalists' quest to ground the held theory. Explanatory naturalists need not offer such an argument, however—they may offer a *naturalistic* argument which responds to the problems legitimately raised by the phenomenon of conceptual diversity.

According to the explanatory naturalists, the arbitrariness charge under consideration is generated by a growing (naturalistic) understanding of our role as theory-holders and theory-changers. That is, the naturalistic study of our condition and predicament exposes our role as theory-changers who are limited to sensory evidence as we construct "posits" which transcend this evidence, and it is this study which clarifies our role as theory-holders who must ultimately recognize the groundlessness of their believing. These naturalistic discoveries seem to suggest that our "acceptance" of our held theory may be capricious. Naturalists maintain that since this arbitrariness worry is generated internally, an internal response is perfectly legitimate.

Their argument here is similar to the one offered in response to skeptical problems raised by the naturalistic studies of our theory-changing role—as we saw in sections 24, 25, and 28, explanatory naturalists maintain that since the skeptical challenges arise within our naturalistic studies, there is nothing inappropriate in an appeal to these studies as we work to answer these internally-generated charges. Similarly, explanatory naturalists maintain that their studies of our condition and predicament provide a response to the arbitrariness worries suggested by the phenomenon of conceptual diversity.

Contemporary biology, physiology, ecology, physics, psychology, linguistics, and naturalized epistemology provide *good naturalistic reasons* for believing that human beings confront a similar nexus of problems, share a basic set of aims, and employ the "theory" of ordinary middle-sized physical objects as they attempt to come to terms with these problems. While the naturalistic studies expose the fact that our theories (even the mundane theory of common-sense objects) transcend our evidence, these studies also provide reasons for believing that others will be in the same boat—they are situated in the same sort of world with the same sorts of problems and resources, and the sort of common-sense theory of physical objects is well-suited to the purposes, processes, and resources which human beings naturally have. The possibility of finding individuals or groups who do not employ this sort of theory is vanishingly small given what the naturalistic studies disclose.

The "theory" of ordinary middle-sized physical objects is so remarkably easy to acquire, so remarkably effective in dealing with many human problems, and so pervasively held, that it may seem odd to term it a "theory." Nonetheless, explanatory naturalists maintain that it is: as is the case with all our other conceptual systems, it is charged with resolving problems, aiding us in achieving goals, and predicting our future experience. Its ease of acquisition, its efficacy, and the strong correlation between its posits and our pretheoretic and intersubjective sensory evidence all provide explanatory naturalists with good reasons for believing that it is unlikely that they would encounter individuals who do not employ this theory. Indeed, Quine goes so far as to claim that this "theory" is "conceptually" fundamental.[1]

As we have seen, this claim may be made both as a descriptive claim with regard to our own case and as a naturalistic claim with regard to individuals in general. I believe explanatory naturalists

should offer *both* such claims. The descriptive claim maintains that this theory provides *us* with our initial socially inculcated standards of truth, reality, and evidence. By itself it does not address the issue of whether *other* individuals (or, better, groups) could employ fundamentally different sorts of held theories—this, of course, is why the descriptive naturalists encounter their problems with arbitrariness.

The second claim (and the naturalistic inquiries which would substantiate it) is important precisely because it provides explanatory naturalists with their way of meeting the arbitrariness challenge. If their naturalistic studies provide us with good reasons for believing that others employ the same sort of initial held theory, we need not conclude that a commitment to this held theory is arbitrary or capricious. The appearance of arbitrariness is removed when one provides good reasons for denying the claim that others may well hold fundamentally different initial theories.

One reason for not taking up such a naturalistic inquiry is that it is easily misconstrued: it is commonly believed that naturalists who offer any argument against fideism, skepticism, realism, or the arbitrariness criticisms are attempting to offer a *strongly independent* justification of their appeal to their held theory. Naturalistic (or internal) claims about the human predicament or the nature of human theorizing are, thus, taken to be independent (nonnaturalistic) claims which may be used to justify naturalism. Of course, explanatory naturalists may not offer such claims. When they discuss our nature and predicament, and when they investigate our theory-changing endeavors, they must do so *naturalistically*. Failure to recognize this point leads many to radically misconstrue their arguments.

As we have seen, Wittgenstein believes that the enablers which he would expose are widely held and he denies that individuals choose their held theory or enablers.[2] Moreover, he does not believe that individuals may continue to "play their language-games" come what may.[3] He maintains that the inquiries which yield such insights do not belong to philosophy, however. I suspect he maintains this because he feels philosophers will treat such remarks as if they were strongly independent justificatory comments—they will be led to adopt something like the pragmatism which Rescher champions, for example. While Wittgenstein believes broadly pragmatic considerations might account for some of the aspects of our held theory and

remove some of the appearance of arbitrariness,[4] he seems to feel that the danger of misinterpretation is great here: "here I am being thwarted by a kind of *Weltanschauung*."[5]

Wittgenstein restricts himself to a descriptivism in order to avoid being "thwarted by the Weltanschauung" which would misconstrue naturalistic inquiries into the "causes" of our held theory (by taking them to be strongly independent justificatory studies rather than internal responses to internally-generated problems, worries, and challenges, for example). His descriptivism encourages the arbitrariness criticism broached above, however—it seems as if others may groundlessly believe in other enablers and restrict themselves to descriptivism and, thus, we seem to be left with an arbitrary choice amongst the different alternatives.

Naturalists who pursue the explanatory inquiries into the nature of our held theory and into our role as theory-changers, *are* able to effectively address the arbitrariness criticism raised by the phenomenon of conceptual diversity—they maintain that their naturalistic studies provide good internal reasons for believing that other individuals will *not* hold fundamentally different held theories. That is, they offer a picture of the human predicament and propensity to theorize which is very similar to the sort of picture provided by the justificatory rationalists discussed in chapter 1. Summarized in the most simplistic of terms, the explanatory naturalists' studies of the human predicament and propensity to theorize reveal the following factors: human beings inhabit an environment which poses problems which they must resolve; they employ their theories to resolve their problems and achieve their aims; the only evidence they have for their theories is that evidence which their senses provide; the human sensory and discriminative abilities are fairly uniform; held theories are socially inculcated and, thus, the acquisition or inculcation process is initially possible only if there is some pretheoretic and intersubjective basis of agreement (while any theory's "posits" will transcend the sensory evidence, held theories which are to be initially acquired or inculcated will have to rely upon a shared tendency to notice and weigh some pretheoretic and intersubjective discriminations similarly); such theories would have to be highly efficacious (if the initially acquired theory was not efficacious in meeting the shared problems, it would be difficult to account for its existence since the inculcation and acquisition processes are complicated and require time and effort, and the individuals in question have problems which

they need to resolve); the "theory" of ordinary middle-sized physical objects which we employ (the "theory" of trees, chairs, and rock slides) is both easily acquired and remarkably efficacious in resolving many fundamental human problems; and there is a strong correlation between the sensory evidence, the common discriminative abilities, many of the basic problems, and the "theory" of ordinary middle-sized physical objects.

By appealing to this picture, explanatory naturalists can indicate why they believe it unlikely that others will initially employ held theories which are fundamentally different from the one disclosed by their analysis: given the overall picture which emerges from their naturalistic studies of our nature and predicament, they maintain, it would be highly unlikely that we would encounter individuals who did not employ the held theory and enablers which they have identified. That is, our biology, psychology, physiology, and naturalized epistemology provide us with good *naturalistic* reasons for maintaining that others will initially share the "basic" aspects of our held theory with us.

While explanatory naturalists may agree with Kekes' claim that individuals who would reject this picture of ourselves and our predicament offer an absurd view, they may not claim that this is so because such theorists deny some independently established facts or necessary truths. The explanatory naturalists' argument is an *internal* one—it appeals to (and employs) our science in responding to the claim that alternative orientations are possible. If the naturalists harbored any justificatory goals at this point, this circularity would be disastrous. They do not attempt to independently legitimate their picture of our predicament (or their preference for their own orientation), however.

In the next section, I will consider the claim that traditional fideistic orientations constitute a counter-example to the naturalists' claim that it is unlikely that we could encounter others who employ a different sort of held theory and enablers from the one which we employ. Before this issue is joined, however, another facet of the explanatory naturalists' response to the arbitrariness criticism must be discussed.

Building upon the problem-solving and aim-oriented views discussed in chapter 1, explanatory naturalists should point out that the claim that the phenomenon of conceptual diversity presents them with the problem of an arbitrary choice amongst enablers presumes

that the diverse held theories in question are *alternatives* or *competitors*; and this requires that there be some problems, aims, or other theories relative to which they may be viewed as alternatives or competitors. That is, if the diversity of held theories is imagined to be a diversity amongst *nonconflicting* held theories, no epistemological problems arise—individuals are free to adopt *each* of the orientations.

When we *are* confronted with alternative theories, however, an appeal to the aims and problems in virtue of which the theories are deemed to be alternatives allows for a nonarbitrary resolution of the problems posed by the phenomenon of conceptual diversity.[6] Here a strongly independent evaluative standard is not called for—the problems and aims shared by the individuals (or groups) who offer the conceptual alternatives provide a *weakly independent* evaluative standard. The theory which best resolves the problems or enables the individuals in question to achieve their aims will be judged preferable, and this judgment is not made arbitrarily.

Since the naturalistic study of the human predicament and propensity to theorize indicates that human beings share a set of problems and aims, and that they theorize to achieve these aims and resolve these problems, it seems that there will indeed be a weakly independent evaluative standard which will be available when we confront any actual problems posed by the phenomenon of conceptual diversity. Together these considerations undercut the presumption of the arbitrariness criticisms—the availability of a weakly independent evaluative standard dispels the appearance of arbitrariness which is suggested by the phenomenon of conceptual diversity.

To imagine individuals who are committed to a *completely different* held theory (individuals who do not share even our most "basic" aims, problems, or theories), on the other hand, would not be to imagine an *alternative* held theory—there would be no common aims or problems in virtue of which the differing orientations could be termed "alternatives." For this reason, such a diversity would not pose a genuine epistemological problem according to the explanatory naturalists—they could allow for the adoption of *each* of the conceptual structures. In response to those who suggest the possibility of such an encounter and demand that the naturalists *justify* their preference for one of the differing held theories in a nonquestion-begging fashion, these naturalists should observe that no choice is

called for and they should note that a demand that they provide an independent or nonquestion-begging evaluation of the differing held theories requires that they fall prey to the "peculiarly philosophical fallacy." They should, of course, forego this opportunity.

This argument may appear to suggest that explanatory naturalists would resolve the arbitrariness problem which arises within naturalism with regard to conceptual diversity by "defining it away"—while wholly different held theories may not make any sense to them, it seems that they must nonetheless recognize that as long as they champion a certain sort of groundless believing, others may well groundlessly recommend another orientation. Here *we* seem left with an arbitrary choice.

Explanatory naturalists reply that this sort of charge misconstrues the problems posed by the phenomenon of conceptual diversity, however. First, naturalists note, it demands that strongly independent evaluations be provided if a "choice" amongst the differing held theories is to be deemed nonarbitrary; and explanatory naturalists respond that the notion of such evaluations and justifications would actually make evaluation, justification, and choice impossible. According to them, the question "Which held theory is correct, appropriate, or proper?" presumes the possibility of a vantage point which could provide the evaluative standards and enablers which would legitimate a choice amongst the different held theories. Weakly independent perspectives are precluded by presumption here, however, and the search for a strongly independent perspective merely leads us to the "peculiarly philosophical fallacy."

Secondly, explanatory naturalists contend, the question presumes that a choice must be made although the diversity we confront here is not, as conceptual diversity usually is, one which involves several *alternatives*. Since the differing held theories are not competitors, however, a choice is not called for; and this means that explanatory naturalists cannot be judged wanting for failing to make the "right" choice.

These arguments, especially when complemented by the explanatory naturalists' studies of our predicament, go a long way toward dismissing the arbitrariness charge which is suggested by the phenomenon of conceptual diversity. The naturalists must confront head-on the fact that traditional fideists have recommended diverse conceptual commitments, however—the fact that they, presumably,

hold such theories may appear to constitute a counterexample which undercuts the argument of this section. The next section takes up this issue.

36. Fideistic "Alternative" Held Theories and Naturalism

The traditional fideists' commitments seem to contradict the explanatory naturalists' claim that while they may not rule out the possibility that others employ radically different held theories *a priori*, they may offer a naturalistic argument which shows that all individuals share the basic aspects of our held theory with us. After all, fideists have traditionally maintained that individuals who champion the naturalists' sort of picture of our predicament misidentify our basic theories, problems, and aims.

In place of the picture of our predicament which naturalistic views present, fideists have traditionally recommended that we substitute a radically different one which maintains that insofar as we theorize to resolve problems and accomplish aims while presuming certain theories or beliefs, we do so in response to a significantly different set of problems and aims while presuming a very different set of beliefs and theories. Pascal, for example, rejects the sort of picture of the human predicament offered by the explanatory naturalists. In its place he would substitute one which holds that man is

> a nothing in comparison with the Infinite, an All in comparison with the Nothing, a mean between nothing and everything. Since he is infinitely removed from comprehending the extremes, the end of things and their beginning are hopelessly hidden from him in an impenetrable secret; he is equally incapable of seeing the Nothing from which he was made, and the Infinite in which he is swallowed up.[7]

According to Pascal,

> it is not to be doubted that the duration of this life is but a moment; and that the state of death is eternal, whatever may be its nature; and that thus all our actions and thoughts must take such different directions according to the state of that eternity, that it is impossible

to take one step with sense and judgment, unless we regulate our
course by the truth of that point which ought to be our ultimate
end.[8]

He goes on to claim that it is *unreasonable* for us to ignore the picture
of our predicament which he specifies and to pursue other aims and
goals.

We briefly considered the explanatory naturalists' therapy argument against the fideistic orientation in chapter 6—naturalists contend that the fideists fall prey to the same peculiarly philosophical fallacy as the skeptics and qualified realists (they neglect our role as theory-holders). We have also seen that while fideists may not be able to offer a critical external attack upon rationalism, they may offer (from within their own perspective) a therapy argument which is designed to expose the error in other theorists' views of the human predicament. In chapter 6 we considered the naturalists' response to the claim that the conflicting therapy arguments itself legitimizes a general arbitrariness charge. What we need to consider at this juncture is whether the fideistic denials of the rationalists' characterization of the human predicament provide the basis for an *internal* criticism of the explanatory naturalists' position.

That is, we must ask whether the fideists' claims about the human predicament provide good reasons, within the context of a naturalistic study of our theory-holding and theory-changing role, for rejecting the naturalists' claim that we all confront the same basic problems, have the same fundamental aims, and bring certain common-sense beliefs and theories to bear on these problems and aims. *If* the fideists' claims function in this manner, they undercut the explanatory naturalists' response to the arbitrariness criticism discussed in the previous section by undermining their claim that it is very unlikely that we will encounter individuals who hold radically different initial held theories.

One way of responding to this sort of objection to explanatory naturalism would be to attempt to offer a strongly independent justification of the sort of picture of the human predicament which explanatory naturalists offer. Kekes' pursues this strategy. He contends that an appeal to "common sense" shows that individuals *cannot but* employ the beliefs in question. According to him, his appeal to "common sense" is an appeal to "nonreflective" beliefs which are physiologically based:

the point of arguing for a physiological base for common sense is not to render it immune to criticism, but to establish it as the base from which any human being must start. The fundamentality of common sense amounts to no more, and to no less, than the recognition that the point of departure for theories about the world is not arbitrary, but determined by the human physiological apparatus.[9]

Kekes believes that the common-sense beliefs provide both the background against which our basic problems arise and a foundation upon which all our theories of reality are built. In and of themselves, they may not provide a sufficient response to our problems, and supplementation may well be necessary. Nonetheless, they provide the bedrock which all individuals *must* share and, thus, fideistic denials of the orientation which he champions are ruled out.[10]

I argued in section 2, however, that what Kekes actually establishes is that the common-sense beliefs which he appeals to are *conditionally necessary*. That is, *if* one accepts the scientific theories which underlie his account (e.g., contemporary human physiology, etc.), then one will characterize the human predicament as he does. Although this scientific account may well provide naturalistic reasons for believing that we should accept this account, such an argument does not provide the sort of strongly independent justification which Kekes seeks; and the fideistic claims about our beliefs, theories, and problems may not be ruled out as absurd because they deny what *must* be held.

If a strongly independent justification of the explanatory naturalists' characterization of the human predicament were possible, it would ensure that no internal problem would arise by ensuring that "alternatives" *could not* arise to undercut the naturalists' views. Explanatory naturalists may not attempt to offer such a justification of their characterization of the human predicament, however. If they were to do so, they would have to abandon their naturalism and embrace a qualified naturalistic position.

They need not offer a strongly independent justification of their view in order to meet the challenge posed by the fideists' claims, however: if the fideists' claims are to raise a serious *internal* objection to the naturalists' characterization of the human predicament, these claims must arise within the context of the naturalistic inquiry into our theory-holding and theory-changing and roles; and, thus, they may be discussed and evaluated from within that context. If the

preponderance of the evidence within this sort of study does not support the fideists' characterization, then these claims do not legitimate a serious internal objection to the naturalists' characterization.

In short, explanatory naturalists may point out that while they cannot rule out *a priori* the possibility that some individuals might not appeal to the beliefs, problems, and aims which their studies indicate are basic, they need not provide such an argument in order to respond to the putative internal criticism being considered here. They may appeal to their naturalistic studies of our theory-holding and theory-changing roles, and can maintain that the fideists' claims are made suspect by what we have discovered about human physiology, the environment we inhabit, and the process of language and concept acquisition.

Moreover, explanatory naturalists may point out that an internal argument against their characterization of the human predicament which appeals to the fideists' claims is actually undermined by what we know about the fideists' own lives. While the fideists may deny that the problems, aims, and beliefs identified by the naturalists are basic, their actions (especially during their early years) provide good reasons for maintaining that *they* have these problems and aims and that *they* employ these beliefs and theories. They learn their language, interact with others and their environment in their youth, work to resolve the basic difficulties which children confront, and attempt to achieve those primary aims which are important to us all in a manner which accords with the naturalists' characterization. While they may act in accord with the sort of characterization which they contend correctly pictures our predicament *later* in their lives, the fideists' early actions and beliefs conform to the characterization which arises from the naturalists' studies and this undermines the claim that the naturalists' orientation improperly characterizes the basic human predicament.

It is also important to note that when the fideists offer their therapy arguments (which are designed to convince us of the correctness of their orientation), they spend a great deal of time arguing that the characterization which they offer is the correct one even though most individuals fail to acknowledge it and instead act as if the sorts of problems, aims, and beliefs which the naturalists identify are the basic ones. Pascal, for example, inveighs against a

misplaced emphasis upon the "worldly" problems when we actually face the threat of eternal damnation.[11]

Indeed, fideists will themselves frequently confess that they shared this myopia with others and will refer to an event of "enlightenment" which made them realize that they had initially misidentified the basic human problems and aims and had employed improper or inappropriate beliefs, theories, and standards. Such "confessions," of course, merely substantiate the naturalists' claim that there are some common problems, aims, beliefs, theories, and standards which we all confront or employ—at least initially.

In considering the fideists' claims as a possible source of an internal objection to the naturalists' characterization of the human predicament, it is important that we note that the "basic" aims, theories, and problems which the naturalists refer to are not those which we find in the fully developed sciences. Instead of appealing to what Quine terms the "naturally fundamental particles" of the developed sciences (the beliefs or theories about quarks, black holes, and carbohydrates which arise within our developed scientific theories), and instead of discussing the various beliefs or theories and "problems of reflection" which arise within the context of these developed sciences, naturalists appeal to what Quine calls the "conceptually fundamental particles" of common sense (the beliefs and theories about tables, apples, and sheep), and they refer to the "problems of life" which are forced upon us by our desire to survive, communicate, and thrive in the world in which we live.

Given the results of the naturalists' studies, the behavior of the fideists during their earlier years, and the fideists' own claims about the perceptions of most individuals, it will be difficult to countenance the claim that the fideists' claims about the human predicament pose a serious internal objection to the naturalists' claims regarding our initial held theory. It should be noted that the response to the arbitrariness charge developed here does not claim that the problems, aims, and theories or beliefs which are identified by the fideists are "unnatural," nor does it attempt to establish that the naturalists' view of our predicament is incontestable. It claims, rather, that the best available evidence suggests that we all share a basic set of problems, aims, beliefs, and theories during our early years.

It could well be that fundamentally different sorts of *developed*

theories emerge from these shared basic problems, aims, and beliefs (the natural scientists' and the fideists', for example). If explanatory naturalists cannot provide some way of resolving the competing claims of such divergent developed theories, the arbitrariness charge will merely have been delayed by the argument of this section. Here explanatory naturalists confront a charge of arbitrariness which is suggested by the phenomenon of *conceptual change* rather than by the phenomenon of conceptual diversity, however. The next two sections examine whether the naturalistic treatment of this phenomenon legitimates such arbitrariness worries.

37. Explanatory Naturalism, Arbitrariness, and Conceptual Change

Even if we all *initially* confront and seek to resolve or achieve certain fundamental problems and aims, and *initially* share the "theory of ordinary middle-sized physical objects," individuals might accept different sorts of revisions to this common beginning point. Since the effects of such choices might be multiplied over time, it is possible that individuals might develop radically different (or incommensurable) conceptual structures. If explanatory naturalism allows this, then the phenomenon of conceptual change will engender the charge of arbitrariness. As was the case in the previous section, the arbitrariness challenge which arises here arises from *within* explanatory naturalism—since these naturalists allow for conceptual change, it is claimed, a similarity of beginning points is not sufficient to ensure that individuals will not legitimately hold radically different orientations for which we may form preferences that are, at best, arbitrary.

In his discussion of conceptual change within science, Stephen Toulmin maintains that the underlying problems and aims of the various disciplines provide constraints which limit the sorts of conceptual revisions which may be considered legitimate. Toulmin does not insist that the underlying problems and aims of the various disciplines must remain constant, however—he maintains that "the unity and coherence of a scientific discipline does not require that its intellectual ambitions should be eternal and unchanging; only that they should maintain a sufficient continuity."[12]

While the underlying problems and aims of a discipline may change, Toulmin maintains, such change is itself to be evaluated in

terms of our fundamental human problems.[13] Pursued with too great a tenacity, of course, such a view engenders a position which would avoid any arbitrariness challenges suggested by the phenomenon of conceptual change by appealing to certain unchanging "fundamental problems of life" or "basic aims" that all human beings necessarily confront. These problems or aims are to provide a strongly independent evaluative standard against which proposals for conceptual revision could be nonarbitrarily evaluated.

Explanatory naturalists may not avail themselves of such a strategy—they must eschew attempts to provide strongly independent evaluations of proposals for conceptual revision. They need not maintain that any revisions whatsoever are legitimate, however. As we saw in section 28, their studies reveal that our held theory generally functions as a tool for predicting and controlling the course of our future experiences, for relating our experiences to one another, and for resolving our problems and accomplishing our goals.[14] Conceptual change is generally called for when our held theory issues faulty predictions, inadequately relates experiences, or does not fulfill our expectations in regard to problem-resolution or aim-fulfillment.

Since *alternative* proposals for conceptual revision will be offered as competitors with respect to their predictive capabilities, their capacities to relate experiences, or their problem-resolving and aim-fulfilling potential, explanatory naturalists may maintain that a *weakly independent* evaluative standard is available as one assesses such proposals. In short, where individuals are presented with alternatives for conceptual revision, their desire for predictive success, their desire for theories which inter-relate their experiences, their problems, and their aims will provide them with a standard which legitimates nonarbitrary (albeit weakly independent) evaluations of the alternatives (and nonarbitrary justifications for their preference for one proposal revision over the others).

More specifically, the naturalists' explanatory studies of our theory-changing role show that as we evaluate proposals for conceptual revision, we generally employ (and should employ) evaluative standards which are essentially pragmatic and empiricistic in nature. Revisions sanctioned by appeal to these standards tend to enable us to make better predictions, allow us to better relate our experiences to one another, help us better resolve our problems, and facilitate us in our efforts to accomplish our aims. Since we engage in such

revision to further these ends, revisions which are recommended by appeal to these standards are the revisions which we should prefer.

Of course, even where there is agreement amongst individuals as to the aims, problems, and standards which provide a weakly independent evaluative perspective, an appeal to these may *not* legitimate the claim that one or another of a group of proposed conceptual revisions is clearly preferable. It is possible that one revision enables us to resolve various problems and achieve various aims although it leaves others unresolved and unfulfilled, while another revision resolves problems and fulfills aims which are unresolved and unfulfilled by the first.[15] While at times it will be possible to form a legitimate preference for one or another alternative in such a situation (because one meets more central aims or resolves more important or pressing problems, for example), naturalists may not rule out *a priori* the possibility that several different proposals for conceptual change might *equally* fulfill whatever weakly independent evaluative criteria we might specify.

Naturalists are not forced to make an arbitrary choice amongst the various proposals for conceptual revision in such situations, however. They may be able to adopt *each* of the revised conceptual structures alternating between them as they pursue differing avenues toward problem-resolution and aim-fulfillment. Where this is possible, they may adopt each of the alternative orientations while waiting to see whether later analysis might uncover a clear-cut advantage to one or another of these orientations. Quine recommends exactly this procedure in such cases.[16]

If for some reason they may *not* work with each of the proposals for revision,[17] explanatory naturalists *will* be forced to make a choice—even if only to reject all the proposals and retain their original conceptual scheme unchanged. After all, they have problems they would resolve and aims they would fulfill, and their conceptual scheme (revised or not) is their vehicle for problem-resolution and aim-fulfillment. In short, these naturalists must admit that individuals might find themselves in a "problematic situation" which *requires* that they either revise their conceptual system exclusively along one or another of the lines proposed or retain their system and discard the idea of pursuing the revisions.

While the history of science seems replete with examples of the pursuit of a variety of differing proposals for revision, explanatory naturalists may not rule out the possibility that a situation where

37. Naturalism, Arbitrariness, and Change

individuals could not work with several equally supportable revised systems might arise. Since the explanatory naturalist's appeal to our problems, aims, and pragmatic or empiricistic evaluative standards does not legitimate a choice of one revision over others in such a situation, one might be tempted to appeal to some *other* standard which could do so. It might be hoped that such an appeal would yield nonarbitrary evaluations and choices and, thus, allow us to avoid the arbitrariness challenge.

Explanatory naturalists maintain that any such attempt would be ill-advised, however. According to them, *there are no other evaluative perspectives to appeal to here*: there are no other weakly-independent evaluative or justificatory standards to which we may appeal (in the imagined situation neither the appeal to problems and aims nor the appeal to the pragmatic and empiricistic evaluative standards legitimates a choice amongst the proposed revisions)[18], and naturalists rule out an appeal to strongly-independent standards since talk of such evaluations leads to the peculiarly philosophical fallacy.

It may seem that the explanatory naturalists' choice of one revision over others in such situations would be arbitrary because they fail to fulfill the epistemological responsibility that their acceptance of the rational maxim imposes. The argument against them would go something like this: since explanatory naturalists demand that we justify our beliefs, theories, and commitments by an appeal to our standards of rational evaluation; since such an appeal would not settle the issue of preference in this case; and since such a choice is (by hypothesis) necessary in such a situation; these naturalists allow for arbitrary choices amongst revised conceptual structures.

In response to this sort of accusation, explanatory naturalists should note that their choice would *not* be made without reference to their standards of rational evaluation in such a situation. The situation is one wherein their appeal to these standards *equally* legitimates several proposals for revision. Were there any relevant consideration in the application of the standards which differentiated these choices (legitimating a preference for one over others), naturalists should, indeed, prefer that choice if they are to fulfill their epistemic responsibility. Since this is not the case in this situation (by hypothesis), their maxim requires that they assign *equal* degrees of preferability to the various proposals for conceptual revision.

Where one may not work with each of several different proposals for revision, of course, the ideal choice would be to make *no*

choice—it would be most appropriate to await further evidence. Explanatory naturalists are not given such a luxury in the hypothesized case however: they are unable to work with each of the proposals, and are required by their "problematic situation" to make a choice now (they have problems to resolve and aims to fulfill).

Since the naturalists' choice cannot itself be uniquely justified by an appeal to their standards of rational evaluation, it appears that there is nothing to ensure that they will choose the "right" avenue of conceptual revision—bereft of an effective appeal to rational standards of evaluation which could legitimate their choice exclusively *vis-à-vis* the others, it seems that they must admit that it will be mere happenstance if they make the *right choice* amongst the various proposals for revision and this, of course, raises the arbitrariness worry. Such a worry is premised upon the presumption that one of the choices is right—or, at least, that one is more correct or appropriate than the others. Explanatory naturalists reject this presumption in this case.

They maintain that talk of truth, adequacy, factuality, or correctness is "immanent"—they maintain that both our evaluative enterprise and our skeptical doubts or questions are possible only given an acceptance of the enablers and standards which support these enterprises.[19] According to them, skeptics and fideists who extend the skeptical doubts or arbitrariness worries to these standards or enablers themselves ignore our (and their) role as theory-holders and fall prey to the peculiarly philosophical fallacy as they extend the doubts and worries beyond the point where they are legitimate.

The different proposals for conceptual revision in the case under consideration are (by hypothesis) *equally* preferable or adequate—there is no difference in the degree to which they satisfy the criteria supplied by our standards or enablers. Since we are here appealing to our basic standards or enablers, and since naturalists allow for no appeal to some other standards at this point, they must (given their view that truth, adequacy, and factuality are immanent) maintain that the differing proposals for conceptual revision are *equally right*—they must reject the presumption that one is more correct, true, or adequate. For them, the question of the "right" choice is one which makes sense only relative to the criteria supplied by our standards or enablers, and since the various proposals for conceptual revision meet these criteria equally well (by hypothesis), they are equally "right."

37. Naturalism, Arbitrariness, and Change

Since we can only sensibly maintain that one proposal is superior (or "right") when it better meets the criteria specified by our enablers or standards, and since the different proposals for conceptual revision are equal in this regard in the imagined situation, the only sense which explanatory naturalists might assign to the notion that one of the proposals is correct, or at least superior to the others, is for there to be some *future* difference in the way the different proposals meet these criteria. Such a difference could only be discovered if the various proposals are *each* pursued, however—their relative problem-solving ability and aim-fulfilling potential in the future can only be determined if *each* of the various avenues of revision is pursued. Of course, where this is possible, explanatory naturalists recommend that we pursue the differing courses of conceptual revision in the hopes that future events will disclose a difference in the way the differing proposals meet the criteria established by our enablers or standards.

In the hypothesized situation, however, the naturalists may pursue only one of the different avenues of conceptual revision. Since relative evaluations of future adequacy *vis-à-vis* our standards are ruled out in this case, and since the proposals presently meet the criteria specified by our standards and enablers equally, explanatory naturalists are forced to conclude that the differing proposals are equally adequate or correct—they are left without anything to which they might appeal in attempting to maintain that one proposal might sensibly be said to be more correct than the others.

Explanatory naturalists will encounter individuals who would maintain that wherever we are presented with options, one must be more correct, or appropriate, than the others. In this situation, these naturalists must reject this claim. In doing so, they may appeal to their therapy argument in response to any arbitrariness charges or skeptical challenges which might arise here. According to them, such challenges are suggested by their treatment of the different alternatives only when one extends legitimate skeptical doubts and arbitrariness worries beyond the limits where they have sense: where there are a variety of proposals for conceptual revision, it generally makes sense (relative to the acceptance of our standards or enablers) for one to ask "Which revision is the correct one?"—meaning, of course, "Which proposal best lives up to the criteria specified?"

In the hypothesized situation, however, the alternatives fulfill the available criteria equally well, there are no other criteria we may

appeal to, and, thus, the answer to the question "Which best meets the criteria?" must be that the alternatives do so equally well. That is, while the question "Which revision is more appropriate or correct?" generally has sense, in the hypothesized case it is undercut. Here the explanatory naturalists' failure to allow for a unique answer to the question speaks to the impropriety of the question rather than to the inadequacy of their view.

38. Alternative Evaluative Standards

Their reliance upon the pragmatic and empiricistic standards for the evaluation of proposals for conceptual change is a key component in the explanatory naturalists' claim that appeal to a weakly-independent standard allows them to avoid the arbitrariness worries raised by the possibility of differing proposals for conceptual revision. Fideists may well find the naturalists' characterization of our standards of evaluation contentious—they may wish to claim that *other standards* are (or should be) the primary ones which are (or should be) employed in the evaluation of proposals for conceptual revision. If explanatory naturalists cannot argue against such claims, the phenomenon of conceptual change will engender an arbitrariness challenge even given the above argument. That is, if others may legitimately appeal to other evaluative standards, then even where individuals begin with similar beliefs, theories, problems, and aims, it may well be the case that they accept such divergent revisions that they end up holding radically different (and, perhaps, incommensurable) conceptual structures.

Some champions of the empiricistic evaluative standard respond to any arbitrariness worries raised by the possibility that others might employ other evaluative criteria by maintaining that we should employ empiricistic criteria in the evaluation of proposed conceptual changes, because the rigorous application of such criteria yields beliefs and theories which are *closer to the truth* than those which arise in the absence of such an appeal. Some champions of the pragmatic evaluative standard take a similar tack—while not wishing to claim that their pragmatism provides them with a theory of truth, they respond to such claims by maintaining that their method is the objectively correct one; and, thus, that only those revisions which it licenses should be accepted.[20]

Such approaches would lead to a qualified naturalism. Explanatory naturalists maintain that the question of the justification of the evaluative standards employed in assessing proposals for conceptual change "evaporates" once one adopts the naturalistic viewpoint, however.[21] Thus, explanatory naturalists must reject attempts to independently legitimate their commitment to pragmatic and empiricistic standards of evaluation for conceptual revisions in the same way that they reject attempts to independently legitimate their picture of the human predicament and their claims about our fundamental problems and aims. According to them, when we accept a naturalistic view, "empiricism as a theory of truth thereupon goes by the board, and good riddance."[22]

Instead of offering a strongly independent defense of the appropriateness or correctness of their appeal to the pragmatic and empiricistic standards, explanatory naturalists offer a naturalistic account of the role, genesis, and efficacy of these standards. They will not be able to rule out *a priori* the possibility that others might employ different evaluative standards when they confront the problems posed by the phenomenon of conceptual change. But naturalists may point out that their naturalistic studies of our theory-changing and theory-holding roles indicate that (i) individuals generally do employ the pragmatic and empiricistic standards, and (b) that individuals who employ these standards as they evaluate proposals for conceptual change have the best chance of resolving their basic problems and accomplishing their fundamental goals.

Of course, there is a circularity involved in claiming that naturalistic studies reveal that we generally employ, and should employ, the pragmatic and empiricistic standards (for the evaluation of differing proposals for conceptual revision) in order to dismiss arbitrariness worries with regard to these standards. The naturalistic response here requires the acceptance of the very standards which are in question. Since this appeal is *not* intended to provide a strongly independent justification (indeed, since the desire for such justifications is dismissed as an atavistic desire spawned by the propensity to fall prey to the peculiarly philosophical fallacy), this circularity is not a vicious one, however.[23]

Explanatory naturalists respond to the suggestion that we employ (or should employ) non-pragmatic and non-empiricistic evaluative standards when we examine proposals for conceptual revision by appealing to their naturalistic understanding of our nature and

predicament. In effect, their explanation for their claim that we generally do, and certainly should, employ these evaluative standards parallels Winston Churchill's explanation of his preference for democracy over other forms of political organization. Churchill said that "no one pretends that democracy is perfect or all-wise. Indeed, it has been said that democracy is the worst form of Government except all those other forms that have been tried from time to time."[24] Explanatory naturalists may note, similarly, that while others have recommended other sorts of evaluative standards, the recommendations for conceptual change engendered by such standards have not proved efficacious—they have not served to resolve our basic problems or to allow us to better achieve our basic goals.

Naturalistic researches into our propensity to employ the pragmatic and empiricistic standards of conceptual evaluation yield insights as to how the propensity to employ such standards arose. (Naturalized epistemologists like Campbell, Skagestad, and Wächtershäuser, for example, offer naturalistic accounts of the emergence of such fundamental cognitive strategies and standards.[25]) These researchers also explain why we continue to employ such evaluative standards (Quine, for example, argues that the creatures who did not exhibit the propensity to employ such basic strategies would tend to die off according to Darwinistic biology[26]).

The picture presented above is, certainly, overly simplistic; and individual naturalists will offer different accounts of the nature, genesis, and efficacy of the pragmatic and empiricistic standards. A diversity of naturalistic accounts here does not legitimate an arbitrariness challenge, however. While their specific accounts of the nature, genesis, and efficacy of our evaluative standards may differ, these differences arise within the context of an attempt to generate a coherent naturalistic explanation of the important aspects of our theory-changing role. They will start from similar presumptions with regard to our physiological make-up, our basic problems, and our basic aims, and they will each claim to offer an adequate account of a generally agreed upon chronology of conceptual revisions (that is, each will attempt to account for the course of conceptual revisions in our past). These common features provide naturalists with a weakly independent yet nonarbitrary perspective which legitimates nonarbitrary evaluations of such competing accounts of our standards of conceptual revision and, thus, the arbitrariness charge is not legitimated by this sort of diversity.

38. Alternative Evaluative Standards

According to the explanatory naturalists, then, an appeal to the naturalistic studies of our theory-changing role provides good *naturalistic* reasons for claiming that others will generally employ, and should employ, the pragmatic and empiricistic standards for the evaluation of different proposals for conceptual revision. According to these naturalists, their studies of our theory-holding and theory-changing roles disclose not only that there is a pervasively held initial theory; they also disclose our propensity to theorize to resolve our problems and achieve our aims, our propensity to revise our theories in light of their problem-solving and aim-fulfilling capacity, and our propensity to employ the pragmatic and empiricistic standards as we evaluate proposals for conceptual revision. Furthermore, these studies provide an account of both the genesis and the efficacy of these evaluative standards.

Given that our naturalistic studies give us every reason to believe that other individuals have the same sort of physiological make-up we have, given that they have the same sorts of basic problems and aims we have, given that they share with us a tendency to theorize in an effort to resolve these problems and achieve these aims, given the similar social conditioning we are all subject to, and given the efficacy of the pragmatic and empiricistic evaluative standards, explanatory naturalists maintain it is likely that others will (and appropriate that they should) share with us a commitment to these standards for the evaluation of proposals for conceptual revision.

As they theorize about our theory-changing role, naturalists need not restrict themselves to a "hierarchical" view which maintains that our basic problems, for example, are "more basic" than our basic aims, theories, or standards. Naturalistic studies *might* provide some reason for believing this to be the case. On the other hand, explanatory naturalists might find reasons for adopting the sort of complex "reticulated model" of assessment advanced by Larry Laudan which allows for a nonhierarchical relationship between our problems, aims, theories, and standards (or "methodological rules").

Instead of requiring a single "bedrock" against which all conceptual changes must, ultimately, be measured or evaluated, this sort of model allows the various "basic" facets of our conceptual scheme to play the role of the evaluative linchpin at different points in time. According to this sort of model, neither the possibility of change in our fundamental problems, theories, standards, or aims, nor the denial of a hierarchical relationship amongst them will legitimate

arbitrariness worries, however. Nonarbitrary evaluations of proposals for conceptual revision (and nonarbitrary justifications of one's preferences) are possible as long as at least one of the "basic" facets of our conceptual structure remains constant while the others change —the constant feature provides a nonarbitrary (yet weakly independent) evaluative standard to which one may appeal in evaluating various proposals for conceptual change.[27]

Whether they adopt such an account or opt for a "hierarchical" one, however, explanatory naturalists may offer a non-static picture of our problems, aims, and standards without falling prey to an internal arbitrariness challenge. Their naturalistic studies provide good reasons for their claim that others do not confront different problems, have different aims, or employ different evaluative standards. While they may not claim to have independently established the warrant, efficacy, or appropriateness of their orientation, explanatory naturalists may maintain that their naturalistic studies of our theory-changing and theory-holding roles undercut the appearance of arbitrariness which arises from within their orientation as one considers the problems posed by the phenomena of conceptual diversity and change.

In addressing the perennial question with regard to rationality, however, explanatory naturalists may not rest content with their ability to offer nonarbitrary preferences for the pervasively held initial common-sense theory of medium-sized physical objects, or for the pragmatic and empiricistic standards for the evaluation of proposals for conceptual revision. They must explain why they believe we *should* be rational. In the final chapter we turn to the naturalists' argument for this claim.

8

Explaining Naturalistically Why We Should Be Rational

39. Naturalism, Being Rational, and the Perennial Question

The question which traditionally motivates the discussions in the perennial arguments with regard to rationality is: "Why should we be rational?" The explanatory naturalists' therapy argument is designed to show skeptics, qualified realists, unqualified realists, kerygmatic rationalists, and fideists how a proper understanding of our roles as theory-holders and theory-changers undercuts much of the force of both the traditional challenge to rationality and their orientations in response to this challenge. While the therapy argument shows what explanatory naturalists believe is wrong with these orientations, it does not provide a positive characterization of what being rational consists of according to the explanatory naturalists, nor does it provide a positive response to the challenge which is posed by the traditional question.

In this section I clarify the explanatory naturalists' characterization of rational activity, and I show why and how the traditional question must be reformulated according to the explanatory naturalists. In section 40 I argue that the reformulated challenge poses a serious problem for the rationalists, and I show that claims that the perennial question is self-defeating are incorrect. In the remainder of the chapter I show how explanatory naturalists meet the reformulated challenge.

As we have seen, explanatory naturalists maintain that their naturalistic studies of our theory-holding and theory-changing roles show that we begin our lives in similar environments with similar physiological capacities, similar problems, and similar aims; and they show that we initially acquire the common-sense theory of ordinary middle-sized physical objects which is socially inculcated, easily

acquired, and generally efficacious.[1] As explanatory naturalists see it, we have little choice but to initially employ the theory of medium-sized physical objects, and little choice but to presume its standards and enablers as we begin to confront our basic problems and attempt to achieve our basic aims.

Explanatory naturalists allow that there could be individuals who do not employ this initial held theory, who do not share these aims, or who do not confront these problems.[2] Their naturalistic studies of our physiology, environment, and theory-changing activities do not establish that individuals have this theory (or these problems or aims) necessarily. Indeed, such studies could not show this.[3] The naturalistic studies ascribe no more than a *conditional necessity* to the initial held theory, the basic problems, or the basic aims. That is, naturalists contend that *given our current scientific understanding of our predicament*, it is very likely that others will also begin where we begin.

The naturalists' therapy argument is employed when they confront theorists who would reject this "given." They try to show such theorists that we cannot engage in our evaluative or justificatory activities independently of our held theory. In section 25 we saw that skeptical questions require an acceptance of our held theory and its enablers, and in section 36 we saw that the fideists' own lives show that their efforts to redirect our attention and concern rely upon an initial acceptance of the held theory which the explanatory naturalists identify. In short, the naturalists' therapy argument shows that while the holding of the held theory (and the having of the basic problems and aims) is not necessary, there is no reason to believe we will confront individuals who do not share this beginning point with us; and there is every reason to believe that as we confront others, they will share this much in common with us.

Indeed, the naturalistic studies of our theory-changing role explain why there is such a pervasive agreement amongst individuals regarding their basic problems, basic aims, and initial held-theory (both throughout time and across cultures). The similar sensory, physiological, and motor capacities; the similar environments and capacities to feel pleasure and pain; and the similar biologically dictated needs and environmentally dictated problems—all conspire to ensure that the basic problems, aims, and theories will be, as Kekes says, "universally human, historically constant, and culturally invariant."[4]

The social character of theory acquisition is another important factor in the naturalists' explanation of this pervasive agreement. The initial held theory is not developed by individuals in a vacuum. The acquisition of this theory depends upon shared perceptual capacities and involves social reinforcement. Individuals who did not acquire the commonly held initial theory of medium-sized physical objects would have to be largely immune to the known forms of social conditioning, and would be largely unable to engage in social intercourse. In short, they would have to mature on their own, and many factors (especially environmental and biological) bespeak of the difficulties which would confront such isolated individuals. Thus, explanatory naturalists contend, it is extremely unlikely that we will confront individuals who do not share the basic problems, aims, and initial held theory.

According to the explanatory naturalists, then, recognizing the complex interplay of our role as theory-holders and theory-changers shows us that an important component of rational activity will be the employment of the pervasively held initial common-sense theory of medium-sized physical objects as one confronts the problems posed by one's nature and environment and as one seeks to fulfill one's basic aims. This theory-holding component of rational activity is not simply within the reach of all, naturalists contend; it is difficult to imagine a human life devoid of this rational capacity—only the most severely impaired or completely socially isolated could manifest a complete lack of such rationality throughout their lives.

Given the unlikelihood that we would encounter individuals who do not initially employ the held theory identified by the naturalists, the question behind the perennial arguments with regard to rationality may more properly be rephrased as: "*Why should we continue to be rational?*" That is, the fideists' and skeptics' challenge to the rationalists should be recast so that they ask, "Given that we all start out with roughly the same physiology, environment, problems, aims, and held theory, why should people continue to employ the theory of medium-sized physical objects to resolve the basic problems and achieve the basic aims rather than renounce this heritage and, instead, adopt the (skeptical or fideistic) orientation which we recommend?"

The posing of this question points to the fact that, according to explanatory naturalists, being rational does not simply consist in the adherence to the pervasively held initial theory. The changing

environment, the lack of specificity inherent in this initial theory, the theory's faulty predictions, its inadequate interrelation of experiences, its disappointments on the problem-resolution and aim-fulfillment fronts, and our desires for increased systematization and simplicity all contribute to the call for revision of the held theory. Thus, explanatory naturalists maintain that rationality is manifested not only in our role as theory-holders (in which we conservatively and tenaciously adhere to our enablers), but also in our role as theory-changers (in which we are bent on revising the initial held theory).

The explanatory naturalists' studies of our theory-changing role provide not only an explanation of the factors which engender our theory-changing activities, but also of the factors which guide and govern them. According to these studies, we employ pragmatic and empiricist standards for the evaluation of putative changes to our held theory as we endeavor to develop a theory which more adequately resolves our basic problems and better enables us to fulfill our basic aims. With regard to our role as theory-changers then, an important component of rational activity will be the employment of these standards when one evaluates differing proposals for conceptual revision in order to effect these ends.

While it is extremely difficult to imagine an identifiable human life wherein the theory-holding component of rational activity is never manifested (where someone never employed the pervasively held common-sense theory of medium-sized physical objects), it is less difficult to imagine individuals who do not manifest the theory-changing component of rational activity. Indeed, given the naturalists' claims regarding the pervasiveness of our initial held theory, it must be our role as theory-changers which presents the opportunity for deviation from rationality. Moreover, if the explanatory naturalists' entreaty that we continue to be rational is not to be empty verbiage, they must be able to explain why individuals at least some of the time fail to manifest such rationality.

At least five different considerations help explanatory naturalists explain such deviation. First, their studies disclose that while we generally employ pragmatic and empiricist standards when we evaluate proposals for conceptual revision, individuals may waive consideration of the effects of such proposals upon the held theory's problem-resolving and aim-fulfilling capacities, and they may neglect

the standards of evaluation which are at the core of their current held theory (or, of course, misapply them).[5]

Second, the held theory which explanatory naturalists appeal to is not a clearly delineated, completely consistent, or fully determinate set of readily identifiable beliefs, theories, aims, standards, and commitments. Instead, it is a complex "web," or working set, of beliefs, theories, aims, standards, commitments, and patch-work solutions. The criteria, standards, and enablers which are implicit in this held theory are not explicitly cataloged, taught, or recognized as such, and this makes it possible for individuals to fail to be guided by them as they evaluate proposals for conceptual revision.

Third, the naturalists' therapy argument helps explain the fact that some individuals will choose to accept and advocate revisions which diverge from those that better accord with the standards and criteria that naturalists claim are implicit in our held theory. As we have seen, individuals who believe we are unable to offer a rational justification for our proposals for conceptual revision may well seek a suprarational one. While naturalists contend that these individuals make the same sort of mistake as that made by the justificatory rationalists (each misunderstands the peculiar role played by our enablers and fails to pay proper attention to our role as theory-holders), the naturalists' studies of our theory-holding role show that the peculiar role played by our enablers is difficult to recognize and understand. This, of course, helps explain why individuals may fail to be guided by the empiricist and pragmatic standards as they evaluate proposed revisions to their held theory.

Fourth, naturalists note that in engaging in the theory-revising enterprise, we regularly find ourselves guided by considerations concerning abstract principles, laws, methods, and the consequences of our revisions upon our practices.[6] There is a significant degree of interplay between such considerations, but there are times where individuals assign paramount importance to laws, principles, or methodological constraints, and other times where they assign more importance to consequentialistic considerations. Understanding the interplay of these factors also aids us as we try to understand how individuals come to make and advocate conceptual revisions which the explanatory naturalists would not approve of.

Finally, an understanding of our predicament and of our roles as theory-changers discloses that individuals may be motivated by

ignorance, prejudice, self-interest, and superstition as they engage in the process of revising their held theories.[7] Futhermore, individuals might overlook any of the following: the effects of proposed revisions upon the theory's problem-solving and aim-fulfilling capacities, the diffuse and loosely structured character of our held theory, the difficulty of recognizing the peculiar role played by our enablers and held theory, and the fact that individuals must balance considerations regarding abstract principles with consequentialistic considerations. When this is taken into account, it becomes even easier to understand how individuals may fail to be rational as they revise their initial held theory (or as they continue to revise their held theories over time).

It is just because the explanatory naturalists allow for deviation from the pattern of rational activity which they recommend that the perennial questions pose a serious problem for their orientation. Were they to claim that we are *necessitated* to be rational, there would be no problem posed by skepticism, fideism, or the phenomenon of conceptual change—individuals would have no choice but to continue to be rational, and asking why they should do so would be largely without point. Given that they do not (and cannot) maintain this, the question as to why we should accept their recommendation that we engage in rational theory-revision gains its force.

In order to positively answer that question (or, of course, the more traditional question "Why should we be rational?"), we need not maintain that individuals may exercise direct voluntary control over either their individual beliefs or their general cognitive strategies. Contemporary epistemologists recognize, as did both Pascal and Sextus Empiricus, that we cannot exercise such direct control.[8] Fortunately, the voluntarism which is required by the question need not be such direct control. The way we *can* influence our beliefs and strategies is *via* "indirection"—we work to adopt certain habits of action and belief formation and, if we are successful, certain beliefs and actions may result.[9]

Generally speaking, we lack the self-control requisite to simply stop eating fattening foods, to believe that our problems are pseudo-problems, to doubt our ordinary knowledge claims, or to engage in critical thinking before accepting any claims and engaging in any actions. We do, however, have a degree of self-control which enables us, with varying degrees of effort and success, to work indirectly to

adopt a strict low-fat diet regimen, adopt a Candide-like optimism, develop a skeptical orientation, or expand our propensity for critical thinking. Instead of championing a voluntarism which requires direct control over beliefs and general cognitive strategies, explanatory naturalists may maintain that we can indirectly influence our general habits and strategies of belief formation.

As we saw in section 25, explanatory naturalists maintain that natural scientists are more self-conscious than other individuals when they engage in their theory-revising efforts. They contend that this increased self-consciousness is an important component of rational activity. According to them, individuals who do not exercise the sort of self-conscious care that is the hallmark of the scientific orientation are frequently unclear with regard to not only the theories or beliefs that they are considering revising, but also the theories or beliefs that they are considering as replacements. That is to say, their understanding of the evaluative criteria or standards which they are employing is often muddled.

Individuals who are not sufficiently self-conscious in these respects, of course, are more likely to accept revisions which are not likely to be as successful in resolving our problems or achieving our aims as are the revised theories of the more self-conscious theory-changers. Since the explanatory naturalists' studies show that we generally revise our held theory in order to more effectively resolve our problems and achieve our aims, and since we do not generally approach our role as theory-changers with sufficient self-consciousness, explanatory naturalists advocate that we exercise a *greater* degree of self-consciousness as we pursue our theory-changing activities.

This call for increased self-consciousness with regard to our theory-revising activities is sometimes phrased, perhaps paradoxically, as a call for *increased* rationality—individuals are encouraged to become "more" rational. In saying that we should endeavor to become "more" rational, however, explanatory naturalists do not mean to appeal to some external standard of rational activity to which our theory-revising activities should be compared. As we have seen, these naturalists maintain that questions of truth, adequacy, and reference must be treated as internal questions—they brook no higher standard than that supplied by their held theory, and they employ their therapy argument when they confront individuals who would attempt to ignore their role as theory-holders, or attempt to

evaluate the enablers in this manner. To attempt to appeal to some external standard here would be for the explanatory naturalists to qualify their naturalism.

The explanatory naturalists' call for "more" rationality is a call for increased self-conscious attention to our role as theory-changers. According to them, the natural scientists' increased attention to the referential implications of their theories, to their predictive implications, to the problems posed by inconsistency and unnecessary complexity, and to failure to coherently interrelate experiences, allows them to revise their held-theory better than the "lay" theory-revisers who do not exercise such care and attention. Explanatory naturalists applaud such care, but believe that it must be extended yet further.

Whereas empirical scientists are more careful in applying the empiricist standards for the evaluation of proposals for conceptual revision, for example, they do not self-consciously consider what the empiricistic standard amounts to or requires; and explanatory naturalists would encourage such self-conscious attention. The naturalists' studies attribute the natural scientists' success to the increased self-consciousness and care with which they pursue their role as theory-changers, and thus these naturalists come to assign a great deal of importance to our becoming as self-conscious as we can in our role as theory-changers.

Explanatory naturalists cannot provide an independent guarantee that the continued employment of the pragmatic and empiricist standards will engender efficacious revisions of our held theory—an argument which attempted to do this would require that they qualify their naturalism. This inability to independently ground these standards does not disturb the explanatory naturalists, however. They understand that they must continue to employ the standards of the held theory as they engage in their theory-changing activities. Moreover, their naturalistic studies reveal no reasons for reticence in the employment of these standards. Indeed, these studies provide reason to believe that it is the increased care and self-consciousness with which they are applied which has engendered the most efficacious revisions of the held theory (and generated the "naturally fundamental particles" of natural science as opposed to the "conceptually fundamental" ones of common sense). In addition, explanatory naturalists note, there are no other standards which promise to be

equally or more efficacious. Thus, explanatory rationalists contend that we have every reason to believe that continued employment of these standards will facilitate our theory-changing activities.

The first component of rational activity, according to the explanatory naturalists, is provided by our role as theory-holders and consists of employing the held theory's enablers and standards. The second and third components are provided by our role as theory-changers; they assign importance to being self-conscious in employing our standards and in our evaluation of proposals for revision, and in being self-conscious about these standards themselves. Although they would, of course, encourage us to continue to be rational, explanatory naturalists actually demand more than this—they believe we should strive to become more so. Given this, the revised perennial question which explanatory naturalists would address should, finally, read: "*Why should we both continue to be rational and endeavor to become more so?*" In the next section I will clarify the challenge to rationality, and then (in the final two sections) I will elaborate the explanatory naturalists' answer to this question.

40. Understanding the Challenge to Rationality

The very asking of the question "Why should we continue to be rational and endeavor to become more so?" (or, of course, the more traditional question "Why should we be rational?") presumes familiarity with the standards and enablers which make rational evaluation and justification possible. Indeed, some rationalists turn this fact into their basic response to the fideists' and skeptics' challenge—they maintain that the endeavor to critique or question the rationalists' orientation is fundamentally flawed because it must commit itself to the rationalists' enterprise when it raises its questions and criticisms.[10] This response may be called the *tu quoque* argument: in response to the fideistic (or skeptical) critique the rationalist says, "In criticizing or questioning rationality, you yourself manifest a commitment to the rational standards and to the rationalists' approach to evaluation and justification. Since you must employ rationality in order to question or criticize it, your critique is fundamentally flawed—you too are a rationalist."

Harvey Siegel formulates this sort of argument as follows:

we meet the demand [for the justification of rationality] by seeing that rationality is *self-justifying*. . . . in order seriously to question the worth of rationality, one must already be committed to it. For to ask "Why be rational?" is to ask for *reasons* for and against being rational; to entertain the question seriously is to acknowledge the force of reasons in ascertaining the answer. The very raising of the question, in other words, commits one to a recognition of the force of reasons. To recognize that force is straightaway to recognize the answer to the question: we should be rational because (for the reason that) reasons have force.[11]

The argument here seems parallel to one often offered in response to the perennial question with regard to morality ("Why be moral—rather than being motivated solely by considerations of self-interest?"). As long as the 'should' in the question regarding morality is read as a moral 'should', the question is clearly self-defeating—asking the moral question "Why should we (or I) be moral?" already presupposes the acceptance of the force of moral considerations.

As a number of authors have argued, however, this question need not be asked (nor need it be answered) as a moral question.[12] Instead of treating it in this fashion, one may (and should) treat it as a question asked from *neither* the perspective of the moralist nor from the perspective of the egoist—it is a question which asks for reasons for adopting one of these orientations as against the other. The egoist who asks the question defeats himself if he is asking for a moral reason—for he is then committed to the acceptance of moral considerations even as he raises the question. Moreover, he begs the question if the 'should' is the self-interested 'should' (and, of course, the moralist begs the question if she interprets it as a moral question or if she offers a moral reason for being moral). As long as one does not ask for (or offer) a moral or a self-interested reason as one raises this question, however, one is not hoisted by one's own petard.

The perennial question with regard to rationality does not seem to allow for such a maneuver—to ask "Why should we continue to be rational and endeavor to become more so?" (or, of course, the more traditional question "Why should we be rational?") is to ask for a *reason*. As Siegel argues, this means recognizing that reasons have force and, thus, accepting the rationalists' orientation. Thus, skeptics

40. Understanding the Challenge to Rationality

and fideists appear to be undercut before they can get started as they try to raise the perennial questions with regard to rationality.

Ultimately, however, the *tu quoque* argument is not successful in addressing the perennial question or the skeptical and fideistic challenges. Pascal provides us with an example of a fideist who puts forward the traditional challenge to rationality without falling prey to self-defeat. He does not try to provide a rational argument against rational argument, and he does not attempt to provide a rational argument for a commitment to his chosen faith (a commitment that he recommends in place of the pervasive commitment to rationality which he claims is all too prevalent). Indeed, a faith founded on reasons (or rational argument) is no true faith. Pascal insists that faith must involve commitment in the absence of reasons: "faith is different from proof. . . . faith is in the heart, and makes us not say *scio*, but *credo*."[13]

Instead of providing *reasons* for his faith (or reasons for rejecting rationality), Pascal utilizes skeptical arguments, his wager argument, and all his religious fervor and rhetorical skill to endeavor to help the rationalists ("dogmatists") of his day see that

> we must know where to doubt, where to feel certain, where to submit. He who does not do so, understands not the force of reason. There are some who offend against these three rules, either by affirming everything as demonstrative, from want of knowing what demonstration is; or by doubting everything, from want of knowing where to submit; or by submitting in everything, from want of knowing where they must judge.[14]

The fideists' version of the enduring question does not ask for reasons but, rather, functions as a rhetorical question—it raises (or reminds one of) the possibility of a different sort of orientation, notes the justificationalists' difficulties, and serves to introduce the reader to the fideists' kerygmatic recommendations. In short, when asking the perennial question, the fideist is not, *contra* Siegel, asking for reasons, and, thus, is not defeating herself.

A more lengthy discussion will help clarify the fideistic challenge to rationality and show why rationalists may not simply dismiss it as self-defeating. Consider Pierre Bayle's discussion of the fideistic force of the skeptical arguments in his *Historical and Critical Dictionary*. At one point Bayle cites Francois de la Mothe le Vayer who says,

we believe that the skeptical system, founded on a simple recognition of human ignorance, is the least contrary of all to our beliefs, and the most appropriate for receiving the supernatural lights of faith. We are saying nothing here that does not conform to the best theology since that of St. Denis teaches nothing more expressly than the feebleness of the human mind and its ignorance about all things divine.[15]

Bayle then continues his discussion of the force of Sextus' skeptical arguments saying that

> this logic is the greatest effort of subtlety that the human mind has been able to accomplish. But, at the same time, one sees that this subtlety is in no way satisfactory. . . . How great a chaos, and how great a torment for the human mind! It seems therefore that this unfortunate state is the most proper one for convincing us that our reason is a path that leads us astray since, when it displays itself with the greatest subtlety, it plunges us into such an abyss. The natural conclusion of this ought to be to renounce this guide [the guide of reason] and to implore the cause of all things to give us a better one. This is a great step toward the Christian religion; for it requires that we look to God for knowledge of what we ought to believe and what we ought to do, and that we enslave our understanding to the obeisance of faith. If a man is convinced that nothing good is to be expected from his philosophical inquiries, he will be more disposed to pray to God to persuade him of the truths that ought to be believed than if he flatters himself that he might succeed by reasoning and disputing. A man is therefore happily disposed toward faith when he knows how defective reason is. This is why Pascal and others have said that in order to convert the libertines they should make them realize the weakness of reason and teach them to distrust it.[16]

In a footnote which discusses this passage, Richard H. Popkin (who edits and translates Bayle here) says that

> it is interesting to compare the calm, almost tepid character of this whole presentation of the debacle of reason and the need for faith with that in Pascal's *Pensées* . . . where the same case is presented with burning religious passion. On the other side, various similar passages in . . . Hume's *Treatise* show the despair of the skeptic without faith. . . . Pascal passionately leaps toward the answer;

Hume desperately tries to overcome his total skepticism and cannot. Bayle unperturbedly reveals the disastrous failure of human reason. . . . And then he just unemotionally states the fideistic answer.[17]

By presenting the wager and by showing the conflict between the positions of the "dogmatists" (rationalists) and the skeptics, Pascal would expose us to the need for faith. Here the perennial question does not seek reasons against the rationalists' (or the skeptics') orientation, nor does it seek reasons for the fideists' orientation. Instead it functions to open our eyes to the possibility of *forsaking* the rationalists' orientation, and to encourage us to adopt instead the sort of faith which Pascal recommends.

A primary tool which Pascal employs toward this end consists of portraying the misery of a life without faith:

> nothing is so important to man as his own state, nothing is so formidable to him as eternity; and thus it is not natural that there should be men indifferent to the loss of their existence, and to the perils of everlasting suffering. . . . They are afraid of mere trifles; they foresee them; they feel them. And this same man who spends so many days and nights in rage and despair for the loss of office, or for some imaginary insult to his honour, is the very one who knows without anxiety and without emotion that he will lose all by death. It is a monstrous thing to see in the same heart and at the same time this sensibility to trifles and this strange insensibility to the greatest objects.[18]

Pascal employs the skeptical arguments to show us that "we have no certainty of the truth . . . apart from faith and revelation."[19] And he employs his wager argument to show that we should forsake a life of reason and, instead, endeavor to have the sort of faith which he recommends. His primary purpose is not with rational argumentation. The *Pensées* tries to show us the misery of man without faith and the happiness which faith may bring. It also tries to show individuals how they might come to have the requisite faith, and it engages in a good deal of Christian apologetics.

Siegel contends that "in order seriously to question the worth of rationality, one must already be committed to it."[20] Pascal must certainly count as a *prima facie* counterexample to this claim. In one sense of 'already', of course, Siegel is correct according to the

explanatory naturalist—Pascal (like all of us) initially acquired and employed the common-sense held theory of medium-sized physical objects as he sought to resolve the basic problems of life and achieve the fundamental aims which he later deemed trivial. Moreover, like the traditional skeptics, Pascal does seem to employ reason in an effort to rationally argue against reason. How, then, does he escape Siegel's version of this traditional critique?

The considerations which Pascal offers and the questions he raises are not intended to provide *reasons* for the *conclusion* that one should forsake reason and, instead, adopt a kerygmatic commitment to Christianity. According to Pascal, the enterprise of seeking reasons will leave us poised between skepticism and "dogmatism" (rationality). He vividly portrays this tension and, having placed the reader squarely in the middle of this conundrum, he would incite us to join him in his fideistic commitment:

> what a chimera then is man! What a novelty! What a monster, what a chaos, what a contradiction, what a prodigy! Judge of all things, imbecile worm of the earth; depositary of truth, a sink of uncertainty and error; the pride and refuse of the universe!
>
> Who will unravel this tangle? Nature confutes the sceptics and reason confutes the dogmatists. What then will you become, O men! who try to find out by your natural reason what is your true condition? You cannot avoid one of these sects, nor adhere to one of them.
>
> Know then, proud man, what a paradox you are to yourself. Humble yourself, weak reason; be silent foolish nature; learn that man infinitely transcends man, and learn from your Master your true condition, of which you are ignorant. Hear God.[21]

Pascal is not presenting reasons against reason here. The enterprise does employ reason (the skeptical arguments are marshaled as is the "Humean" argument against skepticism), but Pascal does not use this tension as a *reason* for adopting the orientation which he champions. The "truth" which he would offer is not one which can be established by rational means:

> we know truth, not only by the reason, but also by the heart, and it is in this last way that we know first principles; and reason, which has no part in it, tries in vain to impugn them. The sceptics, who have only this for their object, labour to no purpose. We know that we do

not dream, and however impossible it is for us to prove it by reason, this inability demonstrates only the weakness of our reason, but not, as they affirm, the uncertainty of all our knowledge. . . . reason must trust these intuitions of the heart, and must base them on every argument [sic].[22]

The passages from Bayle's *Dictionary* cited above are followed by a citation from Calvin's liturgy of Baptism which is intended (by Calvin) to provide beginning instruction for those being initiated into Christianity:

God then admonishes us to be humble and to be displeased with ourselves; and in this he prepares us to wish for and require his grace, by which all the perversity and curse of our basic nature may be abolished. For we are not ready to receive it until we have first divested ourselves of all confidence in our own virtue, wisdom, and justice, and until we have condemned everything that is in us. However, after showing us our unhappiness, he also comforts us by his mercy, promising to regenerate us by his Holy Spirit into a new life, which may be to us as an entrance into his Kingdom. This regeneration consists of two parts, namely denying to follow OUR OWN REASON, our pleasure, and will; but by ENSLAVING OUR UNDERSTANDING and our heart to the wisdom and justice of God, we mortify whatever belongs to ourselves and to our flesh; and then that we FOLLOW THE LIGHT OF GOD to comply with and obey whatever pleases him, as he teaches us by his Word and leads us by his Spirit.[23]

Neither Pascal nor Calvin wish to follow the path laid out by Siegel. They employ skepticism to inspire and arouse us to abandon rationality and adopt, instead, a different sort of commitment. They raise the traditional challenge not to argue against reason but, rather, to encourage our forsaking it for their commitment.

It is also important to note that when traditional fideists are confronted with the rationalists' self-justification or *tu quoque* argument, they may respond with a *tu quoque* argument of their own. They may say to the rationalists: "Given your failure to provide a nonquestion-begging defense of your rational standards and commitment, you too manifest a fundamental non-rational commitment: your 'faith in reason' shows that you too are fideists!" The traditional fideists also point out that while they consciously commit

themselves, the rationalists "blindly" make their irrational commitment without recognizing what they are doing.[24]

W.W. Bartley attempts to show what is wrong with the fideists' orientation in a manner which parallels Siegel's (and the traditional rationalists') claim that the skeptics' and fideists' challenges are self-defeating. He argues that his "comprehensively critical" rationalists (individuals who, like the later Popper, are even willing to countenance criticisms of their commitment to criticism) offer a view which is immune to the fideistic challenge. According to Bartley, the fideists can not offer their *tu quoque* argument as an external criticism of the comprehensively critical rationalists' orientation unless they are willing to allow for the external criticism of commitments (an allowance which would allow the comprehensively critical rationalists to respond with their *tu quoque* against the fideists).

Bartley maintains that while the fideists' *tu quoque* argument internally shields their position from the rationalists' criticisms by holding that any criticism of commitments requires an unargued commitment, the consequence of this is that no criticism of commitments is possible—including, of course, the fideists' criticism of the comprehensively critical rationalists' commitment to criticism.[25] As Bartley sees it, then, the fideists may offer a criticism of the comprehensively critical rationalists' commitment only if they are willing to sacrifice their intellectual integrity and countenance the criticism of commitments. Thus, the comprehensively critical rationalists need not fall prey to the fideists' *tu quoque* since they do not sacrifice their intellectual integrity by adopting an irrational commitment. They can avoid the fideists' *tu quoque* just because they are willing to criticize even their commitment to criticism.

In section 8 I argued that fideists may offer an orientation which is as internally consistent as the comprehensively critical rationalists'. As long as such theorists wholly forsake criticism, they may consistently urge that we adopt the specific dogmatic commitments which they champion. While historical fideists may at times have attempted to rationally convince their readers that the justificatory endeavors of the traditional justificatory rationalists lead them to ignore the true human problems, a modern-day nonjustificatory fideist could content herself with a dogmatic assertion that the critical orientation leads us away from the truly human concerns and truths.

The *tu quoque* argument which she might appeal to would not be used as a *critical attack* upon the rationalist but, rather, as an internal

response to any atavistic rationalistic tendencies which arise in response to the kerygmatic commitment she endorses. She would use it to remind herself that according to her view, the rationalists cannot satisfactorily respond to the skeptics' questions without manifesting an unjustified commitment to rationality. After all, from her perspective, the "logical" question is "Why be rational (and hide one's kerygmatic commitment) rather than straightforwardly fideistic?" She would not use this question to rationally attack the rationalist any more than the comprehensively critical rationalists would dogmatically and kerygmatically assert their commitment to criticism in order to argue against fideism.

The same point may be made in somewhat different language in response to Siegel's "self-justifying" argument. This argument requires that the question "Why should we continue to be rational and endeavor to become more so?" (or, of course, the more traditional question "Why should we be rational?") be a question which seeks reasons. This is what the fideist must deny if she is to avoid the rationalists' conclusion that the rational orientation is self-justified (or the rationalists' claim that her challenge to rationality is self-defeating). The fideist does not ask for reasons in asking the question. Indeed, the question is asked to encourage the forsaking of the whole enterprise of seeking and giving reasons. In short, the "self-justification" argument works only if one is antecedently committed to the enterprise of continuing to seek and provide reasons, and it is this commitment from which the fideist prescinds (and recommends that we forsake).[26]

Siegel and Bartley both urge that we become more critical (or rational). But to make such a recommendation one must recognize that individuals are able to become less so—indeed to *urge* the case is to recognize that individuals are not prone to become more so unless they exert effort to enhance their critical skills. In urging that individuals so exert themselves, Siegel and Bartley accept some degree of responsibility to indicate why we should make such an effort and, clearly, this means that they must offer a positive response to the revised perennial question. Thus even if the earlier responses to these theorists' arguments are inadequate, it is clear that the perennial question is not a senseless one—even those who employ the *tu quoque* argument in an effort to undercut the perennial question accept a responsibility to indicate why we should be rational (and, thus, accept a responsibility to answer the question).

Of course, showing that the revised perennial question is not self-defeating merely focuses our attention. If the explanatory naturalists' recommendations regarding our approach to conceptual change are to be accepted, we must be clear as to *why* they claim that we should accept their sorts of conceptual changes rather than those preferred by the fideists (or by the skeptics). The final two sections develop the explanatory naturalists' answer to this question.

41. Why the Explanatory Naturalists' Recommendations Regarding Conceptual Change Are Preferable to the Fideists' Proposals

Pascal and Kierkegaard recommend that individuals turn their attention away from the concerns which we "normally" consider important (they each term this a concern with the "finite") and, instead, seek to resolve a different set of problems and fulfill a different set of aims (both theorists hold that we need to become more concerned with the "infinite"). Clearly, if the fideists' recommendations regarding conceptual change are to pose an internal problem for the naturalists, then it must be *possible* for individuals to reorient themselves as the fideists recommend. Robert M. Adams criticizes Kierkegaard at exactly this point.[27]

Kierkegaard believes that "objective reasoning" is inappropriate (and undesirable) when it comes to the question of faith. Such reasoning leaves open the possibility of doubt, and "the conclusion of belief [faith] is not so much a conclusion as a resolution, and it is for this reason that belief excludes doubt."[28] As Adams says, for Kierkegaard, "the decision of faith is a decision to disregard the possibility of error—to act on what is believed, without hedging one's bets to take account of any possibility of error."[29] For Kierkegaard, "anything that is almost probable, or probable, or extremely and emphatically probable, is something [one] can almost know, or as good as know, or extremely and emphatically almost *know*—but it is impossible to *believe*."[30] He holds that "faith is the highest passion in a man,"[31] and contends that the truth [or faith]

> is precisely the venture which chooses an objective uncertainty with the passion of the infinite. . . . The sum of all this is an objective uncertainty. But it is for this very reason that the inwardness

becomes as intense as it is, for it embraces this objective uncertainty with the entire passion of the infinite. In the case of a mathematic proposition the objectivity is given, but for this reason the truth of such a proposition is an indifferent truth.

But the above definition of truth is an equivalent expression for faith. Without risk there is no faith. Faith is precisely the contradiction between the infinite passion of the individual's inwardness and the objective uncertainty. If I am capable of grasping God objectively, I do not believe, but precisely because I cannot do this I must believe. If I wish to preserve myself in faith I must constantly be intent upon holding fast the objective uncertainty, so as to remain out upon the deep, over seventy thousand fathoms of water, still preserving my faith.[32]

According to Adams, Kierkegaard maintains that the degree of risk which individuals are willing to take (or the amount that individuals are willing to sacrifice) provides a measure of their passion.[33] Thus an "infinite" passion demands that one hold nothing back (that there be no greater risk that one could be willing to take, or no greater sacrifice one could make). But, Adams contends, this means that Kierkegaard demands the *impossible* of us — human beings are incapable of taking the sorts of infinite risks and making the sorts of sacrifices which Kierkegaard's orientation demands of them. Adams says: "I doubt that any human being could have a passion of this sort, because I doubt that one could make a sacrifice so great that a greater could not be made, or have a (nonzero) chance of success [i.e., negative index of risk] so small that a smaller could not be had."[34] Yet this is just what is requisite if one is to manifest the sort of infinite passion mandated of us by the fideist.

Of course, both Pascal and Kierkegaard recognize the difficulty of attaining the sort of infinite passion which they believe we must come to manifest. Adams' point is not simply that it is *difficult* to arrive at the requisite level of commitment, however. An infinite passion is one of *infinite* intensity, and Adams contends that such a passion is *impossible* for human beings to achieve or manifest. If Adams is correct on this score, we would have a reason for accepting the explanatory naturalists' claim that the fideists champion unsuitable conceptual revisions: the fideists would be recommending that individuals accept their recommendations regarding conceptual revisions so that they could come to have a passion which it would be

impossible for them to have. A recommendation that one give up what seems most promising with regard to "finite" problem-solving and aim-fulfillment (see below) so that one may endeavor to have an *impossible* passion (and, thus, non-objectively confront "infinite" problems and achieve "infinite" aims) does not seem to be a recommendation worth pursuing.

The apparent existence of actual individuals who appear to manifest the sorts of passions in question (i.e., Pascal and Kierkegaard) might be seen as undercutting the possibility that Adams is correct in claiming that the fideists' infinite passion is impossible, however. But even if *these* individuals are able to manifest such passions, it may be most difficult (if not impossible) for many or most individuals to do so. If this is the case, it still might be inappropriate to recommend that human beings come to manifest such an infinite passion.

J.O. Urmson, for example, argues that while it is possible for some individuals to be saints or heroes, it is beyond the capability of many or most individuals to be such.[35] He claims that this means that any morality which demanded that individuals behave in such a manner would be an inappropriate morality for human beings (who would generally be incapable of saintly or heroic acts). This sort of argument might be applied to the case at hand—explanatory naturalists might argue that while certain individuals might be able to manifest the sort of infinite passion recommended by the fideists, such a passion is beyond the capacity of many or most individuals and, thus, the recommendation that we all endeavor to adopt such an orientation would be inappropriate.

Consider in this regard the degree of religious commitment, or passion, shown by the biblical Abraham who serves as an important example of the sort of infinite passion which Kierkegaard recommends.[36] Although Abraham has waited patiently against all odds for the son who he is told will provide the stock through which mankind is to be blessed, when he is required to offer that son as a burnt offering to his deity, he does not hesitate. When tested, Abraham's faith does not falter. He is prepared to offer his Isaac's life without question or complaint. In discussing Abraham, Kierkegaard says,

> Isaac's fate was laid along with the knife in Abraham's hand. And there he stood, the old man, with his only hope! But he did not doubt, he did not look anxiously to the right or to the left, he did

not challenge heaven with his prayers. He knew that it was God the Almighty who was trying him, he knew that it was the hardest sacrifice that could be required of him; but he knew also that no sacrifice was too hard when God required it—and he drew the knife.[37]

While it might be possible for Abraham to be prepared to offer his cherished son Isaac as a burnt offering to his deity, I think it is well beyond the power of most individuals to exhibit such a degree of religious passion.[38] It would be impossible for most parents to offer their children as burnt offerings—indeed, there is generally a response of revulsion when we are confronted with contemporary stories wherein parents sacrifice their healthy children solely because they are responding to the demands of unseen spirits. Indeed, Abraham is portrayed as undertaking his offering without telling anyone what he is doing—no doubt because few of his contemporaries would have been able to approve of (or manifest) the requisite passion.

Burnt offerings are, perhaps, commonplace, and human sacrifice is certainly not unheard of, but the offering of loved ones as burnt offerings is not commonplace. If the fideists' recommendations as to how we are to revise the pervasively held initial theory require that we have the infinite passion of Abraham, they require that individuals manifest a level of commitment which they cannot generally attain. This, of course, constitutes an extremely strong reason for declining to follow these recommendations for conceptual change.[39]

Kierkegaard does not believe that one must be prepared to sacrifice beloved family members to unseen spirits in order to manifest the infinite passion which he recommends, however. Even such a trivial matter as deciding to go for an outing in a park provides an opportunity for one to manifest such passion, according to him.[40] The example of Abraham is meant to draw our attention not to the difficulty of endeavoring to engage in a particular activity, but, rather, to the complete commitment or infinite passion which must be involved. What is important in this example, and what it is supposed to be possible for one to manifest in more mundane activities such as deciding to go to the park, is a particular sort of subjective or passionate orientation:

> How then did Abraham exist? He believed. This is the paradox which keeps him upon the sheer edge and which he cannot make

clear to any other man, for the paradox is that he as the individual puts himself in an absolute relation to the absolute.[41]

Following Urmson's line of argument, and recognizing that it is not the specific act, but rather the subjective orientation which is important here, one may question whether or not most individuals could manifest the sort of infinite passion which Abraham, Pascal, and Kierkegaard apparently manifest. Clearly the portrayal of Abraham in the Bible does not picture his passion as one which everyone shares. Moreover, both Pascal and Kierkegaard clearly recognize that their contemporaries do not generally manifest the requisite infinite passions. Explanatory naturalists could appeal to their naturalistic studies of our nature and environment to explain this fact: the "teleology" of the pervasively held initial theory (with its emphasis upon "finite," or "this-worldly," problems and aims) is sufficiently strong so that at least as long as individuals inhabit an environment as hostile to individuals' survival as the one which human beings have inhabited, it appears most unlikely that many individuals could manifest the requisite infinite passion. The press of "finite" concerns under-cuts the possibility that most individuals could long manifest the requisite infinite passion.

Even if it should turn out that the fideists' infinite passion is one which it is *possible* for most individuals to come to manifest in their lives, explanatory naturalists must consider whether or not it would be *advisable* for individuals to so modify their held theory. If individuals adopt the sorts of conceptual revisions recommended by fideists like Pascal and Kierkegaard, they will not enhance their theory's problem-solving and aim-fulfilling capacity—at least not as long as one refers thereby to the solution of the "finite" problems and the achieving of the "finite" aims which the naturalists' studies (and the pervasively held initial theory) identify as the basic ones. Indeed, since Pascal and Kierkegaard demand that individuals *turn away* from those concerns which they have regarded as most basic (the "finite" ones), and reorient themselves, the revised theory which individuals would come to hold would be one which is unconcerned with the previous problems and goals. Clearly any increase in problem-solving or aim-fulfilling efficacy here (as long as we thereby mean the previous problems and aims) would be merely accidental.

According to the explanatory naturalists' studies of our nature and predicament, however, individuals who succeed in so reorient-

ing themselves would nonetheless remain human beings inhabiting the same environment which they previously resided in. That is, the naturalists' studies indicate that the problems posed by that environment may be ignored, but they do not disappear. Indeed, a preoccupation with "other-worldly" concerns may well exacerbate one's problems in this world. In short, the naturalists' biological, sociological, and epistemological inquiries all conspire to indicate the unavoidability of the basic problems and the importance of the fundamental aims which they identify. Moreover, their naturalistic studies provide no reason for believing that either the problems which the fideists identify or the aims which they recommend are appropriately deemed basic. In fact, according to the fideists, these studies cannot provide any reason for adopting their orientation (the orientation cannot be founded upon reasons—the "infinite" passion must be an expression of faith rather than a result of rational consideration).

While naturalists do not maintain that there is anything sacrosanct about our initial beliefs, theories, standards, problems, or aims (as we have seen, they may allow for change here and are not constrained to adhere to a hierarchical view of the interrelationships of our problems, aims, theories, and standards), they maintain that proposals for conceptual change must be developed and evaluated from within. They also maintain that the appropriate standards for evaluating such revisions are the standards and criteria provided by our held theory. According to them, the mistake which traditional fideists make as they challenge the rationalists' orientation and offer their own view of our theory-changing activities is the very one which the naturalistic therapy argument is concerned to identify—these theorists fail to recognize the fundamental relativity of our evaluations and the importance of our role as theory-holders. In trying to revise their conceptual structure in the manner they recommend, these theorists end up throwing the baby out with the bathwater.

The naturalists cannot conclude that we necessarily have the problems and aims which they identify, nor can they conclude that we must employ the enablers and standards inherent in the initial held theory. But their naturalistic studies of our theory-holding and theory-changing roles explain (a) why these are basic, (b) how they arose, and (c) why they continue to be employed. Individuals who either intentionally or inadvertently misapply or fail to apply the

standards which the naturalists recommend are bound to find their ("finite") problems unresolved and their ("finite") aims unfulfilled. Moreover, no good naturalistic reasons can be offered for accepting the conceptual revisions which the fideists exhort us to make.

The fideistic rejoinder to this argument will be that it carries no force when one is not motivated to resolve the "finite" problems, to achieve the "finite" aims, or to employ the evaluative standards of the pervasively held initial theory. Indeed, it is exactly this sort of change which is at the very core of the traditional fideists' recommendations and entreaties—they would have us renounce these aims, problems, and standards; and they would encourage us to focus, instead, on different aims and problems. They claim that the sorts of problems and aims which the explanatory naturalists discuss are the trivial and unimportant ones. As Pascal says:

> we condemn those who live without thought of the ultimate end of life, who let themselves be guided by their own inclinations and their own pleasures without reflection and without concern, and, as if they could annihilate eternity by turning away their thought from it, think only of making themselves happy for the moment.
>
> Yet this eternity exists, and death, which must open into it, and threatens them every hour, must in a little time infallibly put them under the dreadful necessity of being either annihilated or unhappy for ever, without knowing which of these eternities is for ever prepared for them.
>
> This is a doubt of terrible consequence. They are in peril of eternal woe; and thereupon, as if the matter were not worth the trouble, they neglect to inquire whether this is one of the opinions which people receive with too credulous a facility.[42]

Now the first point in this rejoinder is utterly correct—*if* problems, aims, and standards of the initial held theory are denied, then there is no particular reason to adhere to the conceptual revisions recommended by the naturalists. One large step remains before one can accept the fideists' radical recommendations for conceptual change, however: individuals must abandon their earlier goals and eschew their earlier problems. If explanatory naturalists maintained that the problems, aims, and standards which they identified were *necessarily* ones which we all have, then they could offer an extremely strong argument against the fideists here. They

could contend that in attempting to reorient ourselves, we would be denying our humanity and endeavoring to accomplish the impossible. As we have seen, however, naturalists may not make this claim. They are limited by their naturalism to the claim that we have *good naturalistic reasons* for claiming that such a reorientation is unwise. Their naturalistic studies will not establish that the basic problems, aims, or theories are ones which all individuals must have—this would require that the naturalists stand outside the held theory and claim that its enablers possessed their status as enablers with some sort of necessity.

But the fact that one cannot show that one's opponent is of necessity incorrect does not mean that one cannot provide any reasons for claiming that this is the case. The challenge to be met at this point in the overall argument is one which arises from *within* naturalism. The question to be answered is "What *internal* warrant do explanatory naturalists have for their claim that the fideists champion unsuitable proposals for conceptual revision or change?" It should be clear that their whole naturalistic analysis of our nature and predicament may legitimately be appealed to as naturalists confront and respond to this question.

The fideists' recommendations for conceptual revision are clearly radical. Both they and those they would "convert" recognize that this is the case. Indeed, the fideists recognize that the sort of orientation which the explanatory naturalists recommend is the one which individuals typically adhere to initially—like Pascal and Kierkegaard, they bemoan and condemn this fact. Moreover, they recognize the difficulties which individuals have as they try to pursue their recommendations for conceptual change. Naturalists contend that the radical changes called for and the difficulty (if not impossibility—at least for most individuals) of manifesting the requisite passionate orientation provide important reasons for demurring.

Explanatory naturalists maintain that conceptual changes should leave us with a conceptual scheme which we can hold, and should preserve as much of the currently held theory as possible. Radical revisions of the held theory should be accompanied by significant gains in problem-solving efficacy, simplicity, or predictive power. But the fideists' recommendations promise loss of problem-solving and aim-fulfilling efficacy, and this counts as an extremely important

reason for demurring. Moreover, the naturalists' studies indicate what sorts of consequences will likely befall those who ignore those problems and renounce those aims which their studies identify as basic. Since such individuals will continue to inhabit the same sort of environment, their willingness to reject as problematic the problems imposed by that environment and their willingness to renounce the aims which "finite" creatures have in such a context will place them in peril.

Of course, Pascal clearly recognizes this consideration, and his wager argument takes it into account. He believes that such peril is infinitely less than the peril one places oneself in if one does not reorient oneself as he recommends—the "infinite" problems and aims are not simply more weighty than the sorts of "finite" problems and aims which the explanatory naturalists emphasize; they are *infinitely* more so. Kierkegaard and the other fideists, of course, agree. Explanatory naturalists note that we do not confront Pascal's "pay-off matrix" from a dispassionate and external perspective, however. Like Pascal, they emphasize that we have interests at stake. Like Pascal, they note that we initially confront the call for conceptual change from the perspective of the pervasively held theory with its problems, aims, theories, and standards. Since both the fideists and the naturalists recognize that we initially have these aims, problems, theories, and standards, what we must consider is whether there are any internal reasons which support the fideists' recommendation that we reject the pervasively held initial orientation in favor of the different orientation which assigns no real importance to these problems, aims, theories, or standards and, instead, assigns all importance to a very different set of concerns.

The fideist herself maintains that the naturalists' studies provide no reason for contending that we have the ("infinite") problems or aims which she recommends (such discoveries would constitute reasons for the sort of kerygmatic commitment which she recommends, and this is something which her theory precludes—indeed, Kierkegaard goes so far at to maintain that the recommended orientation is actually contrary to what reason could recommend). When this fact is combined with the radical nature of the fideists' recommendations, the difficulty (or, perhaps, general impossibility) of manifesting the requisite "infinite" passion, the loss in ("finite") problem-solving and aim-fulfilling efficacy, the loss in predictive power, the naturalists' claims regarding the relativity of our evalua-

tions to our standards, and the fact that the naturalists' studies indicate that individuals who so modify their held theory will still confront the initial sorts of problems, there seems to be little to commend the fideists' recommendations for changing our orientation.

The five considerations noted in section 39 help explain why individuals may revise the pervasively held theory along lines not recommended by the explanatory naturalists. These considerations do not provide much reason for believing that such revisions are advisable, however. According the the naturalists' studies, conceptual revision is called for when the held theory inadequately relates experiences to other experiences, fails to meet our expectations regarding predictive power, or when it does not meet our expectations regarding ("finite") problem-resolution and aim-fulfillment. To renounce the aims or problems in such situations may constitute a way of avoiding such "epistemic dissonance," but the cost of this technique is too dear, according the the naturalists.

Explanatory naturalists maintain that the problem-solving and aim-fulfilling orientation which they emphasize is sufficiently central and important so that largely unproductive revised held theories will likely not survive for long.[43] A more plausible occurrence is likely to be one wherein individuals approve of minimally efficacious revisions and develop revised conceptual structures which are not as promising as others which they might have developed. With a sufficiently powerful initial held theory, a number of unpromising revisions might nonetheless allow individuals to survive. Naturalists believe we should be as self-conscious as possible as we revise our held theory so that we can maximize our held theory's problem-solving and aim-fulfilling capabilities. They believe that as we become increasingly self-conscious and knowledgeable about our role as theory-changers, we will not only enhance our theory, but we will also become less prone to accept inefficacious revisions.

While the explanatory naturalists' recommendations regarding conceptual changes are certainly more mundane than those of the fideists, the naturalists' recommendations have a compensating virtue—they promise a more efficacious revised theory rather than a less efficacious one. The issue between these recommendations is not simply one of taste according to explanatory naturalists, however. They do not simply contend that we are initially inclined to be (somewhat) rational, they maintain that we *should* be (increasingly)

rational. In the final section, the "imperative" character of their contention is clarified.

42. The Explanatory Naturalists' "Hypothetical Imperative" of Rationality

As we have seen, explanatory naturalists maintain that justificatory rationalists, skeptics, kerygmatic rationalists, fideists, unqualified realistic rationalists, and qualified realistic rationalists all offer inadequate orientations because they fail to recognize the importance of our role as theory-holders. This failure encourages many of these theorists to seek (or demand) a "categorical imperative" of rationality—a maxim which would unconditionally mandate the rational orientation. The traditional rationalists, of course, hope that in elucidating this imperative they can show the fideists and skeptics that they should also adopt the rationalistic orientation (and show other rationalists the correctness of their particular version of rationalism).

The naturalists' therapy argument reveals that all of these theorists fall prey to the same fundamental mistake—they fail to pay sufficient attention to our role as theory-holders. According to the naturalists, coming to understand the peculiar role played by our enablers helps us understand the relativity of our evaluations, justifications, and preferences to our held-theory. The naturalists' therapy argument is meant to show that once we recognize our role as theory-holders, we can see that we must forsake the search for a strongly independent justification of the rationalistic orientation, the search for a strongly independent evaluation of the rationalistic and fideistic orientations, and the search for a strongly independent ground for preferring one orientation over the others. The quest for a categorical imperative of rationality, then, goes by the boards.

Descriptive naturalists limit themselves to elaborating this therapy argument and clarifying our held theory—they offer an account of our held theory which "simply puts everything before us, and neither explains nor deduces anything."[44] When they are faced with the phenomena of conceptual diversity and change, these theorists are limited to kerygmatically recommending their own orientation while recognizing that others may have differing orientations. While their therapy argument may show that the other theorists in the

internal and external perennial arguments with regard to rationality fail to pay sufficient attention to their role as theory-holders (and to the peculiar role played by our enablers), these "Wittgensteinian fideists" confront a serious arbitrariness challenge: since they acknowledge that others may have different enablers while limiting themselves to describing and acknowledging their enablers, these theorists cannot criticize or evaluate the other theorists' orientations; and, thus, their own commitment appears arbitrary.

The *explanatory naturalists*' studies of our roles as theory-holders and theory-builders allow them to avoid the kerygmaticism and arbitrariness of the descriptive naturalists. These studies provide good naturalistic reasons for the claim that others will share with us a commitment to the pervasively held common-sense theory of medium-sized physical objects. This finding deals a serious blow to any arbitrariness worries suggested by the phenomenon of conceptual diversity—explanatory naturalists have good reason to claim that we all initially acquire this theory. It provides a common frame of reference relative to which we may offer nonarbitrary yet weakly independent evaluations of conceptual alternatives. Appeal to this shared background will greatly undercut the arbitrariness worries suggested by the naturalists' claim that we must accept the groundlessness of our believing.

In addition to providing us with an understanding of the pervasiveness of the initial held theory, the explanatory naturalists' studies explain how we acquire this theory, how it has evolved or developed, and our propensity to engage in theory-revision. These studies disclose that proposals for revision of the initial held theory arise because this theory does not adequately relate experiences to experiences and does not fulfill our expectations regarding problem-resolution and aim-fulfillment. They also disclose that we generally employ pragmatic and empiricistic standards for the evaluation of proposals for conceptual revision. Moreover, the naturalistic studies provide a Darwinian explanation for the development of these standards which also provides good naturalistic reasons for the claim that employing them will generally enable us to identify the most efficacious revisions. Finally, as we have seen, these studies also provide an understanding of the factors which can lead individuals to fail to be guided by these standards.

Appeal to these findings undercuts the arbitrariness worries which are raised by the phenomenon of conceptual change. Explanatory

naturalists contend that we find that we are able to offer nonarbitrary (albeit weakly independent) evaluations of proposals for conceptual revision and, thus, mute the challenge that a preference for revision along one avenue rather than another is, at best, arbitrary. In short, then, the picture of our nature, predicament, and propensities which the explanatory naturalists' studies present ultimately underwrites a *"hypothetical imperative" of rationality* which mandates that as we engage in our theory-changing activities we should continue to be rational and endeavor to become more so. It mandates that when we are confronted with the need to revise our held theory, we should engage in self-conscious employment of the enablers and standards of the held theory as we select those revisions which will enable us to best relate experiences to experiences, best resolve our problems, or best achieve our aims.

This imperative is a *"hypothetical"* one because it specifies that *if* individuals have certain problems, aims, beliefs, theories, and standards, and *if* pursuing a particular orientation will allow them to revise their beliefs and theories so as to maximize their chances of resolving their problems and achieving their aims, then these individuals should revise their theories and beliefs along lines approved of by this orientation. While a "categorical" imperative is binding without condition, a "hypothetical" imperative (if it is binding at all) binds only those individuals who have the problems, aims, beliefs, theories, and standards mentioned—and only if the claim about the particular orientation being the most efficacious one is sustained.

The explanatory naturalists' studies provide good naturalistic reasons for believing that both these conditions obtain. They reveal that we all have certain problems, aims, and initial beliefs or "theories" which are to aid us in resolving these problems and achieving these aims; and they reveal that the empiricist and pragmatic evaluative standards and criteria which have evolved provide us with the best available guide for identifying the most efficacious revisions as we engage in our theory-changing activities.

Not only do the explanatory naturalists' studies of our theory-holding and theory-building roles provide good naturalistic reasons for claiming that the "conditions" specified by the hypothetical imperative of rationality are indeed met, they also provide good naturalistic reasons for accepting the *"imperative"* character of this mandate. Explanatory naturalists note that individuals who neglect or disregard the standards and criteria provided by our held theory,

basic problems, and basic aims will eventually run into serious troubles. The revisions proposed by these theorists will not show promise when measured against the currently accepted standards and criteria. Moreover, these individuals will continue to inhabit an environment which poses the problems that they will not successfully resolve—these problems do not disappear as the held theory is revised. In short, the conceptual revisions proposed by those who fail to follow the obligation specified by the hypothetical imperative of rationality threaten to be inefficacious.

As they participate in the perennial arguments with regard to rationalism, explanatory naturalists must restrict themselves to their therapy argument and to their naturalistic account of our predicament and propensities. They *may* offer any of the following: naturalistic reasons for their claim that individuals all share the same initial problems, aims, and theories; a naturalistic account of the origin of our held theory and of our standards for the evaluation of proposals for conceptual change; a naturalistic account of our theory-changing activities; and a naturalistic account of the efficacy of these initial beliefs and of the evaluative standards. Yet it is, of course, open to individuals to reject these naturalistic accounts and advocate another orientation. Naturalists may only draw such theorists' attention to the way they are misconstruing their role as theory-holders and theory-changers (*via* the naturalistic therapy argument) and to the consequences of the adoption of such orientations (*via* their naturalistic studies of our theory-changing role). Individuals unpersuaded by these arguments will, of course, continue to both advocate and accept the sorts of revisions to their held theory which the naturalists disapprove of.

Indeed, if the fideists are correct in their assertion that they can revise their held theory so that they are concerned with a wholly different set of problems, aims, and theories, then they will not ultimately violate the naturalists' hypothetical imperative of rationality. They will no longer have the problems and aims by which the mandate specifies an obligation. Justificatory rationalists like Kekes wish to offer a "categorical" imperative to close the door finally and completely upon the fideists—they wish to establish *unconditionally* that the fideists are not correct in their assertion that they are concerned with a wholly different set of problems, aims, theories, and standards; they thus wish to show that these theorists offer an absolutely absurd and inappropriate orientation or world view. But it

is because these justificatory rationalists seek a strongly independent ground for their preference for rationalism that their account fails.

The argument used against Kekes' justification of rationality in sections 2 and 36 above shows that Kekes succeeds only in establishing that the beliefs, problems, and aims he appeals to are *conditionally* necessary—if one accepts the scientific views he accepts, one will conclude that these individuals have these problems and aims. Since he wishes to provide a strongly independent (or unconditional) ground for his preference, however, his argument is inadequate. This sort of consideration does not undercut the explanatory naturalists' orientation, however.

Explanatory naturalists offer a therapy argument which rejects the search for strongly independent explanations, justifications, and preferences, and they add to this therapy argument an explanatory account of our theory-holding and theory-building activities—an account which not only indicates that we have good naturalistic reasons to contend that others will share certain initial problems, aims, theories, and standards with us, but also indicates that individuals should revise their held theories in the manner which naturalism suggests. Explanatory naturalists offer a naturalistic argument which offers good naturalistic reasons for believing that the fideists do, indeed, share the beliefs, theories, and standards in question. They recognize that their account is "conditional" and willingly settle for the sort of hypothetical maxim which Kekes and other justificatory rationalists mistakenly eschew.

In place of the attempt to offer a strongly independent justification for rationalism, a strongly independent evaluation of the rationalists' and fideists' orientations, and a strongly independent justification for a preference for rationalism, then, explanatory naturalists offer a therapy argument and a naturalistic explanation of our roles as theory-holders and theory-changers (and of the genesis, acquisition, changeability, and efficacy of our held theory and its standards for the evaluation of proposals for conceptual change). They contend that when one recognizes the relativity of our evaluations, justifications, and preferences, and when one couples this recognition with an understanding of our roles, predicament, and capabilities, one comes to see that we have no good naturalistic reasons for believing that individuals will not share our initial beginning points with us, and no good naturalistic reasons for believing that individuals who offer the sorts of revisions champi-

oned by the fideists offer appropriate revisions. In fact, naturalists contend that their studies show that these theorists offer conceptual revisions which we should eschew—embracing them means disabling our conceptual scheme. In short, explanatory naturalists contend that we cannot afford not to continue to be (and endeavor to become more) rational.

Thus, explanatory naturalists ultimately maintain that descriptive naturalists like Wittgenstein were too quick to reject the claim that we are rational because it "pays." In accepting that this is the case, explanatory naturalists do not merely mean to be describing our held theory, however. Their claim that we cannot afford not to be rational is not simply a description of (and kerygmatic affirmation of) our role as theory-holders and theory-changers. As a result of their naturalistic studies, explanatory naturalists contend that we not only *are* rational, but that we *should be* rational—their studies of our role as theory-holders and theory-changers shows that our well-being is intertwined with our manifestation of theory-holding and theory-changing rationality (indeed, with our manifestation of yet more theory-changing rationality).

In short, the explanatory naturalists' hypothetical imperative of rationality imposes a responsibility to continue to be rational and endeavor to become more so, but only upon individuals like us in conditions like those which we find ourselves in. That is, it applies to individuals who initially acquire and hold the pervasively held theory of medium-sized physical objects, who seek to revise this held theory because it does not adequately relate experiences to experiences and does not fulfill our expectations regarding problem-resolution and aim-fulfillment, and who care about their own well-being. While other sorts of creatures might not be bound by this imperative, the naturalists' studies indicate that we are such creatures and they indicate what is likely to befall us if we ignore the responsibility specified by the merely hypothetical imperative.

Explanatory naturalists should acknowledge that the naturalistic orientation is not categorically or unconditionally mandated, that its continuing efficaciousness cannot be unconditionally guaranteed, and that some will claim that this orientation provides a terribly inadequate account of our belief-forming and belief-changing propensities and capabilities. At the same time, they can contend that it is better than any other account which has been offered. Indeed, explanatory naturalists do contend that by pursuing the sort of

naturalized epistemology which they recommend, we will arrive at a still better understanding of our initial theory and enablers, of our role as theory-changers, of the criteria and standards for the evaluation of proposals for conceptual change which are most efficacious, and of our basic problems and aims. This increased understanding will enable us to be yet more effective in revising our theories, beliefs, and commitments.

Thus, explanatory naturalists provide an account of the reasonableness of rational activity. While their responses to the problems posed by the phenomena of conceptual diversity and change (and to the fideistic and skeptical challenges) are naturalistic responses (offered from within the naturalistic orientation), their therapy argument explains why the demand for strongly independent justifications should be ignored, and their naturalistic studies show why the hypothetical imperative is binding upon us. As we have seen, their studies also account for the all-too-human lapses from the demands of this imperative. According to them, continuing to be rational and endeavoring to become more so provides us with the only effective way to avoid inefficacious revisions to our held theory; and their account of our theory-changing and theory-holding roles provides a better explanation of the reasonableness of the rationalists' orientation than do the accounts provided by the other theorists in the internal and external perennial arguments with regard to rationality.

Notes

CHAPTER 1: JUSTIFICATORY AND KERYGMATIC RATIONALISM

1. Two recent writers who explicitly emphasize the problem and its history are R. Chisholm (in his *The Problem of The Criterion* [Milwaukee: Marquette Univ. Press, 1973]) and N. Rescher (in his *Methodological Pragmatism* [Oxford: Oxford Univ. Press, 1977]).

2. The phenomena of conceptual change and diversity serve as the sparks which ignite the skeptical and fideistic challenges to the rationalists' orientations. Any successful rationalistic response to these challenges must respond to the underlying problems posed by these phenomena.

3. Hume, *Dialogues Concerning Natural Religion*, edited by N.K. Smith (London: Thomas Nelson and Sons, 1947), p. 228.

4. Cf. Kierkegaard, *Philosophical Fragments, or A Fragment of Philosophy* (second edition, paperback printing), D.F. Swenson's translation revised by H.V. Hong (Princeton: Princeton Univ. Press, 1962), pp. 97–106; and R.H. Popkin, "Hume and Kierkegaard," *The High Road to Pyrrhonism* (San Diego: Austin Hill, 1980), pp. 227–36, esp. 234–35.

5. Cf. Pascal's *Pensées*, W.F. Trotter (trans.) (New York: Dutton, 1958), fragments 432 and 434.

6. Cf. R.H. Popkin, "Theological and Religious Scepticism," *Soundings* 39 (1956): 150–58, esp. p. 156. Cf. also his "Kierkegaard and Scepticism," *Algemeen Nederlands Tijdschrift voor Wijsbegeerte en Psychologie* 51 (1959): 123–41.

7. Kekes's works include: *A Justification of Rationality* (Albany: State University of New York Press, 1976); "Rationality and Problem-Solving," *Philosophy of the Social Sciences* 7 (1977): 351–66; "The Centrality of Problem-Solving," *Inquiry* 22 (1979): 405–21; and *The Nature of Philosophy* (Totowa, N.J.: Rowman and Littlefield, 1980). I criticize his defense of rationalism in my "Kekes on Problem-Solving and Rationality," *Philosophy of the Social Sciences* 14 (1984): 191–94.

8. Cf. Kekes, *The Nature of Philosophy, op. cit.*, p. 56.

9. *Ibid.*, p. 19.

10. Many would maintain such a view of human theorizing is too limited—it emphasizes one human goal to the exclusion of all others, leaving no room for "pure" theories or knowledge for knowledge's sake. In his *The Nature of Philosophy*, Kekes maintains there are two distinct contexts of justification. His discussion allows him to distinguish his view from the pragmatists'. I will deal briefly with this modified view in section 7 below.

11. Kekes develops his view of common sense in his "A New Defense of Common Sense," *American Philosophical Quarterly* 16 (1979): 115–22.

12. Cf. Kekes, *The Nature of Philosophy*, p. 136.

13. *Ibid.*, p. 207.

14. *Ibid.*, p. 210.

15. Kekes, "Philosophy, Historicism, and Foundationalism," *Philosophia* 13 (1983): 213–33, p. 227.

16. *Ibid.*, p. 229.
17. Cf. Briskman, "Historicist Relativism and Bootstrap Rationality," *Monist* 60 (1977): 509-39.
18. Others who have made a similar point include I. Scheffler in his *Science and Subjectivity* (Indianapolis: Bobbs-Merrill, 1969), p. 82; and D. Shapere in his "The Structure of Scientific Revolutions," *Philosophical Review* 73 (1964): 383-94 (cf. esp. p. 391).
19. Cf. Briskman, *op. cit.*, p. 532.
20. Briskman also claims these basic aims themselves are not static. They are the result of organic evolution and are modifiable where changes in the environment and continued pursuit of them modify the situation in which the aim is initially situated. As these aims are not static he terms his theory a "bootstrap" one for it allows us to "improve" our concepts, change our aims, and become "more rational" (cf. *ibid.*, p. 525).
21. *Ibid.*, p. 532. Many contemporary biologists would not allow that the basic aims of individuals are those most closely related to *their own* biological survival. Many would maintain that the survival in question is not one of individuals but of genetic structures. Of course, disagreement in regard to the nature of the basic aims plays into the skeptics' hands here.
22. Cf. Annis, "A Contextualistic Theory of Epistemic Justification," *American Philosophical Quarterly* 15 (1978): 213-19. His first citation lists others who have advanced such contextualistic theories.
23. *Ibid.*, p. 216.
24. Laudan develops this view in his *Progress and Its Problems* (Berkeley: Univ. of California Press, 1977). While Kekes criticizes Laudan's emphasis upon problem-solving to the exclusion of truth (in his *The Nature of Philosophy*, *op. cit.*), I argue that his appeal to truth is to no avail in section 7 below. Laudan's, Kekes's, and Annis's accounts of our basic aims, of course, do not exhaust the variety of positions which have been taken here.
25. Cf. Quine, "Two Dogmas of Empiricism," *From a Logical Point of View* (Cambridge: Harvard Univ. Press, 1953).
26. Cf. Rescher, *Methodological Pragmatism*, *op. cit.*, p. 274 and p. 279.
27. *Ibid.*, pp. 264-65.
28. *Ibid.*, p. 177.
29. Cf. Russell, *Philosophical Essays* (London: Longmans, Green, 1910) and Lovejoy, *The Thirteen Pragmatisms and Other Essays* (Baltimore: Johns Hopkins Univ. Press, 1963).
30. Laudan, *op. cit.*, of course, opts for exactly this choice, maintaining that problem-resolution is, and should be, all the scientist is interested in.
31. Both Kekes and Popper attempt to employ a variety of falsificationism to avoid begging the question while establishing such a link. Their attempt will be discussed in section 7.
32. Rescher, *Methodological Pragmatism*, *op. cit.*, p. 90.
33. *Ibid.*, p. 94.
34. *Ibid.*, p. 96.
35. Cf. *ibid.*, p. 120.
36. Cf. *ibid.*, p. 223.
37. *Ibid.*, p. 228.
38. *Ibid.*, p. 230.
39. *Ibid.*, pp. 109-10.
40. *Ibid.*, pp. 264-65. Cf. Rescher, *The Coherence Theory of Truth* (Oxford: Oxford Univ. Press, 1973), p. 32 ff.

41. Cf. Popper, "On the Sources of Knowledge and Ignorance," *Conjectures and Refutations* (New York: Harper and Row, 1963).
42. Cf. Bartley, *The Retreat to Commitment*, 2nd ed. (La Salle, Ill.: Open Court, 1984), esp. ch. 4.
43. Popper, *The Open Society and Its Enemies*, v. 2 (Princeton: Princeton Univ. Press, 1966), p. 230.
44. *Ibid.*, p. 231.
45. Cf. *ibid.*, pp. 232-44. See also Popper, "The History of Our Time: An Optimist's View," *Conjectures and Refutations, op. cit.*
46. Cf. Popper, "Truth, Rationality, and the Growth of Knowledge," *Conjectures and Refutations, op. cit.*, esp. p. 226.
47. *Ibid.*
48. Cf. Kekes, *The Nature of Philosophy, op. cit.*, chs. 6-8. Rescher also, of course, feels that an instrumentalistic theory which does not appeal to truth would be inadequate.
49. Cf. Kekes, *The Nature of Philosophy, op. cit.*, p. 122, and Popper, "On the Sources of Knowledge and Ignorance," and "Truth, Rationality, and the Growth of Knowledge," *op. cit.*
50. In section 11 I will briefly examine one interesting attempt to justify this belief—Gilbert Harman's notion of "inference to the best explanation."
51. Cf. Kekes, *The Nature of Philosophy, op. cit.*, p. 116
52. Cf. Bartley, "Rationality vs. the Theory of Rationality," *The Critical Approach*, M. Bunge (ed.) (N.Y.: Free Press, 1964), pp. 18-19.
53. Cf., Bartley, "Rationality vs. the Theory of Rationality," *op. cit.*, pp. 28-29; *The Retreat to Commitment, op. cit.*, ch. 5; and "Theories of Rationality," *Evolutionary Epistemology, Rationality, and the Sociology of Knowledge* G. Radnitzky and W.W. Bartley (eds.) (La Salle, Ill.: Open Court, 1987).
54. Bartley, "Theories of Rationality," *op. cit.*, pp. 211-12.
55. Bartley, *The Retreat to Commitment, op. cit.*, p. 118.
56. *Ibid.*, p. 82.
57. *Ibid.*, p. 120.
58. *Ibid.*, p. 119.
59. *Ibid.*, p. 121.
60. *Ibid.*, p. 113.
61. Obviously, they may not opt for the justificatory option. Bartley believes they can avoid the kerygmatic option also (cf. Bartley, "Theories of Rationality," *op. cit.*, p. 211, where Bartley cites passages in the early Popper which encourage the "kerygmatic" reading and indicates that comprehensively critical rationalism may overcome this problem; chapters 4 and 5 of his *The Retreat to Commitment, op. cit.*; and chapter 7 of *The Retreat to Commitment* where he deals with the non-fideistic character of comprehensively critical rationalism.
62. Bartley, *The Retreat to Commitment, op. cit.*, p. 162.
63. *Ibid.*, p. 163.
64. In his "On the Status of Science and of Metaphysics," (*Conjectures and Refutations, op. cit.*) Popper maintains his demarcation criterion distinguishes refutable (empirical) and irrefutable (metaphysical and philosophical) theories (cf. pp. 196-97). He does not maintain that the latter cannot be true or false. One example of an irrefutable philosophical theory he offers is that of *epistemological irrationalism*—the post-Kantian view that since we cannot rationally learn about the nature of the things-in-themselves, we must employ some irrational or supra-rational methods. Clearly, Popper believes this view is false. He maintains irrefutable theories are to be discussed critically (cf. p. 199). Here, of course, the demarcation criterion

does not *establish* the superiority of falsifiable theories over unfalsifiable ones nor the preferability of irrefutable yet critically supported ones over irrefutable ones which lack such support.

CHAPTER 2: THE REALIST'S RESPONSE TO THE JUSTIFICATIONALISTS' PROBLEMS

1. Cf. Alston, "Level Confusions in Epistemology," *Midwest Studies in Philosophy*, v. 5 (1980), pp. 135–50.
2. Alston, "Two Types of Foundationalism," *Journal of Philosophy* 73 (1976): 165–85.
3. *Ibid.*, p 183.
4. Kekes, *The Nature of Philosophy, op. cit.*, p. 19.
5. Alston, "Level Confusions in Epistemology," *op. cit.*, p. 148.
6. With Tertullian, Kierkegaard rebels against reason. According to him being Christian entails subordinating one's reason to the authority of revelation which yields beliefs which, from the rational point of view, are impossible paradoxes. It seems clear that he held that revelation yields beliefs which *are* justified and, despite his emphasis upon choice and the primacy of the will, he does not seem to believe that other "ultimate commitments" would be appropriate. Thus Mandlebaum (*History, Man, and Reason* [Baltimore: Johns Hopkins Univ. Press, 1971], p. 32) says "it was essential to his view that Christianity should be literally true in its claims, and, yet, that it should not be considered as reasonable in any sense of that term."
7. Montaigne's skeptical arguments were meant to expose the unsoundness of all reasoning and, thus, show that faith must take primacy to reason. Such faith, however, clearly leads to beliefs and theories which *are* justified according to him.
8. For Augustine, we "believe in order to understand." Rational inquiry reveals the necessity of faith—some fundamental principles must be accepted on faith. He does not require that the principles be *un*justified however.
9. Cf. Pierre Bayle, *Historical and Critical Dictionary*, R.H. Popkin (trans.) (Indianapolis: Hackett, 1991), pp. 421–35.
10. Kierkegaard, *Philosophical Fragments, op. cit.*, p. 105.
11. Cf. Popkin, "Theological and Religious Scepticism," *op. cit.*; and his "Kierkegaard and Scepticism," *op. cit.*
12. Cf. Alston, "Self-Warrant: A Neglected Form of Privileged Access," *Epistemic Justification* (Ithaca: Cornell Univ. Press, 1989), pp. 286–315, esp. pp. 314–15.
13. *Ibid.*, p. 292.
14. Alston, "Level-Confusions in Epistemology," *op. cit.*, p. 148.
15. Alston, "Self-Warrant: A Neglected Form of Privileged Access," *op. cit.*, p. 305. Cf. his "Level-Confusions in Epistemology," *op. cit.*, p. 148.
16. Augustine, for example, maintains that a rational inquiry may (and, perhaps, must) precede a kerygmatic acceptance of some fundamental principles and reveal the need to accept them on faith. Pascal, similarly, believed reason was useful—up to a point. And Kant assigns much importance to rational justification while at the same time maintaining that human reason "is burdened by questions which, as prescribed by the very nature of reason itself, it cannot ignore, but which as transcending all its powers, it is also not able to answer" (*Critique of Pure Reason*, N.K. Smith, trans. [Toronto: Macmillan, 1929], p. 7, B vii). Many fideists, of course, would also countenance a good deal of justificatory effort while maintaining we

must ultimately accept certain valid principles on faith alone. Since they would have us reject justificationalism in regard to these principles and yet, would maintain we ought to believe what is justified, the only central difference between their view and the realists' would seem to be the particular sort of faith which each kerygmatically recommends.

17. Cf. Popper, "Truth, Rationality, and the Growth of Knowledge," *op. cit.*, p. 226. Cf. also his "On the Sources of Knowledge and Ignorance," *op. cit.*, p. 28.

18. As we have seen, Laudan (in his *Progress and Its Problems, op. cit.*) maintains the growth of science has not been inspired by the sort of regulative principle Popper cites. Other problem-solving theorists (e.g., Kekes) agree with Popper's reference to truth, however.

19. Popper, "Three Views Concerning Human Knowledge," in his *Conjectures and Refutations, op. cit.*, p. 114. Cf. pp. 111–14 and 116–17. Cf. also his "On the Sources of Knowledge and Ignorance," *op., cit.*, pp. 12–15.

20. Rescher, *Methodological Pragmatism, op. cit.*, p. 94.

21. *Ibid.*, p. 223.

22. Cf. *ibid.*, pp. 223–24.

23. *Ibid.*, p. 225. Cf. pp. 225–28.

24. Harman, *Thought* (Princeton: Princeton Univ. Press, 1973), p. 112.

25. *Ibid.*, p. 159.

26. Cf. Goldman, "Appearing Statements and Epistemological Foundations," *Metaphilosophy* 10 (1979): 227–46.

27. *Ibid.*, p. 236. His account draws upon that of Keith Lehrer (cf. Lehrer, *Knowledge* [Oxford: Clarendon, 1974] esp. pp. 175 ff.).

28. *Ibid.*, p. 241.

29. Goldman, "Realism," *Southern Journal of Philosophy* 17 (1979): 175–92.

30. *Ibid.*, pp. 185–86. Popper, similarly, feels the realistic account is "deeper" than the instrumentalistic (cf. his "Three Views Concerning Human Knowledge," and "Truth, Rationality and the Growth of Knowledge," *op. cit.*).

31. *Ibid.*, p. 187. Cf. his "Appearing Statements and Epistemological Foundations," *op. cit.*, p. 244.

32. Goldman, "Appearing Statements and Epistemological Foundations," *op. cit.*, p. 244.

33. Goldman, "Realism," *op. cit.*, p. 190.

34. Cf. *ibid.*, p. 195 (footnote 5).

35. Cf. Korner, *Categorical Frameworks* (Oxford: Basil Blackwell, 1970), p. 72, and his "The Impossibility of Transcendental Deductions," *Monist* 51 (1967): 317–31.

36. Aristotle, *Metaphysics, The Basic Works of Aristotle*, W.D. Ross (trans.) (New York: Random House, 1941), bk. IV, ch. 4, 1006a 2–22.

37. Dummett, in the preface to his *Truth and Other Enigmas* (Cambridge: Harvard Univ. Press, 1978), p. xix.

38. *Ibid.*, p. xxxi. Andrew Altman and Michael Bradie, in their "Meaning, Truth, and Evidence," (*Southern Journal of Philosophy* 18 [1980]: 113–22), clarify Dummett's distinction between realism and antirealism, and explain especially the role of the principle of bivalence.

39. Aristotle, *Metaphysics, op. cit.*, bk. XI, ch. 5, 1062a 12–18, and ch. 6, 1062b 12–16.

40. Rescher, *The Coherence Theory of Truth, op. cit.*, p. 32.

41. Rescher, of course, would supply a pragmatic justification and appeal to his metaphysical assumptions here (cf. *ibid.*, pp. 63–64).

42. Alston, "Self-Warrant: A Neglected Form of Privileged Access," *op. cit.*, p. 287.

43. Alston, "Varieties of Privileged Access," *American Philosophical Quarterly* 8 (1971): 223–41, 236. In this article he does an excellent job of distinguishing the varieties of immunity and of arguing that self-warrant is the only defensible form of immunity. Goldman, in his "Appearing Statements and Epistemological Foundations," *op. cit.*; D.W. Hamlyn, in his *The Theory of Knowledge* (New York: Macmillan, 1970); and A.J. Ayer, in his *The Problem of Knowledge* (New York: Penguin, 1956) express similar reservations about the other forms of immunity.

44. Alston himself, it should be noted, now maintains that we should consider the beliefs that he had earlier called "self-warranted" (*Bs*) to be "a limiting case in which the ground is not distinguished from the fact that makes the belief true" ("Self-Warrant: A Neglected Form of Privileged Access," *op. cit.*, pp. 314–15). In the case of these beliefs, he maintains, the fact which grounds them is also the fact that makes them true and, thus, we have "truth-warrant" in the case of these beliefs.

45. Chisholm, *The Problem of the Criterion*, *op. cit.*, p. 12. Cf. his *Theory of Knowledge*, 2nd ed. (Englewood Cliffs: Prentice Hall, 1977), pp. 119 ff.

46. Cf. Chisholm, *Theory of Knowledge*, *op. cit.*, p. 16.

47. *Ibid.*, pp. 18–19.

48. *Ibid.*, pp. 28–29.

49. *Ibid.*, pp. 98–99. Cf. his "On The Nature of Empirical Evidence," *Empirical Knowledge*, Chisholm and Schwartz (eds.) (Englewood Cliffs: Prentice Hall, 1973), p. 245; and his "Theory of Knowledge," *Philosophy: The Princeton Series*, Chisholm *et. al.* (eds.) (Englewood Cliffs: Prentice Hall, 1965), p. 263. Cf. also B. Aune, "Remarks on Argument by Chisholm," *Philosophical Studies*, v. 23 (1972), pp. 327–34.

50. Chisholm, *The Problem of the Criterion*, *op. cit.*, pp. 22–23.

51. *Ibid.*, pp. 37–38. Cf. his *Theory of Knowledge*, *op. cit.*, pp. 121 ff.

52. Indeed, in his *Theory of Knowledge* (*op. cit.*) Chisholm calls his view "commonsensism" rather than "particularism" (cf. pp. 121 ff. and p. 26). Kekes also appeals to common sense (cf. section 2). He is a justificatory rationalist, however, and his view is different from that of the qualified realistic rationalists discussed here—he would *justify* common sense.

53. Many current epistemologists follow the sort of particularistic strategy sketched by Harman (cf. his *Thought*, *op. cit.*, pp. 15–23)—they consult "intuitive judgments" of when people have knowledge as they attempt to reach a general criterion. Cf. the readings in *Essays on Knowledge and Justification*, Pappas and Swain (eds.) (Ithaca: Cornell, 1978) for a variety of essays in this tradition.

54. Both essays are in Moore's *Philosophical Papers* (London: Allen and Unwin, 1959). Cf. his "Certainty" in the same volume.

55. Moore, "Proof of An External World," *op. cit.*, p. 149.

56. Moore, "Certainty," *op. cit.*, p. 247.

57. Cf. Moore's "Proof of An External World," *op. cit.*, pp. 149–50.

58. Moore begins "Proof of An External World" with a citation from Kant who, he says, advances this sort of fideistic view.

59. Moore, "Proof of An External World," *op. cit.*, p. 150.

60. Moore, "Certainty," *op. cit.*, p. 227.

CHAPTER 3: NATURALISM AND THE PROBLEMS IT ENCOUNTERS

1. Cf. W.V. Quine, "Epistemology Naturalized," *Ontological Relativity and Other Essays* (New York: Columbia, 1969); H. Putnam, *Meaning and the Moral Sciences* (London: Routledge and Kegan Paul, 1978); and N. Goodman, *Ways of Worldmaking* (Indianapolis: Hackett, 1978).
2. Briskman, "Historicist Relativism and Bootstrap Rationality," *op. cit.*, p. 511.
3. *Ibid.*, p. 534.
4. Briskman maintains that Collingwood and Toulmin, for example, "historicize" epistemology by replacing the epistemological endeavor with a study of the history of ideas or the history of science. He contends that Kuhn "sociologizes" epistemology by replacing it with a sociology of the scientific community.
5. Briskman, *op. cit.*, p. 509.
6. I will call the strongly independent evaluations "transcendent" in order to emphasize their independence of *all* particular historical structures. Briskman encourages this usage when he asks, if we accept naturalism "how are we to argue ('transcendentally', as it were) that some of the products can actually be rationally preferable to others . . . [and] how are we to rationally settle the intellectual disputes which are likely to arise within it [any given structure]" (*ibid.*, p. 510).
7. *Ibid.*, p. 518.
8. B. Postow, in his "Dishonest Relativism" (*Analysis* 34 [1979]: 115–18) provides an argument which maintains that relativists are dishonest if they hold the Equipreferability Thesis. An honest relativist recognizes that all evaluative judgments are relative to particular conceptual structures and proceeds to utilize the standards of the particular conceptual structure he or she occupies.
9. Since it is Quine's attack upon prior philosophy which Briskman would meet, and since Quine does not advance the Equipreferability Thesis but, rather, argues that the notion of strongly independent evaluations is incoherent, Briskman's criticism is misdirected.
10. J. Meiland, in his "Bernard Williams' Relativism" (*Mind* 88 [1979]: pp. 258–62) offers a brief summary of this sort of argument in his response to a criticism of relativism similar to Briskman's which is offered by Williams in his *Morality: An Introduction to Ethics* (New York: Harper and Row, 1972, p. 20).
11. In sections 25, 27, and 42 I clarify the ways in which naturalists may contend that their conceptual apparatus may be improved.
12. Kekes, *The Nature of Philosophy*, *op. cit.*, p. 19.
13. Cf. James Bogen, "Wittgenstein and Skepticism," *Philosophical Review* 83 (1974): 364–73.
14. Wittgenstein, *Philosophical Investigations*, G.E.M. Anscombe (trans.) (New York: Macmillan, 1953), I, section 50. C.G. Luckhardt's "Wittgenstein: Investigations 50" (*Southern Journal of Philosophy* 15 [1977]: 81–90) provides an excellent exegesis of this passage.
15. Wittgenstein, *On Certainty*, G.E.M. Anscombe and G.H. von Wright (eds.) (New York: Harper, 1969), section 151.
16. *Ibid.*, section 519.
17. *Ibid.*, section 509.
18. *Ibid.*, section 538. Cf. sections 94, 160, 279, 315, and 476.
19. Quine, *Word and Object* (Cambridge: MIT Press, 1960), p. 22.
20. Cf. Wittgenstein, *On Certainty*, *op. cit.*, section 166.
21. *Ibid.*, section 205.
22. *Ibid.*, sections 472 and 476.

23. Cf. Wittgenstein, *Philosophical Investigations, op. cit.*, I, 124. Cf. also sections 109, 116, 126, 654–55, and his *On Certainty, op. cit.*, sections 189, 501, and 628.
24. Wittgenstein, *On Certainty, op. cit.*, section 212.
25. Cf. Wittgenstein, *Zettel*, G.E.M. Anscombe and G.H. von Wright (eds.) (Berkeley: University of California Press, 1967), sections 390 and 330; and *Philosophical Investigations, op. cit.*, II, p. 223, and I, 446–99.
26. Wittgenstein, *On Certainty., op. cit.*, section 611.
27. *Ibid.*, section 612.
28. Cf. *ibid.*, section 608.
29. *Ibid.*, section 317.
30. *Ibid.*, section 378.
31. Wittgenstein, *Philosophical Investigations, op. cit.*, II, p. 226.
32. Cf. *ibid.*, I, 258.
33. M.F. Burnyeat, "Protagoras and Self-Refutation in Later Greek Philosophy," *Philosophical Review* 85 (1976): 44–69; p. 46.
34. J.L. Mackie, "Self-refutation—A Formal Analysis," *Philosophical Quarterly* 14 (1964): 193–203.
35. Burnyeat, *op. cit.*, p. 59.
36. Cf. *ibid.*, p. 51.
37. These formulations are borrowed from Burnyeat's second study of the self-refuting argument with regard to the measure doctrine: "Protagoras and Self-Refutation in Plato's *Theaetetus*," *Philosophical Review* 85 (1976): pp. 172–95. Many other commentators remark upon Plato's misplacing of the relativistic qualifiers in this argument (see p. 174 of Burnyeat for a partial list). Burnyeat offers an interesting interpretation of Plato's argument which attempts to account for this lapse while preserving the charge of self-refutation.
38. W.V. Quine, "Ontological Relativity," *Ontological Relativity, op. cit.*, p. 47.
39. *Ibid.*, p. 48.
40. *Ibid.*, p. 53; see also pp. 48–49.
41. Cf. Quine, "Identity, Ostension, and Hypostasis," *From a Logical Point of View, op. cit.*, p. 79; "On Empirically Equivalent Systems of the World," *Erkenntnis* 9 (1975): 318–28; *Word and Object, op. cit.*, pp. 23–25, 75, 271, 274, and 275–76; and "Things and Their Place in Theories," *Theories and Things* (Cambridge: Harvard Univ. Press, 1981), pp. 21–22.
42. Indeed, insofar as truth is to be treated in a Tarskian fashion—in terms of satisfaction—truth becomes a matter of reference and the *reductio* applies to discussions of truth directly (cf. Quine, "Ontological Relativity," *op. cit.*, pp. 67–68).
43. Quine, *Word and Object, op. cit.*, p. 24.
44. Cf. Quine, "Ontological Relativity," *op. cit.*, pp. 28–29, and "The Pragmatists' Place In Empiricism," *Pragmatism, Its Sources and Prospects*, R. Mulvaney and P. Zeltner (eds.) (Columbia: Univ. of South Carolina Press, 1981), pp. 35–37.
45. J. Margolis, in his "Behaviorism and Alien Languages" (*Philosophia* 3 [1973]: 413–27), and R. Double, in his "Quine and the Determinateness of Reference" (*Kinesis* 7 [1970]: 49–61), question the advisability of this confinement to behavioral evidence. Cf. also K. Schoen, "Introspection and the Inscrutability of Reference," *Southern Journal of Philosophy* 17 (1979): 523–29.
46. Cf. Williams, *Morality: An Introduction to Ethics, op. cit.*, p. 20.
47. Cf. Meiland, "Bernard Williams' Relativism," *op. cit.*
48. Cf. Mandlebaum, "Some Instances of the Self-Excepting Fallacy," *Psychologische Beitrage* 6 (1962): 383–86; and "Subjective, Objective, and Conceptual Relativisms," *Monist* 62 (1979): 403–28.

49. Meiland suggests a qualified relativism in his "On the Paradox of Cognitive Relativism," *Metaphilosophy* 11 (1980): 115–26. He does not recommend this view, however, since he believes the most interesting and challenging features of relativism are lost in the qualification.
50. In his discussion of Williams, Meiland does not consider the possibility that Williams might be offering something close to this sort of view.
51. Cf. Roth, "Theories of Nature and the Nature of Theories," *Mind* 89 (1980): 431–38. I criticize his view in my "Quine's Theorizing About Theories," *Synthese* 57 (1983): 21–33.
52. Cf. Meiland, "On the Paradox of Cognitive Relativism," *op. cit.*, pp. 119–20.
53. Quine, "Natural Kinds," *Ontological Relativity and Other Essays, op. cit.*, p. 126. Cf. his "Epistemology Naturalized," *op. cit.*, p. 83, "Ontological Relativity," *op. cit.*, p. 27, and *Word and Object, op. cit.*, pp. 4–5, 24, 25, and 275–76.
54. Quine, *Word and Object, op. cit.*, pp. 275–76.
55. Cf. Quine, "On Carnap's Views on Ontology," *The Ways of Paradox* (N.Y.: Random House, 1966), esp. p. 134.

CHAPTER 4: THE NATURALISTS' CASE AGAINST QUALIFIED REALISM AND SKEPTICISM

1. Wittgenstein, "On Certainty," *op. cit.*, section 1. All further references in this section which are to this work will be followed immediately by the appropriate section number.
2. Cf. *ibid.*, sections 128 and 129. Cf. also sections 211 and 217 of Wittgenstein's *Philosophical Investigations, op. cit.*
3. Cf. *ibid.*, sections 150, 156, 220, and 292–99. Cf. also sections 241–42 of his *Philosophical Investigations, op. cit.*
4. Cf. *ibid.*, sections 5, 24 and 94.
5. Cf. *ibid.*, sections 150 and 509.
6. Cf. *ibid.*, sections 205–19, 476, and 534–49.
7. Cf. *ibid.*, sections 31–34, 423, 435–49, and 462–67.
8. Cf. Quine, "Ontological Relativity," *op. cit.*, pp. 26–27; "Natural Kinds," *op. cit.*, pp. 126–27; "Epistemology Naturalized," *op. cit.*, p. 83; *Word and Object, op. cit.*, pp. 4–5, 24, 25, 275–76; "Posits and Reality," *The Ways of Paradox, op. cit.*, pp. 239–41; and his "Reply to Stroud" in *Midwest Studies in Philosophy* 6 (1981): 473–75 (esp. pp. 474–75).
9. O. Neurath, "Protocol Sentences," *Logical Positivism*, G. Schlick (trans.), A.J. Ayer (ed.) (New York: Free Press, 1959) p. 201.
10. Quine, "Epistemology Naturalized," *op. cit.*, pp. 75–76.
11. Quine, "The Scope and Language of Science," *The Ways of Paradox, op. cit.*, p. 216. Cf. pp. 216–17; "Posits and Reality," *op. cit.*, pp. 237–39; "Epistemology Naturalized," *op. cit.*, pp. 82–84; and "The Pragmatists' Place in Empiricism," *op. cit.*, p. 28.
12. *Ibid.*, p. 237.
13. Quine, *The Roots of Reference* (Open Court: La Salle, Ill., 1973), p. 2.
14. Quine, "Posits and Reality," *op. cit.*, p. 238.
15. Quine, "On Mental Entities," in his *The Ways of Paradox, op. cit.*, p. 212. Cf. "The Scope and Language of Science," *op. cit.*, pp. 216–17; "Posits and Reality," *op. cit.*, pp. 238, and *Word and Object, op. cit.*, p. 22.

16. Cf. Quine, *Word and Object*, *op. cit.*, pp. 24 and 75; "Ontological Relativity," *op. cit.*, pp. 53 and 67-68; "Notes on the Theory of Reference," in *From a Logical Point of View*, *op. cit.*, pp. 134-37; "The Pragmatists' Place in Empiricism," *op. cit.*, p. 34; and "Things and Their Place in Theories," *op. cit.*, pp. 21-22.
17. Quine, *Word and Object*, *op. cit.*, p. 22.
18. Quine, "Two Dogmas of Empiricism," *op. cit.*, p. 44.
19. Cf. Quine, *Word and Object*, pp. 4-5, and "Posits and Reality," *op. cit.*, p. 239.
20. Cf. Quine, "Epistemology Naturalized," *op. cit.*, p. 83.
21. Quine, "The Scope and Language of Science," *op. cit.*, p. 217.
22. Quine, "Epistemology Naturalized," *op. cit.*, pp. 82-83.
23. Quine, *The Roots of Reference*, *op. cit.*, p. 138.
24. Cf. Quine, "Natural Kinds," *op. cit.*, pp. 126-28; "Epistemology Naturalized," *op. cit.*, p. 90; *The Roots of Reference*, *op. cit.*, pp. 19-20 and 22-23; and W.V. Quine and J. Ullian, *The Web of Belief* (N.Y.: Random House, 1970), pp. 45-46, 57-58, and 82-83.
25. Cf. Campbell, "Unjustified Variation and Selective Retention in Scientific Discovery," and "'Downward Causation' in Hierarchically Organized Biological Systems," *Studies in the Philosophy of Biology*, F. Ayala and T. Dobzhansky (eds.) (New York: Macmillan, 1974), and "Evolutionary Epistemology," *The Philosophy of Karl Popper*, P. Schilpp (ed.), Library of Living Philosophers, v. XIV, 1 (La Salle, Ill.: Open Court, 1974).
26. Campbell, "Evolutionary Epistemology," *op. cit.*, p. 414.
27. Cf. Campbell, "Unjustified Variation and Selective Retention in Scientific Discovery," *op. cit.*, pp. 154-58.
28. Skagestad, "Taking Evolution Seriously: Critical Comments on D.T. Campbell's Evolutionary Epistemology," *Monist* 61 (1978): 611-21, 615.
29. *Ibid.*, p. 616.
30. Günter Wächtershäuser offers yet another model in his "Light and Life: On the Nutritional Origins of Sensory Perception," reprinted in *Evolutionary Epistemology, Rationality, and the Sociology of Knowledge*, G. Radnitzky and W.W. Bartley (eds.) (La Salle, Ill.: Open Court, 1987), pp. 121-38. Bartley comments on the differences between Campbell's and Wächtershäuser's views in his "Philosophy of Biology versus Philosophy of Physics" which appears on pp. 7-45 of the same volume.
31. Cf. Quine, "Philosophical Progress in Language Theory," *Language, Belief, and Metaphysics*, M. Munitz (ed.) (Albany: SUNY Press, 1970), p. 5, and "Ontological Relativity," *op. cit.*, pp. 26-27.
32. Cf. Quine, *Roots of Reference*, *op. cit.*, p. 123.
33. Cf. *ibid.*, p. 124.
34. Quine, *Word and Object*, *op. cit.*, p. 5.
35. "Speaking of Objects," *Ontological Relativity*, *op. cit.*, p. 16.
36. Quine, "Things and Their Place in Theories," *op. cit.*, pp. 9-10.
37. Cf. Quine, *The Roots of Reference*, *op. cit.*, pp. 131-38, and "Posits and Reality," *op. cit.*, pp. 241 and 234.
38. Cf. Quine, "Two Dogmas of Empiricism," *op. cit.*, p. 46; "Identity, Ostension, and Hypostasis," *op. cit.*, p. 79; "The Pragmatists' Place in Empiricism," *op. cit.*, pp. 33-35; and *Word and Object*, *op. cit.*, pp. 271 and 274.
39. Quine, *Methods of Logic* (New York: Holt, Rinehart and Winston, 1950), p. xii.
40. He also offers a *naturalistic* account which explains our conservative

tendencies and our bias toward simplicity considerations (cf. "On Simple Theories of a Complex World," *The Ways of Paradox*, *op. cit.*; and see Quine and Ullian, *The Web of Belief, op. cit.*, pp. 45-46).

41. Quine, "The Pragmatists' Place in Empiricism," *op. cit.*, p. 34.
42. Cf. Quine, *Word and Object, op. cit.*, pp. 24-25.
43. Cf. *ibid.*, pp. 3-4, and "The Scope and Language of Science," *op. cit.*, pp. 219-20.
44. Quine, "Posits and Reality," *op. cit.*, p. 239. Cf. "On What There Is," *From A Logical Point of View, op. cit.* pp. 24-25.
45. Cf. Quine, *Word and Object, op. cit.*, pp. 24-25.
46. Cf. *ibid.*, p. 160.
47. *Ibid.*, p. 274. Cf. pp. 3-4, and "Logic and the Reification of Universals," *op. cit.*, p. 106.
48. Cf. *ibid.*, p. 275.

CHAPTER 5: DESCRIPTIVE AND EXPLANATORY NATURALISM

1. Wittgenstein, *On Certainty, op. cit.*, section 608. All further references in this section to this work will be followed immediately by the appropriate section number.
2. Cf. *ibid.*, sections 107, 92, 262, 264, and 605.
3. Cf. Quine, "Two Dogmas of Empiricism," *op. cit.*, p. 44.
4. Wittgenstein, *Philosophical Investigations, op. cit.*, I, 124. See also sections 109, 116, 126, 654-55, and his *On Certainty* sections 189, 501, and 628. Robin Haack, in his "Wittgenstein's Pragmatism" (*American Philosophical Quarterly* 19 [1982]: 163-71) distinguishes Wittgenstein's *descriptivism* from the explanatory naturalism of many pragmatists: "we could view . . . Wittgenstein's naturalism as standing to the pragmatists' as Kepler's descriptive work on planetary motion stands to Newton's explanatory theory of gravitation" (p. 163).
5. Kai Nielsen, "Wittgensteinian Fideism," *Philosophy* 42 (1967): 191-209. Others believe Wittgenstein may be allowing for or offering a skepticism at such points: Robert Fogelin (in "Wittgenstein and Classical Skepticism," *International Philosophical Quarterly* 21 [1981]: 3-15) maintains that Wittgenstein's view that we cannot justify our enablers provides a powerful skeptical statement, and James Bogen (in "Wittgenstein and Skepticism," *op. cit.*) maintains the phenomena of change and diversity at this level leave open the possibility of skepticism. I believe the remarks in section 23 undercut a skeptical reading.
6. Winch, *The Idea of A Social Science* (London: Routledge and Kegan Paul, 1958), pp. 100-101.
7. Cf., E.E. Evans-Prichard, *Witchcraft, Oracles and Magic Among the Azande* (Oxford: Oxford Univ. Press, 1937), and J. Frazer, *The Golden Bough* (N.Y.: Macmillan, 1950).
8. Cf. Winch, "Understanding A Primitive Society," *American Philosophical Quarterly* 1 (1964): 307-25, p. 309.
9. Nielsen, "Wittgensteinian Fideism," *op. cit.*, p. 202.
10. *Ibid.*, p. 208.
11. Winch, "Understanding A Primitive Society," *op. cit.*, p. 321.
12. Winch, "Nature and Convention," *Proceedings and Addresses of the Aristotelian Society* 50 (1959): 231-52, p. 238.
13. Winch, "Understanding A Primitive Society," *op. cit.*, p. 321.

14. He calls these fundamental characteristics "limiting notions" (cf. *ibid.*, p. 322), and maintains they are necessary (cf. *ibid.*, p. 324).
15. *Ibid.*, p. 322. His discussion of integrity is in "Nature and Convention," *op. cit.* (cf. pp. 250 ff.).
16. Wittgenstein, *Philosophical Investigations, op. cit.*, I, 142.
17. *Ibid.*, I, 470.
18. *Ibid.*, I, 569.
19. Wittgenstein, "Remarks on Frazer's *Golden Bough*," A.C. Miles (trans.) (Retford: Byrnmill, 1979), p. 4e.
20. Wittgenstein, *Philosophical Investigations, op. cit.*, I, 291.
21. *Ibid.*, I, 90.
22. Cf. Wittgenstein, *On Certainty, op. cit.*, 429 and 475.
23. Cf. Wittgenstein, *Philosophical Investigations, op. cit.*, I, 120.
24. Cf. Wittgenstein, *Zettel, op. cit.*, sections 390 and 330, and *Philosophical Investigations, op. cit.*, II, p. 223 and I, 466–99.
25. Cf. Wittgenstein, "Lectures on Religious Belief," *Lectures on Aesthetics, Psychology and Religious Belief* (Berkeley: University of California, 1972), pp. 71 and 55, and *Zettel, op. cit.*, section 388.
26. Wittgenstein, *Philosophical Investigations, op. cit.*, I, 130. Cf. I, sections 118–33.
27. Cf. Wittgenstein, *On Certainty, op. cit.*, 65, 96–99, 256, and 336.
28. Wittgenstein, *Philosophical Investigations, op. cit.*, II, p. 230. Cf. also Part I, sections 81, 89, and especially 109.
29. *Ibid.*, I, 116.
30. *Ibid.*, I, 127.
31. *Ibid.*, I, 126.
32. Quine, *Word and Object, op. cit.*, p. 3. Cf. "Logic and the Reification of Universals," *op. cit.*, p. 106.
33. Quine offers a brief sketch of the language acquisition process in his "Speaking of Objects," *Ontological Relativity, op. cit.* More detailed discussions can be found in his *Word and Object* and *The Roots of Reference, op. cit.*
34. Quine, *Roots of Reference, op. cit.*, p. 34.
35. Quine, "Mind and Verbal Dispositions," in *Mind and Language*, S. Guttenplan (ed.) (Oxford: Clarendon, 1975), pp. 92–93.
36. Quine, "The Scope and Language of Science," *op. cit.*, p. 217.
37. Günter Wächtershäuser, in his "Light and Life: On the Nutritional Origins of Sensory Perception," *op. cit.*, offers an account of the evolution of the eye which differs from the sort of account offered by Campbell. The differences between these naturalistic accounts are interesting and the development of Wächtershäuser's thesis is itself a case study of how the overall naturalistic explanatory program proceeds.
38. Quine, *Methods of Logic, op. cit.*, p. xii.
39. Cf. Quine, "Things and Their Place in Theories," *op. cit.*, pp. 21 and 23.
40. Quine, *Roots of Reference, op. cit.*, p. 89; cf. pp. 131 and 134–37.
41. Quine, *Word and Object, op. cit.*, p. 275.
42. Quine, "Facts of the Matter," *Southwestern Journal of Philosophy* 9 (1979): 155–69, p. 168.
43. Cf. Quine, "Posits and Reality," *op. cit.*, p. 239; section 25 above; and "Two Dogmas of Empiricism," *op. cit.*, pp. 17–19.
44. Quine, "On Empirically Equivalent Systems of the World," *op. cit.*, p. 327.
45. Cf. *ibid.*, pp. 327–28; "The Pragmatists' Place in Empiricism," *op. cit.*, p. 34; and *Word and Object, op. cit.*, pp. 24–25.
46. Quine, "The Pragmatists' Place in Empiricism," *op. cit.*, p. 34. Cf. "On

Empirically Equivalent Systems of the World," *op. cit.*, pp. 327–28; *Word and Object*, *op. cit.*, p. 24; and "Relativism and Absolutism," *Monist* 67 (1984): 293–96.
 47. Quine, *Word and Object*, *op. cit.*, p. 24.
 48. Cf. Quine, "On Empirically Equivalent Systems of the World," *op. cit.*, pp. 327–28.
 49. Quine, "Things and Their Place in Theories," *op. cit.*, p. 21. Cf. "The Pragmatists' Place in Empiricism," *op. cit.*, p. 34, and "Relativism and Absolutism," *op. cit.*, p. 295.
 50. Quine, "Relativism and Absolutism," *op. cit.*, p. 295.
 51. Cf. Quine, *Word and Object*, *op. cit.*, p. 25.

CHAPTER 6: THE APPROPRIATENESS OF THE EXPLANATORY NATURALISTS' THERAPY

 1. Alan Goldman, "Realism," *op. cit.*, p. 190.
 2. Chisholm, *The Problem of the Criterion*, *op. cit.*, pp. 22–23.
 3. Cf. Moore, "Certainty," *op. cit.*, p. 247.
 4. *Ibid.*, p. 227. Chisholm attempts to illustrate the absurdity of the skeptics "doubts" in his *Theory of Knowledge*, *op. cit.*, pp. 25–26 and 48–50.
 5. Cf. Wittgenstein, *On Certainty*, *op. cit.*, section 105.
 6. Kekes, *The Nature of Philosophy*, *op. cit.*, p. 70.
 7. Cf. *ibid.*, p. 176.
 8. *Ibid.*, p. 199.
 9. *Ibid.*, p. 209.
 10. Pascal, *Pensées*, *op. cit.*, section 72.
 11. Alston, "Level-Confusions in Epistemology," *op. cit.*, p. 141.
 12. *Ibid.*, p. 148.
 13. Popper, "On the Sources of Knowledge and Ignorance," *op. cit.*, p. 25.
 14. Cf. Popper, *The Open Society and Its Enemies*, v. II, *op. cit.*, p. 230.
 15. Popper, "Truth, Rationality, and the Growth of Scientific Knowledge," *op. cit.*, p. 226.
 16. *Ibid.*, p. 229.
 17. Cf. *ibid.*, p. 226.
 18. *Ibid.*, p. 245.
 19. Popper, "Utopia and Violence," *Conjectures and Refutations*, *op. cit.*, p. 357. Cf. his "The History of Our Time: An Optimist's View," *op. cit.*, p. 369.
 20. Cf. Popper, *The Open Society and Its Enemies*, v. II, *op. cit.*, pp. 231 ff.; "Utopia and Violence," *op. cit.*; "The History of Our Time," *op. cit.*; and "Humanism and Reason," *Conjectures and Refutations*, *op. cit.*
 21. Bartley, "Theories of Rationality," *op. cit.*, p. 211.
 22. *Ibid.*, p. 212.
 23. Bartley, *The Retreat to Commitment*, *op. cit.*, pp. xiii–xiv.
 24. *Ibid.*, p. 118.
 25. *Ibid.*
 26. *Ibid.*, p. 121.
 27. *Ibid.*
 28. In my "A Dilemma for W.W. Bartley's Pancritical Rationalism" (*Philosophy of the Social Sciences* 21 [1991]: 86–89), I argue that Bartley's orientation confronts a fundamental dilemma, and if there is no way for such theorists to extricate themselves from it, it would seem that the consistency of the view is in question.

29. Bartley, *The Retreat to Commitment, op. cit.*, p. 134.
30. *Ibid.*, p. 161.
31. *Ibid.*, pp. 163–64.
32. Bartley, "Theories of Rationality," *op. cit.*, p. 209.
33. *Ibid.*, p. 210.
34. *Ibid.*
35. *Ibid.*
36. Pascal, for example, seems to claim that one must reject the rationalists' orientation and adopt the faith which he recommends before one can actually recognize the truth about either ourselves or the world.
37. *Ibid.*, p. 165.
38. Chisholm, *Theory of Knowledge, op. cit.*, p. 121. Cf. Moore, "Four Forms of Scepticism," *op. cit.*, pp. 200 and 226, and "Certainty," *op. cit.*, pp. 227–28, and 244–47.
39. Chisholm, *The Problem of the Criterion, op. cit.*, pp. 37–38.
40. The option of showing that the opponents' views are internally inconsistent is ruled out here. As I have pointed out, if one *accepts* the qualified realistic rationalists', skeptics', fideists', kerygmatic rationalists', or unqualified realistic rationalists' beginning points, one will find it difficult indeed to attempt to expose any serious internal difficulty with these orientations: (a) if one accepts the qualified realists' basic claims in the way they do (as immune to error and lack of warrant), no internal consideration could be raised which could lead one to question these claims; (b) if one accepts the fideists', kerygmatic rationalists', or unqualified realists' articles of faith (claims which neither receive nor require argumentative support or proof), no internal considerations could lead to the questioning of these beliefs; and (c) if one accepts the skeptics' unrelenting demand for justifications, their challenge seems unavoidable. I have also argued that attempts to show naturalism is self-refuting are misdirected and incorrect—popular critiques rule out the possibility of a consistent naturalism only by attributing nonnaturalistic views to this orientation.
41. Pascal, *Pensées., op. cit.*, section 435.

CHAPTER 7: NATURALIZED RATIONALITY: EFFECTIVE, NONARBITRARY, GROUNDLESS BELIEF

1. Cf. Quine, "Posits and Reality," *op. cit.*, p. 239.
2. Cf. Wittgenstein, *On Certainty, op. cit.*, section 317.
3. Cf. *ibid.*, section 617.
4. Cf. *ibid.*, sections 358–59, 429, 474, 617–18; and *Zettel, op. cit.*, sections 358, 364, 545, and 700.
5. *Ibid.*, section 422.
6. One may reject the aim-oriented and problem-solving models, of course, but one will nonetheless need to specify *something* in virtue of which the alternatives are termed "alternatives." Whatever one appeals to here, that in virtue of which the alternatives are deemed competitors provides us with a nonarbitrary (but only weakly independent) standard against which we may evaluate our choices, preferences, and commitments.
7. Pascal, *Pensées, op. cit.*, section 72.
8. *Ibid.*, section 195.
9. Kekes, "A New Defense of Common Sense," *op. cit.*, p. 118.
10. Cf. Kekes, *The Nature of Philosophy, op. cit.*, p. 210 and section 2 above.

11. The theme runs throughout Pascal's *Pensées*, *op. cit.*—cf. section 72 especially.

12. Cf. Toulmin, *Human Understanding* (Princeton: Princeton Univ. Press 1972), p. 232.

13. Cf. *ibid.*, pp. 232-42.

14. In addition to the discussion in section 28, the following passages in Quine's works advance such an account: *Methods of Logic, op. cit.*, p. xii; "Two Dogmas of Empiricism," *op. cit.*, pp. 44-46; "Identity, Ostension, and Hypostasis," *op. cit.*, p. 79; *The Roots of Reference, op. cit.*, pp. 137-41; and "Theories and Things," *op. cit.*, p. 1.

15. Similarly, of course, one proposed revision may better meet the criteria set forth by the pragmatic standard, while another may be superior when judged relative to the empiricistic one.

16. Cf. Quine, "On Empirically Equivalent Systems of the World," *op. cit.*, p. 329.

17. Individuals might encounter situations where their abilities or their resources are so limited that they cannot pursue several revisions at once (they might run up against the limited size of their memory or computational capacity, there might not be a sufficient number of researchers to pursue the differing avenues of conceptual revision, or the chances of uncovering a difference in the future might be judged very low relative to the social cost of pursuing several alternatives).

18. If there were some other weakly independent standard to appeal to, naturalists would heartily recommend that individuals appeal to *it* to legitimate their choice. Whatever this was, of course, the hypothesized situation might still arise (one needs only suppose a case where different proposals for revision meet *this* standard equally well). Of course, the naturalists' explanatory account of our predicament, environment, and theory-changing role does not provide any reason for believing that we need to allow for such an additional step—according to their studies, our basic problems, aims, and evaluative standards provide us with our "final" or "ultimate" court of appeal here (though, of course, they advance this claim as a *naturalistic* claim.

19. Cf. Quine, *Word and Object, op. cit.*, p. 24, and "Things and Their Place in Theories," *op. cit.*, pp. 21-23; and Wittgenstein, *On Certainty, op. cit.*, section 205.

20. Cf., for example, section 6 above for a discussion of Rescher's complex view of the connection between pragmatic success and theoretical adequacy (or truthfulness). While he is sensitive to the fideists' and skeptics' challenges and worries here, Rescher claims his metaphysical argument disposes of the worries by showing that the pragmatic methodology which he champions is the correct one for human inquiry. Fallibilists sometimes join empiricists and pragmatists in offering this sort of response. Popper, for example, would avoid advancing a theory of *truth* yet he wishes to claim that the fallibilistic standard he recommends is the objectively correct one (or, at least, that it—unlike any other proposed methodologies—is indeed truth-conducive).

21. Cf. Quine, "Things and Their Place in Theories," *op. cit.*, p. 22.

22. Quine, "On the Very Idea of a Third Dogma," *Theories and Things, op. cit.*, p. 39.

23. Cf. Quine, "Empirical Content," *Theories and Things, op. cit.*, p. 24.

24. From an address by W.S. Churchill to the House of Commons on a Parliament Bill (November 11, 1947) in *W.S. Churchill: His Complete Speeches 1897-1963*, R.R. James (ed.), v. 7 (N.Y.: Chelsea House, 1974), p. 7566.

25. Cf. Campbell, "Evolutionary Epistemology," *op. cit.*; Wächtershäuser,

"Light and Life: On the Nutritional Origins of Sensory Perception," *op. cit.*; and Skagestad, "Taking Evolution Seriously: Critical Comments on D.T. Campbell's Evolutionary Epistemology," *op. cit.*; as well as the discussion in section 25 above.

26. Cf. Quine, "Natural Kinds," *op. cit.*, pp. 126-28; "Epistemology Naturalized," *op. cit.*, p. 90; *The Roots of Reference*, *op. cit.*, pp. 19-20 and 22-23; and Quine and Ullian, *The Web of Belief* (first edition), *op. cit.*, pp. 45-46, 57-58, and 82-83.

27. Cf. Laudan, *Science and Values* (Berkeley: University of California Press, 1984) (esp. pp. 62-66, and 84). Laudan maintains that it is not necessary that one feature remain constant throughout a lengthy series of changes, as long as at particular points in the process there is an unchanging feature which may serve as a weakly independent evaluative standard.

CHAPTER 8: EXPLAINING NATURALISTICALLY WHY WE SHOULD BE RATIONAL

1. Cf. sections 25, 28, 35, 36, and 37 above. Of course, there are important and significant differences in physiological capacities, environments, theories, etc. These differences (especially when they are coupled with the inadequacies of the initial theory) are among the factors which help activate our theory-changing propensity.

2. It is important to remember, however, that explanatory naturalists maintain that we should not speak of individuals as *choosing* their initial held theory (cf. section 18 above), and it is also important to remember that we could not speak of the commonly held initial theory and the other one (should there be such) as *alternatives*—since there would be nothing in virtue of which they could be deemed alternatives (differing as they would regarding even the most basic of problems, aims, and theories).

3. I have argued throughout this work that if explanatory naturalists attempt to develop such an argument, they will be attempting to provide the sort of strongly independent justifications and evaluations which require that, at a minimum, they qualify their naturalism. I have argued that naturalists who endeavor to assign such necessity to the basic problems, aims, or held theory, must ultimately sacrifice their naturalism; and that this argument will not suffice against the skeptics and fideists who will find that such naturalists leave themselves open to question.

4. Kekes, *The Nature of Philosophy*, *op. cit.*, p. 210. Also relevant here are the discussions of Kekes, Briskman, and Annis in sections 2, 3, 4 above; the discussion of Campbell and Skagestad in section 25; and the discussion as to whether fideists such as Pascal constitute a counter-example to the naturalists' claim that we all share the initial held-theory (in section 36).

5. Naturalists would note with Kekes, however, that since we generally theorize in order to resolve our problems (and to achieve our aims), and since the naturalists' studies explicate the particular efficacy of these standards *vis-à-vis* these goals, it would not be particularly prudent to neglect, forsake, or misapply them. This claim will be developed in sections 41 and 42.

6. Cf. Quine and Ullian, *The Web of Belief*, *op. cit.*, p. 92, and the "Introduction" to Quine's *Methods of Logic*, *op. cit.*

7. Quine and Ullian mention the influence of prejudice, self-interest, and ignorance upon the process of theory revision on p. 92 of their *The Web of Belief*, *op. cit.*

8. Cf., for example, W. Alston, "The Deontological Conception of Epistemic Justification" reprinted in his *Epistemic Justification* (Ithaca: Cornell Univ. Press,

NOTES TO PAGES 212-224 257

1989), pp. 115-52, esp. pp. 119 ff. W. Lycan and G. Schleshinger's "You Bet Your Life: Pascal's Wager Revisited" in J. Feinberg's *Reason and Responsibility* (Seventh Edition) (Belmont: Wadsworth, 1989), pp. 82-90 provides an excellent treatment of Pascal on this point. Sextus, of course, recognizes the difficulty of withholding assent and attaining the peace of mind which skeptics seek. The tropes which he offers are meant to aid us in avoiding belief and, thus, dogmatism. He recognizes that it takes both time and effort to modify our general cognitive habits, however, and he certainly does not suggest that we have direct voluntary control over our beliefs (it is, rather, the indirect control model which he has in mind).

9. Cf. Alston, "The Deontological Conception of Epistemic Justification," *op. cit.*, pp. 136 ff.

10. In addition to the arguments of Popper and Bartley discussed in chapter 1, see J. Agassi, "Rationality and the *Tu Quoque* Argument," *Inquiry* 16 (1973): 395-406.

11. Siegel, *Educating Reason* (New York: Routledge, 1988), p. 132.

12. Cf. Kai Nielsen, "Why Should I Be Moral?" *Methodos* 15 (1963): 275-306; "Why Should I Be Moral? Revisited," *American Philosophical Quarterly* 21 (1984): 81-91; and Paul Taylor, *Principles of Ethics*, (Belmont: Wadsworth, 1975), ch. 9.

13. Pascal, *Pensées, op. cit.*, section 248. Pascal maintains that "faith is: God felt by the heart, not by the reason" (*ibid.*, section 278). According to the Bible, "faith is the substance of things hoped for, the evidence of things not seen," The Bible (King James Version), Hebrews 11:1.

14. *Ibid.*, section 268. It is worthwhile to contrast this passage with the passage from Aristotle cited in section 12 where he claims that those who demand a proof of the law of contradiction show a "want of education" (cf. Aristotle, *Metaphysics, op. cit.*, bk. IV, ch. 4, 1006a 2-22).

15. Pierre Bayle, *Historical and Critical Dictionary, op. cit.*, p. 205. Bayle is citing a passage from François de la Mothe le Vayer's *De la Vertu des Paiens*.

16. *Ibid.*, pp. 205-6.

17. *Ibid.*, p. 206.

18. Pascal, *Pensées, op. cit.*, section 194.

19. *Ibid.*, section 434.

20. Siegel, *op. cit.*, p. 132.

21. Pascal, *Pensées, op. cit.*, section 434.

22. *Ibid.*, section 282.

23. Cited in Bayle, *Historical and Critical Dictionary, op. cit.*, pp. 206-7.

24. Cf. Bartley, *The Retreat to Commitment, op. cit.*, pp. 76-77.

25. Cf. *ibid.*, p. 82.

26. Similarly, the skeptic may not be advancing arguments *for* skepticism but, rather, engaging in a therapeutic enterprise designed to transform us from dogmatists into individuals with peace of mind. On this interpretation, the skeptical tropes are not meant to be arguments for a skeptical conclusion but, rather, tools to be employed in the attainment of tranquillity. Cf. Avner Cohen's "Sextus Empiricus: Scepticism as a Therapy," (*Philosophical Forum* 15 [1984]: 405-24) for an elaboration of this sort of reading of the skeptical "arguments."

27. Cf. R.M. Adams, "Kierkegaard's Arguments Against Objective Reasoning in Religion," *The Virtue of Faith* (N.Y.: Oxford Univ. Press, 1987), pp. 25-41.

28. Kierkegaard, *Philosophical Fragments, op. cit.*, p. 104.

29. Adams, "Kierkegaard's Arguments Against Objective Reasoning in Religion," *op. cit.*, p. 27.

30. Kierkegaard, *Concluding Unscientific Postscript*, D.F. Swenson (trans.) (intro-

duction, notes, and completion of the translation by W. Lowrie) (Princeton: Princeton Univ. Press, 1941), p. 189.

31. Kierkegaard, *Fear and Trembling*, W. Lowrie (trans.), in Lowrie's *Fear and Trembling and The Sickness Unto Death* (Princeton: Princeton Univ. Press, 1954), p. 131.

32. Kierkegaard, *Concluding Unscientific Postscript*, *op. cit.*, p. 182.

33. Cf. Adams, "Kierkegaard's Arguments Against Objective Reasoning in Religion," *op. cit.*, p. 27 and pp. 34-35.

34. *Ibid.*, p. 39.

35. Cf. J.O. Urmson, "Saints and Heroes," *Essays in Moral Philosophy*, A.I. Melden (ed.) (Seattle: University of Washington Press, 1958), pp. 198-216. In his "Famine, Affluence, and Morality" (*Philosophy and Public Affairs* 1 [1972]: pp. 229-43) Peter Singer offers an important critique of Urmson's argument. Singer claims that if we have high expectations for individuals' actions, individuals may well be able to accomplish saintly and heroic acts which they would not be able to accomplish without such expectations. Fideists might wish to offer a similar response to the parallel argument regarding passion. However, while it may well be that individuals may be capable of meeting higher expectations than those they are currently held to, this does not mean that they are capable of meeting ever increasing levels of expectation. Individuals may be capable of greater passions than they currently manifest, but this by itself does not establish that they are capable of "infinite" passions.

36. Cf. The Bible, *op. cit.*, Genesis 22 for the story of Abraham and Isaac, and see Kierkegaard's *Fear and Trembling*, *op. cit.*, pp. 30-37, and 69-77, for his discussion of this story.

37. Kierkegaard, *Fear and Trembling*, *op. cit.*, p. 36. Kierkegaard's treatment of the story (like a number of others) ignores the fact that in addition to his son Isaac (with Sarah when he was one hundred years old), Abraham had a son Ishmael (with Hagar when he was eighty-six). Midrashic commentaries on Genesis 22 relate that when asked to offer his son's life, Abraham replies that he has two sons—both the only sons of their (respective) mothers; when asked to offer the life of the one he loves, he replies that he loves them both; and then he is commanded to offer the life of Isaac. I doubt that the level of sacrifice is decreased, however, by the existence of Isaac's brother—it is clear that Abraham's hopes and expectations rely upon Isaac's prospects (why else would he wait patiently for twenty years for a son when he already had one).

38. It is not clear to me whether it is appropriate to speak of the sort of passion which Pascal and Kierkegaard recommend as one which differs from that which we normally have in kind, or whether the difference is simply one of degree. The critical point may be made in connection with either claim, however.

39. A similar sort of objection is classically raised against Pascal's wager argument. It is claimed that to fulfill the spirit of the wager, one must be willing to manifest the degree of commitment of the early Christians who martyred themselves for their religion, and this degree of commitment is one which is beyond the ken of most individuals. Cf. Lycan and Schleshinger's "You Bet Your Life: Pascal's Wager Reconsidered," *op. cit.*, for a discussion of this sort of criticism. In defending Pascal, Lycan and Schlesinger contend that the infinite payoff promised by the fideist undercuts the martyrdom objection, but I believe the line of argument advanced against Kierkegaard above applies here as well—while some individuals might be able to manifest the requisite infinite passion (or commitment), I believe most individuals are as unable to martyr themselves as they are unable to sacrifice their

loved ones as burnt offerings. This level of passion or commitment is, I believe, well beyond that which most individuals are capable of.

40. Cf. Kierkegaard, *Concluding Unscientific Postscript, op. cit.*, pp. 434–45.

41. Kierkegaard, *Fear and Trembling, op. cit.*, p. 72. Cf. Kierkegaard's *Concluding Unscientific Postscript, op. cit.*, pp. 434–45 where he maintains that while pursuing mundane activities such as going to the park, one can manifest a passion which will "bring the God-idea into relation with it" (p. 435) so that one can "stand related to God in an absolutely decisive manner" (p. 440). Whether the activity is an extraordinary one like Abraham's or a mundane one, Kierkegaard maintains that one's "inwardness determines the significance" (p. 442) of the act.

42. Pascal, *Pensées, op. cit.*, section 195.

43. Naturalists would appeal to Darwinian considerations to support this contention—groups which adhered to largely unproductive revised theories should fail to survive over the long run given what naturalists have to say about our basic problems and aims. As is the case with any such Darwinistic argument, however, it must be stressed that such considerations would apply only over a rather long time period and only in the case of a group which adopted a largely unproductive revised theory.

44. Wittgenstein, *Philosophical Investigations*, I, 126.

Bibliography

Adams, Robert M. "Kierkegaard's Arguments Against Objective Reasoning in Religion." In his *The Virtue of Faith*. New York: Oxford Univ. Press, 1987.

Agassi, Joseph. "Rationality and the *Tu Quoque* Argument." *Inquiry* 16 (1973): 395–406.

Alston, William. "Varieties of Privileged Access." *American Philosophical Quarterly* 8 (1971): 223–41.

———. "Two Types of Foundationalism." *Journal of Philosophy* 73 (1976): 165–85.

———. "Level Confusions in Epistemology." *Midwest Studies in Philosophy* 5 (1980): 135–50.

———. "The Deontological Conception of Epistemic Justification." In his *Epistemic Justification*. Ithaca: Cornell Univ. Press, 1989.

———. "Self-Warrant: A Neglected Form of Privileged Access." In his *Epistemic Justification*. Ithaca: Cornell Univ. Press, 1989.

Altman, Andrew, and Bradie, Michael. "Meaning, Truth, and Evidence." *Southern Journal of Philosophy* 18 (1980): 113–22.

Annis, David. "A Contextualistic Theory of Epistemic Justification." *American Philosophical Quarterly* 15 (1978): 213–19.

Aristotle. *Metaphysics*. In *Basic Works of Aristotle*. Translated by W. D. Ross. New York: Random House, 1941.

Aune, Bruce. "Remarks on Argument by Chisholm." *Philosophical Studies* 23 (1972): 327–34.

Ayer, A.J. *The Problem of Knowledge*. New York: Penguin, 1956.

Bartley, William W. "Rationality *vs.* the Theory of Rationality." In *The Critical Approach*, edited by M. Bunge. New York: Free Press, 1964.

———. *The Retreat to Commitment*. 2nd ed. La Salle, Ill.: Open Court, 1984.

———. "Philosophy of Biology versus Philosophy of Physics." In *Evolutionary Epistemology, Rationality, and the Sociology of Knowledge,* edited by G. Radnitzky and W. W. Bartley. La Salle, Ill.: Open Court, 1987.

———. "Theories of Rationality." In *Evolutionary Epistemology, Rationality, and the Sociology of Knowledge,* edited by G. Radnitzky and W. W. Bartley. La Salle, Ill.: Open Court, 1987.

Bayle, Pierre. *Historical and Critical Dictionary.* Translated by Richard H. Popkin. Indianapolis: Hackett, 1991.

Bogen, James. "Wittgenstein and Skepticism." *Philosophical Review* 83 (1974): 364-73.

Briskman, Larry. "Historicist Relativism and Bootstrap Rationality." *Monist* 60 (1977): 509-39.

Burnyeat, Myles F. "Protagoras and Self-Refutation In Later Greek Philosophy." *Philosophical Review* 85 (1976): 44-69.

―――. "Protagoras and Self-Refutation in Plato's Theaetetus." *Philosophical Review* 85 (1976): 172-95.

Campbell, Donald T. " 'Downward Causation' in Hierarchically Organized Biological Systems." In *Studies in the Philosophy of Biology,* edited by F. Ayala and T. Dobzhansky. New York: Macmillan, 1974.

―――. "Unjustified Variation and Selective Retention in Scientific Discovery." In *Studies in the Philosophy of Biology,* edited by F. Ayala and T. Dobzhansky. New York: Macmillan, 1974.

―――. "Evolutionary Epistemology." In *The Philosophy of Karl Popper.* Vol. XIV, 1, edited by P.A. Schilpp. La Salle, Ill.: Open Court, 1974.

Chisholm, Roderick. *The Problem of The Criterion.* Milwaukee: Marquette Univ. Press, 1973.

―――. "On The Nature of Empirical Evidence." In *Empirical Knowledge,* edited by Roderick Chisholm, and Robert Schwartz. Englewood Cliffs: Prentice Hall, 1973.

―――. *Theory of Knowledge.* 2d ed. Englewood Cliffs: Prentice Hall, 1977.

Cohen, Avner. "Sextus Empiricus: Scepticism As A Therapy." *Philosophical Forum* 15 (1984): 405-24.

Churchill, Winston S. *W. S. Churchill: His Complete Speeches 1897-1963.* Vol. 7. Edited by R. R. James. New York: Chelsea House, 1974.

Double, Richard. "Quine and the Determinateness of Reference." *Kinesis* 7 (1970): 49-61.

Dummett, Michael. *Truth and Other Enigmas.* Cambridge: Harvard Univ. Press, 1978.

Evans-Prichard, Edward E. *Witchcraft, Oracles and Magic Among the Azande.* Oxford: Oxford University Press, 1937.

Fogelin, Robert. "Wittgenstein and Classical Skepticism." *International Philosophical Quarterly* 21 (1981): 3-15.

Frazer, James. *The Golden Bough.* New York: Macmillan, 1950.

Goldman, Alan. "Appearing Statements and Epistemological Foundations." *Metaphilosophy* 10 (1979): 227-46.

―――. "Realism." *Southern Journal of Philosophy* 17 (1979): 175-92.

Goodman, Nelson. *Ways of Worldmaking*. Indianapolis: Hackett, 1978.
Hamlyn, D.W. *The Theory of Knowledge*. New York: Macmillan, 1970.
Harman, Gilbert. *Thought*. Princeton: Princeton Univ. Press, 1973.
Haack, Robin. "Wittgenstein's Pragmatism." *American Philosophical Quarterly* 19 (1982): 163-71.
Hauptli, Bruce. "Quine's Theorizing About Theories." *Synthese* 57 (1983): 21-33.
———. "Kekes on Problem-Solving and Rationality." *Philosophy of the Social Sciences* 14 (1984): 191-94.
———. "A Dilemma for W.W. Bartley's Pancritical Rationalism." *Philosophy of the Social Sciences* 21 (1991): 86-89.
Hume, David. *Dialogues Concerning Natural Religion*. Edited by N.K. Smith. London: Thomas Nelson and Sons, 1947.
Kant, Immanuel. *Critique of Pure Reason*. Translated by N.K. Smith. Toronto: Macmillan, 1929.
Kekes, John. *A Justification of Rationality*. Albany: SUNY Press, 1976.
———. "Rationality and Problem-Solving." *Philosophy of the Social Sciences* 7 (1977): 351-66.
———. "The Centrality of Problem-Solving." *Inquiry* 22 (1979): 405-21.
———. "A New Defense of Common Sense." *American Philosophical Quarterly* 16 (1979): 115-22.
———. *The Nature of Philosophy*. Totowa, N.J.: Rowman and Littlefield, 1980.
———. "Philosophy, Historicism, and Foundationalism," *Philosophia* 13 (1983): 213-33.
Kierkegaard, Søren. *Concluding Unscientific Postscript*. Translated by D.F. Swenson. Princeton: Princeton Univ. Press, 1941.
———. *Fear and Trembling and The Sickness Unto Death*. Translated by W. Lowrie. Princeton: Princeton Univ. Press, 1954.
———. *Philosophical Fragments, or A Fragment of Philosophy*. 2d ed. Translated by D.F. Swenson, and revised by H.V. Hong. Princeton: Princeton Univ. Press, 1962.
Korner, Stephen. "The Impossibility of Transcendental Deductions." *Monist* 51 (1967): 317-31.
———. *Categorical Frameworks*. Oxford: Basil Blackwell, 1970.
Laudan, Larry. *Progress and Its Problems*. Berkeley: Univ. of California Press, 1977.
———. *Science and Values*. Berkeley: Univ. of California Press, 1984.
Lehrer, Keith. *Knowledge*. Oxford: Clarendon, 1974.

Lovejoy, Arthur O. *The Thirteen Pragmatisms and Other Essays.* Baltimore: Johns Hopkins, 1963.

Luckhardt, C.G. "Wittgenstein: Investigations 50." *Southern Journal of Philosophy* 15 (1977): 81-90.

Lycan, William, and Schlesinger, George. "You Bet Your Life: Pascal's Wager Revisited." In *Reason and Responsibility,* 7th ed., edited by Joel Feinberg. Belmont: Wadsworth, 1989.

Mackie, John L. "Self-refutation—A Formal Analysis." *Philosophical Quarterly* 14 (1964): 193-203.

Mandlebaum, Maurice. "Some Instances of the Self-Excepting Fallacy." *Psychologische Beitrage* 6 (1962): 383-86.

———. *History, Man, and Reason.* Baltimore: Johns Hopkins Univ. Press, 1971.

———. "Subjective, Objective, and Conceptual Relativisms." *Monist* 62 (1979): 403-28.

Margolis, Joseph. "Behaviorism and Alien Languages." *Philosophia* 3 (1973): 413-27.

Meiland, Jack. "Bernard Williams' Relativism." *Mind* 88 (1979): 258-62.

———. "On the Paradox of Cognitive Relativism." *Metaphilosophy* 11 (1980): 115-26.

Moore, George E. "A Defense of Common Sense." In his *Philosophical Papers.* London: Allen and Unwin, 1959.

———. "Certainty." In his *Philosophical Papers.* London: Allen and Unwin, 1959.

———. "Four Forms of Skepticism." In his *Philosophical Papers.* London: Allen and Unwin, 1959.

———. "Proof of An External World." In his *Philosophical Papers.* London: Allen and Unwin, 1959.

Neurath, Otto. "Protocol Sentences." Translated by G. Schlick. In *Logical Positivism,* edited by A.J. Ayer. New York: Free Press, 1959.

Nielsen, Kai. "Why Should I Be Moral?" *Methodos* 15 (1963): 275-306.

———. "Wittgensteinian Fideism." *Philosophy* 42 (1967): 191-209.

———. "Why Should I Be Moral? Revisited." *American Philosophical Quarterly* 21 (1984): 81-91.

Pappas, George, and Swain, Marshall, eds. *Essays on Knowledge and Justification.* Ithaca: Cornell Univ. Press, 1978.

Pascal, Blaise. *Pensées.* Translated by W.F. Trotter. New York: Dutton, 1958.

Popkin, Richard H. "Theological and Religious Scepticism." *Soundings* 39 (1956): 150-58.

———. "Kierkegaard and Scepticism." *Algemeen Nederlands Tijdschrift voor Wijsbegeerte en Psychologie* 51 (1959): 123–41.

———. "Hume and Kierkegaard." In his *The High Road to Pyrrhonism*. San Diego: Austin Hill, 1980.

Popper, Karl. "Humanism and Reason." In his *Conjectures and Refutations*. New York: Harper and Row, 1963.

———. "On the Sources of Knowledge and Ignorance." In his *Conjectures and Refutations*. New York: Harper and Row, 1963.

———. "On the Status of Science and of Metaphysics." In his *Conjectures and Refutations*. New York: Harper and Row, 1963.

———. "The History of Our Time: An Optimist's View." In his *Conjectures and Refutations*. New York: Harper and Row, 1963.

———. "Three Views Concerning Human Knowledge." In his *Conjectures and Refutations*. New York: Harper and Row, 1963.

———. "Truth, Rationality, and the Growth of Knowledge." In his *Conjectures and Refutations*. New York: Harper and Row, 1963.

———. "Utopia and Violence." In his *Conjectures and Refutations*. New York: Harper and Row, 1963.

———. *The Open Society and Its Enemies*. Vol. 2. Princeton: Princeton Univ. Press, 1966.

Postow, B. "Dishonest Relativism." *Analysis* 34 (1979): 115–18.

Putnam, Hilary. *Meaning and the Moral Sciences*. London: Routledge and Kegan Paul, 1978.

Quine, Willard V. *Methods of Logic*. New York: Holt, Rinehart and Winston, 1950.

———. "Identity, Ostension, and Hypostasis." In his *From A Logical Point of View*. Cambridge: Harvard Univ. Press, 1953.

———. "Logic and the Reification of Universals." In his *From A Logical Point of View*. Cambridge: Harvard Univ. Press, 1953.

———. "On What There Is." In his *From A Logical Point of View*. Cambridge: Harvard Univ. Press, 1953.

———. "Notes on the Theory of Reference." In his *From a Logical Point of View*. Cambridge: Harvard Univ. Press, 1953.

———. "Two Dogmas of Empiricism." In his *From a Logical Point of View*. Cambridge: Harvard Univ. Press, 1953.

———. *Word and Object*. Cambridge: MIT Press, 1960.

———. "On Carnap's Views on Ontology." In his *The Ways of Paradox*. New York: Random House, 1966.

———. "On Mental Entities." In his *The Ways of Paradox*. New York: Random House, 1966.

———. "On Simple Theories of a Complex World." In his *The Ways of Paradox*. New York: Random House, 1966.

———. "Posits and Reality." In his *The Ways of Paradox*. New York: Random House, 1966.

———. "The Scope and Language of Science." In his *The Ways of Paradox*. New York: Random House, 1966.

———. "Epistemology Naturalized." In his *Ontological Relativity and Other Essays*. New York: Columbia Univ. Press, 1969.

———. "Natural Kinds." In his *Ontological Relativity and Other Essays*. New York: Columbia Univ. Press, 1969.

———. "Ontological Relativity." In his *Ontological Relativity and Other Essays*. New York: Columbia Univ. Press, 1969.

———. "Speaking of Objects." In his *Ontological Relativity and Other Essays*. New York: Columbia Univ. Press, 1969.

———. "Philosophical Progress in Language Theory." In *Language, Belief, and Metaphysics,* edited by M. Munitz. Albany: SUNY Press, 1970.

———. *The Roots of Reference*. La Salle, Ill.: Open Court, 1973.

———. "On Empirically Equivalent Systems of the World." *Erkenntnis* 9 (1975): 318–28.

———. "Mind and Verbal Dispositions." In *Mind and Language,* edited by S. Guttenplan. Oxford: Clarendon, 1975.

———. "Facts of the Matter." *Southwestern Journal of Philosophy* 9 (1979): 155–69.

———. "Empirical Content." In his *Theories and Things*. Cambridge: Harvard, 1981.

———. "On The Very Idea of A Third Dogma." In his *Theories and Things*. Cambridge: Harvard, 1981.

———. "Things and Their Place in Theories." In his *Theories and Things*. Cambridge: Harvard, 1981.

———. "Reply to Stroud." *Midwest Studies in Philosophy* 6 (1981): 473–75.

———. "The Pragmatists' Place In Empiricism." In *Pragmatism, Its Sources and Prospects,* edited by R. Mulvaney and P. Zeltner. Columbia: Univ. of South Carolina Press, 1981: pp. 35–37.

———. "Relativism and Absolutism." *Monist* 67 (1984): 293–96.

Quine, Willard V. and Ullian, Joseph. *The Web of Belief*. New York: Random House, 1970.

Rescher, Nicholas. *The Coherence Theory of Truth*. Oxford: Oxford Univ. Press, 1973.

———. *Methodological Pragmatism*. Oxford: Oxford Univ. Press, 1977.

Roth, Paul. "Theories of Nature and the Nature of Theories." *Mind* 89 (1980): 431-38.
Russell, Bertrand. *Philosophical Essays*. London: Longmans, Green, 1910.
Scheffler, Israel. *Science and Subjectivity*. Indianapolis: Bobbs-Merrill, 1969.
Schoen, Edward L. "Introspection and the Inscrutability of Reference." *Southern Journal of Philosophy* 17 (1979): 523-29.
Shapere, D. "The Structure of Scientific Revolutions." *Philosophical Review* 73 (1964): 383-94.
Siegel, Harvey. *Educating Reason*. New York: Routledge, 1988.
Singer, Peter. "Famine, Affluence, and Morality." *Philosophy and Public Affairs* 1 (1972): 229-43.
Skagestad, Peter. "Taking Evolution Seriously: Critical Comments on D.T. Campbell's Evolutionary Epistemology." *Monist* 61 (1978): 611-21.
Taylor, Paul. *Principles of Ethics*. Belmont: Wadsworth, 1975.
Toulmin, Stephen. *Human Understanding*. Princeton: Princeton Univ. Press, 1972.
Urmson, J.O. "Saints and Heroes." In *Essays in Moral Philosophy*, edited by A.I. Melden. Seattle: Univ. of Washington Press, 1958.
Wächtershäuser, Günter. "Light and Life: On the Nutritional Origins of Sensory Perception." In *Evolutionary Epistemology, Rationality, and the Sociology of Knowledge*, edited by G. Radnitzky, and W.W. Bartley. La Salle, Ill: Open Court, 1987.
Winch, Peter. *The Idea of A Social Science*. London: Routledge and Kegan Paul, 1958.
———. "Nature and Convention." *Proceedings and Addresses of the Aristotelian Society* 50 (1959): 231-52.
———. "Understanding A Primitive Society." *American Philosophical Quarterly* 1 (1964): 307-25.
Williams, Bernard. *Morality: An Introduction to Ethics*. New York: Harper and Row, 1972.
Wittgenstein, Ludwig. *Philosophical Investigations*. Translated by G.E.M. Anscombe. New York: Macmillan, 1953.
———. *Zettel*. Translated by G.E.M. Anscombe and G.H. von Wright. Berkeley: University of California, 1967.
———. *On Certainty*. Translated by G.E.M. Anscombe and G.H. von Wright. New York: Harper, 1969.
———. "Lectures on Religious Belief." In his *Lectures and Conversations on Aesthetics, Psychology and Religious Belief*. Compiled by Cyril Berrett. Berkeley: Univ. of California, 1972.

———. "Remarks on Frazer's Golden Bough." Translated by A.C. Miles. Retford: Byrnmill, 1979.

Index

Abraham (patriarch), 226–28
Adams, Robert M., 224–25, 226
Alton, William, 27–29, 34–35, 43, 53
 therapy argument of, 162
Annis, David, 9–10, 63
arbitrariness problem
 and Alston, 34–36
 and fideism, 136, 175, 195
 and foundationalism, 28
 and naturalism, ix, 70, 78–79, 80–82, 84–85, 86, 102, 126, 176, 184, 192, 198, 200, 204
 and naturalism, descriptive, ix, 145, 149, 235
 and naturalism, explanatory, 102, 127, 139, 144, 148, 150, 173, 175, 177–78, 181, 183–90, 196, 199–202, 206, 235
 and Popper, 20, 22, 25, 34, 38, 70
 and Quine, 127, 145
 and rationalism, kerygmatic, 30, 34, 136, 175, 176
 and rationalism, realistic, 30, 44–46, 48, 51–52, 58–59, 67, 68, 136, 152, 174, 175, 176
 and Wittgenstein, 127, 136, 186–87
Aristotle, 47, 48, 50
Augustinian approach, 32
Ayer, A.J., 170
 The Problem of Knowledge, 170

Azande, 128–30

Bartley, William W., III, viii, 2, 16, 20–26, 165–73, 176, 222, 223
 The Retreat to Commitment, 166, 172
 therapy argument of, 169, 171–72
Bayle, Pierre, 2, 33, 219
 Historical and Critical Dictionary, 217–18, 221
Bergson, Henri, 32
Bogen, James, 251 n.5
Briskman, Larry, 7–9, 10, 13, 61–64, 82–85, 96
 Darwinism of, 8, 85, 86, 115
Burnyeat, Myles F., 87–88

Calvin, John, 221
Campbell, Donald T., 140, 204
 and Darwinism, 115–16, 139
categorical imperative, 234, 237
Catholics, 126–27
Charron, Pierre, 33
Chisholm, Roderick, 53–56, 68, 150, 152, 174, 176
Christianity, 168, 175, 218–21
Churchill, Winston, 204
coherentism (ists), 16, 38, 41, 51, 52
comprehensive rationalists. *See* rationalism (ists), comprehensive; *see also* rationalism (ists), justificatory

comprehensively critical rationalism. *See* rationalism (ists), comprehensively critical
conceptual diversity and change, problem of, ix, 1
and Briskman, 7–8
and Laudan, 10
and naturalism, 62, 63, 65–66, 69, 79, 81, 82, 83, 85, 108, 125, 127, 141, 149, 184, 189, 190, 198, 229
and naturalism, descriptive, 234
and naturalism, explanatory, 102, 123, 144, 150, 180, 181, 183, 185, 187, 188–90, 196–97, 202–4, 212, 224, 231, 232, 233, 235, 239–40
and pragmatism, 134
and Quine, 118, 127, 145–46
and rationalism, comprehensively critical, 25
and rationalism, realistic, 31–32
and Toulmin, 196
and Wittgenstein, 127, 132, 133, 136
correspondence theory, 91–92
critical rationalists. *See* rationalism (ists), critical

Darwinism (ists), 5, 6–7, 8–9, 13, 82, 85, 86, 115, 235
Descartes, Rene, 57, 103
descriptive naturalism. *See* naturalism, descriptive
Dummett, Michael, 49–50

epistemic levels, 28–29, 34–37, 46, 162–63. *See also* Alston, William

evaluative perspectives, strongly independent, 10, 64, 65, 83, 178–80
and Kekes, 67, 192, 193, 238
and naturalism, 61–65, 79, 80, 81, 82, 85, 89, 90, 95, 96, 178, 186, 189, 190, 193, 199
and naturalism, explanatory, 180, 184, 192, 193, 197, 203, 240
and rationalism, justificatory, 16, 65, 67, 94
and rationalism, realistic, 48
and Toulmin, 197
evaluative perspectives, weakly independent, 10, 83, 178–80, 198
and Briskman, 62
and Kekes, 10, 16, 63
and naturalism, 80, 82, 90, 94, 178, 189, 190, 198
and naturalism, explanatory, 197, 199, 206, 235–236
and rationalism, justificatory, 10–11, 16, 65
and rationalism, realistic, 48
evaluative standards, nonarbitrary
and Briskman, 8–9
and fideism, 32
and Kekes, 6
and naturalism, 82, 84, 150, 178, 189, 190
and naturalism, explanatory, 197, 198–99, 235–36
and rationalism, comprehensively critical, 22
and rationalism, justificatory, 8–10
and rationalism, realistic, 34, 43
and Toulmin, 197

Evans-Prichard, Edward E., 128, 130
explanatory naturalism. *See* naturalism, explanatory
external perennial arguments. *See* perennial arguments, external

faith, leaps of, 158–59
feedback cycles, 11, 15, 16
fideism (ists), ix, 31–34, 57, 150, 156–61, 175, 178, 179, 193, 194, 195–96, 208, 227, 237
 and Bartley, 168–69
 and Bergson, 32
 Christian, viii, 2, 32, 33, 168
 and Kekes, 156–58
 and Kierkegaard, 32, 33, 158, 159, 225, 227–28, 232
 and logical laws, 47
 and Montaigne, 32, 33
 and naturalism, 150, 161
 and naturalism, descriptive, 144
 and naturalism, explanatory, 160–61, 191
 and Pascal, 32, 157–58, 159, 175, 191, 194, 225, 228, 232
 and Popper, 17, 20, 25, 39
 and rationalism, justificatory, 29, 33
 and rationalism, realistic, 32, 34, 36–37
 and Santayana, 32
 and subjectivism, 88
 and Tertullian, 158
 therapy argument of, 158–60
fideistic challenges
 and Alston, 27
 and Bartley, 21, 171–72, 222
 and Briskman, 9
 and Kekes, 3, 5, 6, 7, 237
 and naturalism, 70, 75, 78, 80, 81, 85, 86, 102, 116, 147, 150, 186, 188, 190, 192, 202, 208, 224, 229–31
 and naturalism, explanatory, 102–3, 183, 191–92, 200, 212, 225, 229, 231
 and rationalism, vii, viii, 1–2, 3, 10, 16, 20, 26, 27, 40, 43, 44, 45, 48, 71, 78, 168, 209, 215, 217, 222–23
 and rationalism, comprehensively critical, 26, 222
 and rationalism, justificatory, 40, 67, 68, 70, 217
 and rationalism, realistic, 36–37, 47, 68–69, 70
Frazer, James, 128, 133
foundationalism (ists), 28, 41, 76, 104

Goldman, Alan, 40–44, 150
groundlessness, of belief, 76–77, 79, 81, 180, 184, 187, 190

Harman, Gilbert, 40–41
Homer, 127
Hume, David, 2, 218–219, 220
hypothetical imperative, 236, 239, 240

instrumentalism, 11, 18, 38, 42, 163, 164. *See also* pragmatism; problem-solving approaches; Rescher, Nicholas
internal perennial arguments. *See* perennial arguments, internal

International Prototype Meter, 125
irrationalism (ists), 6, 17, 23, 24, 25, 26, 31, 165, 168. *See also* fideism (ists)
Isaac (patriarch), 226–27

justification, strongly independent. *See* evaluative perspectives, strongly independent
justification, weakly independent. *See* evaluative perspectives, weakly independent
justificatory rationalism. *See* rationalism (ists), justificatory

Kant, Immanuel, 69
Kekes, John, 84, 156–58, 188, 193
 Darwinism of, 6, 7, 13
 natural sciences, appeal to, 4–5
 Popper, compared to, 18–19
 and pragmatism, 156
 on problem-solving, 4–7, 18–19, 208
 rationalism, justificatory of, 3–7, 8, 10, 66, 237–38
 Rescher, compared to, 13, 16
 See also fideistic challenges; skeptical challenges
kerygmatic rationalism. *See* rationalism, kerygmatic
Kierkegaard, Søren, 2, 5, 7, 32, 33, 158–59, 231
 on infinite passion, 224–28, 232
 Philosophical Fragments, 2
Korner, Stephen, 44

language games, 129–30, 132–34
Laudan, Larry, 10, 205
logical laws, 49–50
Lovejoy, Arthur O., 2
Luther, Martin, 5

Mackie, John L., 87
Mandelbaum, Maurice, 95
Meiland, Jack, 95
metaphysical realism (ists), 29, 34, 93
Montaigne, Michel, 32, 33
Moore, George E., ix, 53, 56–58, 68–69, 73–74, 76, 84, 103–8, 127, 133, 134, 152, 176
 therapy argument of, 103–4, 150
 See also skeptical challenges

naturalism (ists), viii, 99, 107, 141, 153–54, 171, 173, 187, 195
 and ahistoricism, rejection of, 61–66
 and Darwinism, 82, 84, 115, 235
 and justification, rejection of, 61–66, 69–71, 101, 139
 and pragmatism, 203–5, 211
 and problem-solving, 232–33
 and Quine, 108–23
 and rationalism, realistic, 101–3
 and relativism, 61–63, 65, 80, 84, 86, 87, 89–90, 92–94, 108, 115, 125–27
 therapy argument of, 127, 136, 139, 149–51, 153, 154, 159–61, 169, 171, 173, 177, 180, 181, 183–84,

192, 208, 211, 213, 229, 234, 237–38, 240
See also arbitrariness problem; conceptual diversity and change, problem of; fideistic challenges; skeptical challenges
naturalism, descriptive, ix, 102, 123, 127, 128–36, 144, 149, 161, 186, 234, 239
naturalism, explanatory, ix, 102–3, 114, 123, 127, 134, 169, 193, 194, 211, 234
 and language, 140, 142
 and pragmatism, 199, 203, 205, 214, 235, 236
 and problem-solving, 188, 197, 201–6, 207–13, 226, 228, 230, 231, 233, 235, 239, 240
 and relativism, 154
 therapy argument of, 149–51, 153–55, 160–61, 171, 173, 175, 179, 183
 and theory-changing, 136–46, 149, 184, 193, 197, 205–6, 207–8, 210, 213–15, 233, 237, 238, 239, 240
 See also arbitrariness problem; conceptual diversity and change, problem of; fideistic challenges; skeptical challenges
naturalism, qualified, 94–99, 101–2, 132, 134, 145, 149–50, 203, 214
Neurath, Otto, 98, 108, 122, 146
Nielsen, Kai, 128–31, 134, 161

Pascal, Blaise, 23, 212, 224
 and Christianity, 2, 32, 175
 and infinite passion, 225, 226, 228, 230–32
 and Kekes, 7, 157–58
 and naturalism, explanatory, 191
 Pensées, 218, 219
 rationality, critique of, 159, 217, 219–21
 therapy argument of, 194–95
 See also fideism (ists)
Peirce, Charles S., 116
perennial arguments
 and naturalism, 145, 173, 206, 209, 212, 215, 237
perennial arguments, external, 3, 6, 70, 156, 165, 180
 and Bartley, 24
 and Kekes, 3, 6
 and naturalism, 59, 79, 80, 81, 82, 91, 102, 116–17, 173, 179
 and naturalism, descriptive, 235
 and naturalism, explanatory, 147, 151, 160, 177, 181, 240
 and rationalism, justificatory, 67
 and rationalism, realistic, 30, 31, 68, 174
perennial arguments, internal, 3, 4, 6, 66, 70, 180
 and Kekes, 3, 6, 66
 and naturalism, 59, 79, 80, 81, 82, 91, 102, 116–17, 147, 173, 179
 and naturalism, descriptive, 235
 and naturalism, explanatory, 151, 153, 177, 181, 240
 and rationalism, justificatory, 66, 67

and rationalism, kerygmatic, 175
and rationalism, realistic, 30, 68, 153, 161–63, 174, 175
Plato, 18, 89
Theaetetus, 89
Popkin, Richard H., 2, 33, 218
Popper, Karl, viii, 16–20, 23–25, 34, 36, 38–39, 43, 44, 70, 80, 176
Conjectures and Refutations, 18, 163
early views, 17, 20, 21, 22, 23, 24, 25, 44, 67, 163–65, 167, 169, 173, 176
faith, role of, 17, 19, 23
and fideism, relation to, 17, 165–66
and Kekes, 18–19
later views, 20, 166, 222
The Open Society and Its Enemies, 18, 163
therapy argument, 165
pragmatic approaches
and Kekes, 19, 156
and naturalism, explanatory, 197, 199, 202–4, 210, 211
and Popper, 18
and Quine, 120
and Rescher, 11–16, 186
and truth, 13, 15, 18, 19
and Wittgenstein, 132, 133
problem-solving approaches, 4, 5, 7, 10, 12, 18, 38, 188, 197, 201. *See also* pragmatic approaches
Protagoras, 87–89
Putnam, Hilary, 170

Quine, Willard V., ix, 11, 62, 91–98, 102, 108–23, 132, 136–47, 170, 171, 185, 195, 198

and behaviorism, 137–38
Darwinism of, 114–15, 139, 204
and naturalism, explanatory, 102, 127, 134, 136–37, 142, 145–46
on language, 117, 137, 142
and pragmatism, 120
and realism, 145, 146
therapy argument of, 123
See also skeptical challenges
rationalism (ists), comprehensive, 16, 17, 20, 172
rationalism (ists), comprehensively critical, 20–26, 166–68, 222, 223
rationalism (ists), critical, 17, 20, 172
rationalism (ists), justificatory, viii–ix, 8, 10, 11, 29, 33, 58, 65, 66–67, 81, 94, 101, 109, 113–14, 161
aim-oriented, 8, 10
and Alston, 27–29, 36
and Bartley, 20–23, 166, 169–70, 172
and Briskman, 61
contextual, 9–10
and Goldman, 43
and Harman, 40
and Kekes, 3–7, 19, 66–67
and naturalism, 61, 65, 69–70, 75, 84, 94, 98–99, 101, 108, 116, 184, 188, 211
and Popper, 20, 21, 36, 39, 167, 169
and Quine, 109–10, 115, 119
and rationalism, comprehensively critical, 20–23, 25, 166

INDEX

and rationalism, realistic,
 27–30, 32, 33, 36, 45, 46,
 50, 58, 59, 67, 68, 70
and Rescher, 14–16, 19,
 39–40, 44–45
and subjectivism, 88
rationalism (ists), kerygmatic,
 viii–ix, 30, 136, 150, 151,
 152, 163, 164, 165, 167,
 169–70, 173, 175, 176
 and naturalism, 75, 76, 80, 81,
 91, 116, 149, 150
 and Popper, 20, 23, 24, 36, 38,
 39
 and rationalism, critical, 20,
 25, 26
 and rationalism, realistic, 34,
 37, 67, 71
 and subjectivism, 88
rationalism (ists), realistic, viii,
 ix, 26–34, 36–37, 41–42,
 43, 45–46, 70, 101
 and kerygmaticism, 33, 35–36,
 38, 43, 45, 46, 50, 51, 52,
 58–59, 68, 70, 101, 163
 qualified, 30, 46–50, 51–53,
 56, 57–59, 68, 69, 70, 75,
 101–3, 105–8, 116, 149,
 150, 151–55, 160, 173–74,
 175, 176, 178, 179
 unqualified, 30, 34, 46, 48, 50,
 51, 52, 58, 59, 67–68, 70,
 75, 81, 101–3, 116, 136,
 149, 150, 151, 152,
 161–64, 169–70, 173, 175,
 176, 179
rationalism (ists), traditional,
 vii–viii, 1–2, 158. *See also*
 rationalism (ists),
 justificatory
realistic rationalism. *See*
 rationalism (ists), realistic
regulative principles, 38, 39, 40,
 41, 43–45, 165
Reid, Thomas, 53
relativism (ists), 86, 94–95, 127
 and Briskman, 61–63, 82, 86,
 115
 and Evans-Prichard, 128–29
 and naturalism, 61–63, 65, 80,
 84, 86, 87, 89–90, 108,
 115, 125–27, 145, 154,
 232, 238
 and Nielsen, 130, 134
 and Quine, 93, 144, 145
 and rationalism, qualified
 realistic, 51
 and Winch, 129–31, 134
 and Wittgenstein, 130
Rescher, Nicholas, 11–16, 19,
 52, 63, 65, 119, 186
 instrumentalistic evaluation, 11
 Kantian procedure, 13
 Methodological Pragmatism, 11
 and regulative principles,
 39–40, 43, 44–45
Roth, Paul, 95–99, 132, 145,
 146, 150
Russell, Bertrand, 12

Santayana, George, 32
Scheffler, Israel, 242 n.18
self-refuting beliefs, 48–50, 87,
 89, 90
self-warranted beliefs, 35–36,
 41, 51, 52–53, 56, 58
Sextus Empiricus, 88–89, 212,
 218
Shapere, D., 242 n.18
Siegel Harvey, 215–16,
 219–20, 222, 223
Skagestad, Peter, 116, 204
skeptical challenges
 and Alston, 27–29, 162
 and Annis, 10
 and Bartley, 20, 222

and Briskman, 7–9
and Chisholm, 53–55, 152, 174, 176
and Goldman, 41, 43
and Kekes, 4–7
and Moore, 56, 74, 102, 103, 106, 152, 176
and naturalism, ix, 71, 75, 78, 80, 81, 85, 86, 98, 108, 112, 116, 120, 150, 154, 184, 186, 208
and naturalism, explanatory, 128, 147, 149–51, 153, 155, 183, 184, 200, 201, 212
and Pascal, 175, 217, 220, 221
and Popper, 20, 163
and Protagoras, 88–89
and Quine, 102, 108–9, 111, 119, 120, 121–23
and rationalism, 33, 209, 216–17, 234
and rationalism, comprehensively critical, 20, 22
and rationalism, justificatory, vii, 1, 2, 3, 8, 10–11, 16, 20, 22, 29, 48, 67, 70, 75, 94, 98, 152, 155
and rationalism, kerygmatic, 30
and rationalism, realistic, 26, 30, 45, 47, 48, 50–53, 58–59, 67, 68, 70, 152–53, 155
and Rescher, 11, 14, 15, 39–40, 65, 119
and Wittgenstein, 102, 103, 105, 107–8
skepticism/skeptics, 158–60, 175, 177, 179

solipsism, 88
stoics, 89
subjectivism (ists), 87–89, 178

Tertullian, 5, 23, 158
Toulmin, Stephen, 196
tu quoque argument, 2, 215, 217, 221, 222, 223

Urmson, J.O., 226, 228

le Vayer, François de la Mothe, 217

Wächtershäuser, Günter, 204
Weil, Simone, 129–30
Waiting for God, 129
Williams, Bernard, 94–95
Winch, Peter, 128–32, 134
The Idea of a Social Science, 128
Wittgenstein, Ludwig, ix, 71, 73–74, 76–77, 79, 87, 108, 123, 125, 130, 131, 161, 170, 171
and language games, 132–35, 186
and naturalism, 126, 134
and naturalism, descriptive, 102, 127, 128, 134–36, 187, 239
and naturalism, qualified, 132–34
On Certainty, 103
and pragmatism, 132, 133, 186
therapy argument of, 104–8, 136
Wittgensteinian fideism, 128, 171, 235

Xenophanes, 18